THE NEW
35mm
HANDBOOK

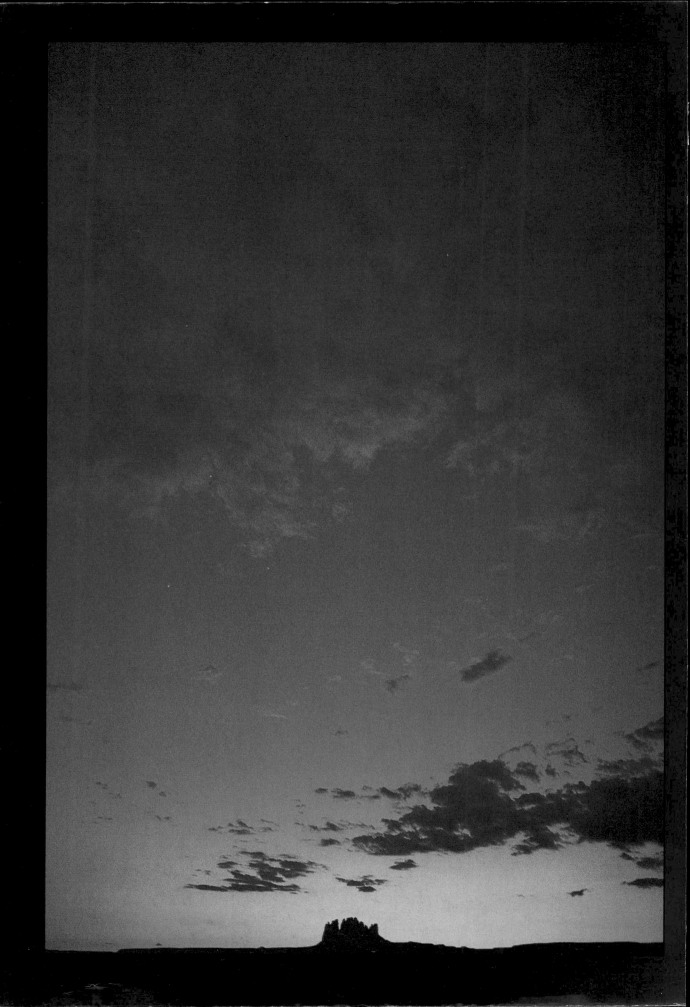

MICHAEL FREEMAN'S

CREATIVE PHOTOGRAPHY

THE NEW 35mm HANDBOOK

HEADLINE

A QUARTO BOOK

Copyright © 1993 Quarto Publishing plc

The right of Michael Freeman to be identified as the author of
the work has been asserted by him in accordance with the
Copyright, Design and Patents Act 1988.

First published in Great Britain in 1993
by HEADLINE BOOK PUBLISHING PLC

First published in softback in 1996
by HEADLINE BOOK PUBLISHING

10 9 8 7 6 5 4 3 2 1

This book was designed and produced by
Quarto Publishing plc
The Old Brewery
6 Blundell Street
London N7 9BH

British Library Cataloguing in Publication Data

Freeman, Michael
 Michael Freeman's Creative Photography:
 New 35mm Handbook. – 2 Rev.ed
 I. Title
 771

 ISBN 0-7472-7775-3

Senior Editors Honor Head, Cathy Mecus
Copy Editor Helen Douglas-Cooper
Senior Art Editor Philip Gilderdale
Designer Allan Mole
Picture Research Manager Rebecca Horsewood
Picture Researcher Anne-Marie Ehrlich
Illustrators Kuo Kang Chen, David Kemp

Publishing Director Janet Slingsby
Art Director Moira Clinch

Special thanks to Nick Clark and Jane Parker

All photographs by Michael Freeman except where individually
credited at the back of book.

Typeset in Great Britain by 212 Design, Bournemouth
Manufactured in Hong Kong by Regent Publishing Services Ltd
Printed by Star Standard (PTE) Ltd.

HEADLINE BOOK PUBLISHING
A division of Hodder Headline PLC
338 Euston Road
London NW1 3BH

Contents

Techniques 1

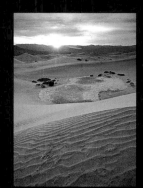

Manipulating the image 3

Working professionally 4

Applications 2

Introduction

Since the first edition of this book, photography has undergone considerable technological change. Micro-electronics and miniaturized components have taken camera automation well beyond the stage of simply adjusting the exposure, while electronic imaging promises to revolutionize the recording, storage and processing of pictures. This in itself is not surprising – cameras are not the only equipment to become computerized – but what is interesting and important is the effect this is having on the way photographs are taken.

Paradoxically, photography is rooted in technology while being by no means dependent on it. Technical progress has made it possible to guarantee for the first time success with certain kinds of photograph, particularly those involving difficult focusing and complicated lighting balance – especially when these need to be shot instantly. For some action, wildlife and reportage photography, the new technology is a boon. And yet, great photographs were made long before automation, and will continue to be made despite it. Would Henri Cartier-Bresson's or Ernst Haas' photographs have been different had they been able to use a modern camera? A

hypothetical question, of course, but I think it doubtful, for the following reason.

In photography, as in any visual medium, the image originates in the eye and mind of the person creating it. The electronic capabilities of a camera, more highly developed in 35mm format than in any other, exist to *help* the photographer to achieve images, but cannot direct them. More than ever before, it is essential to keep a sense of balance between the hardware of photography – cameras, lights and accessories – and the ideas and imagination that lie at the heart of any creative activity. They need to co-exist.

The expressive and creative potential in photography is enormous – in fact unique. It is available to almost everyone, without privilege. It can be a way of experiencing incidents, moments, events; it can channel an interest or vocation; make something tangible out of the imagination; or simply produce a visual record. This potential is the most important contribution by far of the modern 35mm camera, and the underlying theme of this book.

Michael Freeman

1 Techniques

There are two kinds of photographic technique. One is to do with the hardware and handling the equipment and materials; the other is the technique of managing the image itself. The latter is less easy to define in concrete terms as it involves an understanding of the way we see, the graphic characteristics of different lenses, the effect of more or less exposure on the way an image works and the quality of different kinds of light.

This dual nature of technique is a special feature of photography. Only in video and film making does the equipment intrude so much on the creative process. Surprisingly, perhaps, this has not made photography more difficult. On the contrary, increasing automation has meant that most of the operations in using equipment are hidden behind a digital display and pushbutton controls. The important demand that this makes on camera users is to balance the attention they give to the two kinds of technique – hardware and imagery. While many innovations in camera equipment are essentially gimmicks that distract attention from the image, there are more that truly offer the possibility of better pictures – better, that is, in strictly defined ways.

Techniques of whatever kind are only useful in as much as they make successful photographs. This is the *only* yardstick and, with so many possible techniques, the photographer's judgement as to which to use and which to reject is critical.

Sand-dunes, Death Valley, California The image wanted was a landscape with the greatest range possible – from near to far. The technical solution: a 20mm wide-angle lens used in vertical format and close to the ground, stopped down for maximum depth of field. A neutral grad filter held the tone in the sky.

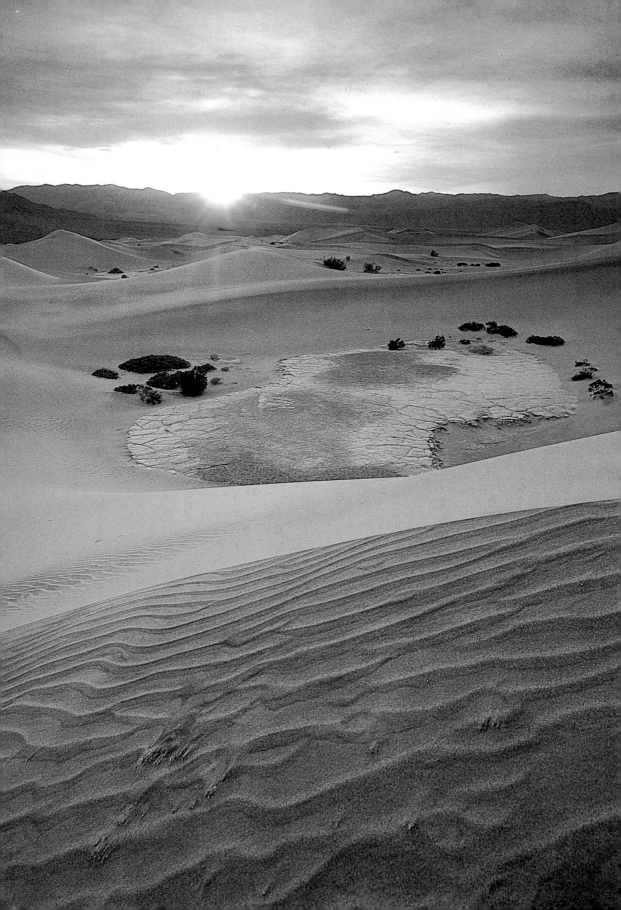

The way we see

In most people, vision is the most highly developed of all the senses. It provides a large amount of our daily input of information, and occupies much of our memory. More than this, however, we select and discriminate visually. We respond emotionally to images, finding pleasure in some while rejecting others.

Photography provides a technical means of recording the images that we see, using processes very similar to the mechanism of the eye and brain. Formation of an image, inside both a camera body and the eye, depends on optics – the physics of light. Recording the image involves a different and more complex process – photochemical in the case of film, electronic in the newer field of digital imaging. In the eye, also, photochemistry is responsible for fixing the image briefly. However in this case the information is then passed on to the brain by means of electrical impulses and chemical transmitters.

Thus the mechanisms of photography parallel those of sight very closely. Ultimately, however, when the photograph has been seen, composed, taken and produced, whether as a print or a slide, or displayed on a screen, it is processed all over again through the eye of the person looking at it. The final part of the process involves our interpretation of the photograph; does it gives us satisfaction, pleasure, a visual jolt or a fresh insight?

Eye and camera

The eye and a still camera are both optical systems that produce, in the end, the same result: a recorded image. Naturally, there are many differences, but a knowledge of one helps an understanding of the other. The most significant difference is that the eye's operation does not end at the retina, which receives the image; the optic nerve connects the eyeball to the brain, where the image is processed and interpreted simultaneously (the psy-

chology of vision is every bit as important as the physiology). The photographic image is processed through the camera, and then through the eye and brain. Both manipulate the same sequence of events: a lens system focuses the disorganized light from a scene by means of refraction; the resulting image is focused upside down on a light-sensitive surface; a tightly packed array of individual sensors use chemical reactions to fix a record of the image.

Forming an image

A lens, in both the eye and the camera, is a device for manipulating light, and is able to do this because of two factors: the difference in composition between it and the air, and the shape of its surfaces. Light travels in waves. A ray of light travels, with a waveform, in a straight line until it strikes a surface. Most materials deflect light (a ray bounces off them at an angle) but some transparent materials like glass and clear plastic allow the light to pass through.

The speed at which light travels is not constant, but depends on the density of the medium through which it passes. As light from the sun travels towards us through space, the earth's atmosphere slows it down a little, to just under 300,000 km per second. The extent to which a material slows down light passing through it is measured in relation to the speed of light through air, and is known as its refractive index. For example, glass, which slows light down to about 200,000 km per second, has a refractive index of 1.50.

The power to bend light is known as refraction, and is the basis upon which a lens works. As the ray of light leaves the glass on the opposite side, and enters air again, it is bent. By shaping the glass so that the angle of its surface changes gradually – producing a curve, in other

Refraction

If a ray of light strikes the surface of glass at a right angle, it travels through the glass more slowly but still in the same direction (below left). If, on the other hand, it strikes the surface of the glass at an oblique angle (below right), it changes direction. This happens because the lower edges of the wavefronts, which are at right

angles to the direction of travel, enter the glass first and are slowed down before the upper edges. As a result, the upper part of the wavefront moves ahead of the lower, and the entire wavefront is angled downwards.

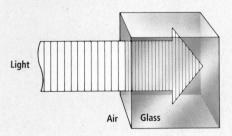

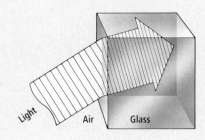

How the eye focuses

Although most of the eye's focusing depends on the shape and thickness of the cornea, the fine adjustments are made by changing the shape of the lens. Because we use distant vision more than anything else, this is the relaxed state of the eye, with the ligaments pulling the lens into a flat disc. For close focusing, the shape of the lens must be more spherical; to achieve this, the ciliary muscles contract.

Close focusing – lens is rounded

Distant focusing – lens is flattened

words – the direction in which the many different rays are bent can be controlled. In particular, they can all be made to converge on one point. As the illustration on page 14 shows, this is the form of a simple lens.

An object – any object, from a person to an entire landscape – can be thought of as an assembly of many points. Each is focused somewhere behind the lens, in a slightly different position from any other. Added up, the result is an inverted, two-dimensional reconstruction of what is in front of the lens – in other words, an image.

The eye

The eye contains a lens that acts in the same way as any other lens, although most of the refracting is done by the cornea at the front of the eye, because its surface has the greatest slowing effect on light as it enters from the air. The lens is responsible for the fine focusing movements needed to deal with nearer objects, and it does this by changing its shape.

The retina, at the back of the eye, is the image recorder, the equivalent of film or an electronic imaging chip. Both silver halide film and electronic imaging are now part of photography, and it is interesting that the retina manages to combine elements from both: photo-chemical reaction, digital sensors and electrical trans-mission. It contains a dense pattern of light-sensitive receptor cells, known as rods and cones, and the density of the photo-receptors helps determine the eye's ability to

resolve fine detail. In the central region of the retina, the fovea, they are packed tightly together, and it is this that gives us our sharpest vision. Away from the fovea, the cells become more spread out, and correspondingly our peripheral vision is more blurred. In some ways, the rods and cones are the equivalent of grains in the emulsion of a film. All contain chemicals that undergo a reaction when struck by light, triggered by the electrons being activated. The individual rods and cones react in propor-tion to the light intensity, and this allows the eye to dis-criminate between tones. To make colour vision possible, the cones are of three different types, each sensitive to one colour: blue, green or red. The eye and brain assem-ble the fine pattern of these three colours into a full-colour image.

Because of their different sensitivities, the rods and cones are like two interlocking emulsions. The cones, for daylight colour vision, have one pattern; the rods, for total vision, have a more widely spaced, coarser pattern. To stretch the analogy, it is like a combination of slow, fine-grained colour film and fast, grainy black-and-white emulsion. As the light alters, stalks contract and push either the rods or cones in front of the others, in order to get the best balance of vision.

In fact, a closer comparison can be made with an imaging chip. The 125 million rods and 5.5 million cones in a retina receive the image like a CCD array. Their neural connections, like the circuitry on the chip, send

Perception The complete coverage of the human eye is approximately 240°, although this varies from person to person. However, with the eye in a fixed position, most of the view is fuzzy and ill-defined, with only a tiny spot covering less than 2°, being completely sharp. Away from this central point of focus, the resolution deteriorates.

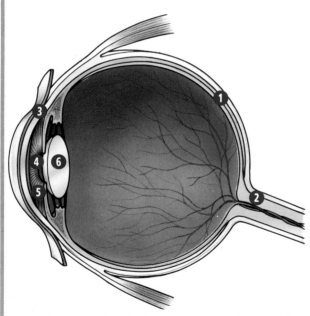

The eyeball Nearly spherical and slightly more than 2cm (¾in) in diameter, the eyeball is filled with a jelly-like fluid – the vitreous humor – that keeps it firm. The transparent cornea is part of the eye's outer surface, and is primarily responsible for forming an image. The iris behind is an adjustable diaphragm that controls light intensity and the lens adjusts fine focus by changing shape. The image is projected onto the light-sensitive retina, which transmits the information to the lens through the optic nerve. This direct neural link to the brain makes the eye virtually an extension of the brain.

1 Retina
2 Optic nerve
3 Cornea
4 Pupil
5 Iris
6 Lens

impulses to the brain for processing into an image. Away from the fovea, the neural connections for numbers of rods and cones converge onto fewer optic fibres; this is a kind of image compression, and results in peripheral vision. In the fovea, where there are only cones, there is little convergence, and the signals from individual cones give much sharper vision. In all, there are only about 1 million optic nerve fibres leading to the brain. In addition, there are lateral connections that help the eye distinguish the contrast between edges.

Colour sensitivity

In reasonably good light, the eye can distinguish millions of colours. It manages this because the cones are divided into three types: those sensitive to blue, to green and to red. As we will see in Chapter 5 (Recording the image), much the same thing happens in film, although there it works in the form of three layers of emulsion, each sensitive to one of the three separate colours. Blue, green and red together embrace the full spectrum, so that by varying the input from each, any other colour can be made. In the case of human vision, this occurs in the brain.

As on the facing page shows, the three kinds of receptor are not equally efficient. We are least sensitive to blue, and the overall result is that the eye is most sensitive to yellow-green. We cannot see ultraviolet – to which film is sensitive – because the eye has two yellow filters, one over the lens and one over the fovea, which probably evolved to reduce chromatic aberration (see Forming an image), at its greatest in violet and ultraviolet light.

Perception

The greatest difference between human perception and a camera lies in the way the brain builds up and recognizes an image. In each eye, the resolution falls away sharply from the fovea, which is smaller than a pinhead and covers an angle of only 1.7°. The views from both eyes overlap and combine. Although such a view is fine for concentrating the attention on one part of the scene, it would be useless for taking in the whole sweep of, say, a landscape, were it not for the way in which the eye works. While we are rarely conscious of it, the eye actually scans a scene constantly with small, jerking movements that each last only a few milliseconds. By means of these saccadic movements, as they are called, the eye and brain build up a sharply perceived pattern of a large scene, in a way quite unlike that of a camera.

The electro-magnetic
spectrum The complete range of waves travelling in space, from the shortest to the longest, makes up the electro-magnetic spectrum. This radiation takes many different forms, yet there are no breaks in the series, simply a steady progression of wavelength. At one end of the scale are the very energetic gamma rays, which can penetrate even thick steel. At the other end are radio waves, which have too little energy to be experienced by the human body. Between these two extremes is a small group of wavelengths which we experience as light. This is the visible spectrum, the precise wavelength determining the colour. For practical purposes, the range of the eye's sensitivity runs from violet to red – that is, from about 400 to 700 nanometers – although it has a slight ability on either side.

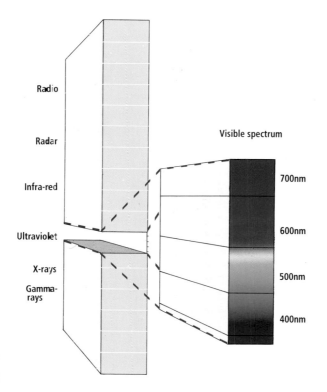

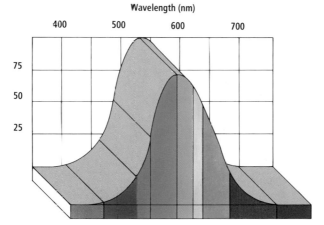

The visual luminosity curve
Combining the three different colour responses of the retina's receptors, a composite graph shows the relative importance of different colours to the human eye. Greens and yellows record the greatest attention, even when they are dark. On the other hand, we find the colours nearer the ends of the spectrum less easy to perceive.

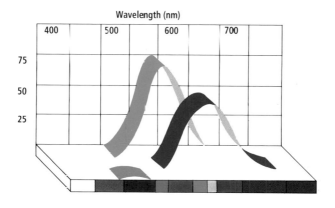

The eye's trichromatic
vision The retina's receptors are sensitive to different wavelengths, some to blue, others to green, and a third group to red. By combining the information from these receptors, and calculating the relative responses, the brain can interpret colour. Colour film uses exactly the same principle. One difficulty, as can be seen from the graph is that the "green" receptors are much more sensitive than the others, and the "blue" receptors much less.

Basic optics

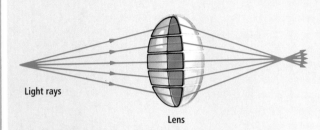

Light rays

Lens

The simple lens A simple lens works as if it were made up of small individual prisms. Like the prism, each lens section bends light rays. By shaping this lens, each refracted ray from a single point can be made to meet at a common point behind the lens. A subject is made up of an infinite number of points. Focusing each of them behind the lens forms an image.

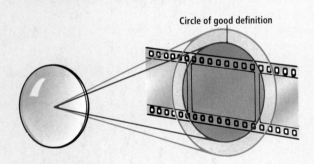

Circle of good definition

Covering power A lens projects a circular image. The image quality is highest at the centre, deteriorating towards the edges. The point at which the image falls below an acceptable standard marks the circle of good definition, and this represents the covering power of the lens. In photography, the film format must fit within this circle. On a camera, the covering power is increased slightly by stopping down the aperture.

Depth of field This is the distance through which the *subject* may be moved before the image becomes unsharp. A related feature, hyperfocal distance, is the closest at which the subject is sharply recorded when the focus is set at infinity.

Sharpness A lens brings light waves to a point only at the focal point. In front of, or behind this point, it projects a circle. This "circle of confusion" increases in size with its distance from the focal plane (below).

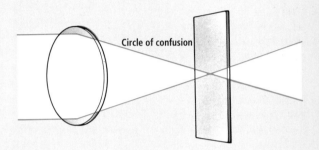

Circle of confusion

The smallest circles of confusion appear sharp enough to be satisfactory. But the images become progressively less sharp with increasing distance from the focal plane. There is a small range on either side of the film plane that gives an acceptably sharp image. This is called the depth of focus, and is defined as the distance through which the *film* or *lens* may be moved before the image becomes unsharp.

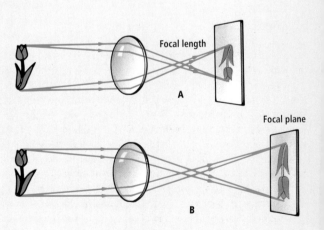

Focal length

A

Focal plane

B

Focal length and image size. By changing the focal length, the size of the image at the focal plane can be altered. Reducing the focal length makes the image smaller (A); increasing it makes the image larger (B).

Lens faults Simple lenses have a variety of faults, some due to the inherent nature of light, others to the inefficiency of the lens itself. Most can be partly corrected at least in the design of a compound lens.

Flare This is caused by reflections from surfaces within the lens, and causes an overall loss of contrast. It is sometimes made worse by reflections within the camera body. A lens hood partly overcomes the problem by cutting down the light that does not play a part in forming the image. More corrections are possible with lens coatings, which are on nearly all modern camera lenses. They work by setting up a second reflection from the lens surface that interferes with the original reflection, nearly cancelling it out The principle is called destructive interference.

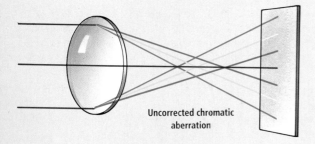

Uncorrected chromatic aberration

Chromatic aberration The different wavelengths that comprise white light travel at different speeds through the lens, and pass through a lens at slightly different angles; this is called chromatic aberration. Blue-violet light is focused slightly closer to the lens than green light, which in turn is focused closer than red light. As the focus is spread in this way, there is some loss of definition. One answer in lens design is to use different lens materials, so that the chromatic aberration of one cancels out the slightly different chromatic aberration of the other. Another effect of chromatic aberration that is less easy to correct is the colour fringe at the film plane caused by the slight divergence of the wavelengths. A recent solution is extra low dispersion glass made by including rare earths in the manufacture of the glass. Fluorite also has low dispersion qualities, but is damaged by the atmosphere and changes shape with temperature changes.

Diffraction The edge of an opaque surface, such as the aperture blades, scatters light waves slightly. If the aperture stop is closed down to its smallest size, this scattering, called diffraction, is increased (stopping down, which tends to correct most lens faults actually worsens this one). In practice, most lenses perform at their best when stopped down about three aperture stops from their maximum – this is called their optimum aperture.

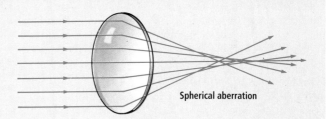

Spherical aberration

Spherical aberration It is cheaper to produce a lens with a spherical curved surface than one in which the curvature changes. The cost of this is spherical aberration, where the edges of the lens focus the light waves at a different point from the centre of the lens, causing unsharpness. In the case of oblique rays passing through the lens, they fall on different parts of the film plane in a blur rather than being superimposed. This slightly different aspect of spherical aberration is called coma. There are several ways of overcoming this, and for lens manufacturers, it is principally a matter of cost. Mirror lenses, which use reflective surfaces, do not suffer from such aberrations.

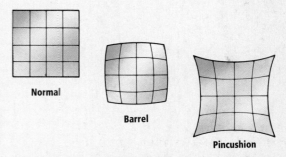

Normal

Barrel

Pincushion

Distortion The aperture stop of the lens prevents oblique light waves from passing through the centre of the lens, and, as the lens surfaces at the edges are not parallel, the image-forming light is bent. This does not affect sharpness, but does distort the image shape. If the shape is compressed, it is called barrel distortion; if stretched, pincushion distortion. Symmetrical lenses (that is, with complementary elements at the front and back) cancel out this distortion, but telephoto or retrofocus designs, which are asymmetrical, suffer to some degree. A fish-eye image is an extreme example of barrel distortion, because the lens uses an extreme asymmetrical design.

Field curvature The focal plane of a simple lens is not precisely flat, but curved so that if the film is flat not every part of the image will be sharp Curving the film is one answer, but some modern compound lenses are designed to have a flat field.

The camera

- Automatic v. manual
- Anatomy of the camera
- Using the viewfinder
- The lens explained

The 35mm camera evolved around the cassette of 35mm film. Not surprisingly, they differ only a little in size or operation from one another, and the most valuable quality of all 35mm cameras is that they are compact, allow straightforward eye-level operation, and yet still offer high-quality images. New models are constantly being launched, some with genuine technological improvements, others simply designed for different needs.

Electronic imaging adds a new dimension to all this. Photographs can be digitized once they have been taken, and the results used in various ways (see Electronic imaging, page 20). More relevant here, however, is their potential for *recording* images electronically. A number of cameras already do this, some at low resolution, others at medium resolution; they are all relatively expensive. While on the face of it an electronic camera would fall outside the scope of this book, the fact is that most of them are more similar in operation to 35mm models than to any other kind. Indeed, one or two are adaptations of 35mm cameras, the film back being replaced by a chip.

The ease of handling and versatility of 35mm cameras have made them photography's standard. For this reason if no other, electronic cameras are included here. The future, at some point, certainly belongs with them.

Automatic or manual

Progress in micro-electronics has led to an increasing number of automated cameras. Whereas once automation was an expensive option and basic cameras were manual, electronic automation has now taken over most areas of camera marketing. The first application is exposure control, in which the shutter speed and/or aperture are set automatically. Others include focusing, film winding, film loading, and electronic flash control. Among the cheaper compacts and mid-range cameras, this automation generally simplifies their appearance and operation, but among high-end models it can result in a proliferation of displays and controls.

There are always occasions when the photographer needs to exercise full control – including control over exposure and focus. The extent to which this is important depends on the type of photography, but there is clearly an advantage in being able to override whatever automatic systems exist. Non-automatic cameras are a rarity today, except for the cheapest snapshot models, but a 35mm automatic designed for serious use should allow the photographer to by-pass the automatic controls if necessary.

The choice, therefore, is usually not between automatic and manual, but between different levels of automation. In a well-designed, high-end camera there may be three levels: specific programmed modes that the

1 Self-timer operation indicator (LED)
2 Grip/Battery cover
3 Grip screw
4 Neckstrap lug
5 Lens release button
6 Depth-of-field check button
7 Manual aperture set button
8 Shooting mode selector
9 Exposure compensation button
10 Shutter button

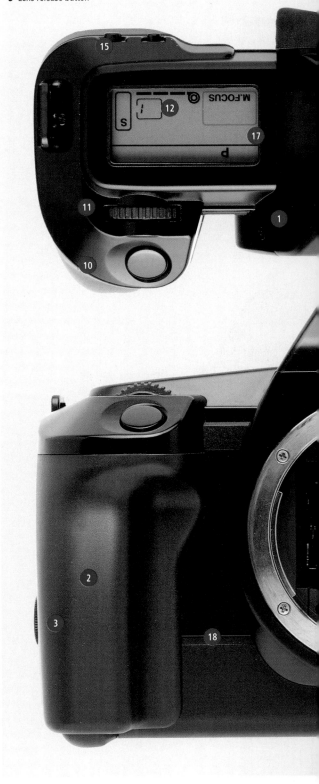

11	Electronic input dial	16	Eyecup
12	LCD display panel	17	Metering panel
13	Accessory shoe	18	Bayonet mount
14	Command dial	19	Shutter
15	Metering panel selector	20	Reflex mirror

The camera lens

1	Manual focusing ring	6	Filter fitting
2	Focus mode switch	7	Depth-of-field scale
3	Zoom ring	8	Bayonet attachment
4	Lens designation	9	Multi-coating
5	Distance scale		

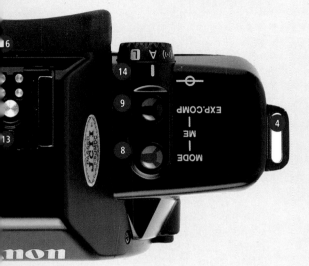

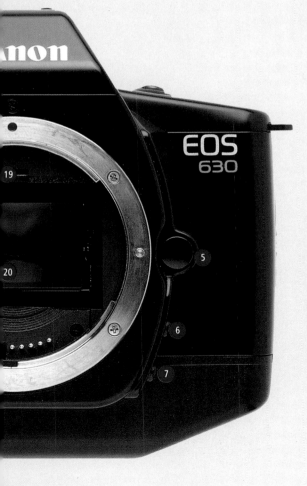

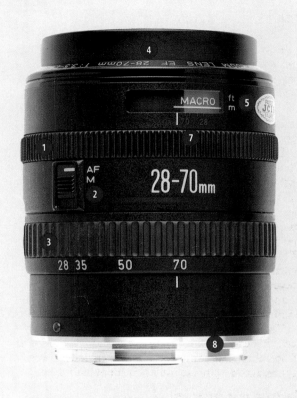

Viewing the image through an SLR system

Light passes to viewfinder

Mirror falls back into place

Mirror goes up when shutter release is operated

Light enters the camera body through the lens, striking a hinged mirror that rests at a 45° angle. This reflects the image up to a flat, ground-glass viewing screen. Directly above this is a glass prism known as a pentaprism. The prism rectifies the image so that it appears correctly left to right and the right way up in the viewfinder.

When you press the shutter release, the mirror lifts up, temporarily blocking the view through the eye-piece. Light entering the lens now has a clear path to the back of the camera. Here, a shutter that lies flat just in front of the film is activated. A window in the shutter-blinds (see Shutter, page 27) passes across the film, exposing it. The cycle ends with the return of the mirror to the viewing position.

photographer must select, and which each cope with one kind of photography (such as close-up or sports); standard automation, designed to deal with most situations and requiring the least decisions from the user; and manual override, which allows the photographer to set the controls.

The range of camera types

In the interests of finding a particular niche for each model of camera and making new designs appear special, manufacturers confuse the range of cameras. At any one time, there are over 100 35mm camera models available from established manufacturers, most trying to be different.

The essential differences, however, lie in just a few areas: the viewing system, the degree of automation, whether the camera focuses manually or automatically,

and the price. There are many permutations of these, but to bring some clarity to the pletheora of equipment, cameras are grouped here as SLR (singe lens reflex) or non-reflex. Under these two main categories, they are sub-divided by the degree of automation and level of sophistication (both of these setting the price).

SLR cameras

The SLR (single lens reflex) camera has been so successful because of its ability to show the photographer the exact view that will be recorded on film when the shutter is tripped. The viewing system necessary to do this consists of an arrangement of a prism and mirror that direct the focused image from the camera's lens into the viewfinder until the moment of exposure. At that point, when the shutter release is pressed, the mirror flips up and the image is directed to the back of the camera, where the film is exposed briefly by the shutter.

Some mechanical sophistication is needed to allow this sequence of events, and an SLR camera has a considerable number of linked moving parts just for this section of the picture-taking process.

The outstanding advantage of the SLR is that the viewfinder shows exactly what the picture will be, not only what is framed, but also what is in focus, and the degree of depth of field. In normal viewing, the lens aperture remains wide open to give the brightest image, but a preview button or lever shows the depth of field at the selected aperture (see Depth of field, page 22).

The mirror can be constructed to pass some of the light to photo-electric sensors for a variety of sophisticated exposure metering systems (see Camera metering, page 68).

Against this, the SLR has some disadvantages. The mechanisms are complex and take up space, while the need for a moving mirror sets a minimum depth for the camera body. This in turn complicates the design of some lenses. Wide-angle lenses, which would normally focus the image a very short distance behind their rear glass element, have to be designed so as to focus much further back. All this additional complexity adds to the price. The viewing system also absorbs an amount of light, making viewing and focusing difficult in low light with a slow lens (that is, a lens with a small maximum aperture). During exposure, the photographer's view is blocked out – not a problem at normal shutter speeds, but it can make some techniques, such as a long panned shot, difficult. Finally, the mirror and shutter mechanism is noisy, which can be a drawback in some reportage and wildlife photography, and the vibration can cause camera shake. On a tripod, with a long exposure, it is advisable to lock the mirror up before pressing the shutter release.

Overall, the advantage of being able to see through the camera's lens has enabled the SLR to sweep the board among photographers prepared to pay moderate to high prices. At close distances there are none of the parallax problems that non-reflex cameras suffer from (see Non-reflex cameras), and only SLR viewing is accurate enough to allow long-focus lenses to be fitted. The widest ranges of interchangeable lenses are those available for top-end SLR cameras.

The distinction between auto-focus and manual focus SLRs is probably the clearest one. Auto-focus, perfected in the 1980s, uses sensors within the camera body to judge the sharpness of a selected central part of the image, and servo-motors in special lenses to adjust the focus accordingly. The advantages are speed and accuracy; the disadvantages are cost and the extra bulk and weight of the lenses.

Non-reflex cameras

The first 35mm camera, the Leica, was non-reflex and until the introduction of the SLR in 1925, the normal viewing system consisted of a separate eyepiece and small lens on top of the camera body.

The viewfinder lens and frame are designed to match the image projected by the lens on the film, and at normal distances with a standard focal length or a wide-angle lens the separation of viewing from picture-taking is no great disadvantage. Focusing in the Leica was handled by a rangefinding system, in which a second, small lens on the top of the camera projects its slightly different view through the eye-piece. By means of stereopsis, the distance to a subject can be worked out mechanically and linked to the focusing ring on the lens. This sounds more complicated than focusing by sight, as happens with a manual SLR, and it is. Until the invention of auto-focus, it was one of the reasons for the general stagnation of non-reflex cameras.

However, the increasing automation of cameras during the 1980s – a direct result of the introduction of micro-electronics – removed some of the advantages of SLRs, at least in areas of photography where simple, fast shooting was more important than a range of inter-

Using the auto-focus mechanism If your subject is in the centre, this works perfectly (top), but in a two-person shot the camera will focus on the background between unless you pre-focus on one subject before framing the shot.

changeable lenses and great adaptability. Auto-focus made long-focus lenses practical, and when linked to a powered zoom lens could take care of most photographers' needs. Through-the-lens (TTL) metering can operate as capably as in an SLR. This has given non-reflex cameras a new lease of life, mainly in the form of what are called compacts. The Leica, meanwhile, continues to hold an unassailable place as the professional non-reflex camera, ideal for certain kinds of reportage photography (see Reportage).

There are several advantages to a non-reflex camera, not the least being that in comparison to an SLR it is relatively light and compact. The absence of a mirror makes it quiet and unobtrusive to use (although this

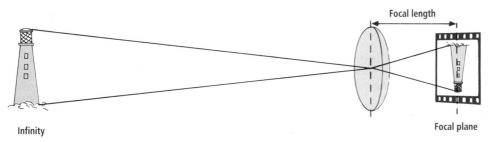

Infinity

Focal length

Focal plane

Focal length The focal length of a lens is the distance behind it at which it focuses an image when set at infinity. In other words, if a 50mm lens is focused on the horizon, the image will be sharp exactly 50mm behind the lens and this is where the film is positioned.

Single lens reflex

Autofocus

Basic

Mid-range

Professional

Manual focus

Basic

Mid-range

Professional

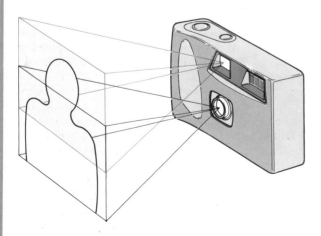

Parallax error Because the viewfinder is in a different position from the lens, it sees a slightly different picture at close range. Most viewfinder cameras indicate the amount of displacement.

applies less to models with servo-motors for auto-focus and zoom lenses). A leaf shutter mounted in the lens, as in the Leica, is also very much quieter than a focal-plane shutter. Viewing, though not so exact as in an SLR, is clearer and brighter, and continues throughout an exposure. And where the viewfinder shows some of the area outside the image frame, the photographer can anticipate people or things moving into shot.

Against these, parallax error is a problem with objects close to the lens (left), and makes it easy to cut off the top of an image inadvertently. The answer to this is either guide marks on the viewfinder coupled with careful composition of close-ups, or a sophisticated viewfinder mechanism that compensates for parallax.

Electronic imaging

Film, as we will see in Chapter 5, is essentially an analog medium, and the image that it reacts to is locked into the emulsion chemically. This has been so integral to photography that it has not, until recently, been ques-

Non-reflex

Autofocus

Fixed lens compact

Zoom compact

New generation

Electronic

Manual focus

Professional

Specialist

Panoramic

Underwater

tioned. Photography needs film, and cameras have traditionally been designed as vehicles for moving it and exposing it. The first 35mm camera, indeed, was built as a way of using an existing film stock.

This is changing. Provided that the sensors are small enough and packed sufficiently tightly, pictures can be recorded digitally – and electronically. All the pictures in this book, although originally photographed onto film, have been processed digitally in order to be printed. This is already a reality, and normal. Less well-developed is the direct recording of images onto an electronic medium, such as a floppy or hard disk, but the technology is progressing.

In one system, the image is projected by the camera lens onto an imaging CCD (charge-couple device) array that takes the place of a conventional film back. This is connected to a digital storage unit, where the image information is transferred onto a disk. At the top end of this method of electronic imaging is the Kodak Professional Digital Camera System, which adapts a reg-

ular Nikon camera. In use, the camera can produce colour images at the equivalent of film speeds from ISO 200 to 1600, or black-and-white images at the equivalent of ISO 400 to 3200. Sequences can be shot at 2.5 images per second, and the hard disk can store up to 158 uncompressed images or up to 600 compressed images. Apart from speed of playback and no need for processing, one of the great advantages of a digital camera is that the image can be processed in a computer (retouched, for instance – see Manipulating the image) and can be transmitted anywhere in the world via a modem.

Another system is still video, not digitized at the time of shooting but easily converted into digital form. The Canon ION Still Video camera captures analogue images on 5cm (2in) re-usable floppy disks, which can store up to 50 high-band pictures. The camera connects directly to a television set for immediate viewing. To use in a computer and take advantage of the various electronic imaging facilities such as digital re-touching and multimedia productions, a plug-in digitizer card is needed.

Camera handling

- Depth of field
- Capturing movement
- Camera accessories
- Cleaning and repair

Cameras are becoming increasingly easy to use efficiently, as micro-electronic circuitry has taken over more and more of the important functions. Most of the key areas, such as focus, exposure measurement and film transport, are now usually automated. In that it frees the photographer's attention for more creative decisions, such as choosing the subject and framing the image, this can only be for the good – provided that the camera user still understands what the machinery is doing, and why. The practical side of photography is very much a craft, and the camera is used best when the photographer is completely familiar with it. Although in some ways it is a cliché to say that the camera should be an extension of the eye, facility in camera-handling makes it possible to react quickly to changing picture situations. Their compactness and efficiency make 35mm cameras the most responsive of all types to rapid operation.

Focus

The basic operation of a lens was outlined in Forming an image (page 10). A single point in front of the camera is focused sharply as a point a short distance behind the lens. An entire scene, which is made up of countless points, focuses behind the lens on a more or less flat plane. Focusing a camera lens involves making sure that this plane lies exactly where the film is. There is nothing complicated about this, except that objects and scenes at different distances in front of the camera come into focus at different distances behind the lens. For this reason, a camera lens has to be moveable. Distant features – the horizon line, for instance – focus close behind the lens. For nearer objects, the lens is moved forward, away from the film. As all modern lenses are compound, focusing usually involves the movement of some of the individual glass elements inside the lens barrel.

In traditional camera designs, focusing is done manually, the photographer checking the focus either visually (through the viewfinder of an SLR camera) or by means of a rangefinder (see Non-reflex cameras, page 19). Most modern cameras, however, have automatic focusing: a small central area of the view is measured, the information is fed to a central processing unit (CPU), and this in turn activates a servo-motor that moves the lens into focus. The details of the operation are more complex than this, but the principle is straightforward. There are some differences between camera makes in how the focus is measured, but the usual method involves checking the contrast between the edges of objects seen through the lens (in an out-of-focus image these edges are blurred, so the contrast is less than when the image is sharp).

In most scenes, some parts will be nearer than others to the camera, and this has important implications for focusing. With the lens focused sharply on one object, such as a face, things nearer to and further from the camera will be out of focus to some extent. The degree of difference in sharpness between nearer and further objects depends on a number of factors, including the focal length of the lens, the aperture being used, and the depth of the scene itself. The depth of sharpness achieved in an image is known as depth of field.

Depth of field

The distance between the nearest and furthest points from the camera at which everything that appears sharp is termed the depth of field. In some photographs the lens is focused on a single element while everything else

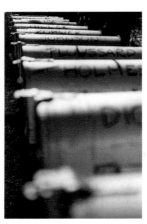

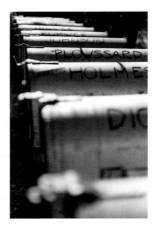

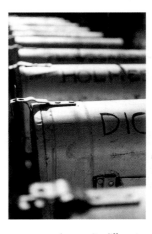

Selective focusing With a subject of considerable depth, the selective nature of focusing can be seen clearly. Focusing a normal 55mm lens at different distances along this row of mail-boxes at full aperture produces quite different images. Note that the movement of the lens elements that occurs during focusing results in the displacement of the nearest part of the image.

Depth of field explained

With a lens of normal length – 55mm – this row of mail boxes was photographed at three different apertures, but in each case the lens was focused on a distance of 2m (7ft). The mail boxes are spaced slightly more than 30cm (1ft) apart. At f3.5, the depth of field extends only a little on either side of the focused point. At f8 the limits of the depth of field are 1.8m (6ft) from the camera and 2.7m (9ft). At f22, stopped down almost to the limit, the depth of field extends from 1.4m (4½ft) from the camera to 4.9m (16ft), bringing most of the boxes into acceptably sharp focus.

■ **Tinted area = depth of field**

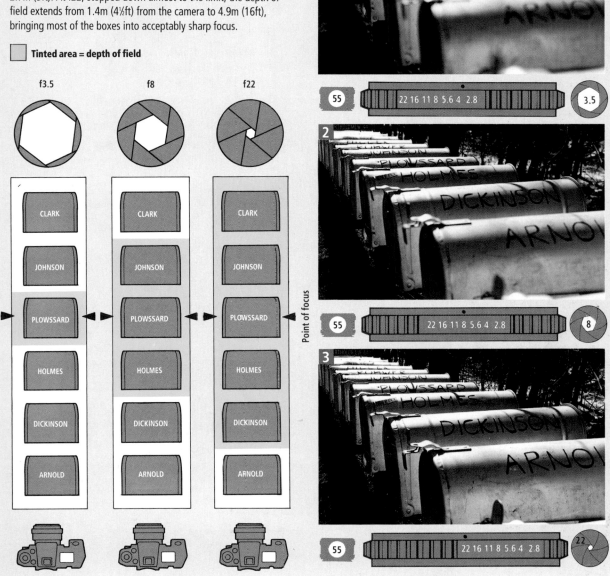

in the frame is noticeably out of focus. The result is that the attention of the viewer is clearly directed to the focused item. This is known as selective focusing (at least, when it is deliberate), and makes use of the difference in sharpness across the view. At the opposite extreme, if a photograph is sharp in both the foreground and the distance, the depth of field is great enough to cover everything. Focusing, then, is not so often just a matter of getting one thing sharp; more usually, it is a matter of judging how much and which parts of a scene need to be *acceptably* sharp.

In fact, whatever the depth of field, shallow or great, one particular distance will be more sharply focused than others. Whether or not this is noticeable depends on the eye's ability to judge sharpness. The limits of depth of field are not precise, but probably the most important way of controlling it is by the size of the lens aperture.

Aperture

The amount of light that passes through a lens is adjusted by means of an aperture inside the lens barrel. The aperture's basic function is to adjust the amount of

Using depth of field

Focus on a near subject In this cemetery in Taos Pueblo, New Mexico, the nearest cross was 7m (23ft) from the camera. With a 180mm lens focused on it, the other crosses were completely out-of-focus at the maximum aperture of f2.8.

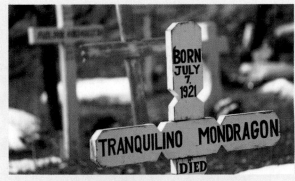

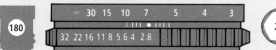

Focus on a far subject With the lens focused on the far cross – 10m (33ft) away – the nearest cross became unsharp. I adjusted the lens focusing ring so that the 7m (23ft) and 10m (33ft) marks of the distance scale were equally spaced on either side of the central focusing mark.

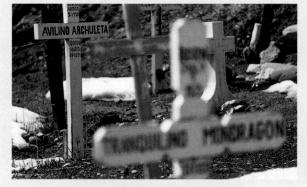

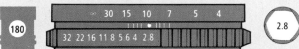

Focus over a broad depth of field The depth of field scale showed that it was just possible to extend the depth of field to these near and far limits by stopping the lens down fully to f32.

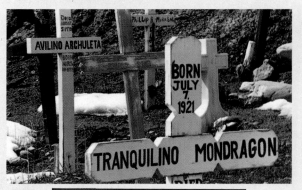

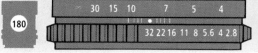

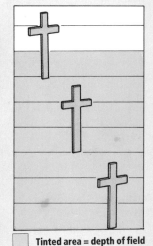

Tinted area = depth of field

light striking the film surface to maintain the right exposure, but it also alters the depth of field and therefore the amount of a scene that seems sharp.

To standardize the aperture measurements between lenses, a system of f-numbers is used. A longer focal length of lens needs a larger picture than does a wide-angle lens to pass the same amount of light. This would be hopelessly confusing if real aperture sizes were used in calculating exposure. Instead, the sequence of f-numbers gives the relative aperture. The sequence reads: f1, f1.4, f2, f2.8, f4, f5.6, f8, f11, f16, f22, f32, f45, f64, although any one lens covers only a part of this

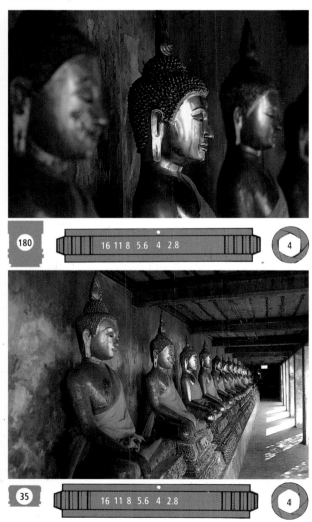

Changing lens to increase depth of field These two photographs of a row of Buddhas were taken from exactly the same distance – 3.6m (12ft). The depth of field for the 180mm lens (top) encompasses only one Buddha, whereas the depth of field for the 35mm lens extends to the two Buddhas on either side (above).

Aperture and focal length

Lens focal length affects depth of field. For any given aperture, such as f5.6 shown here, the actual diameter of the aperture in a wide-angle lens is less than in a normal lens, while in a telephoto lens it is greater – this ensures that the amount of light reaching the film stays the same. Because of this difference in size of aperture, the depth of field is greatest for the wide-angle lens, and least for the telephoto. When focal length and aperture are constant the depth of field will also vary according to your distance from the subject. Focusing on a distant subject produces a greater depth of field than focusing on a near subject.

Changing the lens

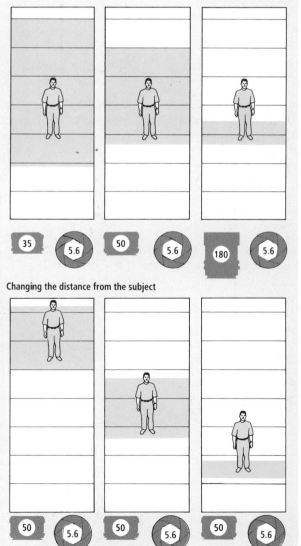

Changing the distance from the subject

Tinted area = depth of field

range. Each number in the sequence allows twice the exposure of the adjacent higher number, and half that of the adjacent lower number. Thus, f5.6 gives double the exposure of f8, and half that of f4.

The same f-number on any lens passes the same amount of light to the film. For example, on a 100mm lens, an aperture setting of f4 means that the actual opening is 25mm (100/4), on a 28mm lens set to f4 the opening will be 7mm wide (28/4). Because the image produced by lenses reduces in brightness in proportion to the increases in the focal length of the lens, this relative aperture system makes it simple for camera users to change lenses. The same f-number on different lenses gives the same exposure.

On lenses where the aperture is set manually, click stops mark each f-number. Although the numbers themselves may take a short while to become familiar, in practice the halving and doubling is simple.

Reducing the aperture size has another important effect on the image apart from altering exposure: it increases depth of field (see page 22). The more the aperture is stopped down, the greater the depth of field, so the aperture becomes an essential tool for managing the amount of sharpness in an image. For a quick guide, lenses have a depth-of-field scale engraved on the barrel, showing the distances from the camera (usually in feet and metres) within which everything will appear sharp at any given aperture.

When front-to-back sharpness is important in a photograph, the usual technique is to stop down the

Shutter speed In the rapids of a fast-flowing river even the individual drops of spray are frozen with a shutter speed of 1/1000th sec; there is no image movement visible. At the other end of the scale, at one second, the water has lost all recognizable characteristics and appears almost as a dense fog.

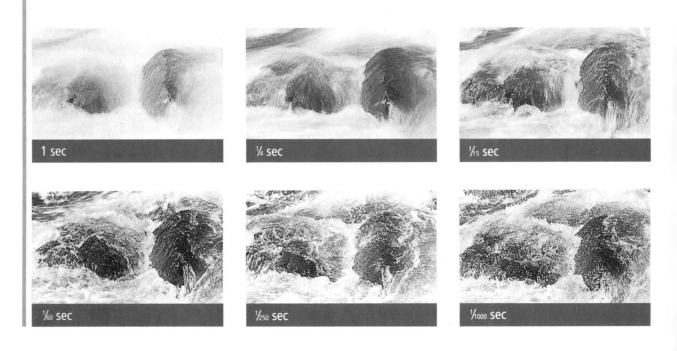

1 sec ¼ sec 1/15 sec

1/60 sec 1/250 sec 1/1000 sec

Panning Panning the camera to follow a moving subject, and using an intentionally slow shutter speed, can turn even the most prosaic image into a graceful design. By choosing a dark background – a group of trees – the seagull (above) was kept clearly visible even through a one-second exposure.
Nikon, 400mm, Kodachrome, 1 sec, f32.

aperture. This in turn cuts down the light reaching the film, so that the photographer then has to turn to the camera's other exposure control – the shutter.

Shutter

Equally important for adjusting exposure is the shutter, of which there are two types used in 35mm cameras – focal-plane and leaf shutters. Like the apterture, exposure control is not its only function; the shutter speed determines the way in which movement appears in the image.

While leaf shutters work perfectly well with non-reflex cameras, SLRs need a different shutter system – one in which the film is protected from exposure even when the lens is open for viewing via the mirror and prism. For this reason focal-plane shutters were invented: a set of flexible blinds travel across and just in front of the film.

For manual operation, shutter speeds are arranged in a sequence that doubles or halves the exposure time, as follows: 1 sec, 1/2 sec, 1/4 sec, 1/8 sec, 1/15 sec, 1/30 sec, 1/60 sec and so on. Because shutter speeds, like aperture

Aperture and shutter speed

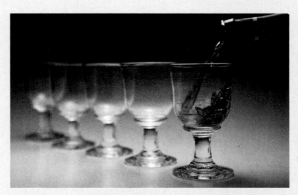

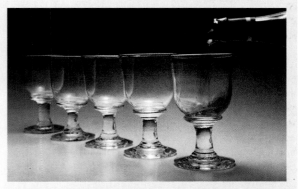

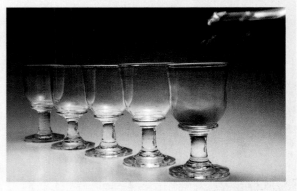

This subject requires a shutter speed and aperture setting to cope with movement of the wine and depth of field of the receding wine glasses. A fast speed (top) with the lens wide open gives little depth of field. Stopping down the lens (bottom) improves sharpness but the movement is blurred. The middle picture is a compromise.

Capturing movement

Objects appear to move fastest when they are travelling at a right-angle to the view. Travelling diagonally towards the camera, their apparent motion is less, and so do not need such a high shutter speed to record sharply on the film. The movement of a cyclist's legs is faster than that of the bicycle itself, and the rotation of the wheels is fastest of all. Therefore, to arrest the movement of the bicycle the shutter speed can be slower than it would need to be to freeze the movement of the spokes.

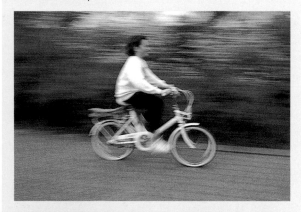

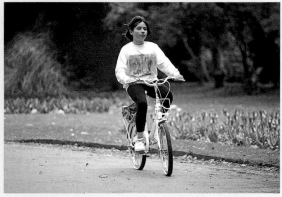

Movement within the frame Through the viewfinder, side-to-side movement appears much faster than head-on movement – what counts is how fast the image moves inside the frame. The image of the girl cycling towards the camera is sharp; cycling past the camera her image is blurred (and blurring of the background is exaggerated by panning).

setting a speed that is faster than necessary requires an over-wide aperture to compensate. What determines the stopping power of a given shutter speed is how fast the subject *appears* to move *across the picture frame*. With a normal lens, the image of a car moving across the field of view at 50mph (80 kph) will flash rapidly through the viewfinder if it passes close to the camera, but may take many seconds at a much greater distance. Similarly, a change to a wide-angle lens will reduce the image size of a moving object, so the object's motion will be relatively slower in the frame.

Stopping all motion is often assumed to be the ideal technique, and while it certainly gives the clearest image, it may not always be the most interesting or effective treatment. A slow shutter speed captures movement as a blur, and managed properly this can give much more of a *sense* of motion. Our appreciation of movement in every-day life comes from observing continuous sequences, and the still photograph that freezes one moment of this sequence can sometimes look static and odd. It is im-portant to know the pictorial effect of various degrees of blurring, so that you can choose the result that best suits the situation.

Aperture/shutter priority

As already explained, aperture and shutter are to an extent interchangeable as controls for exposing the image. Where the lighting is dim or extremely bright

Camera shake To demonstrate the effects of camera shake, the camera was mounted on a tripod and the end of the lens tapped in the middle of an exposure. *Nikon, 180mm, FP4, ⅟₆₀ sec., f16*

settings, are incremental, halving or doubling, aperture and shutter can be worked together. For example, widen-ing the aperture by one f-stop (doubling the amount of light let in) and at the same time increasing the shutter speed by one step (halving the length of the exposure) keeps the same exposure. There is a reciprocal relation-ship between the two systems, and this has a bearing on the behaviour of film at slow speeds (Recording the image, page 50). When the shutter is set automatically, as on modern, automatic cameras, there are no steps between speeds.

Apart from exposing the film, the shutter also controls the appearance of motion. A fast shutter speed "freezes" action, and one of the basic camera-handling skills is to judge the slowest speed necessary to prevent blur;

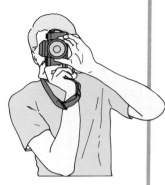

(these are relative values, and depend very much on the sensitivity of the film) there may not be much choice in the settings, but over a wide range of light conditions there are likely to be several possible combinations that will give the same exposure – from a small aperture and slow shutter speed to a wide aperture in combination with a fast shutter speed.

This choice is valuable, allowing either good depth of field with the possibility of some motion blur, or selective focus together with frozen movement. There may be good reasons for favouring either of these effects – for instance, to focus attention on one object in a scene by means of a shallow depth of field, or allowing a controlled amount of blur to convey the speed of a galloping horse – and it is important to have an appreciation of priorities. If stopping movement is critical, then some depth of field has to be sacrificed; if depth of field is more important, some blurring may be inevitable. In many automated cameras this choice is catered for in a selection of different programs.

Holding the camera

Modern 35mm cameras are designed for ease of use, but it still makes a difference to the operation if the camera is held and worked comfortably and efficiently. Like any tool, it performs best when handled with skill and familiarity, and the results usually show in the photographs – a faster, smoother operation means a better chance of catching fleeting images, and fewer technical mistakes. One of the main errors that good camera-handling prevents is camera shake – the unintentional blur caused by jabbing the shutter or a shaky grip. Blur in an image is fine only if it is intended and obvious.

The grip for any particular camera varies, not just according to the make, but to the lens fitted and any accessories being used, and also according to whether the framing is horizontal or vertical. The grips and stances illustrated on this page give broad guidelines, but these may have to be adapted to individual camera designs. Automatic cameras require fewer fingers for operation, and so are likely to be easier to hold steady. As a general rule, the more experienced you are, the slower the shutter speed you can use without camera shake, and this increases the number of picture possibilities. As an example, a shutter speed of 1/30 sec with a wide-angle lens, or even a standard lens, should be possible to achieve with practice.

Just as the shutter speed freezes or blurs a moving object, so the blur from camera shake depends on how much the *image* moves. A telephoto lens, which covers a small area of the entire view, is more susceptible to movement than is a wide-angle lens; the latter is always easier to hold steady at a slow speed.

Horizontal grip Use your right hand and three lower fingers to grip the camera, leaving your forefinger over the shutter release. Rest the camera body on the heel of your left hand, which is cupped so that the thumb and forefinger are free to move the lens controls on a non-autofocus camera.

Standing The steadiest stance is with your feet slightly apart, one a little in front and your weight balanced equally on both feet. Holding both arms close into your body gives extra support.

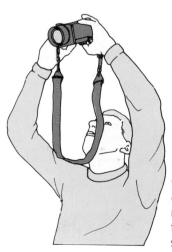

Vertical grip There are two alternative grips, with the viewfinder on the left or the right – the choice is purely a matter of personal preference. In both cases, grip the camera with your right hand, either from on top or with the wrist bent supporting it from below (shown above). In the first case, your left hand bears most of the weight; in the second, the grip is slightly more awkward but leaves the left hand more free.

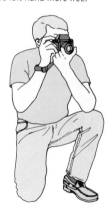

Kneeling An even steadier position, if you have time and the view allows it, is to kneel so that you can rest your left elbow on your left knee – your leg provides a solid vertical rest for the camera.

Overhead shooting In a crowd where your view is blocked, hold the camera at arms' length above your head. Either guess at the composition or, if the prism head is removable, take it off and view the frame directly on the ground glass screen.

Camera supports

Unlike large-format equipment, 35mm cameras are specifically designed for hand-held use, but below a certain light level (which depends on the film speed) some kind of support is essential. Even if you can hand-hold the camera without shake at slow shutter speeds, the depth of field will be shallow because of the wide aperture. A tripod, of which there are many designs and types, solves this problem. Even in normal lighting, a long telephoto lens nearly always benefits from a secure camera support. Another important benefit from a tripod is that it allows precise composition. In a studio, or when photographing buildings or landscapes, for instance, a tripod not only permits fine adjustments to the framing; it actually encourages a more careful approach to picture-taking.

The disadvantage of a tripod is that it is an extra piece of equipment to carry around, which rather goes against the ethos of light, rapid 35mm photography. In general, the heavier and more substantial the tripod, the sturdier it is likely to be, though this depends on it being well designed and well built. A lightweight tripod may have an obvious attraction, but any camera support is only as useful as it is stable. Outdoors, the wind can make a flimsy tripod useless, while even the vibration of an SLR mirror and shutter can transmit a tremor to the image. In the studio, portability is not particularly important, so heavy tripods and even camera stands are usual. On location, the tripod choice is inevitably a compromise between weight and rigidity. Beware of cheaply constructed tripods with centre columns that are raised and lowered by a ratchet and crank; although the idea is good in principle, this is often a weak point in a tripod.

Tripod heads demand separate attention, not only for rigidity, but also for ease of movement and convenience of attachment. There are two general types: heads with separate axes of movement (commonly pan-and-tilt heads) and ball-and-socket heads, which move freely in all directions when unlocked. Ball-and-socket heads are quicker to use, but more difficult to adjust precisely. Some tripods have a facility for fitting a lateral arm – useful for vertical copy shots.

A cable release (see Accessories below) further reduces the risk of camera shake, as does locking up the mirror of a SLR camera. The camera's self-timing shutter release is an alternative to a cable.

Accessories

Accessories comprise any ancillary equipment beyond the basic camera and principal lenses, and range from the useful to gimmicks. While it is tempting to acquire accessory after accessory in the hope that each one will open up new picture possibilities, in reality there are

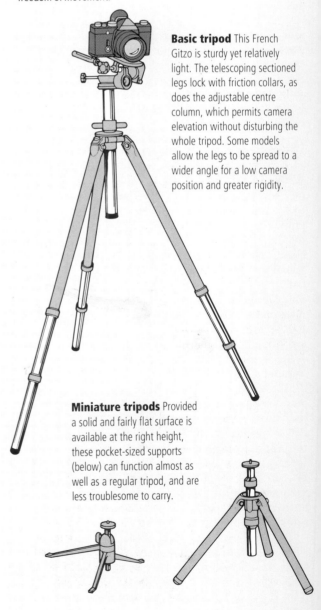

Choosing tripods and tripod heads

When buying a tripod, test not only its ability to hold a steady weight, but also its resistance to torque – the twisting movement caused by weak legs. Grip the head of the tripod and try to rotate it; if there is any significant movement the design is poor. The acid test is to mount a camera and fairly long lens, then tap the end of the lens while looking through the viewfinder. See how much the image vibrates, and use this method to compare tripods. Tripod heads should offer the maximum freedom of movement.

Basic tripod This French Gitzo is sturdy yet relatively light. The telescoping sectioned legs lock with friction collars, as does the adjustable centre column, which permits camera elevation without disturbing the whole tripod. Some models allow the legs to be spread to a wider angle for a low camera position and greater rigidity.

Miniature tripods Provided a solid and fairly flat surface is available at the right height, these pocket-sized supports (below) can function almost as well as a regular tripod, and are less troublesome to carry.

Double tripod for long lenses
Heavy long-focus lenses need greater support, particularly outdoors where wind can cause camera shake. In addition to a heavy main tripod, a second, lightweight tripod (right) attached to the front of the lens gives extra rigidity. Although few lenses have fittings for a second tripod, a home-made collar will be secure enough.

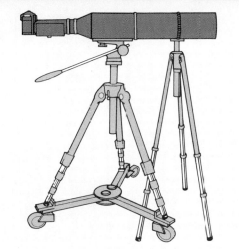

Rifle stocks
(below) are aids to handheld shooting, useful mainly with long lenses.

Monopod
Highly portable, this one-legged support (right) steadies hand-held shots.

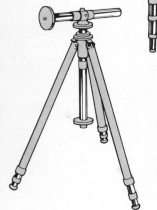

Reversed column
For low camera positions, some centre columns can be reversed (above). For ease of access to the camera controls, this can be combined with a horizontal arm fitting.

Monoball
This Arca-Swiss head (left) is the most secure ball-and-socket design available, capable of holding the heaviest 35mm configuration in any position.

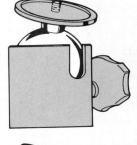

Horizontal arm
A separate horizontal section (left) attached to the centre column is useful when pointing the camera vertically downwards, as in copying. With the camera supported out to one side, the tripod legs do not appear in the shot, a common problem when the camera is used from a basic tripod.

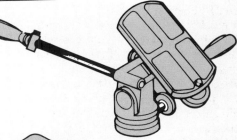

Pan-and-tilt head
Separate movements on this Gitzo Rationelle head (above) allow accurate adjustments.

Ball-and-socket head
Lighter and more widely available than the Monoball, this head (left) is secure enough for most combinations of camera and lens.

only a few that are valuable. Modern 35mm cameras are designed to incorporate all essentials for normal photography. Of course, photographers with specialized interests, such as some scientific or nature subjects, have genuine needs for particular accessories. The following are among the more useful.

Lens shades: Flare degrades an image, even with modern multi-coated lenses. A lens shade, which cuts out extraneous light from outside the picture frame, will improve picture quality, particularly when the camera is aimed partly towards a light source. Some lenses have built-in lens hoods that retract when not needed; most take separate heads that screw or clip onto the front. The most efficient, though bulky, design of lens shade is an adjustable bellows that can be altered to suit the lens's focal length. Alternatively, a piece of black card, or even a hand, held close to the lens will shield it from a single light source, such as the sun.

Motor-drives and winders: Nowadays, these are only an accessory to basic, less-automated camera models, as most modern cameras incorporate a motor-winder to wind on the film after each shot. The value of a motor-drive, which allows for continuous shooting, is that it permits fast action shooting; both it and the more usual motor-winder remove the delay and distraction of having to wind on the film after each exposure.

Filter holders: Filters are described on page 59. Makes of filter that are *not* designed to fit the lens diameter exactly – principally square or rectangular ones – need special mounts. The filter manufacturers normally supply these, whether for gelatin, plastic or glass filters, and they may sometimes double as lens shades.

Accessory shutter releases and triggers: There are a number of ways of operating the camera by remote control, whether from close to or some distance away, which may be useful in special circumstances, such as wildlife photography. The simplest is a pneumatic shutter release, although this alone has no provision for winding on to the next frame and re-setting the shutter. Professional, electronic cameras and some others, have outlets for electronic triggering; the cable can in turn be attached to a remote device such as an intervalometer, which fires the shutter at pre-set intervals. Even more remote control is offered by a radio transmitter with a receiver attached to the camera. Light modulation is the basis of a simpler and less expensive system.

Viewfinders: Some SLR cameras have removable prism heads, which can be substituted for other types of view-

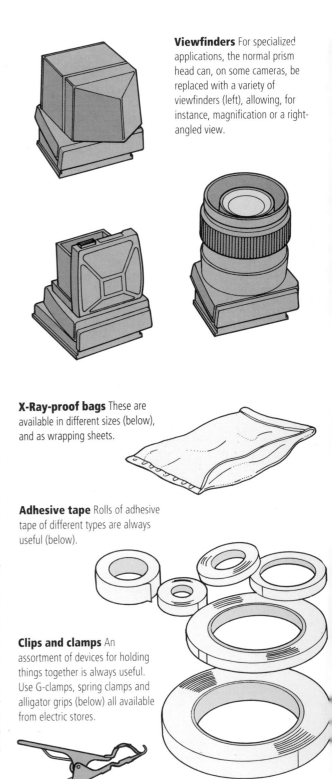

Viewfinders For specialized applications, the normal prism head can, on some cameras, be replaced with a variety of viewfinders (left), allowing, for instance, magnification or a right-angled view.

X-Ray-proof bags These are available in different sizes (below), and as wrapping sheets.

Adhesive tape Rolls of adhesive tape of different types are always useful (below).

Clips and clamps An assortment of devices for holding things together is always useful. Use G-clamps, spring clamps and alligator grips (below) all available from electric stores.

Panorama head Using the spirit level to set it horizontally, this rotating head (below) is calibrated to allow a series of shots that, when placed side by side, give a 360° panorama.

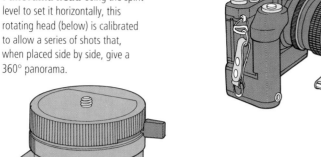

Conventional lens hoods
Designed to fit specific lenses, most hoods are circular (right). Some long-focus lenses have built-in hoods that slide forward over the barrel.

Motor-drives and winders
Motor-drives such as the Nikon MD-2 (below) differ from automatic winders in having a greater range of functions. Both use a battery-driven motor.

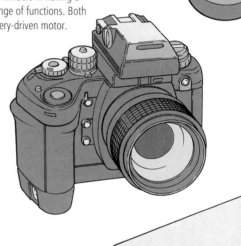

Professional lens shades
Highly controlled shading is possible with a compendium shade, which can be extended or shortened to suit lenses with different angles of view (left).

Filter holders A though glass filters are normally fitted with mounts to attach directly to the lens, the more delicate gelatin filters are best handled in special filter holders.

AC/DC converter Mains electricity, normally between 100v and 240v AC, can be converted into the low-voltage DC current needed to power a motor-drive (right).

Cable releases Cables (far right) allow shutter release without direct contact with the camera, and so reduce vibration. The best can be locked during long exposures.

Soft cable release

Remote control

There are a number of ways of operating the camera at a distance, a useful ability in wildlife and surveillance work. The simplest is a pneumatic shutter release, although this alone has no provision for winding on to the next frame and re-setting the shutter.

A motor-drive or automatic winder is practically essential for most remote control operations. An extension cord attaches to the motor-drive trigger mechanism for operation from a distance. Even more remote control is offered by a radio receiver attached to the camera and a transmitter; there is usually a choice of wavelengths, but you may find that other transmissions, from model aircraft controls for instance, may trigger the camera. Light modulation is the basis of a simpler and less expensive system. Totally independent operation is possible with an intervalometer, which can be set to fire the shutter at pre-arranged intervals from a few seconds to many hours. You can also design your own triggering systems based on wires, photo-electric cells or pressure plates. Two accessories for remote-control systems are bulk film camera backs, accommodating rolls of film of up to several hundred exposures, and servo attachments that automatically adjust the lens aperture with changing light levels.

Remote control For a close photograph of a Malaysian macaque collecting coconuts, remote control was essential to avoid upsetting the animal. *Nikon F3 + motor-drive, 20mm lens, Kodachrome ISO 200, automatic setting*

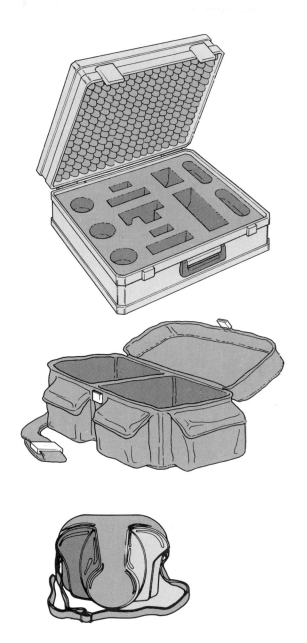

Equipment cases The main function of a camera case is to provide maximum protection. Moulded aluminium cases such as this American Haliburton (left), or the West German Rox, are the most secure, and are gasket-sealed against grit and water.

Camera cases are often rigid and an exact fit for the camera (above).

Lens cases. Cases for indivicual lenses (from left to right) are available in soft padded leather, hard leather. or clear plastic with a screw base.

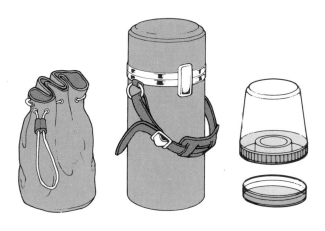

ing heads. A magnifying pentaprism head allows easy viewing of an enlarged screen without the need to press your eye up close to the camera. A waist-level finder is essentially a hood that shades the light from the ground-glass screen and is used for low-level viewing. A high-magnification focusing viewer also facilitates a right-angle view of the image, but is particularly useful for close-up or copy work.

Data back: A replacement for the normal camera back, this prints date, time and other information onto a small area of the film, usually by means of fibre optics.

Special attachments: These are available for fitting cameras to other types of optical systems, such as microscopes (see Photomicrography, page 182), endoscopes, oscilloscopes and astronomical telescopes.

Panoramic head: This graduated rotating attachment fits between the camera and the tripod head, and allows precise alignment of a sequence of pictures taken as a horizontal strip. The alignment is always better with a longer rather than a shorter focal length lens.

Cases: A camera case prolongs the life of equipment. Solid cases, such as those of aluminium or ABS, gasket-lined and watertight, offer the best protection; some have adjustable compartments, others have foam blocks that can be cut to take a particular configuration of equipment. They are, however, more useful for transporting equipment from place to place than for working from. A padded, compartmented shoulder bag is more useful. There are many designs available, but the main criteria for choosing one is size. It should be large enough to take all the *necessary* equipment for normal shooting, but not so large as to be unwieldy.

Cleaning and repair

Like any complex piece of equipment, a camera needs care and maintenance. A certain amount of this is commonsense, such as keeping cameras wrapped when conditions are dusty or wet, and a regular cleaning regime saves camera repair bills later. Constant use, particularly outdoors, causes eventual wear and tear on all parts of the camera system. Lens surfaces, the electronics and moving parts are particularly vulnerable. For external surfaces, use a small brush (preferably a blower brush), lens cloth or tissue, and cotton swabs moistened with de-natured alcohol rather than water; a can of compressed air is also effective for removing dust and grit.

On-the-spot repair is becoming less and less possible as 35mm cameras become more automated and more reliant on miniaturized electronic circuitry. Breakdown normally means that the camera cannot be used until it has been sent to the manufacturer or dealer for professional repair. DIY repair will in any case invalidate any warranty. Nevertheless, if the choice is between this and losing important shots, some repair work might be worth attempting, if the cause of the problem is obvious.

Compressed air or cans of an inert gas (right) are useful for removing dust from inaccessible corners.

Brushes and swabs You will find the following items indispensable for cleaning the lens and/or camera body (from left to right below): lens-cleaning tissue, toothbrush (camera body only), cotton buds, blower brush.

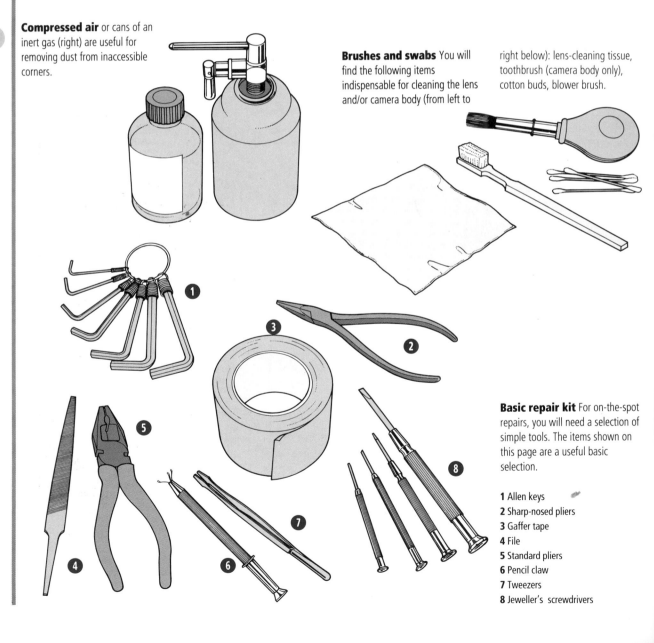

Basic repair kit For on-the-spot repairs, you will need a selection of simple tools. The items shown on this page are a useful basic selection.

1 Allen keys
2 Sharp-nosed pliers
3 Gaffer tape
4 File
5 Standard pliers
6 Pencil claw
7 Tweezers
8 Jeweller's screwdrivers

Loading procedure and unloading

Most modern automatic camera have automated loading – you insert the film cassette in its cylindrical chamber, with the film leader protruding so that it lies across the film gate. When you close the camera back, motorized sproket wheels take up the leader and pull it across to the take-up spool, advancing it so that the beginning of the unexposed film is positioned ready for the first frame. At the same time, a metallized patch on the cassette is scanned for film-speed information and the camera's metering system is set accordingly. The details of this loading operation vary from make to make, so it is essential to read the instruction manual for any new camera that you use. For cameras that do not have automatic loading, develop a set procedure, as shown below. The biggest danger is not fitting the film leader onto the take-up spool securely – the result is that the film slips when you wind on and does not advance. Take special care over this step, particularly if you are in a hurry to change film and continue shooting.

Manual loading

1 For those cameras that don't have automatic loading, open the camera back and pull out the rewind knob. In subdued light insert the film cassette so that the protruding end of the spool is at the bottom. Push back the rewind knob.

2 Pull out the film leader, and by rotating the take-up spool insert the end of the film into one of the slots, making sure that the perforations engage the lower sprocket.

3 Wind on the film until the top row of perforations engage the upper sprocket and the film is tensioned across the film guide rails.

4 Close the camera back and gently turn the film rewind knob in the direction of the arrow until you feel resistance. This is to check that the film is fully tensioned. Advance the film until the frame counter reads "1".

Unloading

1 Press the rewind button. Unfold the film rewind crank and rotate it in the direction of the arrow. Continue to do this until you feel the tension ease. This indicates that the film has been fully rewound.

2 In subdued light, open the camera back. Pull out the rewind knob and take out the film cassette.

Lenses

- ● Fixed, zoom, wide-angle and special lenses
- ● Focal lengths
- ● Forming an image

The one characteristic of a camera lens that, more than anything else, affects the type of image, is its focal length. The focal length (see Forming an image, page 46) is the distance from the lens to the focused image when the lens is set for infinity. In a camera, the image is focused at the film plane. A lens that has a short focal length – 28mm for example – bends the incoming light rays sharply in order to record a large part of the scene in front of the camera. A long focal length lens, on the other hand, refracts the light at a more gentle angle, magnifying the image but taking in only a small area of the view in front of the camera.

Only the most basic 35mm cameras have a single, fixed focal length lens. Others either have a permanently fitted zoom lens that covers a range of focal lengths, or the facility to change lenses. In any case, a choice of focal lengths is essential for dealing with a variety of subjects and being able to treat them in different ways. Although the simplest difference that focal length makes is the angle of view – taking in a broad or narrow part of the scene – there are more complex differences in the style of the image and in the interpretation of reality.

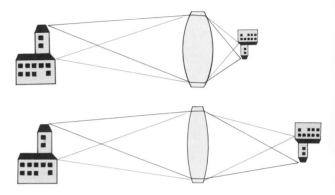

How focal length controls image size The convex lens of a short-focus design bends the light rays from the subject at a sharp angle to bring the image into focus only a short distance behind the lens: hence its name. Because the light is bent so sharply, the image is small. The long-focus lens is less convex than a short-focus design and so brings the light rays together farther behind to form a larger image. This also means that a long-focus lens is more selective, as less of the subject's surroundings are included.

Fixed and zoom lenses

Traditional lenses were designed to work at a single focal length, and it was this that made the concept of interchangeable lenses the mainstay of professional camera systems. Zoom lenses, more complex in design and manufacture, provide a range of focal lengths in one lens. In the early years they were bulky, slow (that is, with smaller maximum apertures than regular lenses) and optically inferior, but continuous improvements have now made them a true alternative to fixed focal length lenses. As a result, except for extreme wide-angle and telephoto photography, a couple of zoom lenses can take the place of an interchangeable-lens camera system. The advantages are convenience and simplicity, while the range of angle of view that they cover is continuous. The disadvantages are that the maximum aperture is never as wide as an equivalent fixed focal length lens, and certain specialized fields of photography, such as wildlife, need extreme focal lengths.

The normal lens

An enormous range of focal lengths is available for 35mm cameras, with angles of view from more than 200° to less than 1°. In the middle of this range are the lenses that give approximately the same angle of view as the human eye; these are the normal, or standard lenses. Of course, given the nature of perception (see Perception, page 13), it is impossible to make an exact comparison, hence the definition of a normal lens is inevitably vague. Lens

Hands, East Flores, Indonesia For closely cropped images when the composition can be changed radically simply by moving the camera, a normal focal length excels. Had a wide-angle lens been used for this photograph, it would have been impossible to exclude the surroundings – and the simplicity of tone and colour which are essential to the success of this shot would have been lost. A telephoto lens would have had to be used from an inconvenient distance.
20mm lens, Agfachrome ISO 50, ⅟₁₀ sec, f22

Mount Fuji, Japan Normal lenses are notable for their lack of visual character. The perspective in this photograph is as a viewer would expect to see it in reality. Neither compression nor distortion interfere with the strong basic elements of the scene.
50mm lens, Kodachrome ISO 200, automatic setting

Normal lens

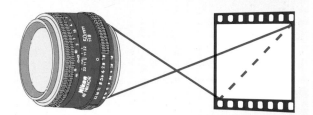

A "Normal" lens is one that produces an image much the same as that seen by the naked eye. Technically, a lens that gives this normal-looking view is one with a focal length that is about the same as the diameter of the image it projects. In other words, it is the diagonal of the film frame. The larger the camera format, the longer the focal length needs to be. Strictly speaking, a normal lens for 35mm would be 43mm, but 50mm has become standard. Some photographers use a 35mm lens as normal.

An effective demonstration of the characteristics of lenses of different focal lengths is to choose one viewpoint and, with a selection of lenses from very short to very long focus, shoot the same scene with the camera pointing in the same direction. The opportunities for making as good a composition with every lens are very rare, and inevitably one or two stand out as more effective. In this series of photographs of a building in Mount Vernon, the camera position was unchanged, but the lenses used ranged from a 20mm lens to 400mm lens. The pictures at either end of the scale are inevitably completely different.

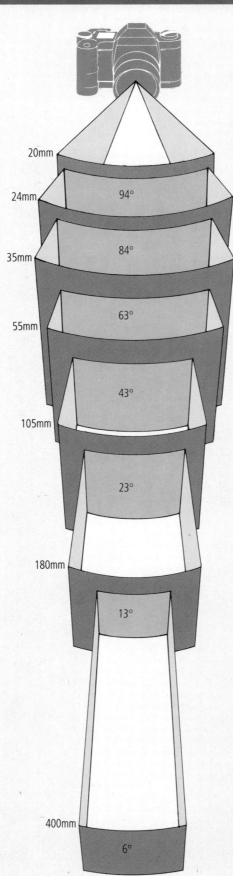

20mm
24mm — 94°
35mm — 84°
55mm — 63°
105mm — 43°
180mm — 23°
400mm — 13°
6°

Focal length variations from 20mm to 400mm

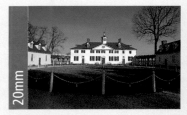
20mm

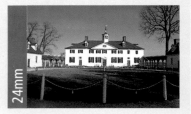
24mm

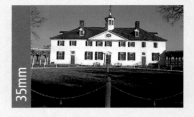
35mm

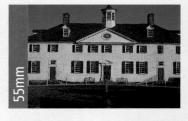
55mm

105mm

180mm

400mm

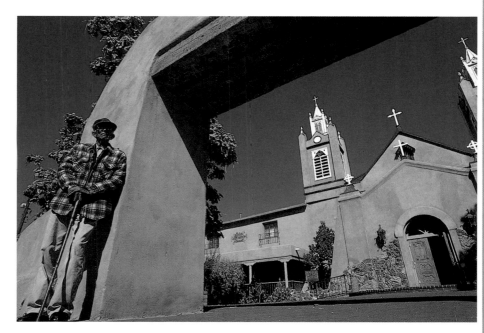

Wide-angle graphics A ground-level viewpoint of the adobe cathedral in Albuquerque, New Mexico, gives a deliberately distorted image. This angular composition is more important for this photograph than upright verticals. As the camera appeared to be pointing directly at the steeple, the man standing by the arch at left did not realize he was included in the picture.
20mm lens, Kodachrome ISO 64, ⅟₆₀ sec., f16

descriptions such as normal, wide-angle and telephoto depend on the film size, for a lens that gives a certain coverage on one film format will project a wider angle on a larger format.

Because normal lenses record an image in much the same way as the eye sees it, they are the least obtrusive picture-making tool. They bring none of the unusual visual effects associated with extreme focal lengths, and are the choice par excellence for a faithful, straightforward treatment of a subject. They have a special place, for instance, in reportage photography, where many photographers feel it is essential to present a plain, unaltered view of life and its events.

Another practical advantage of a normal focal length is that it is easier for lens manufacturers to increase its light-gathering power and therefore its speed. The additional optical problems of wide-angle and long-focus lenses restrict their maximum aperture. The fastest lenses have normal or close-to-normal focal lengths, and maximum apertures of around f1 to f1.2.

Wide-angle lenses

For 35mm cameras, focal lengths less than about 35mm are considered wide-angle – the usual term for a short focal length lens design. Practically, there are two categories: moderate wide-angle lenses, which give little noticeable distortion; and extreme wide-angle lenses, which unmistakably impose their graphic stamp on the picture. All of these short-focus lenses enable the photographer to cover a wide angle of view, even in small spaces, and at the same time they give great depth of field.

Together, these properties open up exciting possibilities for controlling the relationships between different elements in a scene.

The overriding property of a wide-angle lens is its coverage, around 60° in the case of a moderate wide-angle such as a 35mm lens, and close to 100° with a lens such as a 20mm. In cramped conditions where the photographer cannot move back far enough to take in all the important elements with a normal lens, a wide-angle lens is essential. Its generous coverage gives a feeling of space to

Subjective wide-angle treatment Using a 24mm lens on a procession for the inauguration of a Cambodian temple gives immediacy and a sense of being in among the crowd of people. Focus and depth of field are important in this type of shot, which to be effective needs people close to the camera.
24mm lens, Kodachrome ISO 200, automatic setting

interior views and will often convey the sweep of an open landscape better than other lenses. Also important is its ability to include both the immediate foreground and the distance, which allows the relationship between details and backgrounds to be explored (see Landscapes, page 152). Photographs that make use of this tend to have the quality of drawing the viewer into the scene. For this reason, wide-angle lenses can be used for an involved, subjective treatment.

Because the lens compresses the image at the film plane, it is very efficient at gathering light, so the actual maximum aperture of a wide-angle lens is relatively small. As a result, the depth of field is greater than normal. In reportage photography, for example, this can be perfect for unanticipated shots that must be taken in an instant. With, say, a 28mm lens on a fairly bright day with average film, everything from a few feet to infinity can be rendered sharp, so the photographer can aim and shoot without adjusting the focus.

Extreme wide-angle lenses

Lenses with focal lengths shorter than about 24mm introduce a degree of distortion that goes beyond our normal experience of a scene. They have angles of view of around 100° and more, with the most extreme of all in

The fish-eye lens

The special design of fish-eye lenses is uncorrected, giving a very characteristic, curved distortion in which straight lines, except radial ones (those passing through the centre of the lens), are bent around the circumference of the image. True fish-eye lenses give a circular image; so-called full-frame fish-eye cover the entire 24x36mm frame. The distortion they create easily swamps the subject matter and restricts their use. If possible, compose the picture in such a way that familiar shapes are near the centre, where the distortion is less. Complicated outlines are normally poor subjects since they are further complicated by the distortion.

Near-far composition By stopping down the aperture so that the depth of field covers the entire scene, and by experimenting with the viewpoint, a wide-angle lens can be used to juxtapose a close, small-scale foreground with a distant, large-scale background – in this instance a red sandstone outcrop with an ancient Native American dwelling at Wupatki in Arizona.
20mm lens, Kodachrome ISO 64, ⅛ sec., f32

excess of 180°. Clearly valuable for an enveloping view of cramped interiors, the price of this exceptional coverage is extreme distortion, demanding careful and restricted use.

Because of the wide coverage of these lenses, it is often difficult to avoid having the sun in frame in an outdoor shot. As a result, it is important to take great care when setting the exposure as the sun or a large area of pale-toned sky in the frame can easily result in the main subject being underexposed. A precaution when making an exposure reading is to exclude the sun, either by aiming the camera in a slightly different direction, or by covering the image of the sun with one hand.

Tight cropping with a telephoto The narrow angle of view that a long-focus lens gives makes it possible to frame tightly on a subject, excluding any distracting background, as in this shot of a Navajo Indian herding sheep down a slope.
180mm lens, Kodachrome ISO 64, automatic setting

Long-focus for reportage
Lenses with focal lengths between about 135mm and 200mm are ideal for photographing people at distances of several metres. This typical across-the-street type of shot, in Montreal, Canada, was made with a 180mm lens from suf-ficiently far away for the two women to be unaware of the photographer.
180mm lens, Kodachrome ISO 64, ¹/₁₂₄ sec., f8

It is possible for the curvilinear distortion of the lens to be corrected, at a price. Such lenses, when around 15mm focal length, are usually bulky and very expensive, and none can reach the coverage of an uncorrected fisheye. In any case, although all straight lines do appear straight in the picture, there is considerable angular stretching towards the edges, and familiar shapes, like circles and faces, appear badly distorted if near the corners of the frame.

Filters can be difficult to attach, as the angle of view is so wide that the rim of the filter would normally appear in frame. Consequently, such extreme lenses have built-in filters situated between the elements. For filters not supplied like this, it is possible to cut and bend a large gelatin filter to shape, and tape it to the lens.

Long-focus lenses

If the wide-angle lens draws together all the components of the scene and involves the viewer, the long-focus lens is a device that isolates and detaches. Because it magnifies, it can be used to pick out individual elements from a scene. This ability to select is enhanced by the shallow

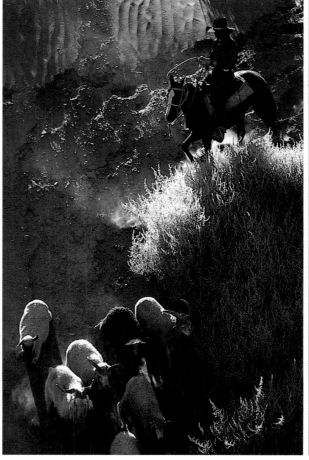

Normal lens This standard 50mm lens has a 46° angle of view that gives a natural perspective and a moderately wide minimum aperture of f1.8. Its six elements arranged in five groups allow the manufacturer design flexibility to correct most common aberrations.

Zoom lenses Using very recent design techniques, wide-angle zoom lenses can now be manufactured to adequate optical standards. Zoom lens technology has always been hampered by problems of distortion and aberration, particularly with the designs needed with wide-angles, but these are now being overcome significantly. The lenses shown here are (from left to right) 80-200mm, 35-80mm, 75-300mm, 28-80 mm.

Shift lens Several manufacturers supply "perspective correction" lenses in a mount which allows the lens to be moved laterally. This is mainly used to avoid converging vertical lines in architectural photography. At least one manufacturer – Canon – also offers a "tilt" facility, which allows you to hold receding planes in focus without stopping down.

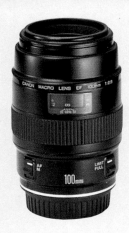

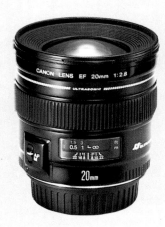

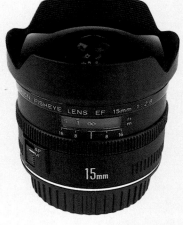

Macro lens Unlike normal designs which perform at their best when focused on infinity, this 100mm f2.8 lens (above) is intended for optimum use at close distances.

Wide-angle lens The 20mm lens (above), with an angle of view of 94°, uses a retrofocus design to lengthen its extremely short focus so that it can be used with the reflex mirror in the camera housing. To overcome the problem of poor image quality at close focusing, the elements "float" inside the housing. Their relative positions can therefore be changed as the lens focuses closer.

Fish-eye lens Designed for its pictorial effect rather than for scientific use, this f2.8 15mm full-frame fish-eye lens (above) covers an angle of view of 180°.

Long-focus lens A favourite of many photo-journalists, the fast 200mm lens (right) has a maximum aperture of f2.8 which makes it fairly easy to hand-hold at quite slow speeds. For colour work in poor lighting conditions it is an ideal telephoto lens.

Extreme long-focus lens One of several relatively recent long-focus lenses, this 400mm f2.8 telephoto design is too large for hand-held shooting. Extra-low dispersion glass is used, and although this is expensive, it reduces chromatic aberration, the chief cause of unsharpness in long-focus lenses. It also allows the lens to operate at its optimum performance while at full exposure.

depth of field of all long-focus lenses. Because they need to gather more light for their magnified images, they have large actual apertures; as a result, the depth of field is limited even when the lens is stopped down to its smallest aperture, and the subject in focus often appears with a blurred foreground or background, or both. Since long-focus lenses have a long focal length they tend to be physically large, and a traditionally designed 1000mm, for instance, can be very heavy and unwieldy. For this reason, most long-focus lenses use a telephoto design to shorten the internal distance.

Another way of shortening the length of a long-focus lens is to fold the light path by means of two mirrors. This design, borrowed from astronomical telescope technology, is known as a catadioptric mirror lens, and can be quite short and stubby. Long-focus lenses have the great advantage that the photographer can work at a distance – especially useful with wildlife and when making unobserved photographs of people.

An alternative to a long lens is a tele-converter, essentially a supplementary set of elements that fit behind the lens to increase its focal length. At some cost in quality and lens speed, tele-converters have some value when used with a moderately long-focus lens to upgrade its magnifying power.

Extreme long-focus lenses

Lenses longer than about 300mm present both new opportunities and problems. Foreshortening is an essential quality with such lenses, making distant objects, such as mountains or a setting sun, loom large over middle distance and foreground. Their extreme magnification allows them to be used at considerable distances from subjects that might otherwise be unapproachable, such as wildlife. In reportage, these lenses allow completely unobserved candid photography, although the style of the image is noticeably distanced – the opposite of the close, subjective wide-angle treatment.

The very shallow depth of field confers a special advantage: if the aperture is kept wide open, distracting foregrounds such as foliage are thrown so far out of focus that they virtually disappear. In effect, the lens shoots right through the obstruction.

Telephoto juxtaposition
When a scene contains distinctly separate elements, such as in this photograph of the superstructure of a Japanese ship and Mount Fuji, the characteristic perspective effect of a long focal length makes unusual juxtapositions possible.
400mm lens, Fujichrome Velvia ISO 50, automatic setting

Inevitably, such lenses are heavy and bulky, even with space-saving improvements in design. They combine all the worst camera-handling problems. They are heavy and difficult to hold steady, and any camera shake is more apparent at these greater magnifications. Relative movement of the subject is also greater, and needs a faster shutter speed (from the same viewpoint, a moving object will cross the picture frame of a long-focus lens faster than that of a normal or wide-angle lens). To make matters worse, long-focus lenses tend to be slow in that they have smaller maximum apertures; designs that improve this are very bulky and expensive.

One reason why the very best long-focus lenses are so expensive is the cost of correcting chromatic aberration.

Telephoto perspective The slope of a Sri Lankan tea plantation (left) seems steeper than it really is in the view made with a 400mm lens. Such foreshortening is typical of photographs made with very long focal length lenses.
400mm lens, Kodachrome ISO 64, automatic setting

Telephoto compression In an effect similar to that of the tea-pickers (left), a line of Confederate cannon at an American Civil War battle-site (below) appears to be compressed. To make the most of this, the lens was stopped down to a small aperture for maximum depth of field (the resulting slow shutter speed made a tripod essential).
400mm lens, Kodachrome ISO 64, ¼ sec., f32

This natural lens fault (see page 15) is more apparent at the great magnifications of this kind of lens. Even when its characteristic coloured fringe has been corrected, the image may still be a little unsharp unless costly glass elements are used.

Zoom lenses

The increasingly standard zoom lens has a variable focal length, which means that, in a single housing, a range of magnifications and angles of view can be combined. The image quality possible with this kind of lens used to be noticeably poorer than that which could be achieved with a conventional, fixed focal length design, but modern zoom lenses can have excellent optics.

**A zoom lens' choice of
framing** The great advantage of a
zoom lens is that its range is
continuous, allowing exact framing.
This view of a southern-Californian
reconstructed mission offers two or
three images within this wide-angle
frame.
*Zoom lens, Fujichrome
Velvia ISO 50, automatic
setting*

For cameras that accept interchangeable lenses, zoom lenses are available in different ranges from wide angle to long focus. These often overlap, so that the complete spread of focal lengths can be encompassed with very few zoom lenses. There are two clear advantages to zoom lenses. Firstly, although the lens may be heavier and bulkier than any single, fixed focal length lens within its range, it is much lighter than the several conventional lenses it replaces. For photographers who need a broad selection of focal lengths, a zoom may be more convenient and portable. Secondly, precise framing is possible without changing the camera position; this is particularly valuable when access to a subject is restricted, as in a sports stadium, or when the subject changes position quickly.

Another, more specialized, use of a zoom lens is to operate the zooming control during a slow exposure. This produces a highly characteristic streaking of the image, which can be used (but also over-used) as a special effect.

Close-up and macro lenses

The greatest magnification that a normal lens can give is in the region of 1/7 the size of the subject – in other words, a reproduction ratio of 1:7. For magnifications greater than this, special equipment or extended focusing is needed. The usual method of lens focusing involves moving the lens (or some of the lens elements in a compound lens) further away from the film. In close-up photography (magnifications greater than ⅐ times subject size), the alternatives are to add a simple supplementary close-up lens that attaches to the front of the camera lens; or to fit an extension ring between the lens and the cam-

era; or to use a specially designed macro lens, which not only has extended focusing but which performs best at short distances. Photomacrography – commonly abbreviated to "macro" – covers the range of magnification from about lifesize (1x, or a reproduction ratio of 1:1) up to the point at which a microscope is needed (about 20:1).

Image sharpness, depth of field and lighting are the three main problems of close-up work. Most lenses are computed to perform at their best at normal focusing distances – between 1 metre (1 yd) or so and infinity – and the image deteriorates when they are used significantly closer. At magnifications beyond 1x, close-up sharpness can be improved by using a normal camera lens in reverse, attaching it by means of a reversing ring.

Depth of field at these magnifications is extremely shallow, and it is often not possible to keep the entire subject in sharp focus. To improve this, work at small apertures (for this reason, macro lenses stop down to at least f32) and position the camera carefully in relation to the depth of the subject.

Medical macro lens This specialized macro lens has a built-in ringflash for simple, convenient lighting. The flash tube surrounds the front of the lens and gives shadowless lighting. Its effects depend very much on the reflectivity of the subject. Used on a silicon chip (left), it picks out the circuitry very effectively.
200mm Medical-Nikkor lens, Kodachrome ISO 64, 8x magnification, automatic setting

Zooming during an exposure This technique involves using a shutter speed slow enough to allow the zoom control to be operated during the exposure. It was used below to make a gory studio prop appear a little less gruesome for the cover of a book of horror stories.
35-70mm zoom lens, Ektachrome Type B ISO 50, automatic setting at ½ sec.

A special lighting difficulty at close working distance is that the lens itself can cast a shadow over the subject. Some ingenuity may be called for in using reflectors and even small mirrors in order to re-direct light into shadowed areas, and precise positioning of lights is critical. Because everything is on a much smaller scale than usual, normal lighting appears more diffuse. Sometimes this is an advantage, but to give crisp, definite shadows very small light sources are needed, such as detachable portable flash units. The lens extension needs an increase in exposure to compensate for the light fall-off (light intensity obeys the inverse square law – see Using light, page 72). A camera's internal metering system, however, will automatically compensate for this, and if a dedicated flash unit is used (see On-camera flash, 89), its light output will also be controlled.

Special-purpose lenses

Specialized, and consequently expensive, lenses are needed for certain limited areas of photography. Their use depends entirely on the photographer's interests. A perspective-control (PC) or shift lens borrows a technique normal in large-format view cameras – the lens slides vertically or horizontally to alter the coverage.

Typically, buildings are photographed from ground level, which usually means tilting the camera upwards to take in everything. This, however, causes the verticals to converge, which may sometimes be interesting, but more often just looks wrong. With a shift lens, the camera does not need to be tilted; instead, the camera is aimed horizontally, which keeps the verticals looking vertical, and the lens is shifted to bring the top of the building down into frame.

Aspherical lenses feature a specially ground front element surface to correct coma. This usually has more technical than pictorial importance, although one application of it is in fast lenses for use at maximum aperture in dim light, when street lamps and other points of light near the edges of the frame would ordinarily record as tear-drop shapes.

Recording the image

- **How film works**
- **Film types**
- **Filters**
- **Electronic imaging**

The task of the camera and lens is to form an image; the job of film and, increasingly, electronic media. Although at first glance film and electronic media may seem diametrically opposed, there is in fact considerable correspondence between them. Essentially, both record images as a mass of tiny, individual units of tone and colour; viewed at a normal distance this finely patterned mosaic looks continuous. Mechanically, of course, they work quite differently, and electronic media have the special, invaluable property of digitizing the picture. Once digitized, an image, like a set of numbers or a block of text, can be processed and manipulated in almost any way. The process of creating an image on film occurs in two main stages. The first stage is the exposure, when light-sensitive crystals, or grains, in the film emulsion undergo electro-chemical change in response to being struck by photons (particles of light). At this point a latent (hidden) image is formed. The second stage is the film development, when the sensitivity of those crystals that were struck by light is increased by the chemicals in the developer – in the order of about 10 million times – so that the image finally becomes visible.

Silver halide emulsion

The first photographic emulsions were black and white, and although this is now relatively little used, and restricted to enthusiasts and some professionals, its chemistry remains the basis of all films. The detailed workings are explained in the box (right), but in principle an invisible electro-chemical change is triggered in the silver halide crystals when they are exposed to light. The pattern of these changes across the entire surface of the emulsion forms a latent image. Colour film works in essentially the same way, except that there are three layers of emulsion sandwiched together, each sensitive to a different part of the spectrum.

The active ingredient in film is silver halide (a light sensitive chemical compound). It takes the form of a mass of crystals, commonly known as grains, distributed as evenly as possible in the gelatin layer that makes up the body of the film emulsion. The size and distribution of these grains varies according to the type of film, but in an average emulsion each measures about 1/1000th mm across. The silver and halide components are held together in a lattice arrangement by electrical bonds; when the photons strike a grain they disrupt its electrical status quo by adding energy to it.

Most of the improvements and alterations that film manufacturers make to their products have to do with the size and shape of these grains and the way in which they are suspended in the emulsion.

Although all film reacts in the way described, the end product can be a colour negative, a black-and-white negative, a colour transparency, or even a black-and-white transparency. The negative images are, in turn, intended to be converted into enlarged prints. In each case, the original exposed grains must be treated chemically. In standard black-and-white film the grains are converted to black metallic silver; in colour film, dyes replace the silver halide grains. Transparency film requires an extra processing sequence in which the tones, and colours, of the developed negative image are reversed.

Apart from colour quality, which is dealt with a little later, the two characteristics that most concern photographers are sensitivity to light (speed) and resolution (ability to show fine detail). To contrast and improve these, film manufacturers have had to experiment with the granularity of the emulsion.

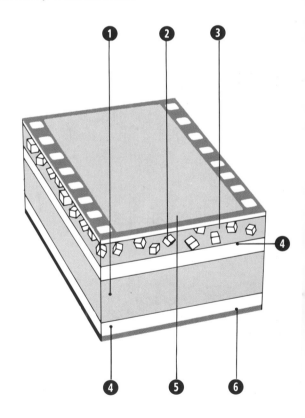

How film is constructed The construction of black-and-white film starts with the film base (**1**), typically a cellulose acetate that is tough, stable and almost non-flammable. On top of this, the emulsion of silver bromide grains (**2**) in gelatin (**3**) is attached with an adhesive layer (**4**). The emulsion is protected by a thin coating that resists scratching (**5**) and an anti-halation layer (**6**) backs the film base to prevent unwanted light being reflected into the emulsion.

How film reacts to light

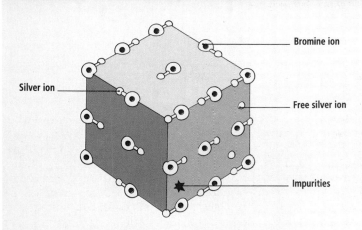

Silver ion

Bromine ion

Free silver ion

Impurities

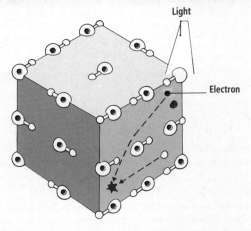

Light

Electron

1 Unexposed, a grain of silver bromide is a crystal composed mainly of pairs of silver and bromine atoms. Because these atoms do not have the same number of electrons as ordinary uncharged silver and bromine atoms, they have an electrical charge and this holds them together. In this form, they are called ions; the silver ions are missing one electron and so have a positive charge; the bromine ions have an extra electron (represented by the small red dots) and have a negative charge.

In addition to this basic lattice, there are two irregularities – a few independent silver ions (also with a positive charge) and small specks of impurity, such as silver sulphide. It is these irregularities that start off the process of building an image.

2 Light striking the crystal excites the extra electron in the bromine ion, giving it higher energy and freeing it to move around the crystal. The specks of impurity seem to be a site for the accumulation of these wandering electrons which give the specks a negative charge. They then attract the free positively charged silver ions.

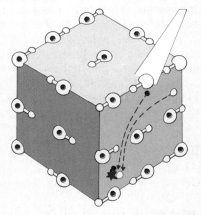

3 As light continues to add energy to the system, more electrons are freed and they in turn migrate to the specks of impurity, pulling after them more free silver ions. The small clumps of silver ions become silver metal.

Film speed, contrast and density

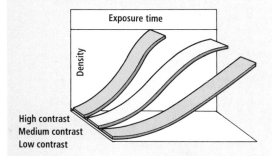

Exposure time

Density

High contrast
Medium contrast
Low contrast

Although more exposure to light naturally results in an increase in density of the image, the rate at which this happens is not constant. At first only a few free electrons are excited and there is a slow start. Later the established clumps of silver act like magnets for further silver ions and electrons. Finally, very few free silver ions remain and the process slows down again. The speed at which this happens depends on the type of film. This change in the pace of image formation is graphically represented by the resulting S-shaped curve. If the curve is steep, this shows that the film achieves maximum density very quickly and therefore has a high contrast. If, on the other hand, the slope is shallow, then the film has low contrast. A long flat toe indicates lack of detail in the highlights and a flat shoulder shows compression of tone in the shadows.

4 These aggregations of silver constitute the latent image. It is still invisible and will only turn into a real image when exposed to the action of a developer.

Grain and speed

To make a film more sensitive to light – to increase its speed – a greater area of each affected grain needs to be exposed. Traditionally, this was done by using larger grains, but a more modern development is to use grains that are flatter rather than lumpy; if they lie flat side towards the light, the result is greater sensitivity without more silver halide bulk. Film with larger, or flatter, grains reacts more readily to light and is therefore "faster". However, the price that has to be paid for this increase in film speed is a coarser image – more so with large- than with flat-grain emulsions. The increased granularity gives rise to a grainier appearance, which in the very fastest films or with great enlargement actually breaks up the image into a pronounced speckled texture.

Graininess runs counter to the ideal of good resolution. For this second important quality, film manufacturers set smaller grains into a thinner emulsion, so as to reduce the internal reflections that degrade the image in a thick layer of gelatin. This type of emulsion has a fine-grained appearance, but reacts less quickly to light and is

Fine-grained film A fairly slow film speed of ISO 64 (above) coupled with particularly thin emulsion layers help Kodachrome to achieve its traditional high-resolution images with a hardly distinguishable graininess. The contrast is relatively high, which in this view of the Shaker village in New Hampshire gives a clean, crisp effect.
24mm lens, Kodachrome ISO 64, automatic setting

Grain and graininess The same subject (right) was photographed on slow, fast and ultra-fast film. As can be seen from the three sectional blow-ups above, graininess increases steadily with increasing film speed, from left to right ISO 32, ISO 400 and ISO 2000. Whether an individual subject requires a slow, fine-grain film or a fast, coarse-grained one is both a technical and an aesthetic decision.

Fast, grainy film For a dim, interior close-up of an opium-smoker preparing a pipe, almost solely lit by the small oil-lamp (right), a high-speed film was essential. The inherent graininess of this ISO 400 reversal film is exaggerated by its having been rated at ISO 800 – and consequently push-processed
35mm lens, Ektachrome ISO 400 rated at ISO 800, 1/30 sec., f1.4

therefore "slow". The improved sensitivity of flat grains is also used in combination with cubic grains for fine-grained emulsions, which can produce exceptionally sharp images. An even distribution of the grains and a fine internal structure contribute to this.

Ultimately, the photographer must choose between these two ideals – sensitivity to light or detail. If high speed is essential, as in low-light or action photography, then fine grain must normally take second place. On the other hand, if it is more important to preserve the finest detail, then the exposures will have to be longer.

A quality that is related to graininess is sharpness. It is important to realize that sharpness is a subjective impression, but it is a good indication of how well edges are recorded. The objective measurement of this is called acutance. Together, graininess and sharpness make up the even more subjective impression of definition. Of the two, graininess is normally considered less objectionable than loss of sharpness. Indeed, graininess can slightly compensate for loss of sharpness because the edges of the grain-clumps themselves are clear.

Colour film

A basic silver halide emulsion reacts simply to light – across more or less the whole spectrum. The developed image is also monochromatic. Most photography, however, is in colour, and the steps needed to create a colour image from black-and-white emulsion are fairly complex. What makes colour reproduction possible is that the full white-light spectrum can be broken down into three equally spaced wavelengths: blue, green and red. These colours are each located in a third of the spectrum. Combined equally they make white light, but combined in other proportions they can reproduce almost any other colour. This is the three-colour principle of reproduction.

There are two ways of using these three colours for reproduction: additive and subtractive. In the less commonly used additive method, blue, green and red are combined. The subtractive process, which is the basis for most colour films, uses dyes or pigments to subtract selectively from white light. To do this, it makes use of the three colours that are complementary to red, blue and green – these are cyan (blue-green) yellow and magenta (purple-pink). Each one absorbs its opposite primary colour; thus, cyan absorbs, or blocks, red light; yellow absorbs blue, and magenta absorbs green.

Using this three-colour principle, a colour film can be constructed with the same basic emulsion as black-and-white film: i.e., using a silver compound that is sensitive only to the amount of light reaching it. Colour film has three layers of emulsion, each one of which has been made sensitive to one of the three primary colours – blue, green, red – by means of built-in dye filters. The technical term is integral tri-pack film.

Colour negative film: During exposure, three separate latent images are formed. When developed, they become three negatives, corresponding respectively to the blue, green and red light in the subject. (This is very similar to the separation negatives necessary to print the colour images in this book). There is just one development, and the process is completed by bleaching out the unwanted silver to leave three colour dye images. When projected in an enlarger, the three transparent layers combine to give an image that is reversed not only in tone, but also in colour. Colour negative film has a distinct orange appearance; this acts as a mask, designed to compensate for colour distortions that would otherwise occur in printing.

Colour reversal film: Reversal, or transparency, film has essentially the same tri-pack construction as negative film. Its development, however, involves an extra step in order to create a positive image from the negative. In this second stage, after the negative image has been

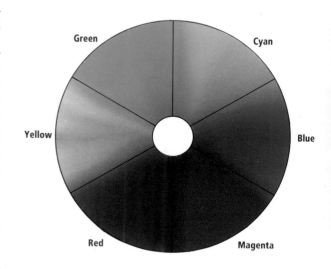

The colour wheel This is really a simplified spectrum bent into a circle clarifying the relationships between colours. Any three equally spaced colours (blue, green and red, or yellow, magenta and cyan) combined together equally give white. Combining any two colours that are directly opposite each other also produces white. For example, yellow, when added to its complementary colour, the primary blue, produces white in the additive process. Conversely, in the subtractive process superimposing yellow and blue (or red and cyan, or green and magenta) gives black.

Additive and subtractive colours The two sets of circles (below) show the two ways of creating colours photographically. The three primary colours – blue, red and green – when mixed equally create white. In combinations of two they create complementary colours – blue and red make magenta, green and red make yellow, and blue and green make cyan. This is the additive process. In the subtractive process, complementary colours subtract from white light to produce the primary colours and black.

Additive

Subtractive

Negative processing

Original-positive image

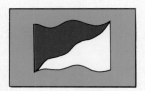

Negative

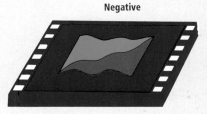

In colour negative processing, the negative itself is only an intermediate stage. The three layers of film responds to particular colour. During development the three complementary coloured dyes – yellow, magenta and cyan – form in the same places as the images

formed by the basic silver process. The final step is simply to bleach away the silver. An orange "mask" is always built into colour negative film, to correct colour distortions that would appear in the final print if the pure dyes alone were used.

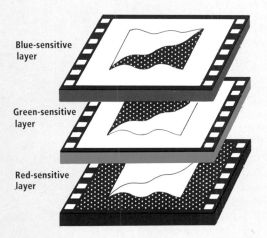

Blue-sensitive layer

Green-sensitive layer

Red-sensitive layer

1 Exposure produces three negative latent images in the silver compounds, each corresponding to one of the primaries.

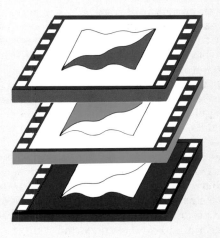

2 During development a complementary coloured dye image is produced in the same places as the silver image. Bleach then removes the silver, and the three layers of colour that remain form a negative image ready to make a positive print.

developed, the film is briefly "exposed" (originally to light, now chemically) so that the silver compounds that had remained unaltered now form reverse, positive images. This is the reversal that gives this process its name. A second colour development is then given to these newly activated compounds. Following this stage, the three layers of emulsion each contain a silver negative image (which is not needed) and a positive colour

The colour sensitivity of eye and film Some of the most obvious anomalies in the way black-and-white film records colour are explained by comparing its colour sensitivity to that of the human eye. Although the eye

reacts most strongly to green, film, by comparison, overreacts to the blue end of the spectrum. Orthochromatic film does not respond at all to red, but modern panchromatic films cover the full range of visual colours.

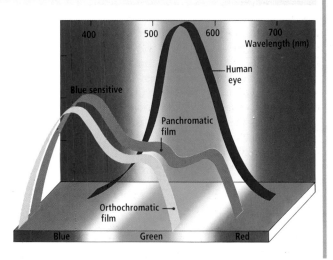

Reversal processing

During exposure, the three layers of film each respond individually to particular colours, and this latent image begins development with the basic silver process. The images are then "reversed" by a brief second exposure, and complementary coloured dyes formed at these new sites. When the original silver is finally removed, a sandwich of these transparent layers remains which, when projected, gives the final positive image.

Original-positive image

Transparency-positive image

❶

❷

❸

Blue-sensitive layer

Green-sensitive layer

Red-sensitive layer

1 Exposure produces a latent image which is converted by the developer into metallic silver. Each layer is sensitive only to one third of the spectrum, and forms the base for producing the positive images.

2 A brief exposure to light, or a chemical that performs the same function, starts a second image-forming process: the silver compounds that remained after the first development are now fully converted by the second developer. Special compounds known as "couplers" then combine with the oxidized developer to produce a

separate dye in each layer complementary in colour to its original sensitivity.

3 Everything is now present in the tri-pack film to form the full colour image, but the metallic silver formed by the two developments obscures the colours. This is now bleached out, leaving three layers of pure colour. The image is viewed by shining light through it (in a projector or on a light box) and the complementary dyes subtract the colours not needed, producing a positive image.

image. The silver is bleached away, leaving three coloured layers that, when seen against the light, give the effect of the original subject colours.

A different process – K-14 – is used by Kodak for its Kodachrome reversal films, which are the only remaining brands of what are called non-substantive emulsions. These films as used by the photographer contain no colour couplers; they are added later at the processing stage. This adds to the complexity of the processing, and few laboratories are equipped to handle Kodachrome. The advantage, however, is that the emulsion is thinner when exposed and the dye can be spread more evenly, giving reduced graininess and very good resolution.

Additive colour film: Only a handful of additive colour processes have ever been used significantly in photography. The most recent is Polachrome instant slide film, a black-and-white emulsion laid over a screen of fine lines in the three primary colours. These give the colour effect, but the drawbacks are a dense image (more murky than conventional slides) and the limited enlargement possible because of the screen lines.

Colour quality

Our judgement of colour is a complex process, both physiologically (see Colour sensitivity, page 12) and psychologically. For the film manufacturer the problems are not simply those of trying to reproduce colour accurately, but

also of meeting the preferences of photographers – and these are not all the same. That different makes of colour film produce different results is not necessarily because one is more advanced than another; film manufacturers have different policies towards colour balance. For example, some makes of colour film deliver noticeably more intense blue skies than do others – more intense than in real-life, too – because a part of the photography market prefers this richness in holiday and travel pictures. Apart from this, the dyes used in film are all, to some extent, imperfect. Achieving accuracy in one hue may make it extremely difficult to reproduce another hue precisely. Trade-offs between colours in the manufacturing process account for differences between film brands, and consequently the preference that some photographers have for certain brands.

As colour film depends on the basic silver halide emulsion already described, manufacturers face the same dilemma in trying to produce fast films and good resolution at the same time. The two qualities are essentially incompatible, even though the metallic silver responsible for graininess in black-and-white film is bleached out of colour film. Instead, the colour dyes that replace the silver during processing form "dye-clouds", which give a similar impression to graininess. Fortunately, these dye-clouds measure only a few thousandths of a millimetre across and the unaided eye cannot distinguish between them, or the three different

Branded colour differences
There are inevitable differences in colour rendering between different makes of film. The contrast here, between Kodachrome 64 and Fujichrome Velvia is marked. Despite being less obvious on a printed page than in the original transparencies, overall the Velvia image is warmer toned. More important is the different rendering of the dark green of the trees, and the amount of separation between hues.
180mm lens, Kodachrome ISO 64 and Fujichrome Velvia ISO 50, automatic setting

Polachrome's additive colour In the additive process of 35mm Polachrome, a black-and-white emulsion is given colour by means of an adjacent screen of finely spaced red, blue and green transparent lines. As a result, the resolution is low and the highlights muted by the additional layer.
24mm lens, Polachrome ISO 50, automatic setting

colours of dye-cloud would make colour film look even grainier than black and white. As it is, the magenta clouds cause most of the grainy appearance, because they absorb the green light to which the eye is most sensitive (see page 13).

Light balance

One major distinction between different colour films is the type of light for which they are intended. There are important colour differences between daylight and artificial light (see Colour temperature, page 74). Humans have no difficulty adjusting their eyes from one light source to another, but film cannot adapt in the same way as the human eye. In practice, if a film that is intended to be used in daylight is used indoors with tungsten lighting, the result will be an orange-tinted photograph.

Photographic lighting, described fully under Using light, page 72, is provided by flash, which has the same colour as daylight, or tungsten, which is much more orange. For this reason, a few films are made balanced for tungsten lighting. With colour negative film, the difference in colour cast from different light sources is not quite so important as it is with transparency film, as it can to some extent be corrected during printing. Ordinary non-photographic tungsten lamps, as in most domestic interiors, are even more orange than photographic tungsten, and if they need to be neutralized, a bluish filter should be used over the camera lens even with tungsten-balanced film. Other artificial light sources, such as fluorescent light, do not have specially balanced films made for them, and so also call for filters.

Saguaro, Arizona The shot left was taken without a filter. In the shot above, the scattered reflections from the blue sky have been polarized by a filter. This darkening effect is strongest at 90° to the sun. With a wide-angle lens a variation in tone is noticeable across the sky.
Nikon, 20mm, Kodachrome ISO 64, ½₅₀ sec., f8 (top), ½₅ sec., f5.6 (bottom)

Filters

The principal use for filters with colour film is to balance the colour of the light source. One range of filters, from bluish to amber, balances the colour temperature of the light. For example, a strong bluish filter from this range can be used with regular daylight film in tungsten light to neutralize the colour cast. Another range of filters is available in different strengths of the primary colours, blue, green and red, and in their complementaries, yellow, magenta and cyan. These can be used to correct deficiencies in either the film (which can change colour with age or because of poor storage conditions) or the light source.

Selective filtration is not easy, as most filters simply change the overall colour. A polarizing filter, however, is one of the few ways of making a noticeable change in colours. Light from the sun travels in waves that vibrate in all directions, but when light bounces off certain kinds of material – notably glass and water – the waves are re-oriented to vibrate in just one plane. This reflected light creates reflections, but the structure of a polarizing filter, which acts like a grid with extremely narrow parallel slats, passes only those light waves oriented at the same angle, and can be used to eliminate reflections. Blue sky also reflects light, and for the same reason that a polarizing filter works on reflections from glass or water, it can darken the appearance of blue sky at right angles to the sun. It also enhances colour saturation by suppressing white-light reflections from particles in the air.

An ultraviolet (UV) filter also improves haze penetration, reduces the overall blue cast associated with atmo-

Polarizing filter

A polarizing filter cuts down on unwanted reflections and enhances blue skies. Compare the top right segment of the image below taken without a filter to the bottom left segment taken with a polarizing filter.

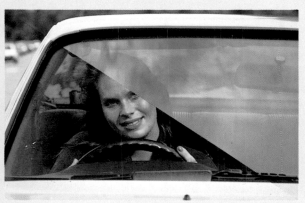

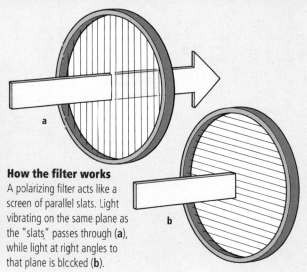

How the filter works

A polarizing filter acts like a screen of parallel slats. Light vibrating on the same plane as the "slats" passes through (a), while light at right angles to that plane is blocked (b).

Petroglyph, Utah The shiny surface of this weathered sandstone rock illustrates the effect of a polarizing filter. In the upper half of the picture, taken without the filter, the reflections virtually swamp the Indian carvings. In the lower half, taken with the polarizing filter, the reflections are eliminated.
Nikon, Kodachrome ISO 64, 55mm, automatic settings.

Canyonlands, Utah With no filter over the lens, this distant scene over the Colorado River canyon has a blue cast and weak contrast due to haze (below). An ultraviolet filter (centre) noticeably improves colour saturation and contrast, but the best result is with a polarizing filter (bottom). *Nikon, 400mm, Kodachrome*

Toning down the sky

A neutral graduated filter shades smoothly from clear to a pale grey, in this photograph of sunrise over an ancient artificial lake at Angkor, Cambodia. The two-f-stop difference caused by this shading restores the colours of the sky, which would otherwise be washed out. The soft edge of the shading merges with the horizon. *20mm lens, Fujichrome Velvia ISO 50, automatic setting*

spheric haze and increases colour saturation. The effect is particularly marked when using a long-focus lens on a distant scene. Another occasionally useful filter is a neutral-density (ND) filter, which simply reduces overall exposure without altering colour. Occasionally, for instance, there may be too much light for a particular shot, as when a slow shutter speed is needed on a bright day to create deliberately blurred movement. Neutral-density filters are available in a range of strengths.

Black-and-white film

Colour film's realism, and the natural pleasure that colours give, account for it dominating modern photography. However black-and-white film has special graphic qualities that keep it popular among a small number of photographers. The essential simplicity of an image that varies only in tone makes it favoured in photography that aims for a powerful image, and also for some subjects that benefit from being distilled and simplified, such as certain types of landscape and photo-journalism.

As with colour films, there is a choice available from very slow and extremely fine-grained at one end of the scale, to ultra-fast but grainy at the other. Because there is only a single tonal range – and a single emulsion layer – rather than the tri-pack structure, black-and-white film is easier to manipulate. In particular, alteration of the film's development is an uncomplicated procedure; this can be used not only to compensate for too little or too much exposure, but also to change the contrast.

Filter checklist for black-and-white film

All the filters below, except the polarizer, are available in either glass or gelatin. As the glass thickness can distort, high optical quality is important in a filter, and this is expensive. Gelatin filters, on the other hand, are too thin to affect the optics of a lens, but must be handled carefully to avoid marking.

Filter (Kodak Wratten No.) and effect	Use	Filter factor*
Yellow (8) Absorbs UV and some blue	Darkens blue sky to a normal tone, accentuating clouds. Lightens foliage	**2x** (1 additional f stop)
Deep yellow (18) Absorbs UV and most of the blue	Similar to yellow but more pronounced. Also darkens blue water and lightens yellow subjects	**4x** (2 additional f stop)
Red (25) Absorbs UV, blue and green	Darkens blue sky and water, increases contrast and deepens shadows. Cuts haze and lightens red objects	**8x** (3 additional f stop)
Green (58) Absorbs UV, blue and red	Lightens foliage and slightly darkens sky. Makes red objects and skin tone darker	**8x** (3 additional f stop)
Blue (47) Absorbs red, yellow, green	Lightens blue subjects, increases haze in landscapes	**6x** (2½ additional f stops)
Neutral density + up Absorbs all colours in equal proportions	Reduces exposure, enabling a slower shutter speed or wider aperture to be used	**Various** Depends on which filter factor
Polarizing Controls reflections and darkens blue skies at right angles to the sun	Can eliminate reflections in still water and windows. May darken blue skies	**2.5x** (1½ additional f stops)
Ultraviolet Absorbs ultraviolet	Cuts haze in landscapes, giving sharper image with better colour saturation	

* This list of filter factors and the related increase in aperture is based on normal daylight. When the colour temperature changes, in the evening, for instance, these factors will change.

One different monochrome process borrows some of colour film's technology. In so called "chromogenic" films, the original silver is removed after the first development and replaced with a dye. The result is considerable flexibility of exposure and a virtual absence of the traditional grainy texture. Also, because such films can be processed in standard colour negative chemicals, it is easy to find a commercial processing lab to handle them (traditional black-and-white processing is relatively rare on a commercial basis).

Filters for black-and-white film

Although the single layer of silver halide produces a monochrome image, it still reproduces colours – but as different shades of grey. Technically speaking, its sensitivity to different wavelengths varies, so that it reacts more strongly to blue than other hues. Most general-purpose films, known as panchromatic, incorporate dyes to adjust their sensitivity to all the visible colours. Nevertheless, they still remain rather over-sensitive to blue and under-sensitive to red.

In our experience of colours, some hues are brighter than others: an average yellow, for example, seems brighter than an average blue. If the tones in which different colours are reproduced in a black-and-white photograph approximate to this experience, the image seems realistic. However the blue sensitivity of black-and-white film can result in clear skies looking too pale; a yellow filter – which absorbs blue – restores the expected appearance. The table lists the variety of effects and the different compensation needed.

Special-purpose films

A few films are made for specialized fields of photography. One of the most striking in its pictorial effect is infra-red film, available in colour and in black and white. The three layers of colour infra-red film are sensitive to infra-red, green and red respectively, rather than blue, green and red as in a normal film. This is technically a false-colour film, and intended for surveying healthy versus dead vegetation. A yellow-orange filter gives the most normal-looking results, but healthy plants reproduce a striking red. Other filters give less predictable results, depending on the subject matter. As regular exposure meters do not measure the infra-red component, it is important to follow the packed instructions and to bracket exposures.

Black-and-white infra-red film is very sensitive to infra-red wavelengths far into the infra-red region of the spectrum – as far as 1200 nanometers, which is much further than we can see. Hot objects emit infra-red light in the far infra-red region, and so are "bright" to this film. Also, the infra-red reflectivity of materials is not the

Yellow

Magenta

Cyan

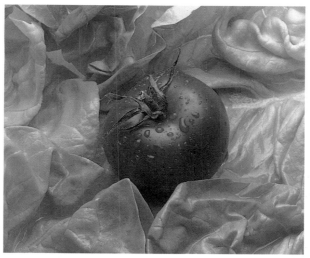

Red filter

Green filter

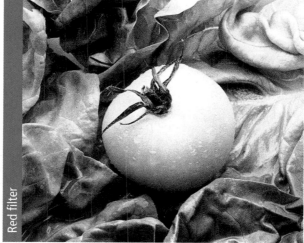

Using filters to improve contrast

A coloured filter placed in front of the lens will pass more of its own colour and block the light of other colours. The contrast between, for example, a red tomato and green lettuce leaves in a salad is immediately obvious when viewed in colour, but not at all in a black-and-white photograph. Filters can create contrast: a red filter will pass the light reaching the film from the tomato unhindered, and it will appear very pale in a print; at the same time, the green light from the lettuce will be blocked, and reproduce darkly in a print. If, on the other hand, a green filter is used, the opposite occurs: the tomato appears dark because its red light is blocked on the way through the lens, while the lettuce appears pale.

Subtracting white light

These diagrams show how coloured filters subtract from basic white light. The three filters are of the complementary colours, yellow, magenta and cyan. The yellow filter blocks the path of blue light rays, allowing red and green to pass unhindered. In the same way the magenta filter blocks green light rays, and the cyan filter blocks red. When all three filters are combined together no light at all is allowed through, and the result is black.

Mazaruni River, Guyana
False-colour infra-red film and a recommended yellow-orange filter reveal this South American rainforest (left) as a healthy red, due to the infra-red reflectivity of chlorophyll.
Pentax, 55mm, Ektachrome Infra-red, ½₅₀ sec., f4

same as their white-light reflectivity. Water droplets, such as in clouds, reflect infra-red quite strongly, and clouds appear a brilliant white in black-and-white infrared photographs. Healthy vegetation behaves in a similar way, and leaves and grass have a snowy appearance. These films need an opaque filter to give their most intense effect, to prevent the infra-red "view" being weakened by the ordinary white-light appearance.

Electronic imaging

In electronic imaging systems, film is replaced by an imager – typically a CCD array – and a means of storing the electronic information, usually in the form of a floppy disk or hard disk. Built-in colour filters make colour images possible. The resolution depends on the density of the array and is measured in pixels. For instance, if the pixel size is 16x16 micrometres, a CCD covering the full 35mm frame could resolve to more than 1 million pixels: 1024 rows by 1280 rows in the case of the Kodak Professional Digital Camera System.

Another system for handling images that have already been shot on conventional film is Kodak's Photo CD. In this system, processed slides or negatives are taken to a photofinishing outlet and recorded digitally onto a compact disc.

Electronic images can be viewed on a television monitor, or hard copies can be made via a printer. If the image is loaded into a computer, the choice of output devices is increased: as well as prints, slides can be produced, or even direct separations for printing in a magazine or book. This last option is particularly useful for desktop publishing.

Palm trees, Florida On high-speed infra-red film, this landscape (left) is an ideal subject. The clouds and vegetation all reflect infra-red radiation strongly, and appear brilliantly white. A Wratten 87 filter cuts out visible light to which the film is also sensitive.
Nikon, 180mm, ¹/₃₀ sec., f16. Correct focus: ¼ of 1% closer than visible focus

Polapan One of the very few black-and-white transparency films available, 35mm Polapan gives an attractive, luminous quality to its images, and has the added advantage of being virtually instant. The emulsion side is, unusually, uppermost, requiring special care when handling and viewing.
20mm lens, Polapan ISO, automatic setting

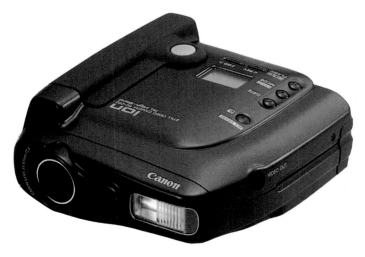

Still video One kind of electronic imaging system uses video technology. The Canon ION still video camera records onto a small floppy disk. Each disk can store 25 pictures, which can then be displayed on a television monitor. Disadvantages are that the resolution is good for a television screen only, and that the images are not digital, and so cannot be manipulated with a desk-top computer.

Exposure

- Measuring exposure
- Camera metering systems
- Exposure latitude
- Hand-held meters

Aperture and shutter speed control exposure, and in most cameras they are set automatically to give a photograph that matches. as closely as possible, the way we see the image. This means, for a typical outdoor daylit scene, a picture that has a range of brightness from nearly white to almost black. The actual lighting conditions can vary enormously, of course. On a foggy day, for example, there may be just a few close shades of grey, with no bright highlights and no deep shadows. In bright sunlight, on the other hand, some shadows can be 200 times darker than the most brightly lit parts. Certain kinds of artificial lighting at night can produce an even more contrasty effect. Making an exposure involves capturing these many different ranges of light on film, and doing it so that the scenes remain recognizable.

Although it may be tempting to think of photographs in terms of "correct" exposure, there is in fact always a choice, and it is one that depends very much on the photographer. At dusk, for instance, there is a case for making a darker-than-usual exposure in order to convey the impression of evening. While the camera's automatic exposure system, if left to itself, will produce an averagely exposed image, all but the simplest cameras allow the photographer to adjust or override it. There are, sur-prisingly, many picture situations in which different photographers would choose different exposures. Although there is one single exposure for any view that will give the most complete record of everything in the scene, this is no more than an objective ideal. Tastes differ, and individual preference is important.

Exposure latitude

The human eye can rapidly accommodate different levels of brightness, flicking from highlight to shadow with little difficulty. Film, however, has a fixed range, below which there are no details recorded from the shadows, and above which the highlights are completely white. This exposure range is crucial to making a satisfactory exposure, and varies from one film emulsion to another. Most fast films, for example, record a relatively small range of tones; in other words, they are contrasty. Some very slow emulsions, on the other hand, record very gradual changes in tone over a wide range.

Most films have an exposure range that is greater than the range of brightness in an average subject. In practice, this means that there are a number of different exposures that can be made without losing detail. This freedom of choice is called exposure latitude; technically speaking,

The exposure latitude of colour film

This sequence of exposures, each varying by two steps, shows how one popular make of colour film, Kodachrome 64, reacts to different quantities of light. The through-the-lens (TTL) meter reading, averaging all the tones in this scene of an Indian pueblo in New Mexico, indicated an exposure of 1/30 sec at f11. This is the exposure shown in the second picture. With two stops more exposure (first picture), all the lighter tones are washed out and have a slightly greenish tinge.

Decreasing exposure, shown in the two bottom pictures, is subjectively more acceptable to many people. Two stops under-exposure (bottom left) seems quite satisfactory, with little loss of shadow detail and an actual improvement in colour saturation. With progressive under-exposure, shadow areas become featureless (bottom right).

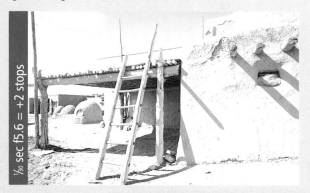
1/30 sec f5.6 = +2 stops

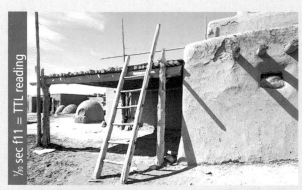
1/30 sec f11 = TTL reading

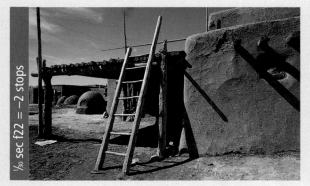
1/30 sec f22 = –2 stops

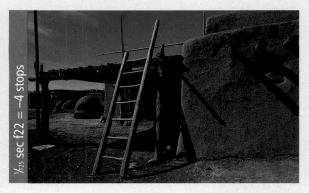
1/125 sec f22 = –4 stops

it is the increase in exposure that can be made from the minimum needed to record shadow detail while still preserving detail in the highlights. If the film's exposure range is exactly the same as the brightness range of the subject, then just one exposure setting will record everything well. If, however, the scene is harshly lit and the range between shadow and highlight is greater than the film's exposure range, no exposure will record all the details. In a case like this, the photographer should choose where to sacrifice detail – whether in the brightest or darkest areas.

Parliament Buildings, Ottawa This image would be unlikely to cause problems to any metering system, however unsophisticated. Despite the bright sunlight and the fact that a third of the frame is taken up with sky, there are no bright or dark areas large enough to sway a reading.

An average reading of all the tones gives a saturated image, and there is little latitude for under- or over-exposure – not more than half a stop lighter or darker than average would be acceptable to most people.
24mm lens, Kodachrome ISO 64, automatic setting

Metering

There are two steps in making an exposure, whether this is done automatically or manually. The first is to record the levels of light that actually exist in the scene in front of the camera. The second is to translate these measurements into the exposure setting that will best suit the film speed.

Most 35mm cameras incorporate light-sensitive cells that run their own metering systems, and readings are taken of the actual image about to be recorded on the film. This through-the-lens (TTL) metering automatically compensates for the different light-transmitting properties of lenses and extensions. The sophistication of the metering system varies between camera models. One of the simplest is to measure the average brightness of the entire picture area.

The most advanced systems, under various trade names, measure a mosaic of the picture area and then weight the importance of each section according to a pre-programmed set of rules. Thus, a small bright area slightly off centre, set against a dark background, would be accounted for – the photograph on page xx is typical of such a situation, which a simpler, averaging meter system would over-expose. In between are systems that

Metering systems

Light-sensitive cells that permit TTL (through the lens) metering can be fitted in a variety of positions inside the camera. The system shown here allows multi-pattern metering of light from the scene as a whole reflected onto cells near the viewfinder. Spot metering is provided by a cell just in front of the film plane. This cell also provides the information for flash metering and automatic focusing.

1 Light path
2 Cell position for spot and flash metering
3 Cell position for multi-pattern metering
4 Film plane

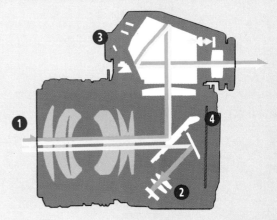

Spot metering This method, which is extremely precise, is offered as an alternative in a few cameras which allow a choice of metering modes. All the sensitivity is concentrated in a very small angle of view – again, marked on the screen – so that the camera functions just like a hand-held spot meter. This is useful when the subject is small and very different in tone to the surroundings and for measuring the range of brightness in a scene.

Centre-weighted average metering The most common simple metering pattern allows, in a crude way, for the way that most people frame pictures, that is, with the subject more or less in the middle and a horizon near the top. The metering is "weighted" towards the centre and virtually ignores a band at the top of the frame (where a bright sky might throw off the reading).

Multi-pattern metering The most sophisticated measurement system to date takes readings from different parts of the image, and then compares the resulting pattern with information already stored in the system's memory. Each pattern signifies a high probability of a particular kind of photograph (eg back-lit, or a strong light source in view), and the exposure is adjusted according to what is known to work best.

Small, contrasting subject

A shaft of sunlight striking a carving in Chartres Cathedral, France, provides a classic example of a small bright subject against a dark background. Given the off-centred composition, an average meter setting would have overexposed the image. Instead, the camera's centre-spot metering mode was used to measure the lit area, and the frame was then re-composed. *180mm lens, Kodachrome ISO 64, automatic setting (centre-spot)*

weight the exposure towards the centre of the image (where most photographers tend to place the main subject of interest).

The simplest way of operating an exposure system is for the photographer to adjust the shutter or aperture (or both) to match the display in the viewfinder; this is *metered manual* exposure. Moderately automated cameras require the photographer to set the aperture, and they then automatically adjust the shutter; this is *aperture-priority* exposure. Most sophisticated models allow a choice: aperture priority, *shutter priority*, in which the user sets the shutter and the camera adjusts the aperture, or any of various *program modes*, in which the camera sets both aperture and shutter according to a particular set of priorities. Some of these various modes are related to specific types of photography, such as sports or close-ups, which have special needs, such as the highest shutter speed possible or good depth of field.

With such automation, there are few occasions when there is any need to take separate readings manually. Nevertheless, there are certain types of lighting condi-

River Thames, London A high contrast image such as this sunset view forces you to decide which part of the scene should have priority. An average reading would be unreliable. The brightness range of this scene is too great to record detail on colour transparency film in both the shadows under the bridge and the bright water beyond. The priority was given to the orange reflections in the mud, and the camera's centre-spot meter used to measure this area. *135mm lens, Agfachrome ISO 50, ⅟₃₀ sec, f8*

Mission church The shades from white to off-white of this Spanish colonial building (left) are clearly the important tones in this architectural detail shot; the sky is of no importance for the exposure reading. There is a real danger here of under-exposure. The technique used was to move the camera slightly to make a reading of the white-washed building alone, and then to increase the exposure by 1 1/2 stops from this. Several bracketed frames were exposed to ensure a correctly exposed shot.
180mm lens, Fujichrome ISO 50, ¹⁄₁₂₅ sec, f11 (average reading as framed ¹⁄₁₂ sec, f16; of the building alone ¹⁄₁₂₅ sec, f19)

High contrast – choice of treatment Some high contrast scenes offer a choice of acceptable exposures; in particular, those including silhouettes. In this view of Cantonlands National Park in Utah, the difference between a short exposure, used here, and a long exposure would be in the sky area visible. An increase in exposure time of two stops, for example, would have reduced the depth of colour immediately around the setting sun, but extended it over the sky at the right. The choice is a matter of personal taste, but many photographers would bracket the exposures and reserve judgement until later.
20mm lens, Kodachrome ISO 64, automatic setting under-exposed by 1½ stops.

tions that will fool most automatic cameras – snow scenes, for example, which ought to appear as a mainly white image, would be exposed by an automatic camera as grey. The principle on which all exposure meters work is to average the area they read; normally they then produce a setting that will give a mid-toned exposure. If the photographer wants the image lighter or darker than average, it is usually a simple matter to compensate, either by manually overriding the camera or, in some models, by operating a special over-/under-exposure control. Beyond this, however, there are hand-held meters for taking more serious, independent measurements.

Hand-held meters

Though by no means essential, hand-held meters are very flexible instruments, and can be used in situations that are difficult for the camera's TTL meter. All have a light-sensitive cell, a read-out that is usually digital but may be analogue (such as a moving needle against a scale), and a calculator.

Whereas camera TTL meters measure the light reflected from a subject or a scene, most hand-held meters offer the option of measuring the actual light itself. The two methods are known respectively as reflected-light and incident-light readings.

Spot-meters are a special variety of hand-held meter, with a lens and viewer. They take reflected-light readings, but through an optical viewing system with an angle of acceptance of as little as 1°. With such precision, they can measure the brightness levels from the smallest areas of a scene. One technique is to measure the differently lit parts of the view and then calculate the average (a digital spot-meter can usually make this calculation itself). Another is to measure one small representative area. Although a spot-meter takes time to use, it is the most accurate of all the meters and comes into its own when the main subject has a completely different level of brightness from its surroundings.

Hand-held meter Most hand-held meters can measure both continuous light and flash. As a camera's own TTL metering system is perfectly accurate for direct light readings, hand-held meters are used mainly for incident readings. The meter shown here can also be fitted with a reflected-light attachment.

Black on black Only the rim-lighting from a late afternoon sun defines a black swan against a shadowed pond in Kew Gardens, near London. This type of subject is a recipe for overexposure. To avoid this, a reading was taken from nearby sunlit trees out of frame. The exposure used was about two stops darker than the camera's reading of this frame.
180mm lens, Kodachrome ISO 64.

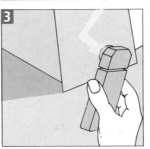
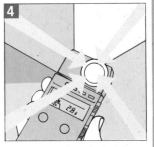
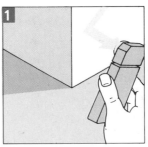

Using hand-held meters
1 With the reflected-light method, the meter is pointed directly towards the subject.
2 With contrasty subjects take readings from the brightest and darkest areas of the subject and then make a compromise between them.

3 An 18% grey card, which has average reflectance, can be used as a substitute for the subject.
4 An incident-light reading measures only the light falling on the subject.

Using light

- **Colour conversion filters**
- **Weather and light**
- **Artificial lighting**
- **Flash photography**

A reasonable exposure is only one step in handling light, and though essential is, for the most part, fairly mechanical. Much more interesting, and ultimately much more important to the success of a photograph, is your judgement of the quality of light and your skill in putting it to its best use. This is not something that can be learned by rote, but is a skill that develops from appreciating and enjoying the nuances of light, both natural and artificial.

The quality of light from all sources varies enormously. Tonal differences are immediately obvious to the eye – compare the smoothly graduated tones under an overcast sky with the extreme contrast in subjects lit by car headlights. Less obvious, but no less important, are the variations in colour; our vision accommodates small colour changes in the overall light sources so that we think we are seeing by white light even when, in reality, we are not.

Light intensity

Light is visible radiation, and is a small part of the electro-magnetic spectrum. It has three characteristics that are important to photography: intensity, wavelength and polarization. Intensity sets the brightness; wavelength establishes its position in the electro-magnetic spectrum, and therefore its colour; polarization is the angle at which the waves are oriented and controls, among other things, how reflections appear in a photograph.

Only part of the science of light has a practical bearing on photography, but here is a short summary: light is generated at the atomic level when an electron drops back from a high-energy orbit around the nucleus to a more stable orbit. Light is emitted as part of the released energy. Light waves are part of a series of waves, each with a different wavelength, that make up the electro-magnetic spectrum. At one end, with wavelengths of as little as .000000001mm are gamma rays, while at the other end are radio waves that can measure up to 6 miles (10km) between wave crests.

The human eye is sensitive only to a narrow band between about 400nm (nanometers) and 700nm – a nanometer is 10^{-9} metre; this is the visible spectrum. Photographic emulsions have a similar sensitivity, but most are more sensitive to the blue, violet and ultraviolet end of the spectrum than the human eye, and a few are sensitive to infra-red. Wavelength determines colour: the

Colour temperature scale

Colour temperature, expressed in degrees Kelvin or mireds, varies throughout the day and ranges around what we see as visual "white" – the colour of direct sunlight at midday in summer in the mid-latitudes. At the beginnning and end of the day, the colour temperature is nearly always lower, that is, the light is more orange or even red. This depends very much on the weather conditions.

When sunlight passes through clouds, the colour temperature is raised very slightly because some of the reflected light from the blue sky above is added. In shadow on a sunny day, the colour temperature can be very high, that is, blue, because all the light comes from the blue sky.

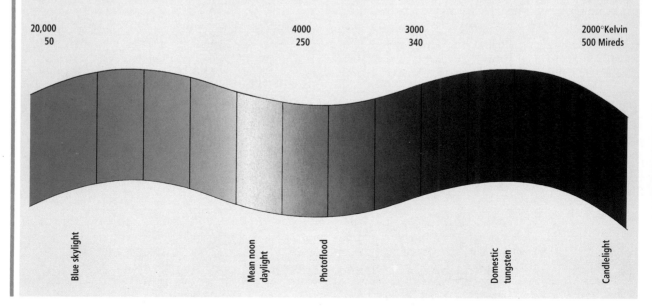

| 20,000 | | 4000 | 3000 | 2000°Kelvin |
| 50 | | 250 | 340 | 500 Mireds |

Blue skylight Mean noon daylight Photoflood Domestic tungsten Candlelight

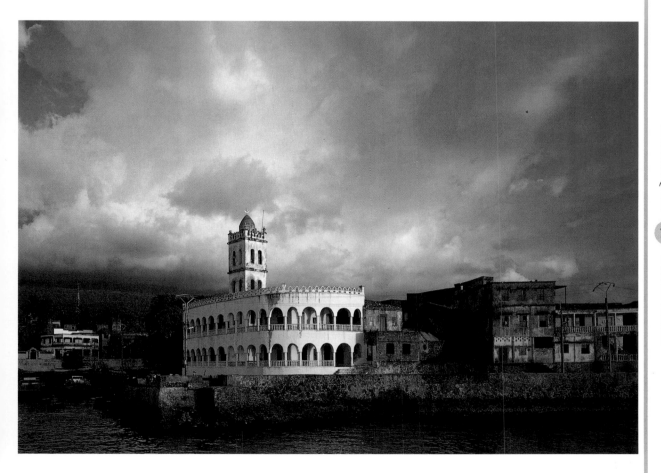

shorter wavelengths appear violet and blue, the longer wavelengths red. A rainbow or prism shows this quite clearly.

Photography's main light source is the sun. Films, lens apertures and camera shutter speeds are all designed to work optimally in bright daylight. In most situations, the sun is the brightest source of light, but at short distances an artificial light such as a flash unit can be brighter. The sun, being so distant, has the same brightness anywhere on earth. Small light sources, however, are brighter when close, and lose intensity rapidly with increasing distance. What are normally called light sources actually radiate light – they generate their own energy. The sun does this as it burns, and so does the filament of an electric light bulb.

Most materials, however, simply reflect light. If they are very reflective, like snow, they bounce back nearly all of the light, and we call them "white". If they absorb most of the light energy that reaches them, we call them "black". A lump of coal does this, although if it is heated it will start to radiate energy and glow red, and so become, briefly, a light source.

Using light Late afternoon sunlight bathes the mosque and harbour of Moroni in the Comoros Islands and the majestic display of clouds over the mountains behind.

Colour conversion filters

A wide range of filters is available to raise or lower the colour temperature of light reaching the film. The table below shows which filters you can use with which films to produce a normal lighting effect.

To work out your own filter requirements it is easiest to work in mired shift values which can be calculated by dividing one million by the colour temperature in degrees Kelvin.
(eg daylight at 5500K has a value of

$$\frac{1,000,000}{5500} = 182).$$

To convert any light source to any colour temperature find the difference on the mired scale and then select the filter, or combinations of filters, which have that value. For instance, the difference in the mired values between 5500K daylight (182) and 2900K tungsten lighting (345) is 163. To raise the colour temperature means lowering the mired value, for which you would need, in this case, an 80A filter (–131 mired shift value) and an 82B filter (–32 mired shift value) combined. Adding filters reduces the effective film speed. The mired scale gives the exposure increase needed.

Light source	5500K	3400K	3200K	2900K	2800K
Film type Daylight	No filter	80B	80A	80A+82B	80A+82C
Tungsten type A	85	No filter	82A	82C+82	82C+82A
Tungsten type B	85B	81A	No filter	82B	82C

Mired shift values for Kodak filters

Filter (yellowish)	Shift value	Approx. f/stop increase	Filter (bluish)	Shift value	Approx. f/stop increase
85B	+131	⅔	82	–10	⅓
85	+112	⅔	82A	–18	⅓
86A	+111	⅔	78C	–24	⅓
85C	+81	⅔	82B	–32	⅓
86B	+67	⅔	82C	–45	⅔
81EF	+53	⅔	80D	–56	⅔
81D	+42	⅓	78B	–67	1
81C	+35	⅓	80C	–81	1
81B	+37	⅓	78A	–111	1⅔
86C	+24	⅓	80B	–112	1⅔
81A	+18	⅓	80A	–131	2
81	+10	⅓			

Colour temperature

The colour of the sun is different from that of, say, a tungsten light bulb or a fluorescent lamp, and the reason has to do with wavelength. It is this that determines the colour of any light source, and most emit not just one single wavelength, but many. They have what is called a continuous spectrum; if they radiate more energy at some wavelengths than others, then they have a definite colour. Some artificial light sources, on the other hand, radiate energy in just a few narrow lines of the spectrum. Sodium and mercury-vapour lamps are of this type, and have discontinuous spectra; not only do they have a definite colour, but it may be impossible to change it by filtering. Fluorescent lamps have spectra that peak sharply at certain points.

One special way of describing the colour of a light source – especially relevant to photography – is colour temperature. Its scientific basis may seem a little removed from the practicalities of photography, but as a way of choosing filters and films, it works.

Any solid material, such as a lump of metal, begins to glow red when it is heated sufficiently. As it gets hotter, the colour changes through orange and yellow to white.

An outdoor studio Thought of as a large studio set, any outdoor scene contains light source, diffusers and reflectors. The sun is a constant spotlight, changing angle throughout the day. The sky acts as both diffuser (more effective when the sun is low and its rays have to pass through a greater thickness of atmosphere) and reflector, making shadows blue during the middle of a cloudless day. Clouds, mist and fog are more variable but stronger diffusers and reflectors. Some light is even reflected back from the ground.

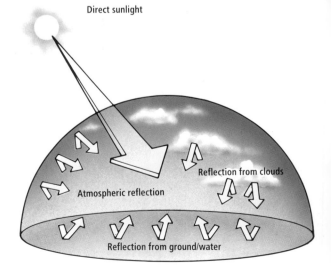

Direct sunlight

Atmospheric reflection

Reflection from clouds

Reflection from ground/water

Light through the day

1 When the sun rises and sets, the colour of its light appears to change – to yellow, orange or red. This is because the atmosphere acts as a screen, scattering some wavelengths. Short wavelengths at the ultraviolet and blue end of the spectrum are those most affected.

2 As the sun rises higher, light shines through the atmosphere at a less oblique angle, and is subject to less filtration, so appears a purer white. The same scattering that gave the reddish hues of sunrise now makes the sky appear blue; the light wavelengths penetrate the atmosphere more easily to give an overall blue cast away from the angle of the sun. This is called "skylight" and works as a vast bluish reflector.

3 At its zenith, the sun casts the deepest shadows and the contrast range is at its greatest. The midday sun is at its highest in summer, and highest of all close to the equator. Many scenes are, aesthetically, least pleasing under this kind of light, although this is ultimately a question of taste. The very starkness of an overhead sun can be effective with subjects having inherently strong shapes, tones or colours.

4 The afternoon and evening are essentially a re-run of the morning in reverse. Many photographers prefer the lighting conditions at the very beginning and end of the day, when the quality of light changes most rapidly. An hour or so after sunrise or before sunset, the angle of the light is low enough to use in different ways: as back-lighting, side-lighting or head-on axial lighting.

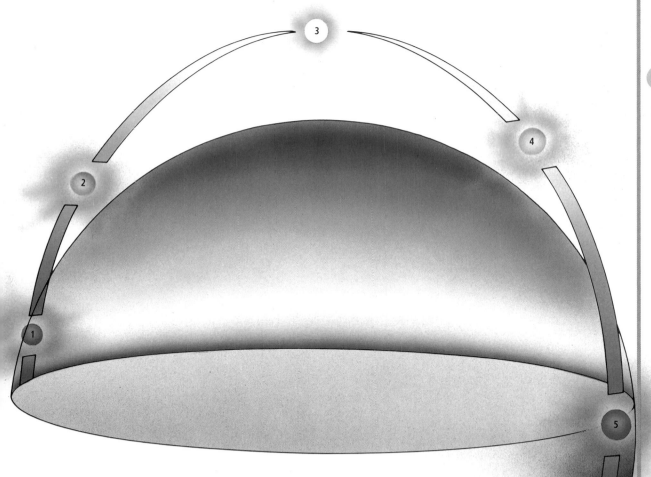

5 Sunset, similarly, is a re-play of sunrise. A clear sky usually gives less interesting colours and patterns than one in which there are a few clouds.

6 As the light fades into night, it passes below our threshold of colour vision and we see shades of grey and black, even in moonlight. In fact, the moon is a neutral reflector of sunlight, albeit 400,000 times weaker. The visual surprise of a photograph taken by moonlight with a sufficiently long exposure is that the effect is almost exactly that of daylight, and a clear sky is blue.

At extremely high temperatures, provided there is no chemical change, it will glow bright blue, like some stars. Regardless of the composition of the material, any colour in this range, from red through white to blue, can be given a value according to its temperature.

Strictly speaking, this is intended only for measuring incandescent (glowing with heat) lights, but in practice the differences between most light sources can be measured, and this indicates what film to use with a particular light source and what filters, if any, to put over the lens.

Colour temperature is measured in degrees Kelvin (K) – similar to the Celsius scale but starting at absolute

Dawn The sequence of lighting conditions throughout the day under a clear sky begins a few minutes before sunrise. The sky has a smooth gradation of both tones and colours, from white through orange to deep violet. A wide-angle lens captures the full range. *20mm lens, Kodachrome ISO 64, automatic setting*

Sunrise Immediately after sunrise, the sun's pink glow is reflected in this shot of Cambodian fishermen on the Mekong River. The elevated camera position and a telephoto lens make it possible to exclude the sky and so limit the contrast range. *180mm lens, Kodachrome ISO 64, automatic setting*

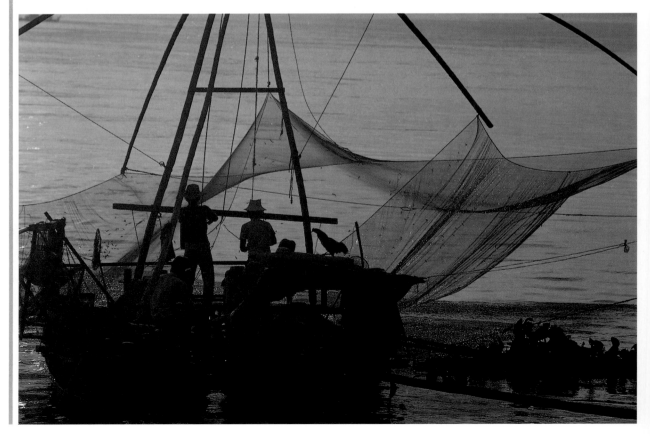

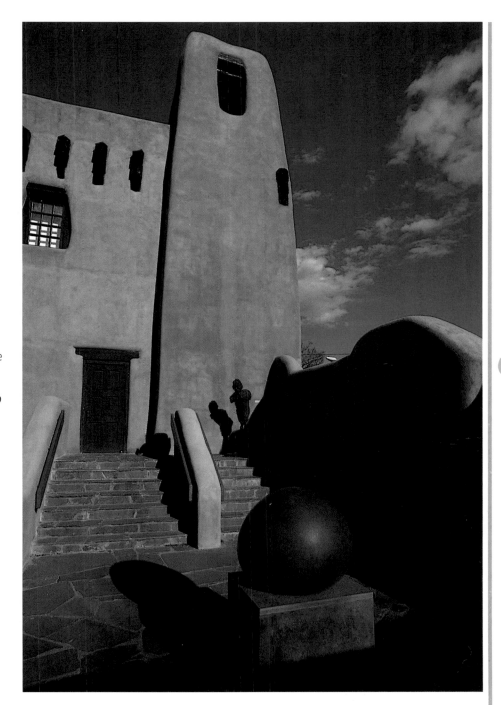

Strong sun, deep shadows
During the middle part of the day, the sun in a clear sky casts strong local shadows, so creating high contrast. In this photograph of Santa Fe Museum on the high plateau of New Mexico, the altitude (2,135m/7,000ft) further enhances the contrast.
20mm lens, Kodachrome ISO 64, automatic setting

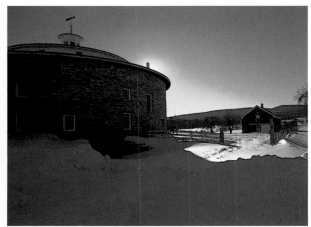

Blue shadows from skylight
Easily visible on white, reflecting snow, blue sky gives a blue cast to shadowed areas at this Shaker village in Massachusetts on a winter's day. To the eye at the time, however, the blue is much less apparent, as the brain accommodates such colour anomalies.
20mm lens, Kodachrome ISO 64, automatic setting

The day's range of colour temperature

The slow changes of light throughout the day give the eye and brain plenty of time to adjust, and the striking differences in colour are hardly noticed. Film preserves them, however, as in these two exposures from early to late afternoon of the bizarre steeple of the First Presbyterian Church in Port Gibson, Mississippi.

Back-lighting, late afternoon A moderately low sun, though still above the horizon, gives the opportunity for silhouettes against water. The essential condition is a high camera viewpoint, here a bridge over the Chaophraya River in Bangkok.
180mm lens, Kodachrome ISO 64, automatic setting

Frontal lighting, late afternoon With the sun almost directly behind the camera, colours are well saturated. In this photograph the hull of a fishing boat being pushed into Moroni Harbour in the Comoros Islands. Rich browns of skin tones and timber predominate.
400mm lens, Kodachrome ISO 64, automatic setting

Cross-lighting, late afternoon A low sun's lighting versatility is completed by using it at right-angles to the view. The sand ridges and earth-movers at this open-cast rutile mine in Western Australia cast a strong pattern of shadows about an hour before sunset.
180mm lens, Kodachrome ISO 64, automatic setting

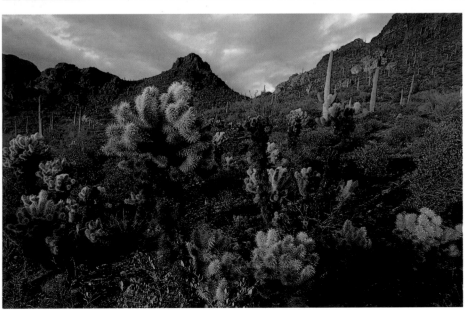

The palette of lighting from a low sun A series of shots (left) of a stand of jumping cholla cactus at Saguaro National Monument near Tucson, Arizona, illustrates the varied options close to sunset (the same would be true of sunrise). From top to bottom, cross-lit, back-lit and frontally-lit views were all shot within minutes and a few feet of each other – providing three quite different effects.
20mm lens, Kodachrome ISO 64, automatic setting

Detail in cloudy light The good saturation and absence of shadows makes cloudy weather ideal for certain kinds of close-up, particularly those rich in detailed information (right). The colours of this dish of beans are perfectly rendered in a close view, taken in a Korean street market.
55mm macro lens, Kodachrome ISO 64, automatic setting at 1/30 sec.

zero. Occasionally also, it is measured by mired (pronounced my-red) value, which is calculated by dividing 1 million by the temperature in degrees Kelvin. The practical benefit of the mired scale is that both light sources and filters can be given numbers, and these can be added and subtracted easily. Using the table on page 74, mired shift values can be combined to calculate any filtration needed. The colour temperature scale covers most of the light sources encountered in photography. The key value for photography is that for white: 5400K and known as *mean noon sunlight*.

A colour temperature meter gives an even more accurate guide. Light from fluorescent tubes and other sources with discontinuous spectra does not fit particularly well into the colour temperature scale, and readings with a meter from these are not guaranteed to be completely accurate.

Sunlight

One single light source illuminates the earth, yet with the help of the atmosphere and a constantly changing pattern of clouds and weather, it creates an infinite variety of lighting conditions. The greatest variation occurs in the direction, quality and colour of sunlight. These in turn depend mainly on three things: the season, time of day and weather. Altitude and latitude also affect the quality of natural light, but this only becomes noticeable at heights above about 1,000 metres or close to either the equator or the poles.

No studio can reproduce all the variations of natural light, and it is these variations that give outdoor photography so much of its surprise and unpredictability. This said, one useful way of appreciating the variables is to think of an outdoor location as an enormous, natural studio set. The earth's atmosphere acts partly as a diffusing screen for the sun, and partly as a large reflector (a little light is reflected back from the ground, more from snow, sand and other bright surfaces). Finally, a constantly changing screen of clouds and suspended particles function as a complex array of filters.

Atmosphere and weather

Natural light is even more varied when the conditions in the atmosphere change. There are innumerable patterns of cloud cover, and not only do they alter the appearance of the sky itself, but they also filter, diffuse and reflect the light from the sun. Clouds, in all their forms, are made up of water droplets, which are too large to scatter wave-

lengths selectively. Instead, they scatter the entire spectrum, and appear white or grey. They work as reflectors, and at sunrise and sunset are responsible for dramatic colour effects.

A thin haze reflects more white than blue, and softens shadow edges. As cloud cover increases, the sun's light is diffused over a larger and larger area until, on a completely overcast day, the entire sky is the light source and

Clouds for dramatic effect
In this sunset view of East Flores (left), the fragmented remains of tropical storm clouds filter the sunlight into a fan of rays.
20mm lens, Kodachrome ISO 64, automatic setting

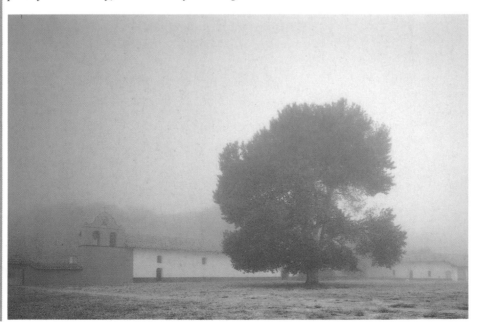

Morning fog Normally bathed in intense, clear sunlight under bright blue skies, the muting of colours and tones from mist and fog brings a welcome change of pace to an assignment on southern Californian missions (left).
20mm lens, Ektachrome ISO 64, automatic setting

Snowscape Snow lying under a sky that threatens a further fall presents a subdued range of tones and even fewer colours, giving a rather sombre mood to this shot of the Shaker village of Pleasant Hill, Kentucky. Under-exposure is a slight risk.
180mm lens, Kodachrome ISO 64, automatic setting from centre-spot reading from the middle of the frame covering the trees and façade of the house equally

there are practically no shadows at all. This flat lighting gives poor modelling, but can be very effective for complex shapes and gives faithful colours. A highly detailed garden, for example, might look clearer in such light.

In extreme weather conditions such as in falling snow and heavy rain, both contrast and colours are subdued, and subtle, even impressionistic results are possible.

Driving rain Without the reflections from direct sunlight, individual raindrops rarely register on film. What conveys the effect of rain is the secondary effects, such as glistening surfaces and the attempts of people to shelter, as in this view of Cambodia's capital, Phnom Penh, in the monsoon.
180mm lens, Kodachrome ISO 64, ¹/₁₂₅ sec., f2.8

Available light

Apart from sunlight, all the other main light sources used in photography are artificial, and there is a considerable range of types, intensities and colours. The most basic distinction is between lights that are intended for photography, and the rest. This latter group embraces everything from street lamps to candles, and can be thought of as "found" lighting. Commonly referred to in photography as available light, it is artificial, but for the photographer it is not normally possible to control.

The problems include high contrast, dimness and strange colour casts, but like nearly all "problems" in photography they can be turned to advantage. The new ultra-fast films make it practical to shoot almost as easily at night and indoors as in daylight. Adding flash to available light extends the shooting possibilities even further, but for now we will look just at available lighting. Used well, the results can convey a naturalism that would be difficult to create intentionally with photographic lighting.

By and large, available light sources are rather weak for photography, and this restricts the choice of film, lenses, depth of field and shutter speed. Often some compromise is necessary, sacrificing some picture quality such as resolution or viewpoint in order to be able to take an acceptable picture. For this reason, many available-light techniques are concerned with getting enough quantity of light to the film. Ultra-fast lenses – that is, with very wide maximum apertures of f1.2 or wider – are

Daylight indoors Sunlight filtering through doors and windows is often underestimated as a creative effect, and can produce unexpected results, particularly when the sun is low enough to cast shadows on walls. Here, the windows of a Catholic church in Indonesia catch the afternoon light as the bell-ringer climbs to the tower.
24mm lens, Kodachrome ISO 200, ⅓₀ sec., f2.8

A blend of available light
A winter, full-moon festival in northern Thailand is the occasion for a mixture of different illumination: tungsten, fluorescent, candles and the moon itself. The combination of colours is never as intense to the eye as it appears on film, but is nearly always attractive, and frequently brings surprises when editing. Some of the reddish cast is due to reciprocity failure on this particular film, but itself adds to the effect.
20mm lens, Kodachrome ISO 200, 2 sec., f4

Available tungsten: two solutions Except when it must appear neutrally white, available tungsten can be acceptable even if uncorrected for the film. In the photograph of a trading-post in Arizona (left), daylight film was used without any blue correcting filter, while the reception scene at a Lord Mayor's dinner in the City of London (below) was shot on type B film, and so partly balanced.
20mm lens, Kodachrome ISO 200, automatic setting

24mm lens, Type B Ektachrome ISO 160, automatic setting

Reciprocity failure

Most films are designed to work best at short exposures, such as around 1/125 sec or 1/60 sec. At long exposures – usually above 1 sec – reciprocity failure occurs. The reciprocity between aperture and shutter speeds – exposure = light intensity x duration – fails when the shutter speed is very low. For instance, at an exposure of a few seconds, most films will need extra exposure. Colour films also experience a colour shift, as the reciprocity failure nearly always affects one of the colour emulsion layers before the others. There are two solutions. One is to follow the manufacturer's recommendations for extra exposure and for adding filters; the other is to use a tungsten-balanced film.

intended for low light, and are ideal except for their high cost. For most photographers, the essential techniques are to do with film and time exposures.

The film choice is the first important decision; in colour and black and white, negative and reversal, there are now ultra-fast emulsions made especially for shooting under these conditions. Some of them are designed for "push-processing" at choice; in this technique, extended development increases the effective film speed.

Time exposures are another solution to the problem of dim lighting, and call for a tripod or some other solid support. Long exposures, of several seconds or more, work when the subject, or at least most of it, is static. City views, for example, are often very effective when treated in this way: the streaking of car headlights and blur of crowds and traffic add movement and pattern.

Sometimes the blur of passing people is so extreme as to be unnoticeable in the image.

Tungsten lighting: Tungsten lamps, most common in domestic interiors, are incandescent lights – they work by burning a filament. Some photographic lamps operate in exactly the same way, but household lamps emit less light. The colour temperature depends on how brightly they burn, but is generally 2900K, and so they give a reddish light (see Colour temperature above). Variations in voltage also affect colour temperature, as does age (blackened deposits inside old lamps make the light redder).

To bring the colour of tungsten lighting back up to "white", either a tungsten-balanced film or bluish conversion filters are needed, or both together. Most tung-

sten-balanced films are designated Type B, which means that they are balanced for 3200K; a very few are Type A, balanced for 3400K. With either type, domestic tungsten lights will still appear reddish, but this often looks more appropriate than perfect correction. If, nevertheless, it is important to balance the lighting to the film, use an appropriate conversion filter; with Type B film, try an 82B or 82C filter.

With daylight film in the camera, it is easier to use a stronger blue conversion filter than change in mid-roll to a tungsten-balanced film. An 80B or 80A filter combined with an 82C will render most found tungsten lighting nearly white. These stronger filters naturally call for longer exposures.

Fluorescent lighting: Fluorescent lighting is probably the most common source in public buildings and offices. Although usually visually white, fluorescent lighting nearly always records as greenish on film – but to an unpredictable degree. There are so many types of fluorescent lamp that the only way to be absolutely certain of the colour is to measure it with a colour temperature meter first, and then test it on film. In practice, however, this is out of the question in most situations, so the general

Fermenting wine, Napa Valley This barrel-ageing room in a Californian winery is typical of many industrial interiors, lit by overhead fluorescent lamps. The uncorrected exposure (below) has a characteristically green cast. Being unable to check the make of

lamps, I tried several filter combinations: the most successful was CC30 magenta (bottom). *Nikon, 180mm, Kodachrome, ¼ sec, f3.5 and f2.8*

solution is to use a proprietary filter (usually designated an FL filter), or a 30M or 40M magenta filter. A more elaborate alternative is to replace the existing tubes with those colour-corrected for photography.

Vapour lighting: Three main types of vapour lamp, all used principally in large public or industrial areas, are sodium, mercury and multi-vapour. The difficulty with these for colour photography is their unpredictability. Sodium vapour lamps, as used in street-lighting that is orange to the eye, have a discontinuous spectrum that cannot be corrected by filters – it records on film as yellow. Mercury vapour can be corrected to an extent, using reddish filters, but normally appears blue or blue-green. Multi-vapour lamps are more nearly colour corrected, and when they are used in sports stadiums they can usually be relied upon.

Mixed lighting: When different light sources are mixed in the same scene, the effects can be difficult to predict. In some situations, the combination can simply be colour-ful, and acceptable for that reason alone. In others, particularly with close-ups of people, the contrast of

Mercury vapour blue Mercury vapour spotlights illuminate the State Capital tower in Annapolis at dusk. The contrast with the remaining daylight makes the blue cast even more apparent. The degree of blueness is not always obvious to the eye, and this lighting is easily confused with that from the more balanced multi-vapour lights.
20mm lens, Ektachrome ISO 64, automatic setting

Sodium vapour yellow
Essentially unpredictable by filters because they emit in just a narrow band of the spectrum, sodium vapour floodlights, as seen here in London's Trafalgar Square, give a distinct yellow hue.
20mm lens, Kodachrome ISO 64, 2 sec., f5.6

Mixing two light sources
In this interior shot of a Napa Valley Winemaker at work in the cellars, the orange cast of tungsten partially cancels out the greenish hue of overhead fluorescent strip-lights. The colour effect, though not conventionally balanced, is certainly acceptable.
35mm lens, Ektachrome ISO 400, automatic setting

colour on flesh tones can look odd. Generally, long views in which the different light sources can be seen pose less of a problem than closer shots in which the viewer expects the lighting to be consistent and balanced. In the latter case, an intelligent choice of camera angle and position can overcome the problem to an extent. With a portrait, for example, try to favour one of the light sources, and use the filter appropriate for that.

Also decide which of the light sources, if uncorrected, would look least unpleasant. If an interior is equally lit by daylight and tungsten, and a blue filter is added to balance the film to the lamps, then the daylight will be blue and this will usually look stranger than if the tungsten lamps were left uncorrected. Tungsten lighting, being orange, can actually go a long way towards neutralizing the greenness of fluorescent lighting (a tip that can be put to use with a little more effort by aiming a photographic tungsten lamp up towards a ceiling in which are set fluorescent strips).

On-camera flash
The simplest and most commonly used photographic lighting is a small flash unit attached to the camera – in

Exposure settings for difficult available light conditions

These are approximate guides to use as starting points for a bracketed series of exposures where exposure readings are difficult to make. If the shutter speed still seems too slow for the subject, use a faster film or increase the development.

Film speed (ISO)	25	64	125	200	400
Brightly lit night time street scene	⅛ sec f2.8	¹⁄₁₅ sec f2.8	¹⁄₃₀ sec f2.8	¹⁄₆₀ sec f2.8	¹⁄₆₀ sec f4
Very brightly lit night scene, eg nightclub district	¹⁄₁₅ sec f2.8	¹⁄₃₀ sec f2.8	¹⁄₆₀ sec f2.8	¹⁄₆₀ sec f4	¹⁄₆₀ sec f5.6
Flood-lit football stadium	¹⁄₁₅ sec f2.8	¹⁄₃₀ sec f2.8	¹⁄₆₀ sec f2.8	¹⁄₁₂₅ sec f2.8	¹⁄₂₅₀ sec f2.8
Moon-lit scene (full moon)*	2 min f2	2 min f2.8	1 min f2.8	30 sec f2.8	15 sec f2.8
Town at night in the distance	1 min f2.8	30 sec f2.8	15 sec f2.8	8 sec f2.8	4 sec f2.8
Lighting	T f2	T f2.8	T f4	T f5.6	T f8
Firework display	T f2	T f2.8	T f4	T f5.6	T f8
Flood-lit industrial factory at night (eg refinery)	2 sec f2.8	1 sec f2.8	½ sec f2.8	¼ sec f2.8	⅛ sec f2.8
Moon in clear sky (full or nearly full)	¹⁄₆₀ sec f5.6	¹⁄₁₂₅ sec f5.6	¹⁄₁₂₅ sec f8	¹⁄₁₂₅ sec f11	¹⁄₁₂₅ sec f16
Candle-lit close-up	¼ sec f2.8	⅛ sec f2.8	¹⁄₁₅ sec f2.8	¹⁄₆₀ sec f2.8	¹⁄₁₂₅ sec f2.8
Neon sign**	¹⁄₁₅ sec f2.8	¹⁄₃₀ sec f2.8	¹⁄₆₀ sec f2.8	¹⁄₆₀ sec f4	¹⁄₆₀ sec f5.6
Fairground	¼ sec f2.8	⅛ sec f2.8	¹⁄₁₅ sec f2.8	¹⁄₃₀ sec f2.8	¹⁄₆₀ sec f2.8
Boxing ring	¹⁄₁₅ sec f2.8	¹⁄₃₀ sec f2.8	¹⁄₆₀ sec f2.8	¹⁄₁₂₅ sec f2.8	¹⁄₂₅₀ sec f2.8
Theatre stage, fully lit	⅛ sec f2.8	¹⁄₁₅ sec f2.8	¹⁄₃₀ sec f2.8	¹⁄₆₀ sec f2.8	¹⁄₁₂₅ sec f2.8

* Reciprocity failure is the chief problem here, and that varies with the emulsion. For some colour film more exposure may be needed. Try to use a fast lens rather than long exposure times. ** If the neon sign is a changing display, use an exposure time long enough for a full cycle.

Basic flash In a crowded corner of Kew Gardens, famous for its plant collections, a botanist examines one of the specimens. In this indoor location, a simple on-camera flash provides effective illumination with the minimum of shadows. This uncomplicated lighting, together with the typical fall-off to a dark background, helps to define the complicated pattern of plants.

Fill-in flash In order to balance the daylight entering this traditional perfume shop in the heart of Old Delhi, flash was used to illuminate the shadow areas. Holding the flash unit 0.5m (2ft) to the left of the camera gave slightly more modelling than an on-camera flash would have provided.
24mm lens, Kodachrome ISO 200, automatic setting

many models, indeed, it is built into the camera body. More often than not, flash units made specifically for one model of camera are "dedicated"; they are linked electronically not only to the shutter, but to the exposure control system as well. This link can be as sophisticated as causing the angle of the flash beam to widen or narrow according to the zoom movements of the lens.

The chief drawback of basic on-camera flash is that it produces an unchanging and rather mean quality of light; it is almost a point source, and is so close to the lens as to be almost head-on to the subject. Certain subjects are suited to this flat, near-axial lighting, but there are more that look stark in pure flash lighting. Nevertheless, on-camera flash is convenient, making possible pictures that would otherwise not be worth attempting.

Arguably the most successful use of on-camera flash is to combine it with the ambient lighting, and for this reason the most highly evolved camera-flash systems regulate the flash output so that it balances the other light sources. The most common treatment is to lighten shadows with the flash, such as in back-lit shots in daylight. Here the shutter-and-aperture exposure combination is set for the day-lit scene; the flash output is then adjusted so that it is less than would be needed were it the only light source. It is possible, even with a non-automatic flash unit, to calculate this balance, but for any photographer intending to use on-camera flash regularly, it makes much more sense to buy an automated camera and flash that will do this conveniently and instantly.

To an extent, the quality and direction of on-camera flash can be varied, depending on the model; this mostly applies to detachable flash units. The light can be softened a little by placing a diffusing material in front of the flash, or by tilting the flash-head upwards to bounce the light off a ceiling (which should be low and white for the technique to work well). An extension sync cable, coiled

Using flash at night

Flash can be used in dim lighting with a long exposure. Hand-held, in the evening, for instance, the crisp parts of the image frozen by the flash can combine interestingly with the streaked ambient lighting. Used with a moving subject, such as a person walking or running, this treatment works particularly well if the flash is timed to fire at the end of the exposure, so that the streaking tails back from the flash-frozen image, rather than leading on from it. This "rear-curtain" flash synchronization is available on some cameras.

Flash units

While an increasing number of cameras feature built-in flash, the standard equipment for providing simple additional lighting remains the portable flash unit. Such units vary in size and sophistication, the largest being powered by a separate battery pack, which allows not only a very large number of flashes and high output but also fast recycling, all of which can be important in news photography. Almost all portable flash units offer some form of automatic exposure control, either through their own sensor or by linking to the camera's internal meter. A choice of operating modes is increasingly common, allowing, for example, shadow fill that is adjusted to the ambient lighting. Some flash units that are dedicated to the particular camera feature a zoom mechanism that adjusts the spread of the light beam to the angle of the lens.

Portable flash unit

Flash linked to internal metering

Built-in flash with beam linked to lens angle

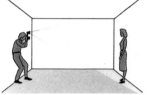

Direct flash without diffusion

Direct flash with diffusion

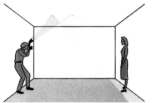

Flash bounced off ceiling

Softening the light from a portable flash The harsh light from the small tube and polished reflector of a portable flash can be unflattering to many subjects. One basic method of diffusing the light is to bounce it off a large white or neutral surface, such as a ceiling or wall. This drastically reduces the light reaching the subject, but the hard shadows are eliminated. Some flash units are deliberately designed for this, with heads that swivel upwards. If the flash unit is automatic, then the sensor must still point towards the subject to give the correct exposure automatically.

A few flash units have special attachments either to diffuse or reflect the light, and so soften it. Although these are quite useful, they are usually small, and provide much less softening than a ceiling.

The inverse square law This states the rate at which the illumination from any light source falls off with any increase in distance from the subject. The reduction in illumination will be the square of increase in distance. For example, if a subject at 1 metre from a light source is moved a further 1 metre away, the illumination be will 4 times less — that is, one quarter of its original strength.

1 metre

1 metre

Studio lighting's controlled effects Used well, studio lighting brings precision to images that are set up rather than found. For this still life of a Chinese jade leaping carp, an area light suspended overhead provided the basic illumination, while a carefully positioned light covered with a coloured gel was aimed from below through a curved sheet of translucent plastic. Flash was used in preference to tungsten to avoid over-heating the plastic.
55mm lens, Ektachrome ISO 100, flash sync., f32

or not, allows the flash to be aimed from some distance away from the camera, for more definite shadow modelling; to retain full exposure control, this extension should be a dedicated cable.

Sync junctions or photo-electric slave triggers allow more than one unit to be used at the same time; a second flash, for instance, could be used at a greater distance to fill in shadows cast by the main flash. At this point in manipulating flash units, however, it might be better to consider a more powerful flash alternative.

High-output portable flash
The step up from on-camera flash is the range of units that feature a separate, battery power-pack and detach-

Tungsten lighting

Although now largely superseded in professional studios by flash, tungsten lighting has the advantage of being relatively inexpensive and better able to light very large areas (through increasing the exposure time). Its major disadvantage is the inconsistency of the light output, particularly the colour temperature.

Tungsten lamps used in photography are essentially up-rated versions of domestic light bulbs; consequently they have shorter lives, some as little as two to three hours. They have colour temperatures of either 3200°K or 3400°K, compared with about 2800°K for domestic lamps. With use, the tungsten in the filament gradually forms a deposit on the glass envelope, reducing the light output and colour temperature. One answer to this problem is the quartz-halogen lamp, in which vaporized tungsten disperses in the halogen gas and re-deposits on the filament. The output and colour thus remain constant, but as high temperatures are necessary, quartz is used instead of glass as the envelope.

In fact, any tungsten lamp, even the low-wattage domestic type, can be used in photography, provided the colour temperature is known and compensated for with colour-correction filters. A colour temperature meter should be used for complete accuracy in studio work.

Tungsten lamps are available in different intensities: (a) Clear spotlight lamp with coiled filament gives high intensity; (b) Reflector bulb is partly silvered inside; (c) No. 2 photoflood; (d) Regular photoflood.

Designs of tungsten lights vary considerably, from small, compact units, such as the Lowell Totalite (above right) to the larger spotlights normally used in film studios (right).

able heads, and output in excess of 200 joules. These units weigh a couple of kilograms, but give a fair imitation of proper studio lighting. The dry-cell batteries are rechargeable, and power can be switched between more than one head. Many of the diffuser and reflector attachments made for studio flash equipment can be fitted to these portable heads.

Studio flash

The top end of lighting equipment is designed mainly for use in a photographic studio, and is both heavy and mains powered. Portability is not really a consideration, although the trend is inevitably towards miniaturization of components and reduced weight. The range of equipment available is formidable, less in the basic units than in the attachments to alter the quality of the light. Without the tremendous variety of natural light, the studio photographer starts from scratch, and in order to create lighting effects that range from the subtle to the dramatic, needs to be able to draw on a bank of reflectors, shades and diffusers. To achieve precise lighting effects for specialized subjects, many photographers even construct their own diffusers and reflectors, or adapt commercial makes.

Large studio flash units take the form of a power pack that can be connected by cable to a number of flashheads. For convenience, and portability on location, some smaller units are integral: the power unit and flash-

head are all housed in one unit. A transformer steps up the voltage from the mains supply, and a rectifier converts the alternating current to direct. This current is then fed into the capacitor (or capacitors in a large unit), which stores the charge until the flash is triggered and it is discharged through the flash tube. The variety of flash-head fittings, such as diffusers and reflectors, make comparisons of light output meaningless, and so the power of a flash unit is measured in electrical output rather than light intensity. The unit of measurement is the joule, or watt-second. Small studio flash units have outputs of a few hundred joules; large units reach a few thousand.

Recycling times are rapid compared to battery-powered portable flash, and of course remain consistent. The output can be reduced, and in units with separate power packs, the power can be distributed unevenly (known as asymmetrically) between different heads.

The two extremes of photographic light source – and the extremes also in terms of equipment – are large-area lights and focusing spotlight. By comparison, a small on-camera flash is quite primitive in its possibilities, however advanced its technology. Area lights, which can vary from a head the size of a medium light-box used for viewing transparencies up to a unit larger than most domestic windows, are box-like constructions fronted with translucent sheeting. This can be fabric or, for more permanence and evenness, milky Perspex. The origins lie in the traditional northlight of an artist's studio, and the effect

is very much like the light from a window: directional but soft. Alternative names for this kind of light are window-light, soft-light, fish-fryer and even, for the largest, swimming-pool!

By contrast, spotlights of one kind or another focus the light into a tight beam. The most precise of these feature lenses can be adjusted in different positions, and the effect is highly directional, producing very strong high-lights and shadows. Used at some distance from the sub-ject, a focusing spot can imitate direct sunlight, as can often be seen in food shots that appear to have been taken with a low sun streaming through a window.

In between these two extremes is a wide range of light-ing attachments. They work in one of three ways: by altering the diffusion of the light (soft to hard), by reflect-ing it to a greater or lesser degree, or by shading it from the subject.

Studio tungsten lighting

Less commonly used overall than flash, tungsten lighting nevertheless has admirable properties that keep it popu-lar in certain kinds of studio work and other highly

Studio lighting Photographic tungsten lighting is ideally suited to interiors where exposure can be long and where it is important to be able to see the colour effects of the lighting before shooting.

organized photography. Although it is of little use for stopping movement, tungsten lighting, being continu-ous, is ideal for illuminating large areas – only the exposure time needs to be adjusted. Flash has a lower limit – the output of a single discharge – and to increase the illumination beyond this, it is necessary to trigger the flash a number of times. This is not only inconvenient, it can easily build up into an impractical number of flashes (twice the exposure needs only 2 flashes, but 4 times needs 16 flashes, and so on).

Tungsten's other great advantage is that its effects on the image are visible; to borrow a phrase, what you see is what you get. The most commonly used type of tungsten lamp is the quartz-halogen lamp but up-rated lights sim-ilar to domestic lamps and known as photofloods are also available at low cost. Most tungsten lighting operates at 3200K, which is markedly less yellow than domestic lamps, and it is for this that Type B film is balanced.

The studio

A studio is what passes in photography for a controlled environment, and is inextricably linked to lighting. A few daylight studios exist, making use of large windows in the same way as an artist's studio. However, for controlled work, particularly in colour, even they need photographic lights as well. Studio design must usually conform to available space; fully purpose-built studios are an uncommon luxury. The type of work for which the studio is planned determines the minimum requirements of space and layout; less room, for instance, is needed for still life than for portraits or fashion, while much more is needed for room sets or car photography.

When considering size, always allow plenty of room *behind* a subject, so that backgrounds can be separately and efficiently lit (wrinkles in background paper are also less obvious if they are several feet out of focus). The choice of lens focal length also affects the dimensions of the studio: a long-focus lens, for example, gives more flattering proportions than a normal lens, but needs more room. A high ceiling is an advantage for still-life photography, and a requirement for any larger subject. The main reason for this is to provide lighting positions, as lights frequently need to be rigged overhead. You need to be able to black out any windows, either by painting them or fitting light-tight roller-blinds of the type made for darkrooms. With the windows sealed, air-conditioning extractor fans are necessary.

Lighting, as already detailed, is the principal equipment in a studio, followed by a range of backgrounds. These can vary from neutral (such as white, grey or black paper, or a white wall) to very specific (such as part of a room set to complement a still life, for example a kitchen wall behind a food shot). Once again, the type of work will suggest what is most useful. The larger the subject, the bigger the background area that is needed. Seamless paper rolls are a basic staple background, and need a rigging system. A danger of standardizing backgrounds in this way, however, is that it gives a visual sameness to shots. It is usually much more effective if the background can contribute to the image in some way rather than just fill in the space around the edges. The choice, or invention, of a background derives from the photographer's imagination.

In addition to lighting and backgrounds, a wide range of tools is also necessary, ranging from staple-guns to woodworking equipment. Many shots require on-the-spot improvisation, as the studio is, or should be, a neutral space that can be adapted at short notice.

1 Film storage refrigerator
2 Film changing room
3 Models' dressing room
4 Seamless background roll
5 Storage area for hard board, polystyrene sheets and background rolls
6 Storage shelves
7 Wall storage for background rolls

The darkroom

- Colour processing
- Black-and-white processing
- Developing prints
- Making a contact sheet

Although commercial photo-finishing laboratories are numerous, and turn round processing and printing jobs rapidly, so that most photographers never even see the stages between using the camera and receiving the prints or slides, a darkroom still offers the ultimate control over image quality. In a typical commercial laboratory, processing and printing is automated, and this delivers fast, inexpensive results. In many circumstances this is a desirable compromise between cost and quality, but individual attention is inevitably missing. This matters little for the processing, but the difference between machine prints, as they are known, and ones made carefully by hand can be considerable. Black-and-white processing and printing, moreover, is now so uncommon that it has become relatively unprofitable on a commercial basis and it can be very difficult to find a photo-finishing shop that will handle it.

Darkroom layout

The layout of a darkroom, if it is being built from scratch, needs careful planning. The various stages of processing and printing need to be carried out with precise timing, many of them in either near or complete darkness. The prime requirement, therefore, is that the room be completely light-tight; in turn, this means that adequate ventilation is essential to disperse chemical fumes.

1	Enlarger	**14**	Thermometer
2	Film drying cabinet	**15**	Contact printing
3	Focusing magnifier	**16**	"Dry" storage cupboard
4	Easel	**17**	"Wet" storage cupboard
5	Light box		
6	Shelf for film processing equipment		
7	Flat bed print dryer		
8	Safe light		
9	Extractor		
10	Print washing tray		
11	Graduate and stirrer		
12	Timer		
13	Developer, stop bath and fixer trays		

Wet and dry Draw an imaginary line through the middle of the darkroom to separate wet processes from dry ones. With equipment that is used in both, such as developing tanks, scrupulously remove all traces of moisture before returning them to the dry side.

Black-and-white processing equipment

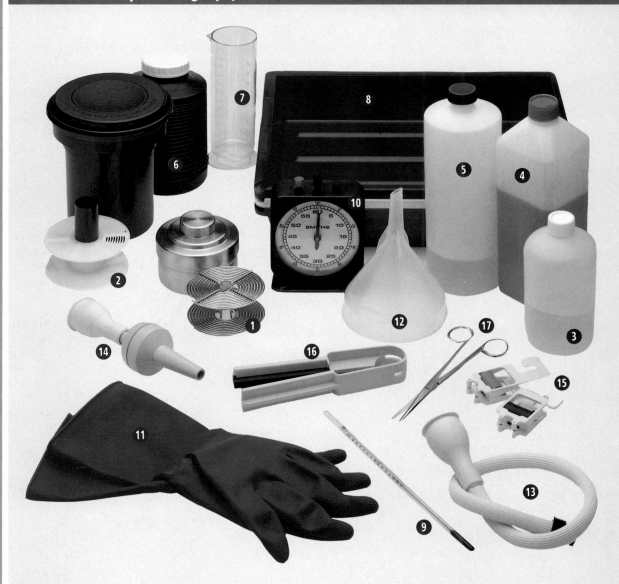

Developing tanks are available in two basic designs – with a stainless steel reel (**1**), and with a plastic reel (**2**) which is easier to load but less durable. Developer (**3**), stop bath (**4**), and fixer (**5**) should be kept in clearly labeled, light-tight stoppered bottles; an even better alternative is an expanding container with a concertina shape (**6**) which adjusts so that air is excluded. For mixing chemicals, a graduated measuring flask (**7**) is essential, and to maintain them at a constant 68°F they should be placed in a tray (**8**) filled with water at that temperature, using a thermometer (**9**).

A timer (**10**) can be pre-set to the recommended developing and fixing times. Rubber gloves (**11**) prevent skin irritation from prolonged contact with the chemicals and a funnel (**12**) prevents spillage when returning chemicals to the bottles. A water hose (**13**) and filter (**14**) are used for washing the film, which is then hung to dry on clips (**15**). Excess moisture can be removed with a pair of squeegee tongs (**16**). The film is finally cut into strips with scissors (**17**). Wetting agent (not pictured) is added to the final wash to help the developer spread more easily and to prevent drying marks.

Black-and-white processing

Black-and-white processing is a relatively straightforward operation, and the equipment is neither elaborate nor expensive. Although colour film is more commonly used today, if you are new to working in a darkroom, it is worthwhile shooting some black-and-white film and then practising the processing procedures before moving on to colour work.

Equipment: A photographic darkroom is not essential for processing, although it is obviously the ideal. Total darkness is only needed at the start, for loading the film into the processing tank. All that is required for this is a small, light-tight space where the film can be removed from its cassette and loaded into the tank. This can even be a closet, provided that all the gaps have been efficiently sealed (test before using the first time by exposing a short strip of unused film. A cloth changing-bag is also useful. With one single development, fix and wash, black-and-white film processing is simpler and quicker than it is for colour film. Processes are less standardized, too, and this offers the advantage of a choice of proprietary kits, each with special features. Developers are available either in powder form (mixed before use, and less expensive) or as concentrated liquid (more easily prepared). Different types of developer enhance particular film characteristics, giving a measure of creative as well as physical control over the image, even at this late stage.

Temperature is not as critical for black-and-white as it is for colour film processing and the number of chemical solutions used is smaller. If using developer powder, prepare it by filling a container with three-quarters of the final volume of water at a temperature of about 52°C (125°F). Add the powder a little at a time, stirring constantly until it has completely dissolved and the solution is clear (if the powder is added too quickly, it will accumulate at the bottom of the container and dissolve more slowly). Add the remaining quarter of the volume of water. Prepare the solution well in advance, as it will have to cool to 20°C (68°F) before use. It is essential, as with any chemical process, to follow the set procedures faithfully; consistency is what counts.

All the chemicals have limited lives, even when they are not being used. Exactly how long depends on how well they are stored, and they should be protected from both strong light and contact with air. Use dark, well-stoppered bottles, and fill them to the top; the less air, the more slowly the solution will deteriorate. Some containers are made to expand when they are filled with solution and contract as they empty, to minimize the amount of air inside them.

Altering development

You can alter the development, temperature or strength of the processing solution for deliberate effect, and with experience you will be able to achieve a surprisingly wide range of control over the film's tonal range. The most basic use of altered development is to correctly increase the exposure by one stop to compensate for this.

Increasing development increases the density of the image and increases the contrast (expands the tonal range). Reducing development reduces the density and reduces the contrast (compresses the tonal range).

Black-and-white processing procedure

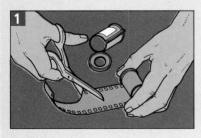 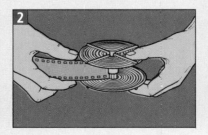

1 In complete darkness, open the cassette by prising off the end with a bottle opener or special cassette opener. Take out the film and cut off the tongue.

2 Holding the film by its edges, bow it carefully and attach the end to the spike or clip at the core of the stainless steel reel. Rotate the reel so that the film is pulled out along the special grooves and thread the film inwards from the rim.

3 Trim off the end of the film that was attached to the cassette spool, lower the loaded reel into the developer tank and replace the lid. The room light can now be switched on.

Black-and-white processing procedure

1 Having loaded the film into the developer tank as described on page 101, check the temperature of the developer solution and pour it quickly into the tank. When full, tap the tank to dislodge air bubbles, and fit the cap that covers the lid's central opening.

2 Trip the timer switch. During development, agitate the tank by rocking it backwards and forwards to ensure even application of the solution. Agitate for 15 seconds every minute.

3 At the end of the development time, quickly pour out the developer. Pour in stop bath and agitate continuously for 30 seconds. Pour out and refill with fixer for the time recommended by the manufacturer.

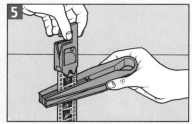

4 When the fixing period is over, empty the tank, take off the lid and insert a hose from the cold water tap into the core of the reel. Wash for at least 30 minutes in gently running water. Strong water pressure may damage the emulsion.

5 Before removing the reel from the tank, add a few drops of wetting agent to avoid dying marks. Attach film to a hanger clip, pull out and gently wipe off the bulk of the moisture. Hang to dry in a space free from dust and air movement.

Faults on the negative
1 An ill-defined dark area is characteristic of accidental exposure to light. Here, this includes the rebate, suggesting that the leak occurred outside the camera.

2 Two adjacent pieces of the film stuck together in the developing tank, preventing full exposure to the processing solutions.

3 The scratch was probably due to rough handling. Dust and grit adhered to the soft emulsion during drying. There are also water marks.

4 This crescent-shaped mark is often found close to the beginning of rolls and is caused by crimping the film too hard.

The tonal range

1 In this normally exposed, normally developed negative of an Indian pueblo in New Mexico, the tonal range is quite full, but with a predominance of middle-greys in the centre of the tonal range. The shadow and highlight areas occupy only a small part of the image, but are extreme. The film can just record all the important details at either end of the tonal scale.

2 By overexposing this negative (above centre) one-and-a-half stops and then reducing the development time, the middle grey tones of the adobe wall remain the same. However, the whole tonal range of the film has been severely compressed, and the effect is flat.

3 This negative (above right) was underexposed by the same amount, one-and-a-half stops, and later overdeveloped. Again, the mid-tones over most of the picture are unaltered, but the highlights and shadows have lost a great deal of detail. The tonal range has been expanded, and the contrast increased, but this has gone beyond the film's capabilities of recording.

Processing chemicals for film and paper

Print developing has much simpler needs than film processing. Only three chemicals are needed – developer, stop bath and fixer – and these are standard.

Developer Print developers, either MQ or PQ or PQ types, are used at higher concentrations than film developer so that the image appears within a reasonably short time – 1½ to 2 minutes. Developers oxidize rapidly.

Stop bath A typical acid bath is used to stop the developer's action. It is re-usable. Some printers prefer to use water instead. Although this considerably shortens the working life of the fixer which becomes contaminated more quickly, a print that has been "stopped" by a plain water wash can be returned to the developer if necessary.

Fixer Prints are normally fixed in an acid hypo solution, at weaker dilution than for film. As soon as discoloration is evident, discard.

Hypo eliminator An oxidizing agent can be added to the wash to clear hypo from the film chemically. This can cut washing time by as much as five-sixths.

Wetting agent A few drops of wetting agent can help the developer spread more easily over the film, and also reduces water marks.

Types of developer

Different developer solutions are designed to alter or enhance the particular characteristics of a film – speed, grain size or contrast. Just as there is no ideal emulsion that combines the best of everything, so there is no perfect developer. You must not only choose the developer for the characteristic you value most; you must also match the developer to the emulsion. A fine-grain developer does not magically impart a fine grain to all emulsions, and if you have already chosen a fast (and therefore grainy) film, you should use a developer that enhances that characteristic.

Fine grain developers These help to prevent the overlapping of individual grains that is visible as clumps in the developed image. They are slow and tend to produce low contrast.

High energy developers These developers enhance graininess but enable the film to be used at a higher speed rating. They are very active, and produce higher contrast.

High contrast developers These are used when maximum contrast is needed, and can produce extremely dense blacks in line film. For certain kinds of copying and masking work, they are ideal.

High acutance developers These increase the apparent sharpness of the image by developing the grains near the surface of the emulsion. The silver image is therefore in a thinner layer, and there is less blurring from the gelatin thickness.

Development can be altered by varying the time, temperature or dilution of the chemicals. There is a limit to how little development time you can give, and under three minutes there is a real danger of uneven development (as a precaution, pre-soak the film in water before beginning processing). The latitude in temperature is also small; below about 13°C (55°F) some solutions stop working, and above 24°C (75°F) the emulsion becomes soft and is easily damaged.

Generally, changing the dilution is the best method of altering the development, although you can combine two or even all three of the methods. Follow the film manufacturer's specifications; but as a general rule, you can achieve one-stop differences in development by halving or doubling the dilution of the developer. Two stops on either side of normal recommended development is about the limit for a satisfactory image. Although you can alter the development by greater amounts, the image quality will suffer very much, and will probably be acceptable only when the lighting of the original scene is so dim that any kind of image is welcome.

Colour processing equipment

In addition to the developing tank and other basic items needed for black-and-white film processing, colour film needs its own developer, bleach, fixer and stabilizer, a graduated thermometer and a deep bowl that is filled with warm water to maintain the temperature of the chemicals at the right level.

Colour processing

Colour processing follows many of the procedures of black-and white darkroom work. Most of the working principles established there still apply to colour materials and most of the equipment can still be used. The large majority of colour films are designed for development in one of two proprietary processes: C-41 for colour negatives and E-6 for colour transparencies. These are available in kits of different sizes for various quantities of film. As with black-and-white film processing, colour processing requires consistency in following procedures.

Steps for processing colour film

The tables below summarize the basic steps for processing a typical colour transparency film (Ektachrome) by the E-6 process and a colour negative film (Kodacolor) by the C-41 process.

Processing "Kodak Ektachrome" Films (Process E-6)

Processing step	Minutes*	°C	°F
1. First developer	7†	37.8±0.3	100±½
2. Wash	1	33.5–39	92–102
3. Wash	1	33.5–39	92–102
4. Reversal bath	2	33.5–39	92–102
5. Colour developer	6	37.8±1.1	100±2
6. Conditioner	2	33.5–39	92–102
7. Bleach	7	33.5–39	92–102
8. Fixer	4	33.5–39	92–102
9. Wash (running water)	6	33.5–39	92–102
10. Stabilizer	1	33.5–39	92–102
11. Drying	10–20	24–49	75–120

* Includes 10 seconds for draining in each step
† See instructions for using solutions more than once

Processing "Kodacolor II" and "Kodacolor 400" Films (Process C-41)

Processing step	Minutes*	°C	°F
1. Developer	3¼	37.8±0.15	100±¼
2. Bleach	6½	24–40.5	75–105
3. Wash	3¼	24–40.5	75–105
4. Fixer	6½	24–40.5	75–105
5. Wash	3¼	24–40.5	75–105
6. Stabilizer	1½	24–40.5	75–105
7. Drying	10–20	24–43.5	75–110

* Includes 10 seconds draining time in each step

Colour processing

1 Having loaded the processing tank with film in total darkness, as described for black-and-white processing on page 101, mix and pour out measured quantities of the solutions into separate, clearly marked containers.

2 Fill a deep tray with water at about 44°C (110°F) and put in the loaded tank and numbered graduates. Leave to stand for a few minutes, when all solutions are between 35° and 40.5°C (95° and 105°F).

3 Check the temperature of the developer solution and pour it quickly into the tank. When full, tap the tank to dislodge air bubbles, and fit the cap that covers the lid's central opening.

4 At the end of the development time, quickly pour out the developer. Pour in stop bath and agitate continuously for 30 seconds. Pour out and re-fill with fixer for the time recommended by the manufacturer.

5 Follow the same procedure for every solution. Hold the tank at an angle to pour in the solution. Start the timer, then, agitate the tank, as recommended, placing it in the water bath between agitations. Use the final ten seconds of each stage to drain the tank.

6 When all processing and wash stages are over, empty the tank, take off the lid and insert a hose from the cold water tap into the core of the reel. Wash for at least 30 minutes in gently running water. Strong water pressure may damage the emulsion.

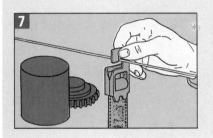

7 Before removing the reel from the tank, add a few drops of wetting agent to prevent drying marks. Attach film to a hanger clip, pull out and gently wipe off excess moisture. Hang to dry in a space free from dust and air movement.

Altering development of colour film

As in black-and-white, colour film can be rated at different speeds and over- or under-developed to compensate. However, the three different layers of emulsion in colour film react differently to altered processing.

Follow manufacturers' instructions for the mechanics of overdeveloping ("pushing") and underdeveloping ("cutting"). As an example, Kodak E.6 reversal films can be treated in the following ways:

The effects of over- or underdevelopment vary between makes of film, but in general over development of reversal film causes: loss of maximum density, causing thin, foggy shadow areas; increase in contrast; shift of colour balance. This varies by make of film. This is only pronounced when pushed more than one stop. Underdevelopment of reversal film causes loss of contrast in the highlights and shift of colour balance.

Camera exposure	Desired effect	Alteration of first developer time
2 stops under	Push 2 stops	Increase by 5½ mins
1 stop under	Push 1 stop	Increase by 2 mins
Normal	Normal	Normal
1 stop over	Cut 1 stop	Decrease by 2 mins

The temperature in colour processing is critical – for the first development stage to within 0.15°C (0.25°F) in the C-41 process. For this reason, it is important to have some means of keeping the several chemicals at a consistent temperature. The simplest method is to use a deep tray or dish filled with water warmed to that temperature; more reliable is a purpose-built dish-warmer. Make sure that every piece of equipment is kept scrupulously clean, and is dry when it should be dry. Separating the wet stages of the process from the dry stages helps avoid contamination. Do not allow chemicals or water close to the area where film is loaded. If a tank is being used more than once in the same processing session, the spiral reel should be dried thoroughly before re-loading.

Black-and-white printing

Printing offers very creative opportunities for print manipulation. Although consistency is not as crucial as it is in film processing (printing mistakes simply waste paper and chemicals, but do not destroy original images), repeatable accuracy makes printing easier and helps improve the quality of the final image. To this end it is helpful to use an electronic timer, either separate or built into the enlarger, to regulate exposure times, and a voltage regulator to prevent changes in the electricity supply that would affect light intensity. The basics of printing in black-and-white are similar to but far simpler than those you will find in colour printing, and for this reason many people prefer to start by printing black and white. The simplicity of black-and-white printing is matched by the great range of image manipulation that is possible, largely stemming from the range of printing papers available. To compensate for low or high contrast in the negative, a range of papers of different contrasts may be used. Alternatively, multi-grade paper gives a different contrast response according to which filter the negative is exposed through. The higher the number of contrast grade, the higher the contrast. Two is considered normal, 1 soft and 3 hard. The more extreme numbers – 0, 4 and 5 – are for emergency procedures. Other variables in paper

Paper types

Paper-based Until recently, all papers had a paper base with an emulsion coating on one side. Those with the traditional paper base are still the most commonly used.

Resin-coated Resin-coated papers have a plastic coating on both sides that is applied before the emulsion. This effectively seals the paper and the washing and drying stages are shortened considerably. Although popular because of this convenience, they have a limited range of textures, none of which corresponds to the standard "glossy unglazed". A more serious disadvantage for professional photographers is that they take retouching very poorly.

Weight Various paper weights are available and, although the thickest – "double weight" – is more expensive, it is less liable to creasing.

Texture Apart from "glossy" and "matt", a range of special textures can be bought, but most have a gimmicky appearance. Glossy papers give the richest-looking blacks.

Tint Each make of print has its own subtle tone, and in addition there are more noticeable ranges of base tint that include cream and strong primary colours.

Grade Printing paper is normally available in several contrast grades – usually 0 to 4 in increasing contrast (see right). The choice of grade can be used to compensate for variations in negative density or can be used to create special effects.

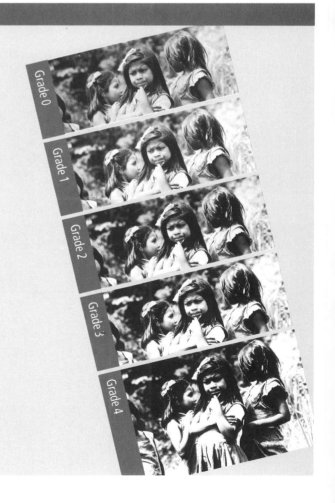

Grade 0
Grade 1
Grade 2
Grade 3
Grade 4

The enlarger

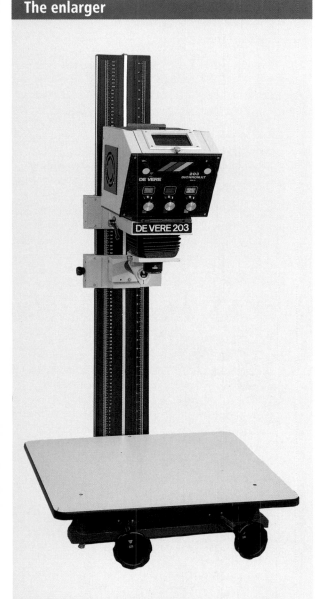

The basic components of an enlarger are quite simple – a light source, a holder for the negative, and a lens to project the image over a background, but for the highest picture quality and ease of use, the construction is often elaborate. When selecting an enlarger, follow two principles: first, the quality of the enlarger and lens should be at least equal to that of the camera and its lens. If the quality of the equipment in each stage of the picture-making process is not consistent, then the final image will be limited by the weakest item.

are the weight, texture and tint. Texture, in particular, affects the image: a smooth surface scatters less light making for richer blacks. However, an increase in reflections can interfere with the view.

The most commonly used papers are resin-coated. These, like colour printing papers, are air-dried. Fibre-based papers tend to curl if air-dried, and should be treated in a heated drier (a flat-bed machine is normal) to ensure they stay flat.

First, make a contact sheet, and use this to select a negative for printing. Examine the negative carefully for blemishes, and to assess its density. Follow the procedures for printing and processing the print described on page 102. All steps up to partway through the fix should be performed with red safe-lighting; after that, the room lights can be switched on. Once you have chosen a negative for enlarging, the next stage is to make a test strip and exposure test; it is needed only to judge the exposure and to check the paper grade. You will then be ready to make a final print.

Shading and printing-in: One of the most useful and important controls of a darkroom printer is to be able to alter the exposure given to small areas of the print. By holding back some parts of the negative, and giving more time to others, the final print can be completely altered. Holding back details is called "shading" and giving extra exposure is known as "printing-in".

Having assessed the negative and made a test print, you will be able to judge if any parts of the print need special attention. The most frequent need for shading and printing-in is when the contrast range of the negative is too high for the paper, and the highlights would appear "blocked" or the shadow areas lose their detail. From the test print, make a base exposure for the areas of average density. While you are doing this, shade the thinnest part of the negative with your hand, a piece of card, or a special shading tool, keeping it moving, so that the borders of the shaded area blend in with the rest of the print.

Without moving the baseboard or enlarger, print in the densest areas of the negative. Use either a large sheet of black card with a small hole in the centre or cup your hands to form a gap of roughly the right shape. Again, keep moving so that no hard edges are formed, but take care that no unwanted light spills onto the corners of the print.

Colour printing

The essential piece of equipment for colour printing is an enlarger with a lens of at least the same quality as the camera, as well as a first-rate colour filtration system. The least sophisticated arrangement for introducing filters is a drawer and holder into which filters – such as the

Black-and-white printing equipment In addition to the enlarger, you will need the following items for black-and-white printing: developer (**1**), stop bath (**2**), fixer (**3**) and trays for each (**4**). Separate tongs (**5**) are needed to avoid contamination of the chemicals. Trays must be large enough to take the size of paper (**6**) you will be using. A focusing magnifier (**7**) allows the sharpness of the projected image to be checked accurately. For contact sheets (**8**) the negatives (**9**) are arranged with the paper in a contact printing frame (**10**). A technical pen (**11**) can be used to mark the negatives for identification, and a magnifying glass (**12**) is useful for selecting frames for final printing in the enlarging easel (**13**).

Printing a contact sheet

A contact sheet provides you with a useful preview of the quality of each frame. Although on 35mm format it shows little detail, you can use it to select negatives for enlargement; without a positive image it can often be very difficult to judge which are the best frames on a roll. Making a contact sheet is a simple process and, because the negatives are exposed in contact with the printing paper rather than being projected, it can even be done without an enlarger.

Cut the film into strips of six frames; the whole of one 36-exposure roll can be contact-printed on to a single sheet of 8x10 inch (20.3x25.4cm) paper. A hinged contact printing frame is the most convenient way of sandwiching the negatives and paper together, but it is almost as easy to use a plain sheet of clean glass, placing this carefully on to the strips of film arranged on the paper.

1 Take the strips of film from their sleeves and dust them with an anti-static brush to remove particles.

2 Clean the contact frame with a damp sponge and then with a dry cloth.

3 Identify the emulsion side of the film (the side that has a matt finish towards which the film curls). Fit the negative strips into the glass cover of the frame, emulsion-side down.

4 Position the frame directly under the enlarger head, and raise or lower the head until an even rectangle of light more than covers the area of the frame.

5 Under safelight illumination, place a sheet of normal (Grade 2) paper, emulsion side up, in the printing frame, under the negative strips, and close the glass cover.

6 Make the exposure. The time will depend on your enlarger lamp and density of your negatives, but, as a guide, start with a five-second exposure with the enlarging lens at its widest aperture.

Contact sheet Use the contact sheet to select the best exposure.

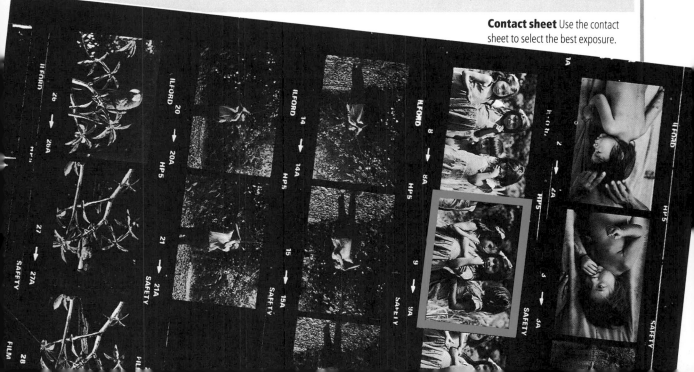

Assessing the black-and-white exposure test A standard series of exposure times, from five to twenty seconds, gives a good indication of what the final exposure should be. From the examination of the negative, the central part of the picture with its range of skin tones is the most important, and the test bands were arranged so that the most likely exposure falls in this area. Twenty-second and fifteen-second exposures are too dark, with obvious loss of detail in shadow areas, while five seconds leaves the highlights white and featureless. The ten-second exposure is nearly right, although perhaps a fraction too dark.

Making a test strip

1 Place the negative in the enlarger's negative carrier (emulsion side down), cleaning off any dust preferably with an anti-static brush or a blower.

2 Insert the carrier in the enlarger head. With the room lights out, the enlarger lamp on and the lens aperture wide open, adjust the enlarger head until the image is focused and to the size you have chosen.

3 Make fine adjustments to the focus until the image is critically sharp. You can do this by eye or by using a focus magnifier which enables you to check the sharpness of the film's grain; irrespective of whether the image is sharp, as long as the grain is focused you will have the sharpest print possible.

4 Close down the lens aperture about two stops (normally this would be f11). With a negative of normal density this will let you use reasonably short exposure times, and the lens performance will be at its peak. The increased depth of field will also compensate for slight focusing errors.

5 Under safelight illumination, and with the enlarger lamp off, insert a sheet of normal (Grade 2) paper, emulsion side up, into the printing frame. Set the timer to five seconds.

6 Hold a piece of black card over the sheet of paper, leaving just a quarter of its width exposed, and give a five-second exposure. Move the card along for second exposure of five seconds. Make third and fourth in the same way. The whole sheet will be exposed for the final exposure. Process as an ordinary print.

Shading and printing in

The negative of this harp player in a Peruvian café (above left) had an exceptionally high contrast range; the only illumination had come from the open doorway. A straight undoctored print would have lost all shadow detail and the highlights would have been washed out. A soft paper grade would have turned the potentially rich blacks into greys. The only solution was to shade and print-in. Paying attention only to the shadow areas, an exposure of 10 seconds at f11 (above centre) leaves most of the print overexposed. Whereas a print made to record just the highlight details – 30 seconds at f11 (above right) – is mostly a featureless black. For the final print (below), the lower right-hand corner was shaded by hand (see below).

1 The lower right-hand corner was shaded by hand for two seconds during exposure.

2 A shading tool was used to shade the two shadowed faces.

3 Cupped hands were used to control the size of the area during printing-in.

Developing black-and-white prints

1 Check that the three chemicals – developer, stop bath and fixer – are in the right order, and that the developer is at 20°C (68°F). Make the exposure.

2 Slide the paper, emulsion side down, into the developer tray. Press it down with the developer tongs so that it is fully immersed.

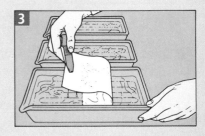

3 Turn the paper over so that the emulsion side is facing up and you can see the developing image.

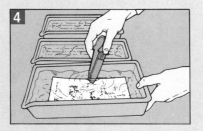

4 Agitate the solution by rocking the tray gently. This ensures that the paper receives even development. Develop for 90 seconds.

5 Lift the paper out of the developer tray with the tongs and allow excess solution to drip off. Transfer the paper to the stop bath, take care not to dip the developer tongs into the stop bath. Rock the tray as during development.

6 After 10 secs, lift the print out of the stop bath and drain. Transfer to the fixer (some mixture of stop bath to the fixer causes no harm) rocking the tray at intervals. After one or two minutes, you can switch on the room lights and examine the print. Leave it in the fixer for at least 10 minutes, but no more than 20 minutes.

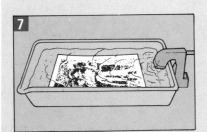

7 Wash the print in running water to remove all traces of the chemicals: washing time varies according to paper manufacturer's recommendations. If the paper is resin-coated, it needs washing for only 4 minutes; paper-based papers need about 15 minutes. Put the print against a smooth flat surface, and wipe off water drops.

Drying the print

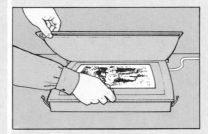

Paper-based prints These should be dried in a heated dryer (a flat-bed machine is normal). Glossy prints can be glazed by being placed face down on the dryer's metal plate. The majority of professional photographers use glossy paper unglazed (ie dried face up).

Resin-coated prints Dry them flat without using a dryer. Air-drying print racks are ideal, as water cannot get trapped underneath the prints.

Kodak Wratten gelatin series, and a UV-absorbing 2B or CP2B filter – can be inserted. More convenient is a dial-in head, which works by moving three filters, corresponding to the subtractive printing colours yellow, magenta and cyan, progressively into the enlarging light as the controls are altered.

As well as a good colour enlarger, a colour analyser may also be useful. This calculates exposure and filtration from the baseboard, and is a valuable aid to accuracy; it should be calibrated for a typical negative and the particular enlarger.

Inevitably, there are batch differences in colour paper, and the eye is very sensitive to such colour variations when they are compared side by side, particularly with neutral and familiar hues. To allow for these inconsistencies, manufacturers label the batch numbers on boxes of paper, and give an indication of the recommended filtration.

Basic printing procedure: The same basic procedure applies to both colour negatives and colour transparencies. The difference is that in printing from a transparency, filtration and changes in exposure are the opposite to those for negatives. Thus, with a transparency, adding a filter of one colour increases the same colour in the print, while increasing the light gives a lighter image. The print edges concealed under the easel frame will be black, rather than white as in a print from a negative.

Two tests are normal before attempting a final print, and for these it is more economical to use a strip cut from a sheet rather than an entire sheet. The first test is for the exposure; at this stage the filtration is estimated. The second test, once the aperture and exposure time are known, is for the filtration alone. Sometimes, with luck, the first test is sufficient; at other times, more may be needed.

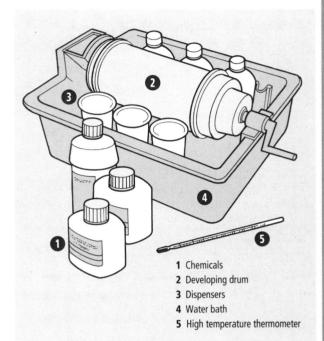

1 Chemicals
2 Developing drum
3 Dispensers
4 Water bath
5 High temperature thermometer

Because colour paper should be handled in near or total darkness, it is advisable to use a light-tight drum for paper processing, rather like a film developing drum. This also reduces the likelihood of mixing different chemicals, improves control over temperatures and agitation, and requires less chemicals than trays. Paper processing drums can be hand or motor-driven, and some float in their own water bath, which helps to maintain solution temperatures. Rubber gloves are essential when handling colour chemicals.

Making an exposure test in colour

A colour exposure test is made in much the same way as a black-and-white test (see page 110). The text provides the basis for the next stage in the procedure – assessing and adjusting filtration (see page 114). When assessing the exposure test, look at it as a black-and-white print, ignoring colour and concentrating on tone and detail.

1 Set the filtration to an estimated combination. Then insert the filtration negative into the enlarger and compose and focus the image on the baseboard.

2 In total darkness, insert a piece of printing paper large enough to include a representative section of the image. Using a black card as a mask, make a series of increasing exposures.

Making a filtration test

Use the exposure test as a . basis for estimating the likely filtration. Accurate estimation at this stage comes with experience, but at the start you may find it easier to try a few different filtrations. Do not make the changes too great, and remember to compensate in exposure for filtration changes. Make three or four separate exposures with different likely filter combinations.

Red bias

Assessing the filtration test After processing and drying, judge the prints in good light, preferably natural. The small prints (right) show definite bias towards a primary colour (red , green and yellow) but the large print appears correctly balanced. A final perfect print can now be made with this filter combination. Remember that with colour negatives, a colour bias in the print is corrected by increasing the filter strength of that colour. In other words, if a test print appears too yellow, you must add yellow (or subtract blue) (see table).

Filter variations The strips of different colour filtrations (far right) show the effect of using varying strengths of the primary filters – blue, green and red – and the comple-mentary filters – yellow, magenta and cyan (bottom row). In each case, the departure point is the correctly filtered normal print. At the beginning, you may find it helpful to prepare a similar strip from a standard negative; by referring to it when making new prints, assessing filtration can be made easier.

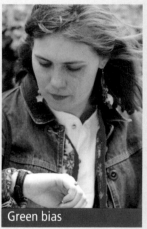

Green bias

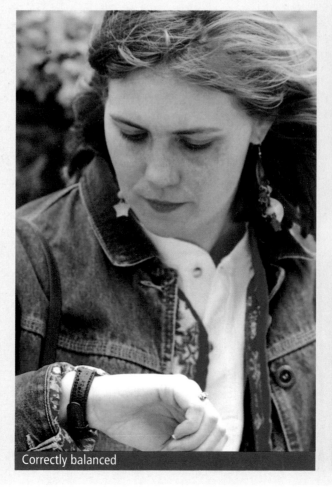

Correctly balanced

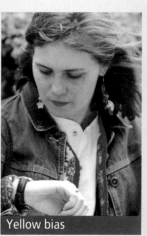

Yellow bias

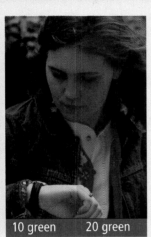
| 10 blue | 20 blue | 10 green | 20 green |

| 10 red | 20 red | 10 yellow | 20 yellow |

| 10 magenta | 20 magenta | 10 cyan | 20 cyan |

Keeping filters to a minimum

Every filtration should be of no more than two of the filter colours. A third colour cancels out some of the other two by creating neutral density, and results in longer exposure times. It can be eliminated in every case by simply subtracting the lowest filter value from the total filtration. For example, a filtration of 55Y+50M+10C uses all three filter colours, creating neutral density. Subtracting the lowest filter value – 10 – throughout gives a filtration of 45Y+40M that will give the same colour in the print with a shorter exposure time.

Because the negative, with its reversed colours and orange cast, gives no visual indication of the original colours, fine-tuning the filtration relies on the photographer's memory and preferences. For any photography that demands absolute colour accuracy, such as copying a painting, it is important to include in the image a standard colour strip, such as a Kodak Colour Separation Guide. The actual strip can then be compared in the darkroom with the printed image. Normally, however, within broad limits of "acceptable" results, two people may well produce different prints from the same negative. Experience allows photographers to refine their assessment to a point where the initial tests are already very close to what is wanted as a final print.

Areas of subtle colour, such as skin tones, and areas of white or grey most readily betray any colour bias in a test

Filter factors

This table shows filter factors from which you can calculate your new exposure to allow for filter changes – divide your original time by the factor(s) for the filter(s) you have removed. Then multiply the result by the factor(s) for each filter you have added and round off your result to the nearest second.

Filter	Factor	Filter	Factor	Filter	Factor
05Y	1.1	05M	1.2	05C	1.1
10Y	1.1	10M	1.3	10C	1.2
20Y	1.1	20M	1.5	20C	1.3
30Y	1.1	30M	1.7	30C	1.4
40Y	1.1	40M	1.9	40C	1.5
50Y	1.1	50M	2.1	50C	1.6
05R	1.2	05G	1.1	05B	1.1
10R	1.3	10G	1.2	10B	1.3
20R	1.5	20G	1.3	20B	1.6
30R	1.7	30G	1.4	30B	2.0
40R	1.9	40G	1.5	40B	2.4
50R	2.2	50G	1.7	50B	2.9

Developing colour prints

1 In total darkness, insert the exposed print into the developing drum, emulsion side inwards. Replace the drum lid and turn on normal lighting.

3 Check the temperature of the developer, and when it is correct, pour it into the drum. Start the timer and agitate the solution by revolving the drum. About 15 seconds before the end of each stage, begin to drain the drum. Return the drum to the bath and repeat the same routine with the next solution.

2 Wearing rubber gloves, pour out all solutions into the dispensers. Place these, with the drum, in a water bath and add hot or cold water to the bath until the solutions are within the recommended temperature.

4 Remove the print from the drum (having taken off the gloves), and wash it thoroughly for the recommended time. Finally add the stabilizer. Air-dry the print, as for black-and-white resin-coated paper, preferably on an air-drying rack.

print. These are the first parts of a print to examine, and a negative with these hues and tones makes the best standard test negative. The cardinal rule for controlling print colour from a negative is that in order to remove a colour cast, add the same colour to the filtration. Because the filters work subtractively, adding a yellow filter reduces yellow in the print. In order to help assess colour casts, a useful first step in setting up a darkroom for colour printing is to take a standard negative (of the type just described), and print it with all six filter colours.

The strength of the filtration has an effect on the exposure time, as does the degree of enlargement.

Raising the enlarger head, for example, reduces the light reaching the print, and so requires more exposure.

Selective exposure: A straight print, in which an unmanipulated exposure is given, is rarely the best that can be achieved. The original image itself may have unsatisfactory contrast – between land and sky or between sun and shadow – or have an unwanted colour cast, such as from tungsten lighting on daylight film. In addition, if the print is being made from a slide, reversal and Cibachrome processes tend to heighten contrast. More than this, however, is the opportunity for fine-tuning the

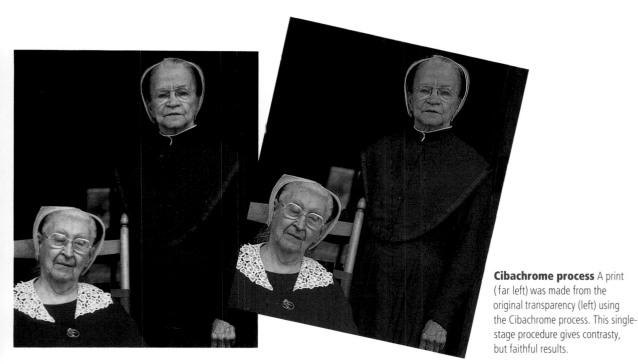

Cibachrome process A print
(far left) was made from the
original transparency (left) using
the Cibachrome process. This single-
stage procedure gives contrasty,
but faithful results.

image, and being able to make tonal and colour alterations with time to reflect. Shading and printing-in techniques described on p. 107, can be used to make exposure adjustments to the final colour print. This may be no more complicated than darkening a pale sky, or it may involve a sophisticated pattern of exposure covering several parts of an image.

When printing from a colour negative, shading creates a lighter area, while printing-in darkens. Printing from a transparency, however, reverses these effects.

From the test print, a rough plan can be made of the shading and printing-in needed for the final print. If both are required, it is usual to start with the base exposure, shading an area during this. The printing-in can then be done with one or more additional exposures. Note the shading and printing-in given on the back of the print, lightly and in pencil near the edge. A development

of this print manipulation, although not common, is to change the filtration for some of the printed-in areas.

Processing the colour negative print: Although a series of trays can be used for processing colour prints, it is much easier to maintain the correct temperature and agitation with a print-processing drum. The most convenient of all equipment is a print drum supplied with its own heated bath and automated agitation.

First prepare sufficient quantities of the solutions according to the instructions, and place them, in containers, in a warm water-bath several degrees higher than the processing temperature. This is usually 32.8°C (91°F), with a latitude of 0.3°C (0.5°F). When the solutions have reached the correct temperature, begin printing.

In darkness, load the exposed paper in the drum. Then add the first solution, agitate as recommended, and then pour it out. As in film processing, allow about 10 to 15 seconds at the end of each stage to allow the drum to drain. Then pour in the next solution. All the chemicals, once used, should be thrown away.

Processing the colour transparency print: In most respects, the procedure is the same as for processing prints made from negatives, although the steps themselves are different. There are two types of process: reversal, which as its name implies, uses the same principle as in processing colour transparency film to produce a positive image, and Cibachrome. For reversal processing, the temperature is rather higher than the standard Ekta print process described as above: 37.8°C (100°F), with a latitude of 0.3°C (0.5°F). The processed print has a bluish cast when wet, but this disappears as it dries. The Cibachrome process is shorter, and the image dyes, which are already present in the unexposed paper, are very well saturated and resistant to fading. Cibachrome chemicals in particular, and all colour processing chemicals in general, are harmful to skin, making it essential to use rubber gloves when handling them.

Differences between reversal and negative/positive colour printing

Exposure correction

	Reversal	Neg/Positive
More exposure	final print lighter	final print darker
Less exposure	final print darker	final print lighter
Printing-in	area is made lighter	area is made darker
Shading or dodging	area is made darker	area is made lighter
Covered edges	gives black borders	gives white borders

Correcting colour casts

	Reversal	Neg/Positive
Print too yellow	reduce yellow filters	add yellow filters
Print too magenta	reduce magenta filters	add magenta filters
Print too cyan	reduce cyan filters	add cyan filters
Print too blue	reduce magenta and cyan	reduce yellow filters
Print too green	reduce yellow and cyan	reduce magenta filters
Print too red	reduce yellow and magenta	reduce cyan filters

2 Applications

The techniques described in the first section of this book form a substantial body of skills. The 35mm camera, with a choice of focal length and a bank of electronically controlled options, offers a wide array of possible images, given the ability of the photographer to put them to work. Ultimately, however, the techniques of photography have to be applied to concrete subjects.

The 35mm camera was invented for portability and rapid picture-taking and is at its best when used simply and naturally – to capture scenes from real life and the environment. In this section of the book, we change the focus from camera equipment and materials to the subjects. The enormous versatility of 35mm cameras – more now than ever before – means that this section embraces almost everything that can be visualized. There is hardly any subject that we can see that cannot be photographed, however dark, distant or small. With the help of computers and scanners, the range of subjects even extends to views that spring purely from the photographer's imagination.

This section begins with the field most closely identified with the 35mm camera: reportage. This is closely followed by portraits, both in and out of the studio, and fashion. From people, we then move on to the environment – landscapes and wildlife in particular. After action photography, the last applications covered are the ones over which the photographer has more control: architecture and still life.

Vietnamese girls in traditional dress, Saigon
Reportage is one of the fields in which 35mm photography excels. Precise but instantaneous framing like this is the hallmark of a telephoto lens used with an SLR.

Reportage

- **Different approaches**
- **Shooting unobtrusively**
- **Picture essays and assignments**
- **News photography**

If any area of photography can lay prior claim to the 35mm camera, it is the rich and diverse field of reportage. The progenitor of all 35mm cameras was the Leica, invented in 1925 by a German, Oskar Barnack, as a means of using the recently developed, sprocketed motion-picture film stock. Press cameras of the time took sheet film, were bulky, and encouraged a one-shot approach to news events with little possibility of being discreet. The Leica changed all that. By comparison with its predecessors it was truly a miniature camera. It could be used quickly and quietly, and a full load of film enabled its users to continue shooting.

The appearance of the Leica, and the other 35mm cameras that followed, coincided with the appearance of

Children's fancy dress competition, London Special events, when people willingly put themselves on display and are easily approachable, nearly always offer good opportunities for reportage shooting. The expressions of two children dressed as characters from *Alice in Wonderland* (left) are the focus.

Brooms, lap Lae, Thailand While a controlled shot was being set up in another part of an outdoor broom factory, this girl (right) walked quickly behind the camera. There was barely enough time for even one exposure and the manually focused 105mm lens at almost full aperture left no margin for error. The naturalness of movement and expression would have been impossible to arrange, and are characteristic of true reportage photography.
105mm lens, Kodachrome ISO 64, 1/125 sec., f2

Alfried Krupp The portrait of the German industrialist Alfried Krupp made by Arnold Newman in 1963 was deliberately lit for a menacing effect, using two undiffused lights from behind and on each side.

Man and bull Reportage is largely concerned with events, and, in particular, special moments. Timing is clearly very much of the essence in this photograph, taken at a village fair in Colombia in which members of the public allow bulls to chase them. On occasion, the bulls are faster.
180mm lens, Ektachrome ISO 400, ½₅₀ sec. f8.

a new type of magazine, first in Europe and a little later in the United States. *The Munchner Illustrierte Presse*, *Picture Post* and *Life* were current events picture magazines built around the use of photographs. Their policies were to take the reader beyond the immediate news already covered by daily newspapers and, as the 1936 *Life* manifesto began: "To see Life; to see the world; to eyewitness great events; to watch the faces of the poor and the gestures of the proud...". The new 35mm photography helped to shape these magazines, and they in turn encouraged an inquisitive, in-depth style of reporting photography. The French term for this, now absorbed into English, was *reportage*. Photo-journalism is another description, although not quite as broad in its scope as this field of photography really encompasses.

Ceremonial guard, Sofia The picturesque has a part in reportage, and particularly in travel photography, where the camera is often used to show subject matter that is slightly more exotic than commonplace. The uniforms of these Bulgarian soldiers dominate this tightly cropped – and so telephoto – shot.
180mm lens, Kodachrome ISO 64, ¹⁄₁₂₅ sec. f11.

Subject matter

At the heart of reportage photography lies an interest in people. Individuals may be subjects because of some uncommon interest – they may be famous or unusual personalities – or for precisely the opposite reason – they may be typical of a quality that the photographer wants to convey. The important social dynamics that are the subject of reportage photography are the interactions between people and their community, their environment and other individuals.

In the frozen instant of a still photograph, the shifting currents of interpersonal relationships are ideally captured. By means of composition and juxtaposition, the camera is also perfectly suited to showing the relationship between us and our environment, the extent to which we control it as well as the ways in which we are influenced by it. The image of, say, an individual dwarfed by a giant construction project, can show at the same time both our ability to shape our environment at will, and the amount by which it can come to dominate our lives.

Curiosity in people's actions and activities, both individual and in social groups, underpin good reportage photography. This clearly borrows some of the skills of journalism, but is by no means necessarily the same as news photography (reporting current events at great speed). In fact, the logistical problems of meeting urgent deadlines tend to preclude in-depth picture coverage. Some of the strongest single photographs have certainly been hard news pictures, but one of the most highly

developed forms – the picture essay – is principally a product of the less urgent format of feature journalism.

Style and interpretation

The actions and juxtapositions of people are at the core of most reportage images. How they are chosen, and then framed, largely determines the style of the photography. One of the key elements in reportage photography is timing; the most influential photographer in this field, Henri Cartier-Bresson, coined the phrase "the decisive moment" to describe the precise point in time at which a photograph captures the essence of an action. The still photograph inevitably freezes action, and the captured momentary image can either sum up the complete flow of events, or show an unusual instant that the eye might otherwise not catch. Cartier-Bresson himself practised this with extraordinary skill, often having to react very quickly to catch fleeting gestures and composition. The modern automatic camera makes this much easier.

Implicit in the idea of the decisive moment is the argument that for any potential picture situation there is a notional best moment at which all the elements mesh. This concept has influenced generations of photogra-

Coconut farmers. Indonesia The smoke from this rural copra business on the Indonesian island of Flores made a visually attractive setting, but it was the exact timing that provided the opportunity for interest and movement. The continuous sequence of actions as the men worked gave a choice of gesture – this frame had the most fluidity.
20mm lens, Kodachrome ISO 64, 1/125 sec. f5.6.

Men at work Precisely because work continues independently of the photographer, there is usually time and opportunity to explore – and to find images that are graphically interesting. The top picture, of Greek shipyard workers, derives its appeal from the high camera angle and the splattered colours that merge the men with the setting. In the lower picture, the back-lighting of a late afternoon sun creates the striking silhouette of a man scraping a buffalo hide in Java.
Both 180mm lens, Kodachrome ISO 64, metered settings.

phers, but it has inevitably encouraged a reaction among others. Opposing the decisive moment is the type of image that deliberately avoids instants of importance, stressing instead the typical and the ordinary. In the scheme of reportage, this is equally valid, although less likely to be as eye-catching or dramatic.

Reportage photography, therefore, is as open to differences in style as any other field of photography. Other stylistic variations come from the focal length of lens that is normally used. The ways in which focal length influences working method and composition, and how long and short focal lengths each impart their own character have already been described (see Lenses). Longer lenses, such as 135mm and 180mm, tend to give a more distant, across-the-street look to images, while wide-angle lenses tend to draw the photographer – and so the viewer – into the thick of things.

Interpretation is yet another variable in reportage, and the degree of comment, social or otherwise, that a photographer chooses to put into a picture varies widely. Some subjects, such as poverty and other obvious social ills, clearly invite more comment than others. One of the most powerful tools for comments is juxtaposition – rich against poor in the same picture, for example. Nevertheless, despite the admirable tradition of "concerned photographer" that has attended reportage photography since its beginnings, the photographer is not necessarily committed to making a social statement in every picture. What remains a constant thread running

Close candid shooting Even though the photographer is right next to the subject (left), the man eating a snack in a Soho Street in London, remains unaware. The photographer here uses a medium wide-angle lens and by aiming off appears to be photographing the alleyway beyond.

though good reportage photography is the ability to make the viewer aware of something more than just the visual components of the scene.

The unobtrusive camera

One of the purest forms of reportage is photography in which the camera only observes, but does not intrude on its subjects and has no influence on their behaviour. The only way of completely guaranteeing this is to shoot without being seen, and the rewards are spontaneity and naturalness. One of the principal difficulties for most pho-

tographers in doing this for the first time is simply the embarrassment of intruding in other people's lives, with the possibility of confrontation. This is an entirely natural reaction, and although one eventually tends to become inured to it, this sensitivity is arguably better than a completely thick skin.

There are a number of techniques for using the camera without being seen, but in principle the photographer does everything to blend into the situation and to seem not to be a professional photographer.

Some locations are noticeably easier than others for unobtrusive photography. Where people's attentions are occupied with other things, such as a market or fairground, there is more freedom to shoot unobserved; moreover, if there is something of obvious spectator interest, as in a museum, cameras are expected. Street photography, on the other hand, demands faster reactions from the photographer, and more subtlety in pointing the camera. Anything that makes the photographer obvious, such as a large new camera case or an emblazoned carrying-strap, works against this. Specific problem locations include politically charged events, people in dispute, and certain societies – Muslim communities in particular – that object in principle. In some other communities, notably parts of India, the risk attached to being discovered using a camera is to be surrounded by an instant crowd, each member of which wants to be in the picture.

Highly automated cameras have a clear advantage in this kind of reportage photography. If both the exposure and focus are automatic, the photographer can concen-

Candid photography tips

- Working at a distance with a longer lens reduces the chances of not being noticed, but even a wide-angle lens can be used unobtrusively from a short distance away, provided that the photographer works very quickly.
- Avoid pointing the camera in anticipation – sooner or later the subject will notice. Instead, wait for the right moment and then raise the camera and shoot immediately.
- Because a wide-angle lens takes in such a large angle of view, it is possible to use it very close to a subject by aiming it slightly away – most people assume that a camera records only what is directly in front of it.
- Some cameras allow the prism head to be removed. This enables you to focus directly on the ground-glass screen without holding the camera to your eye. As you are looking down at the ground-glass screen, rather than at the subject, they are less likely to notice you.

trate exclusively on timing and composition, and the camera needs to be raised to the eye only for a second or so. The alternative, with a less-automated camera such as the Leica, is complete familiarity through practise and regular use.

Events

One of the most approachable and picture-rich situations is a public (but not political) event. This catch-all term includes all those situations where people get together to take part in ceremonies, celebrations and parades, whether it be St Patrick's Day in New York, the Bun Festival in Hong Kong, or the Lord Mayor's Show in London. On occasions like these, people are actually putting themselves on display, and the photographer has a free hand. They may not be typical of everyday life, but they nearly always provide good visual material, and they are invaluable for building confidence.

These events are usually well publicized, but planning ahead is the key to success. There are two kinds of preparation to make in advance: to find out exactly what

Parade, Siena In a parade or procession a wide-angle lens can be used to pull the viewer into the event and give a sense of immediacy – provided that you shoot from close to the subject. At this parade in front of Siena's cathedral, preceding the annual Palio, costumed participants toss banners in the air. To catch both banner and surroundings, the shooting angle was very low – almost on the ground. Timing and positioning are crucial in this kind of shot.

The Palio, Siena: the race

Twice each summer, the Tuscan city of Siena stages an event that still retains all the importance of its medieval origins. The focus is a no-holds-barred, bare-back horse-race around Siena's principal piazza (above), but underlying this is the complex flux of rivalries between the *Contrade*, or wards into which the city is divided. What would elsewhere have degenerated into a tourist spectacle is here virtually reserved for the Siennese (balcony seats in the sealed-off piazza are both costly and perennially sold out).

is going to happen and at what time, and to find the best locations for shooting. Events have organizers, and they can answer these kinds of question. An early visit to the place will give you an idea of what to expect. A view from a height – a balcony along the route of a procession, for instance – will give an overall shot, but is of little use for interesting details and close-ups, and can limit the variety of pictures. In front of the crowds, where press photographers are often found, is often an ideal position, and may not be too difficult to reach, with perseverance. Nevertheless, although it may be tempting to follow the local press photographers in order to find the best site, their aims are generally news-directed.

Some of the most rewarding picture possibilities are the ones that a news photographer might ignore – behind-the-scenes preparations and the unselfconscious expressions of spectators. Off-duty participants can be a rich source of interest, whether they are photographed candidly or posed. With the event under way, spectators are easy to photograph, and often display a variety of

unposed, natural expressions – rapture, boredom or excitement.

People at work

Work is one of the basic human activities, and a prime area for reportage photography. Most people, when working, are too preoccupied with the job in hand to pose for the camera or be distracted by it. They tend to be less self-conscious about their working lives than they might be during more private moments, making it easier to capture natural expressions and gestures. The exercise of a skill can itself show much of a person's character, and the location may also make it possible to show a relationship with the surroundings and the society.

The working environment can be used as a convenient place for shooting unobserved or, with the subject's cooperation, it can be the source of an in-depth photographic coverage. Many jobs are highly specific to a place or a

The Palio, Siena: the festivities Surrounding the race, which lasts barely two minutes, are other events: a parade (above and right), blessing the horses, *contrada* dinner (left), and so on. Photographic coverage, which first required the organization of permissions and viewpoints a few weeks in advance, needed to address the variety and fervour of the Palio.

particular type of community, and can be interesting simply because they are unusual. Most of us are fascinated by what other people do, and few activities are clearer than work and the way in which people do it. It is rarely enigmatic, but it can be revealing.

People and the environment

The scope of reportage photography goes beyond a close view of people and their activities. It includes the relationship between people and their environment; the way they use it, assimilate themselves into it, or ignore it. There is the relationship with the natural landscape, a matter of increasing concern. There are also the special environments that society creates for itself. Villages, towns and cities reflect the way in which different human societies function. The modern urban industrial landscape is the most intensely developed form. Sometimes this landscape is deliberately planned as a purpose-built habitat to suit a particular human activity or style of life; more often than not, however, it has simply evolved.

In one sense, cityscapes can be treated in a manner similar to landscapes (see Landscapes), but the human element makes a substantial difference. The graphic possibilities are normally abundant, but these elements can also be used to describe or comment on the way people live. An industrial town might seem ugly and depressing, but another photographer might focus on its productivity – a place where things are being created.

Urban environments are always a rich source of detail. Stay alert to the possibilities of close-ups, for example; signs, symbols and graffiti. They can be representative or idiosyncratic, and may offer the opportunity to make an oblique comment through highlighting one small detail.

The picture essay

The nature of reportage photography usually requires more time, work and images than a single-shot approach. An hour or so of street photography usually offers a variety of picture possibilities, while a complex subject, such as the life of a city or a section of society, demands the kind of coverage that only a set of images can provide. The picture essay, or picture story, is the format established since the 1930s for using a series of pictures to cover a subject in depth.

While the step from a single picture to a series might seem simple enough, the picture essay is conceptually different, and in professional practice, such as for a feature magazine, its execution normally begins with a picture script. Understandably, a picture essay calls for planning and management. Although the picture has professional origins, and is the mainstay of magazine photography, it translates very easily into self-assigned, non-professional photography.

The City of London

A picture essay should attempt to present, if not the totality of its subject, then at least a coherent view of it that covers most of the basics. Typically, picture essays deal with subjects that are relatively large – in what they contain or in what happens in them. The theme here is the workings of the City of London, at the same time one of the world's principal financial centres and a place with a long history and continuing traditions. The total photographic coverage spread over more than a year in short visits, produced more than 100 selected images, of which these are only a small sample. The way in which a picture essay is presented – the layout – makes an important contribution, but is unfortunately impractical to produce in this limited space.

Picture essay – Wildlife hospital

These photographs were culled from a larger selection shot as a picture story for a wildlife magazine. The story is about the day-to-day running of a small, independent animal hospital set up in Buckinghamshire, England, to cope with the accidents and illnesses suffered by local wildlife attempting to survive in an increasingly developed countryside. Injuries to animals involved in road and rail accidents and that have been abandoned and trapped form the basis of the hospital's activities. The story is an example of a small, tightly-focused magazine feature. Given that no more than about eight photographs would be used by the magazine on this kind of story, it was important to show both variety (of image and situation) and action. Hence these four pictures cover the range from regular schedules (feeding and inspection) to emergency call-outs.

Emergency call-out Rail staff had reported a muntjac deer struck by a passing express in a railway cutting. The ambulance crew use stretcher and blindfold to take the injured animal back to the hospital (above).

Constant monitoring A veterinary nurse checks the cards in the hospital's intensive care unit for hedgehogs (left).

Focusing on detail Feeding an abandoned baby hedgehog with a syringe (above).

On the operating table A badger with a broken pelvis as a result of a car accident is prepared for surgery (left).

The assignment

Another professional reportage concept is the photographic assignment, but again, it is entirely relevant to photography for personal interest. The essential element in either case is that the reportage has a firm direction and meets a deadline. Professionally at least, an assignment entails an obligation to deliver images to a certain standard, and can involve all kinds of work and negotiations that have little to do with actual shooting. Logistics, which in photography embrace everything needed to put the photographer and cameras in front of the subject, play an especially important role. More often than not, the skill of being in the right place at the right time is the paramount quality.

News journalism

A highly specific, and frankly professional, kind of reportage concentrates on news events, from political photo-opportunities to natural disasters and wars.

Images from extreme conditions, particularly violent and suffering, can be extremely powerful in their emotional content, and can be shocking. An important issue is whether, in magazines and newspapers, they produce

Return to the Killing Fields

An assignment for the *Sunday Times Magazine* in London, this emotional story featured the first return to Cambodia after the Pol Pot years of Dith Pran, whose story was the subject of the film *The Killing Fields*, and Haing Ngor, the academy-award-winning actor who played his part, and who himself suffered during the Khmer Rouge four-year regime of terror. The coverage took five days, from arrival at the capital's airport (left) to a Buddhist ceremony (below left) honouring Dith Pran's parents, who had died, and the gruesome discovery of a neglected pile of skulls and bones exhumed from a provincial killing field (below). For the photography, it was essential, as in any similar assignment, to be on hand all the time, and to anticipate reactions.

the indignation that they should (and are usually intended to), or whether constant repetition merely anaesthetizes the public's senses. It can also be argued that such images are in a way pornographic, and certainly there is the suspicion that some publications use such photographs not to enlighten their readership, but rather as a form of sensationalism to increase circulation.

In these situations there have always been some photographers who have been able to go beyond the immediacy of the event and its simple news value to a publication, and have used the circumstances to make something more personal and committed.

The photo opportunity

In an impromptu type of photo opportunity, there is less time for the photographer to find the best position and to react sufficiently quickly. In this now famous photograph of President Bush addressing American troops in the 1991 Gulf War, the gesture is clearly intended to appear heroic,

and this photographer does it full justice by a combination of timing, camera position, and an intelligent choice of lens that is not so tightly framed on Bush that his audience is excluded. From here, side-on, the President raises his arm not only to the troops, but also to the sun.

The violent event A failed attempt to assassinate President Pinochet in 1984 brought some 100,000 Chileans onto the streets of the capital Santiago in demonstration. Only marginally protected by being on this side of the police line, the photographer catches the movement and the depth of political feeling in one frame that carries at least five individual scenes within the picture (left). In a situation like this, it is normal to shoot continuously because of the unpredictable action; the most successful images will be selected in later editing.

The extremes of emotion An Albanian family mourn the death of a young man killed by police in Yugoslavia's southern province of Kosovo during ethnic riots in 1990 (below). At moments like these, the photographer is rarely a welcome guest, and must exercise tact and sensitivity. Disturbingly, much of the power of this picture rests in the almost classical composition and lighting: the inevitable painterly comparisons jar with the distressing actuality.

Portraits

- Using light
- Portraits on location
- Children and groups
- In the studio

ortraiture differs from reportage in that its images are deliberate and considered, and are made with the cooperation of the subject. There is also a wider range of settings: portraits can be made on location – even with exactly the same kind of street or other outdoor backdrop as a reportage image – or indoors, or very commonly in the photographer's studio. The amount of control that the photographer chooses to exercise varies accordingly, from a casual picture that has all the appearance of a snapshot, to a formal, carefully lit studio portrait in which the sitter poses as directed.

Portraits are the single largest use of cameras and film. Indeed, the original success of photography was launched on the portrait, which was the principal use of the daguerrotype, invented in 1839. The later, cheaper tintype introduced during the 1850s was also used primarily for this. The arrival of the Kodak box camera in 1888 made photography available to everyone, and more than anything, the public wanted it for the weekend and holiday portrait of themselves, their families and friends. Whether taking this kind of casual shot, or a more professional pre-arranged session, 35mm portraiture is the heir to one of photography's oldest uses.

Lighting the face

As the ideal in most portraiture is to reveal something of the character of the person being photographed, the majority of portrait shots are framed close in to the face. Even with a full-figure shot, the face remains a key focus of attention, and for this reason one of the crucial skills is lighting. There are as many styles of lighting as there are portrait photographers, although it is in the studio where real control can be exercised. The first consideration for lighting is the shape and structure of the face itself. Quite apart from any stylistic element that a photographer may want to introduce, there are certain basics for showing the face and its expression clearly – and attractively.

Eyes usually carry most of the expression, and benefit from a lighting angle that does not throw them into shadow. For this reason, be careful with a directional overhead light source, particularly if the subject has a strong brow. Reflections in the eye are known as catch-lights, and can do much to enliven an expression; the main light, if sufficiently frontal, can provide these, as can a small secondary light or reflector.

Natural lighting: Outdoors, the variations in weather and natural light are beyond the control of the photographer, but the location can be chosen to take advantage of naturally occurring reflections and shade. A high, bright sun normally gives a harsh effect similar to undiffused top-lighting and is usually not the best choice. An added difficulty is that it encourages people to narrow their

Studio lighting set-up

If several lights are used, only one should be dominant. The normal practice is to set up the main light first, and then add the others to perform their particular functions. One light, for instance, may be used for shadow-fill, another to illuminate the background separately, another to highlight the hair from high and behind, and another to provide the catch-light in the eyes.

eyes. On bright days, the alternatives are to shoot when the sun is low, or to use open shade. Reflectors, and in particular flexible circular reflectors that fold up neatly, can be used to redirect sunlight into a shaded area. Equally, on-camera flash can be used to fill shadows, and this can work well if the subject is back-lit by the sun. Soft daylight with a weak sun is generally much easier to use, if a portrait can be timed to suit the weather.

Lighting styles: With photographic lighting, either taken out on location or in the studio, there is clearly more choice in the final effect. Lighting styles for portraiture go through fashions. One of the most famous of all portrait photographers is the Canadian, Yousuf Karsh, who specialized in photographing the great and the famous, and who developed a lighting style to suit – typically dramatic, with strong side-lighting against a black background. He worked exclusively with photographic lighting, normally on location. "Tungsten light", he said, "gave me freedom of movement". He considered light the most important quality in a portrait: "You must have the skill, the sensitivity, to know how to apply it to the human face".

One extreme of lighting technique was reached in Hollywood publicity glamour photography in the 1930s and 1940s, with the use of a large number of carefully positioned, masked and shaded spotlights. Some were used to accent certain areas of the face, others filled in

William Boyd This shot for *Vanity Fair* magazine was taken at the London home of this English author. The soft lighting was created from a single spot bounced off a wall behind the photographer.

138

Marlene Dietrich A particular style of portrait lighting evolved during the 1930s to glamorise Hollywood's movie stars. In this photograph of Marlene Dietrich, taken on the set of the 1936 movie, *The Garden of Allah*, the judicious use of spotlighting from several sources gives not only a balance of illumination, but also a bright glow, charged with romanticism. The back spot in particular contributes a halo-like fringe to the hair. The deliberately limited focus, which fixes attention on the eyes and mouth, also plays a role in the lighting effect, giving an unfocused diffusion to the many highlights.

shadow areas precisely, and the effect was quite glittering, but time-consuming.

In contrast is the technique in which a single light, diffused with an umbrella, is used in a three-quarter frontal position. The effect is efficient and quick to set up, if a little plain; it evolved with the introduction of studio flash units powerful enough to light a person with a single lamp. Its disadvantage is that its very simplicity draws no attention to the lighting technique, so that in theory at least the sitter's expression comes across without distraction.

Direct frontal illumination: Such as that given by a ring-flash, results in completely shadowless lighting (and some-

times also the "red-eye" effect caused by reflections off the retina). This style enjoyed a vogue in fashion photography, combined with strong make-up to overcome the lack of modelling. The soft illumination from a northlight is another technique, and can be reproduced by bouncing photographic lights off large white surfaces, such as the ceiling and walls of a studio, or off free-standing flats.

Studio lighting: The choice of type of studio lighting runs from natural daylight to studio flash and tungsten. Daylight through a north-facing window (a northlight, in other words), has attractive qualities, being slightly directional to give modelling, but soft enough to keep

Harry Connick, Jnr The background for this studio shot for *Sky Magazine* was grey paper. No lighting other than the natural soft side/top light from a window in the studio was needed.

facial shadows gentle. Because the colour balance varies with the weather and time of day, it is easier to use with black-and-white film than with colour.

Studio flash is in some ways easier than tungsten, as it allows the subject to move freely with no risk of motion blur. Modelling lights are standard in mains-powered flash heads, so that if the studio is darkened, the effect can be judged precisely while shooting. Umbrellas, used as both reflectors and diffusers, are the best all-round light sources, and a selection of types is useful, from translucent to silvered, white or gold. The umbrella can usually be adjusted in relation to the flash tube; moving it further away diffuses the light more. Tungsten lighting creates some build-up of heat, which can be uncomfort-able in a small studio, but has its usual advantage of showing the exact lighting effect and intensity.

Studio portraits

Control over lighting is the most significant feature of studio portraiture. Beyond this, however, composition and pose give scope for a distinctive image. The closer the framing on the face, the more predictable the compo-sition; pulling back gives more freedom.

At one extreme is the close-up that crops into the face. Its degree of intimacy can be striking, although it neces-sarily shows up every facial detail, and this may not suit a portrait that aims to flatter the sitter. The most common type of framing is a head-and-shoulders shot, and for

John Piper For this studio portrait of British painter John Piper, the photographer used a dramatic low-key lighting set-up of the type popularized over many years by Karsh. The key light to the left and in front of the camera provides the basic illumination. This strong and undiffused light gives maximum definition to the subject's textured skin and prominent eyebrows. A weaker diffused light at right fills in the shadows.
Canon, 80-200mm, Kodak T. Max 100

Natural poses Halfway between portraiture and reportage, this photograph of a woman with her dog taken in Paris, France, has an evident spontaneous quality. This comes not only from the timing – at a moment when the subject's concern is her pet rather than the photograph being taken of her – but from the unconventional use of an extreme wide-angle lens and a fast film printed to reveal its gritty texture.
Canon, 20mm, Kodak TRI-X, ISO 800

this, the background simply needs to be unobtrusive – a plain black or white is often the most effective. Pulling back to show all or most of the figure involves more thought for both the setting and props. The most basic props here are furniture for the subject such as chair, stool, table or desk.

The choice of lens depends on the scale of the shot, but a basic consideration is that the perspective compression from a longer focus lens gives the most flattering proportions to a face. Used close, even a normal lens exaggerates the nose and front of the face. This in itself does not invalidate a shorter focal length, but it is important to anticipate the effect. In practice, lenses of between 100mm and 150mm are popular in studios, as they give a good compromise between flattering perspective and a convenient working distance. A much longer lens needs a longer studio space, and has the additional disadvantage that the photographer is far from the subject, which makes control and conversation more difficult.

Portraits on location

Despite the lack of control over elements such as lighting, one of the advantages of photographing people where they live or work, in surroundings that they know, is that it tends to put them at their ease. This in turn makes a naturalistic approach possible, which can show something of the everyday behaviour and environment of the subject. Any portrait is raised from being a simple

The unexpected angle With no attempt at a comfortable, natural portrait, the photographer has here used a variety of techniques to construct an aggressive and graphic image. Taken in New York around the reservoir in Central Park, the jogger was having a stretch after running around the perimeter of the lake. Low camera angle, extreme wide-angle lens, geometric precise composition and the use of unflatteringly high direct sunlight all combine to make an unusually striking portrait.
Canon, 20mm, Kodak TRI-X, ISO 800

Photographing the photographers Organizing more than 50 photographers who had arrived from all over the world to shoot a week in the life of Malaysians was in itself a challenge. Viewpoint and lighting were decided following a reconnaissance the previous day (early morning in a city park from a slope opposite). Arranging the group so that all the faces were visible took about 20 minutes. Shooting took almost as long, because of the need to ensure at least one frame in which everyone was looking at the camera. *Ektachrome ISO 100.*

physical likeness if the photographer is able to give some insight into the life, feelings or attitudes of the subject, and a familiar setting can often help.

In this kind of portrait, there is a good case for arranging natural-looking poses, with the subject at ease and comfortable. Under normal circumstances, however, most people do not feel particularly relaxed in front of a camera. One of the reasons for this is that the technical aspects of photography get in the way – waiting for the photographer to adjust the settings, find the best position, choose the right lens, and so on. The simple answer is to prepare all this in advance, starting with the choice of a visually attractive or interesting setting that will complement the subject.

Group portraits

Portraits of groups of people need good organization on the part of the photographer, and confident stage direction. To make several people appear coherent as a group, there should first be some visual rationale or identity – a shared interest or work, for instance. Where possible, include a visual reference to whatever it is that has created this group.

The practical issues of shooting a number of people together revolve around placement – finding a suitable setting and arranging the group so that its shape is fairly compact and every face is visible. It is normal to have taller people behind, and different members of the group kneeling, sitting and standing. An alternative, with everyone standing, is to shoot from a higher viewpoint, looking down on the group.

When shooting, allow plenty of film. It is axiomatic in group portrait photography that there is nearly always someone doing the wrong thing – looking away, talking to someone else, blinking, or doing some inappropriate action. The risk of this increases in proportion to the number of people.

Children

Children are much more difficult than adults to direct, and have a low boredom threshold. In child portraiture, the photographer must take a flexible approach, and be prepared to change the setting or circumstances. Keep the session relaxed and informal, prepare the photographic side of things in advance, and either shoot quickly, or use a prop, such as a toy, that will keep the child interested. A studio portrait with lighting may be less easy than a rapidly composed outdoor shot. Professional photographers who specialize in child portraits often have a supply of different toys and other attractions that can be brought out to keep the child's interest when boredom sets in.

Focusing

The tighter the framing on the face, the shallower the depth of field. A smaller aperture is an advantage, but the focus at least needs to be accurate. The eyes are the key element in a face, and ideally the depth of field should extend forward to include the nose. Bear this in mind when using an auto-focus camera; if necessary, lock the focus on the eyes before re-composing.

Natural distractions Above
two boys on the upper gallery of
Blackpool Tower, overlooking the
beach of this north-of-England
seaside resort, share a moment of
hilarity and are briefly oblivious to
the presence of the photographer.
Timing is everything here – the
expression of the boy nearer the
camera lasted only a fraction of a
second.

The unobserved moment
This young girl's rapt attention is
an easy subject for a quietly taken
photograph, using a fast, medium
telephoto lens.

Lighting the face

The series of pictures of a model head illustrates the basic range of lighting direction, diffusion and shadow-fill; some are clearly more unusual than others, and would only be chosen for a specific effect. The less diffuse the light, the harsher it is on a face. Completely diffuse light, however, gives a flat appearance with none of the modelling that gives the shape of a face its interest.

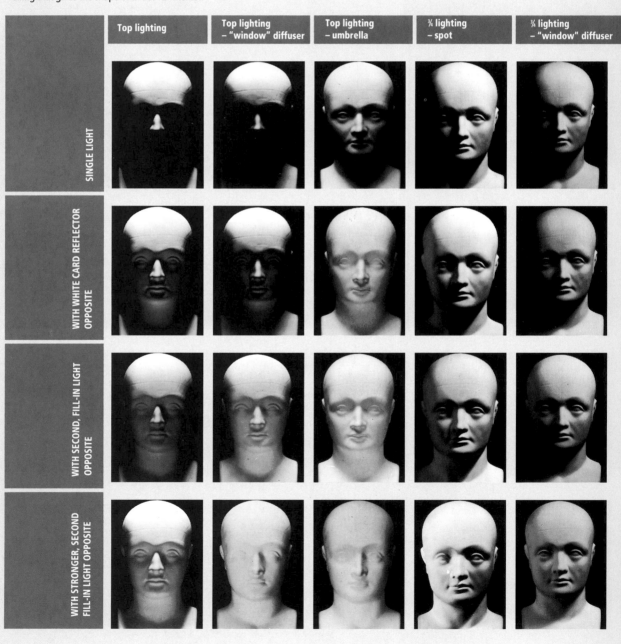

	Top lighting	Top lighting – "window" diffuser	Top lighting – umbrella	¾ lighting – spot	¾ lighting – "window" diffuser
SINGLE LIGHT					
WITH WHITE CARD REFLECTOR OPPOSITE					
WITH SECOND, FILL-IN LIGHT OPPOSITE					
WITH STRONGER, SECOND FILL-IN LIGHT OPPOSITE					

¾ lighting – umbrella	side lighting – spot	side lighting – "window" diffuser	side lighting – umbrella	Frontal lighting	Back lighting

Fashion

- **Style and technique**
- **The model**
- **Photogenic features**
- **Making-up for the camera**

Fashion, which is almost exclusively professional, is ostensibly about selling clothes and accessories, but although it would not exist without the commercial foundation of fashion magazines, couturiers and the clothing industry, it attracts some of the best talents in photography and by its example has a great influence on photography in general. The principal reason for this is that, in order to succeed, fashion photography must not only be exactly in tune with general movements in taste, it must anticipate them.

Style and technique

By its nature, fashion photography is concerned almost totally with the elusive subject of style, and this means that a perfectly accurate sense of style is essential to the photography itself, both in the content of the shot and the technique. If the photographic treatment is perceived to be boring or out of date, then it fails. While the content, which includes the choice of clothes, accessories, setting and model, is often planned in advance by the client, which is usually a magazine, the technique relies more heavily on the individual photographer's imagination. To remain fashionable, fashion photography technique can never stand still, and there is constant experiment and change with time. Styles vary from precision lighting in a studio to extreme naturalism through a snapshot technique on location. At the formal, controlled end of this range can be seen meticulous composition and highly graphic images; at the opposite, apparently casual end are anti-techniques such as deliberate camera shake, angled framing and uncorrected colour balance. All have their place in the right circumstances, and the circumstances are simply what are considered to be at the current leading edge of fashion.

The model

The role of the model varies in importance. In catalogue photography, for instance, the models are normally used to do no more than display the clothes. In a major magazine feature, on the other hand, the personality and appearance of the model may dominate the shots, and some models have developed powerful reputations, jealously guarded by the agents, magazines or even photographers who have nurtured them.

In the actual shooting session, where the reaction and pose of the model are critical, the photographer has to establish a very precise relationship. The rapport between photographer and model does not have to be intimate or even cordial, but it does need to be controlled, usually to a greater degree than in most portraiture. Most professional models are familiar with the needs of the job and can usually respond quickly to the photographer's ideas.

Photogenic features

In photography more than in real-life, strong facial features tend to come across best. A pronounced facial bone structure, and in particular high cheekbones, emphasizes shape. Large, well-spaced eyes are also considered striking. More than anything, given the importance of a physical ideal in this kind of photography, the age of a model is crucial: skin texture and muscle tone are generally at their best in youth, and for extreme close-ups without wrinkles, such as around an eye or the mouth, the best models are rarely beyond their teens.

Fast film, street location Borrowing reportage techniques to make pictures that look like a street photographer's reaction shots (below), fast film has been chosen here for its grainy texture and for its de-saturated colours.

Studio fashion This picture (right) exemplifies the precision of much studio fashion photography. The hard, clean lighting, with a separately lit background, ensures that every detail of the clothes is visible.

Shooting in sequence The important technique here is the timing and composition to catch the movement of the fabric. A wind machine plays on the model, who is instructed to strike a variety of poses; this kind of image demands a large number of frames to give an adequate choice.

Make-up

Make-up is both an essential adjunct to fashion photography and, on occasion, the subject itself of a beauty shot. Although changes in make-up style can be as ephemeral as clothes fashion, there is an underlying practical basis for applying it. Essentially, the task of make-up is to enhance appearance, and there are certain principles that relate to the structure of the face.

It is important to remember that this type of photography is concerned with an idealized image; a face with character rather than skin perfection also has its uses, but in a different kind of shot. To an extent, of course, the attributes that are thought of as the most desirable change with time and vary between societies and cultures, and it is not useful to generalize a great deal. Nevertheless, for the most part this field of photography concentrates on physical attraction and the presentation of ideal appearances. Homely faces and figures play little part in this.

In professional fashion photography, once the model has been chosen, make-up and styling are a matter for expert attention. For men, make-up is often limited simply to keeping down skin reflections, but for women it is more complex.

Beauty make-up

Well-considered and carefully applied make-up is the most important single element in successful beauty photography. The structure of the model's face will dictate some of the techniques used, as will the lighting and the intended results.

Make-up must also be designed to suit the camera. Normal beauty lighting is high frontal or three-quarters in position, well-diffused and with ample use of reflectors to fill in shadows. Most make-up techniques go well with this effect, but harder, less diffused lighting needs smoother and softer make-up. Completely frontal lighting, on the other hand, is flat, and strong, so hard make-up can be applied. If black-and-white film is being used, avoid reds, which will record much darker than they appear in colour. Brown is a good substitute, particularly when the same make-up is being photographed in both black-and-white and colour.

1 Start with moisturizer, and then apply the foundation with a sponge pad. The foundation does three jobs – it provides a basic surface, gives an underlying colour, and smooths the surface of the skin.

2 Powdering sets the foundation before the next stages, and also flattens the shiny parts of the face.

3 To give a wider appearance to the eyes, the eye shadow is brushed on more heavily at the outer corners. For the lids, the model should lower her eyes.

4 Use a fine brush to apply eyeliner.

5 As a final treatment for the eyes, apply mascara to the upper and lower lashes, using an eyelash comb to separate the lashes from each other.

6 The shape of the face is now refined by shading. Here, this model's face needs little emphasis, chiefly under the cheekbones.

7 Use blusher to add colour over the natural line of the cheekbones.

8 If the model has attractive lips, strong shaping and colouring is possible. Using a brush, first define the shape and then fill in with the chosen lip colour.

9 Complete the preparations by styling the hair. Make the final adjustments to the lighting and reflectors.

Landscape

- ● **Approaching landscape**
- ● **Extremes of weather**
- ● **Equipment for landscapes**
- ● **Mountains and deserts**

Landscape is one of the classic areas of photography with a tradition reaching back to the beginnings of photography itself. The subjects are familiar and accessible – they are all around us, and most obvious scenic views are now catalogued tourist attractions with established viewpoints. Landscapes are accessible in a different sense also: they are permanent fixtures, and all that is necessary is for the photographer to get there with a camera. And, for simple shots, there are no particular technical difficulties.

What has attracted so many photographers to shooting landscapes is that, given this easy accessibility, the subjects are rich and diverse, and can be viewed and interpreted in so many ways. However well-photographed a particular landscape, there is nearly always an opportunity to do something new with it. Personal interpretation, in fact, is at the heart of good landscape photography.

There can be outstanding differences between an ordinary snapshot taken without thought, and the finest creative landscape images. Many casually conceived photographs of interesting views that originally stimulated the photographer turn out to be disappointing images, failing to capture the essence of the scene. Often this is precisely because landscapes are such familiar, accessible subjects – many photographers do not put a great deal of effort into a shot, believing that the subject itself will somehow carry the picture through. In reality, to lift a landscape photograph out of the ordinary requires considerable perception and technique.

Spider Rock, Arizona A stormy sunset over the Canyon de Chelly and the surrounding high desert plateau. This photograph brings together two elements that virtually guarantee a spectacular landscape image – a special location under special conditions. The tall, sandstone pillar known as Spider Rock is, in fact, such a special feature that it has already been heavily photographed from all of the limited viewpoints. The difficulty with such a well-known view is to treat it differently. Fortunately, after a heavily overcast day, the spring sun broke through from beneath a bank of stormclouds for just a few minutes before setting – and shone straight up the canyon. Taking advantage of such quickly changing situations is the essence of 35mm landscape photography.
24mm lens, Kodachrome ISO 64, automatic setting at 1/30 sec., tripod

Cristate organ-pipe cactus
Landscapes work photographically on different scales, and moderate close-ups are an important way of showing the variety of detail. This unusual form of a species of cactus was found through using the published trail guide for Organ Pipe National Monument in southern Arizona.
180mm lens, Kodachrome ISO 64, automatic setting at 1/60 sec.

Equipment

All basic 35mm camera equipment is applicable to landscape pho-tography. Wherever possible, it is valuable to use a tripod as an aid to careful composition, which is central to landscape photography. It is particularly important with a telephoto lens, or in a wide-angle view in which maximum depth of field requires a slow shutter speed. More often than not in landscape images, sharpness across the whole field is desirable.

Filters play an important role (see Filters in Part 1). UV filters reduce haze in distant and mountain views, and protect the front surface of the lens. A polarizing filter can intensify the colour and tone of a clear sky, thus heightening the contrast with isolated clouds and with the horizon, and can be used to adjust reflections in water. As skies so often play an important part in landscapes, yet are often considerably brighter than the ground in an image, a neutral graduated filter offers the possibility of darkening them to balance the tones across the picture. In black-and-white, there are other ways of achieving this: one is to burn in the sky area when making an enlarged print (see Shading and printing-in, The dark-room in Part 1), another is to use a strongly coloured filter between yellow and red (see Filters for black-and-white film in Part 1).

Responding to the landscape

Most people react to seeing a landscape in an intuitive way. Without trying to pinpoint the elements that appeal to them, they form an overall impression, the visual components of which may be only one part. The wind, the sounds, the smells, the relationship to distant mountains to nearby rocks – all these things are the landscape, but the task of the photographer is to isolate the important aspects and convey them in a purely visual manner. A casual snapshot usually fails in this. Apart from any other faults, it may include too much in the frame, cluttering up the image, or it may exclude elements that forethought would have indicated were crucial.

The first step, then, is to decide precisely what it is about a particular landscape that characterizes it, and at the same time to define the nature of the photographer's subjective impression. It may be the inherent spectacle and drama of a grand view or it may be an unusual play of light and shade on a more modest corner of a landscape. It could be the lushness of fields and copses in summer, or the transience of a spring shower over a desert. In most cases the scene is not going to change in the next few minutes, so it is worth taking time to think.

Grand Canyon from Yavapai Point Deliberately evocative in its approach rather than informative, this view of the Grand Canyon (above) uses atmosphere and colour for their impressionistic effect. By waiting until the sun had set, and shooting towards it with a telephoto lens, a hazy separation of planes was ensured.
180mm lens, Kodachrome ISO 64, automatic setting at f16

West Fork Canyon, Sedona
In landscapes a telephoto lens gives a characteristic compression which, combined with the way such a lens crops tightly into a view, easily produces graphic, patterned images such as this. The strong curves of the water-cut rock (left) were enhanced by shooting from ground level, to mirror them in the water.
180mm lens, Kodachrome ISO 64, 1/30 sec., f11

Juniper, Bear Wallow Canyon One of the most effective landscape uses of a wide-angle lens is to draw together the overall shape of the scenery with the detail on the ground. The distant cliffs (above right) offered a wide choice of viewpoint the camera position was selected for foreground interest, a gnarled juniper, and almost the smallest aperture was used to ensure depth of field over the complete frame.
20mm lens, Kodachrome ISO 64, 1/15 sec., f22

35mm landscapes

The 35mm format's contribution to landscape photography is freedom of movement and speed of working. These qualities, which are further enhanced by the modern, automatic camera, used well, can bring a vitality sometimes lacking in the more traditional, studied approach of medium-format and large-format photography. Two examples of this are backpacking, much easier on difficult trails with smaller, lighter equipment, and the ability to snatch brief changes in lighting at a few seconds' notice. Another attribute of the 35mm camera that allows a unique type of image is the range of very long-focus lenses available. By virtue of the small size of the format, lenses that produce images magnified by 15 or 20x are practical. The result, as described in more detail below, is a compression of perspective that can make unfamiliar juxtapositions.

Style and approach

There is a danger, in categorizing styles of landscape photography, of suggesting too many limits. There is so much room for personal statement that here the range of choices is just outlined. At opposite extremes, a landscape photograph can be representational or abstract. A representational photograph attempts a faithful, informative evocation of the subject. An abstract approach selects strong graphic elements from the landscape, and tends to be more subjective. In the past, photography, and particularly landscape photography, has drawn

Cathedral Rock, Sedona In all three of the photographs on this page, the combination of lens and light is crucial. Above, a wide-angle lens used from just above the water-line in the middle of a river unifies this composition. The reflection is almost as light as the sky itself.
20mm lens, Kodachrome ISO 64, ⅟₃₀ sec., f8

Dawn, Dedham Vale, Suffolk The pink light from sunrise suffuses morning mist lying over water meadows, and gives an unusual variation to this kind of scene. To enhance the misty effect, a telephoto lens was used.
180mm lens, Kodachrome ISO 64, automatic setting, tripod

heavily on the traditions of painting, but a great deal of modern work has explored the medium's own potential.

Character from the lens

The chapter on Lenses in Part 1 described the different visual effects of varying focal lengths. In landscape photography, wide-angle lenses enable a type of image that works on the relationship between nearby objects and the distance, such as between ripples in a sand dune and a desert horizon. This "near-far" treatment – so called by Ansel Adams, one of the greatest landscape photographers – involves the viewer in the scene, and can bring a sense of completeness to the landscape image. By using a wide-angle lens and a low viewpoint, the photographer can encompass several of the different scales that exist in a landscape, from detail to the topography. This kind of view usually calls for great depth of field, and even though this is inherently good in a wide-angle lens, a small aperture and slow shutter speed are normal.

By contrast, a telephoto lens can be used to isolate given elements, and will compress perspective, making distant features more dominant in relation to nearer objects. It can give a more remote, detached feeling, and is often excellent for selecting items to give abstract patterns. The scale at which different parts of a view are imaged is unusual for the eye, and so can bring a dramatic element to the picture. Really long-focus lenses – 400mm and more – are practical only for 35mm cameras, for reasons of size and bulk, making the extreme type of this image unique to the format.

Light

The variety in the treatment of landscapes comes principally from the daily and seasonal changes in lighting. Even one viewpoint can provide infinite picture possibilities, depending on the weather, time of day, and season of the year. Usually, though, the photographer has a limited choice in this respect; few people can afford the time to make repeated visits to a location in order to capture just the right moment. Nevertheless, within the constraints, it helps to anticipate the appearance of a scene at different times, and then try to work to the preferred one.

Sunrise and sunset are often good times of day, giving a wide variety of lighting conditions in just one or two

Summer evening, Chanctonbury Landscape detail has been suppressed in this wide-angle view in favour of the light and cloud formation, for which the exposure was set. Even so, in order not to lose the foreground completely, a neutral graduated filter was used to darken the sky relative to the ground.
20mm lens, Kodachrome ISO 64, 1⁄60 sec., f4

hours, often with attractive sky colours and low-angled lighting to show up textures. The flat lighting of a high midday sun is often hard to cope with adequately, and if it works well at all it is usually with scenes that have inherently strong shapes, tones or colours.

Dull, overcast skies limit the choices in another way, and unless the clouds are dark and stormy enough to look interesting, it is difficult to work a relationship between sky and ground into the picture. Usually, and especially with a colour transparency film, which has relatively little latitude (see Exposure latitude, in Part 1), the contrast between sky and land is too great to record both at an acceptable exposure. A graduated filter over the lens, or print shading in the darkroom, may compensate for this extreme contrast. Nevertheless, the diffuse lighting from an overcast sky can give good, saturated colour and clarify many details, such as in vegetation, that would be too confusing in bright sunlight.

Extremes of weather

Bad weather may be immensely frustrating to a photographer who can well imagine how things would appear at a better time, but adverse conditions provide a challenge and an opportunity for unusual and original images (after all, driving hail or a dust storm are precisely the conditions that cause most photographers to pack up and leave). Also, such conditions are an essential element in the profile of a landscape.

Rain, hail, snow and dust show the landscape in a less hospitable light, and for anyone searching for an original treatment of a well-known scene, they offer good possi-

Wood near Fylingdales, Yorkshire Shooting into a moderately low sun stresses the atmospheric quality of light, given a few basic precautions. To limit flare, a wide-angle lens was used and the camera carefully positioned so that foliage would partly mask the sun. It is important in this kind of shot to beware of flare reflections, which commonly appear as a line across the picture from the sun.
20mm lens, Kodachrome ISO 64, automatic setting.

Tree bark detail Cloudy weather that can often be dull for larger landscape views is frequently very effective in close-up. The pattern and subtle coloration of this tree bark reproduces clearly and simply in the shadowless lighting.
55mm lens, Kodachrome ISO 64, automatic setting at ¹/₁₅ sec.

Equipment care in bad weather

Conditions to beware of are heavy rain (or prolonged exposure to moderate rain), saltwater spray near the sea, airborne dust, snow, and freezing fog. Follow these simple guidelines for keeping equipment safe in these conditions:

• If you are using a non-waterproof camera, wrap it in a clear plastic bag, using a rubber band to secure the bag's opening around the front of the lens. If necessary, cut a small hole for the viewfinder eyepiece and secure that with another rubber band.

• Keep all equipment wrapped until you actually need it.

• A shower or moderate rainfall won't damage even a non-waterproof camera – but wipe it down when you have finished shooting.

• In very cold weather, the main danger is condensation when you bring equipment suddenly into a warm room. In this situation, warm cameras up slowly, for example, by leaving them in a front porch before taking them indoors, and if possible keep them in a sealed pack so that condensation forms on the outside. Avoid breathing on the camera when outdoors.

Rainbow, Scotland A rainbow is an optical effect that depends entirely on the position of whoever is looking at it – if you change the camera position, the rainbow will move with you, which is useful if you want to set it against a slightly different background. For a view of the full arc of a rainbow, shoot with a wide-angle lens, such as the 20mm used here. For a more detailed view of the colours, use a telephoto lens. The conditions for rainbows rarely last very long, and it is important to shoot quickly.

bilities. The scene can change constantly and rapidly under these conditions, and often fast reactions are needed. Here, once again, the 35mm automatic camera comes into its own. The one essential precaution is to protect the equipment.

Extremes of place

Less hospitable environments, such as mountains, deserts and rainforests, are the least accessible, yet they offer the most dramatic forms. In particular, an absence of people in such places gives more scope. To anyone seriously interested in landscape photography, a visit to one of these regions is essential, and can give a concentrated opportunity to develop ideas. Each has its special photographic problems, and all of them, as potentially harsh environments, need to be approached with commonsense and caution.

Mountains: The mountain photographer does not have to be a mountaineer, but without rock- and ice-climbing skills, many shots will inevitably be missed. Ultraviolet scattering at high altitudes is considerable and so a strong UV filter is essential, particularly with telephoto

Monochrome stormscape
Rough seas and a storm produce a landscape that looks more extreme than the actual conditions would suggest – no more than a miserable summer's day on the south coast of Wales. The appearance was enhanced by darker than usual exposure and a neutral graduated filter to deepen the sky. The result is a study in grey and black.
20mm lens, Kodachrome ISO 64, ¹⁄₃₀ sec., f8, neutral graduated filter

St Mary Lake, Montana
Weather conditions in the mountains often change rapidly, and dramatic cloudscapes are not uncommon. Here, the remains of a late summer storm hang high over the mountains of Glacier National Park. A graduated filter enhances the colour and tone of the upper part of the evening sky.
24mm lens, Ektachrome ISO 64, ¹⁄₂₅ sec., f9, neutral graduated filter

White Sands, New Mexico

These white gypsum dunes near Alamogordo present clean, simple lines ideal for a minimal, graphic treatment. Low sunlight throws ripples and dunes into relief. *20mm lens, Kodachrome ISO 64, automatic setting*

Volcan Purace, Colombia

Mountains give tremendous visual variety because of the variety of forms and the weather effects they create. The fumaroles of the semi-alive volcano in South America provide the action in this photograph. Back-lit against the setting sun, visibility at altitude can be, as here, extremely good, with a clarity that brings very high contrast between light and shade. *20mm lens, Kodachrome ISO 64, automatic setting*

The horizon line

lenses. The physical difficulties of mountaineering make it important to carry the minimum of equipment. Low temperatures shorten battery life considerably – a crucial matter for electronic cameras.

Deserts: Deserts offer different problems, chiefly dust and heat. Use a clear lens filter to protect the lens, and keep equipment in a well-sealed case when not needed – and keep this in the shade as much as possible. Desert daytime temperatures in summer in the American south-west, for example, regularly exceed 43°C (110°F), and the black finish on most cameras makes them absorb heat very quickly. This in turn can weaken the lens cement and alter the sensitivity of the film.

Although dunes are not quite as typical of desert landscapes as many people imagine, they make strong, graphic images in almost any lighting conditions, and particularly under low-angled sunlight, which throws into relief the texture of ripples and the patterns of dune crests.

The placing of the horizon deserves careful attention when you compose the image. The most conventional position is approximately a third of the way up, or down, the picture, but there can be good reasons for breaking this convention. If the horizon is low in the frame, it emphasizes the sky, which would be appropriate if, for instance, the pattern of clouds were a strong visual element. Positioning the horizon in the middle of the frame is usually the least satisfactory solution, except in the special circumstance of a very clear, mirror-like reflection in water. If placed high, as here, it concentrates attention on details of the landscape, particularly in the foreground, and also gives a more enclosed feeling to the landscape.

Rainforest, Mount Kinabalu, Borneo Swathed in cloud one morning, this forest on the slopes of a mountain provided the relatively rare opportunity for a shot that brought some order to the tangle of vegetation. Low light levels make a tripod essential.
20mm lens, Kodachrome ISO 64, automatic setting, tripod

Photographing in snow

Snow, at whatever altitude, is a special photographic problem. Realistic rendering is not easy, and underexposure is a common error. Exposure meters essentially average the reading, so that a completely snow-covered scene is likely to be recorded as grey rather than white. Overriding the automatic exposure and increasing it so as to lighten it by one or two stops will usually give a more acceptable result. Snow crystals are also good reflectors of ultra-violet, and snow in shadow under a blue sky will appear as a distinct blue on colour film. Low-angled sunlight is best for bringing out texture in snow, and back-lighting can give a sparkle to the crystals.

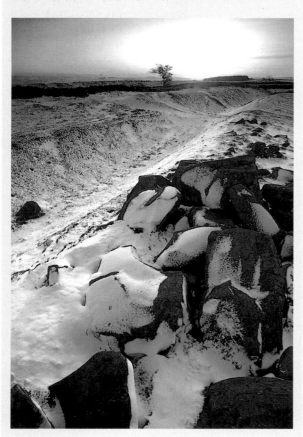

Rainforests: Rainforest, mainly in tropical South America and some parts of Asia and Africa, forms one of the least explored parts of the planet, and for this reason alone offers exciting landscape possibilities. Nevertheless, it is not without difficulties for photography. Primary forest is characterized by dense stands of tall hardwood trees, and typically offers only limited views and very low light levels. In the atmosphere of cathedral gloom, which can be expressive if captured well, long exposures and a tripod are nearly always essential. Open views are generally possible only at the margins of the forest, and the most common location for this is the edges of river banks.

The combination of heat and high humidity, typical of a rainforest, is particularly damaging to film and equipment. Make regular inspections of equipment for green mould, and examine lenses in particular for a rash of small spots that may be the first indication of a fungus that, if not removed, will etch in to the surface of the glass and ruin the lens. As in deserts, an airtight camera case is important, and a desiccating agent such as crystals of silica gel should be packed with the cameras. Once the silica gel has absorbed as much moisture as it can (the most useful type changes colour to indicate this), it can be re-activated by being dried in an oven or over a fire.

Detail of vegetation, Mount Kinabalu Rainforests offer countless possibilities for detailed close-ups.
55mm lens, Kodachrome ISO 64, ¼ sec., f4, tripod

Wildlife

- Making a hide
- Birds in flight
- Close-up techniques
- Photomicrography

Wildlife photography has developed markedly over the years, both in response to a stronger public and media interest, and because improved camera technology has opened up many new picture possibilities. There are, in addition, many more photographers now who are prepared to put considerable time and effort into breaking new ground. The thrust of modern wildlife photography is animal behaviour. The best work in this field has long since passed the 19th-century stage of showing what an unusual or rare animal looks like to those who have never seen one. Its aims are to give new insight into the way creatures behave, and to achieve high pictorial standards.

Here, there is a real need for specialized knowledge beyond that needed purely for the photography. So, for example, while it is possible to practice reportage photography on native wit, and landscape photography on a personal rapport with the environment, prior knowledge and experience of the animal subjects is a prerequisite for successful wildlife pictures. The rewards, however, are considerable: more and more, images of wildlife in a natural environment contrast greatly with the organized urban life with which most people are familiar.

Hippopotamus and ox-pecker Wherever possible and appropriate, wildlife photography should include a component of animal behaviour. Alone, this hippopotamus (right) would have provided a reasonably attractive portrait. The arrival of an ox-pecker to pick parasites added a new level of interest. Much of wildlife photography involves waiting for such moments.
600mm lens, Kodachrome ISO 64, ¹⁄₂₅₀ sec., f4

Egret, afternoon light Even common subjects, such as this egret, can produce strong images given sufficient attention to light and composition. The dappled, late-afternoon sunlight plays an important part in this image, and is emphasized by the off-centre composition of the bird.
180mm lens, Kodachrome ISO 64, automatic setting based on spot-reading of sunlit area

Equipment

As so much wildlife photography is concerned with getting close to shy or elusive animals, the basic tool is the long-focus lens. Indeed, the majority of techniques revolve around its use. Although there are certainly many situations in which a moderate telephoto is sufficient, and remote-control techniques make it possible to use even normal lenses sited very close, the lens of choice is very long and very fast (that is, with a large maximum aperture). These, unfortunately, are the two most expensive lens qualities, but for a professional wildlife photographer the prime piece of equipment would have to be a telephoto in the order of a 600mm f4 lens. Less costly alternatives are to use a tele-converter (see Extreme long-focus lenses) to increase the focal length of a less powerful telephoto, and to settle for a smaller maximum aperture. If the latter, mirror lenses represent good value for money, and offer powerful optics in a compact form.

The value of a fast lens, however, lies in its ability to extend the lighting conditions for shooting, and this translates directly into picture opportunities. As the depth of field with long telephotos is extremely shallow in any case, and the normal way of using them in wildlife photography is at a distance, there are virtually no occasions when it is worth stopping down the lens significantly. These telephotos are nearly always used wide open. A difference of two stops in the maximum aperture, therefore, means that as the evening draws on, a faster lens allows the photographer to continue working for appreciably longer. In general, a great deal of wildlife

Pere David's deer, Woburn Abbey A long telephoto lens, ideally with a wide maximum aperture to allow high shutter speeds and continued shooting in low light, is the standard piece of equipment. Its basic function is to allow frame-filling compositions of animals that would not tolerate a close approach. This stag is fully aware of the photographer's presence, but is distant enough not to feel threatened.
600mm lens, Kodachrome ISO 64, ¹⁄₂₅₀ sec., f5.6

Burchell's zebra, Lake Manyara, Tanzania In stalking, there may be very little time – if any at all – between spotting an animal and being seen by it. These conditions favour automatic settings for exposure and focus, or else require good anticipation of the camera setting. In woodland such as this, shooting opportunities are usually restricted to narrow "windows" in the tree cover and vegetation. *600mm lens, Kodachrome ISO 64, automatic setting*

Great Egret, La Guajira One solitary clump of mangroves on a long stretch of desert coastline in Colombia has become an oasis for flocks of egrets and herons. Close approach was easy, as the dense vegetation kept me hidden, and although the view of this bird (left) was partially obscured by leaves, a long lens reduced this screen of foliage to a soft blur. *Nikon, 300mm, Ektachrome, 1/250 sec., f8*

activity takes place as daylight fades, so this is particularly relevant. The same, of course, applies early in the morning, and in dark locations such as dense forest.

The choice of film enters this equation. A faster film extends the shooting possibilities in the same way as a faster lens, but the extra graininess may offset the advantage. The convention in wildlife imagery is for high resolution, and medium-speed films are the normal choice (even slow films in circumstances where there is guaranteed to be sufficient light, as in close-up flash photography). Fast films are normally an emergency option.

The weight, and magnification, of a long telephoto makes a tripod essential. Exposures for wildlife are rarely longer than 1/15 sec, but an extreme focal length magnifies even a slight unsteadiness to the point where it gives a blurred image (see Extreme long-focus lenses). To an extent, a lighter monopod may be useful, but a weather-resistant tripod is more adaptable.

If your camera has the option to fit one, a motor-drive is well worth the slight extra weight, as it can cram the maximum amount of pictures into the short flurry of activity that is common in many wildlife situations. It also makes it possible to shoot an action sequence which can then be displayed as a series of pictures (see Action, Sequences in Part 2). The principal disadvantage of a motor-drive is its noise, which in some instances will

Louisiana heron, Florida Everglades A moderate telephoto lens also has an important role in wildlife photography, particularly during stalking, when shooting distances are unpredictable and varied, as in this woodland encounter with a heron. In these circumstances, when speed is essential, it can help to carry two cameras, one fitted with a long telephoto, the other with a medium telephoto.
180mm lens, Kodachrome ISO 64, automatic setting

startle an animal more easily than would the manual shutter release. Some camera models are noisier than others in this respect.

Stalking

One of the most straightforward techniques, though it has a high failure rate, is stalking. To be successful, it depends heavily on the photographer having the knowledge and experience to find the animals in any locality, and then to be able to move with sufficient stealth that they are not aware of being approached. In many ways, the photographer is on an equal footing with the subject. Shooting is normally hand-held; practise holding and

using a long lens to improve the slowest shutter speed at which a sharp image can be guaranteed (see Camera-handling, Holding the camera).

A long lens has a special advantage that aids stalking. Because of its shallow depth of field, foregrounds such as foliage and branches may be thrown so far out of focus as to be hardly visible. So, not only is it less important than one might imagine to have a completely clear view, there are times when a light foreground obstruction, while not interfering with the image, helps conceal the photographer from the animal.

It may be necessary to exercise some fine judgement on making the first exposure. If the animal is skittish, it

Being unobtrusive

There are a number of precautions to take in order to be unobtrusive. Dress in clothing that blends in with the tones and colours of the surroundings; camouflage material is ideal. Cover or darken exposed fair skin, and tape over the chrome parts of your equipment. Carry nothing that rattles, and walk as silently as possible, avoiding skylines and open ground. When approaching an animal, stay downwind and move slowly with long pauses.

may bolt as soon as the shutter is released. Typically, an animal will head off in the opposite direction, and a rear view of an animal in flight is fairly useless. This is particularly a problem with birds on a perch or nest; too close an approach will put them to flight away from the camera. It may be better to sacrifice some distance for the opportunity to photograph them flying off when *they* choose, possibly towards the camera.

Hides

Hides are camouflaged camera positions situated close to wherever animals are likely to visit regularly, such as

Lioness with wildebeest kill, Serengeti In some habitats, particularly grasslands, the most convenient, and prudent way of stalking is by four-wheel-drive vehicle. The limitation is the noise and visibility of the vehicle, but here, in the Serengeti, most large animals are perfectly accustomed to it.
600mm lens, Kodachrome ISO 64, ½ sec., f8

Jackal, Lake Ngorongoro A jackal (below left) makes off along the water's edge with the leg of a flamingo, probably killed by a hyena earlier in the day. A long lens from the shore allowed a sequence of several shots as the camera was panned from left to right.
600mm lens, Kodachrome ISO 64, ¹⁄₂₅₀ sec., f8

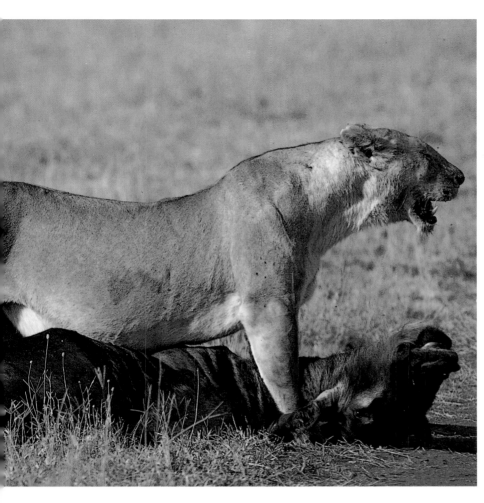

Buffalo and egrets, Ngorongoro Crater Photographed from across a river bank, this African buffalo was motionless and uninteresting until it finally decided it had had enough of the attentions of a small group of egrets and turned rapidly. Some such movement was anticipated. A high shutter speed was set and the camera was trained on the buffalo for about 10 minutes before the exposure was made.
600mm lens, Kodachrome ISO 64, 1/500 sec., f4

nests or watering-places. In established wildlife reserves and sanctuaries there may be permanent hides maintained by wardens or rangers. Elsewhere a customized hide may have to be erected by the individual photographer, and this calls for preparation, forethought and patience. Hide photography is relatively cautious, and relies little on the serendipitous encounter that plays such a large part in stalking. For long-term observation, close to the most sensitive places in most animals' lives, it is the only practical method.

A portable design is adequate for general use but for certain kinds of work it may be better to construct a hide that is specifically tailored to the surroundings. Makeshift hides, using materials such as branches and leaves, can be effective even though extremely simple, while for a serious long-term project a permanent shelter of wood can be built, possibly even over a pit.

A hide is only as good as the way it is used. The objective is to work inside an animal's safety zone unobserved, so the most critical times are when you enter and leave it. Whenever possible, do this when the animal is absent. Otherwise, enter with a companion, who then leaves; this can fool most animals into thinking that humans have arrived and left. Inside, move quietly and carefully, and avoid touching fabric walls. Also be careful when pushing the lens though an opening in the wall; some photographers leave a tube or bottle end in place of the lens when not in the hide, so that the animals become familiar with the shape.

Keep checking the light level, even with a fully automatic metering system, and monitor its effect on the shutter speed. As mentioned above, there is little value in stopping down a long lens, and there is nearly always a demand for a faster shutter speed. Early and late in the day, when most activity takes place, the light level changes the most rapidly, and it is important to know which shots are worth attempting. For example, with the camera trained on a subject just before sunrise, the maximum shutter speed may be only 1/30 sec, which would mean waiting for pauses in an animal's activity; a little later, as the sun rises, a faster shutter speed would mean that even the animal's more abrupt movements could be captured successfully.

Hides are often used in conjunction with baits or lures, but this requires specialized knowledge. In particular, they can disrupt an animal's normal life, and should only be used with experience.

Birds in flight

Photographing birds in flight requires consummate skill; even with a good viewpoint close to a flight path, there is likely to be a shooting window of only a few seconds, and in this time the bird has to be followed, framed and

Hides

This box-frame construction is fairly straightforward to build from fabric and sectioned aluminium poles, but can also be bought ready-made from specialist suppliers. It is designed in much the same way as a tent (and a camping supplier should be able to provide most of the materials). Guy ropes secure the frame, and should be tight enough to prevent movement. Pegs secure the base of the fabric, which should be drab in colour, or a camouflage pattern. A small hole at the front is just large enough for the lens, while the rear flap, here shown partly open for entry, is closed securely when the hide is being used.

Usually found in established wildlife reserves, this kind of hide has a more solid construction – this example is build partly into the ground. Because it is intended to be a regular fixture in the landscape, there is more time for the animals to become accustomed to it. Therefore it may not be necessary to camouflage it completely. Nevertheless, as a precaution, some vegetation can be encouraged to grow around and over it.

Teal For most water-birds, a hide set up at the water's edge is virtually essential for close photography. The typically low camera position tends to give good reflections of the birds, but it is important to site the hide so that at the expected time of shooting, the sun, as here, is not in front. *600mm lens, Kodachrome ISO 64, ½₅₀ sec., f5.6*

Openbill stork with nesting material The middle of a colony of nesting openbill storks provided perfect opportunities for shots of the birds in flight as they returned with twigs and leaves in their beaks. The difficulty lay in limited visibility because of the surrounding trees, which allowed hardly any notice of an incoming stork, making focusing extremely difficult with the manual lens. Here, an auto-focus lens would have been a great advantage. Exposure was pre-set to the shutter speed and aperture known to be right for the film speed rating in bright sunlight. *600mm lens, Kodachrome ISO 64, ½₅₀₀ sec., f5.6*

focused accurately. Larger birds, such as storks, are the least difficult, not only because of their size, which fills the frame at a greater distance, but because they tend to fly more slowly.

A long telephoto is essential, but its long focal length gives very shallow depth of field and calls for precise focusing. In these situations, an auto-focus lens has an overriding advantage.

With a manual-focus lens, there are two basic techniques. One is to re-focus continually as the camera is panned to keep the bird in frame; the other is to focus ahead of the bird and wait until it flies into focus. In either case, without the benefit of auto-focus, the shot must be timed with great precision, and focussing errors are normal.

The odds are shortened for this kind of picture if the camera can be located close to a known flight path. The most obvious place is close to a nesting site at a time when the birds are either collecting nesting materials or feeding chicks. Then there are likely to be frequent sorties, with the added advantage that the birds flying over may be carrying things in their beaks.

Exposure may be another problem. As in all wildlife photography, it is essential to expose correctly for the subject rather than its surroundings. Against a definite blue sky this should create no special difficulties for an automatic exposure system, but a white or pale sky is likely to cause underexposure, particularly if the bird occupies only a small part of the frame.

Locations

The easiest places to see and photograph wildlife are organized sanctuaries. These vary considerably, not only in how efficiently they are run, but in the density and accessibility of the wildlife. North America, for example, is particularly fortunate in having a well-organized net-

Giraffe scratching, Serengeti Established and controlled wildlife reserves such as this usually offer the easiest access to animals. The habitat is also an important factor: this open grassland not only gives good visibility, but also supports good numbers of large mammals.
180mm lens, Kodachrome ISO 64, automatic setting

Pelicans in formation There were several seconds to prepare this shot, taken with an extreme telephoto mounted loosely on a tripod. Unusually for an in-flight shot, the background of thunderclouds is darker than average, and the exposure was set to one stop brighter than the overall reading.
600mm lens, Kodachrome ISO 64, ½₅₀ sec., f5.6

Puffin, Farne Islands A good location accounts for most of the success of many wildlife photographs. This puffin was part of an isolated but visitable colony on a small, rocky island off the northeast coast of England, and there were just enough visitors for the birds to be unconcerned. Although a long lens was used to separate the puffin from the background, as far as approach was concerned a medium telephoto lens could have been used.
600mm lens, Kodachrome ISO 64, automatic setting

work of national parks and wildlife refuges, staff with knowledgeable and good information on what to see and where. Given the inherent difficulties of photographing animals, it is best not to attempt to photograph rare animals in an inaccessible environment without considerable experience.

Professional wildlife photographers make full use of local knowledge, recruiting local guides to accompany them. The noted wildlife photographer Frans Lanting calls them "my eyes and ears; without them I'd be as lost as a babe in the woods". A good local guide will be able to advise on the best times to visit, the techniques needed for particular species, and precise locations.

The habitat

A combination of landscape and wildlife photography is the environmental portrait. A broad view of a complete environment, taking in life at all levels, creates the opportunity for a coherent set of images of the complete habitat – a version of the picture essay. By covering a range of subjects, including animals, plants and landscapes, the series of photographs automatically takes on an ecological slant.

Think of the habitat as a complete unit, with every element, from weather and landscape to plants and insects, interconnected. This is an essential key both to understanding and shooting it. Photographically, such a treatment gives the opportunity for visual variety that may be difficult when dealing with only one animal. Indeed, visual variety is essential, and can be achieved by paying close attention to the lighting, to different scales (from over-views to close-ups), to varying the focal length of lens used, and to composition.

Close-up

Landscapes and life on a small scale offer some of the richest picture possibilities for outdoor photography. Surprisingly few people pay much attention to the real detail of the environment – the plants and creatures that live on a scale measured in centimetres and millimetres. For this reason alone, photographs of life in miniature have the ability to surprise. Moreover, even when a larger landscape lacks visual drama, or if the light is flat and dull, a tiny piece of the same habitat may well hold the potential for a striking image.

Simple observation is one thing, however, taking a successful close-up photograph is another. Just as our eyes are more comfortable working at normal distances, so cameras and lenses are easiest to use with full-scale subjects. To fill the frame of a 35mm slide or negative with an insect or small flower, the lens has to be able to focus down to a small distance only, and must also be able to give sharp images at such a short distance.

Regular lenses generally focus no closer than about 30cm (1ft) and are designed by the manufacturers to perform best at distances greater than this. As a result, close-up photography often needs additional equipment and some special techniques to go with it. This said, the reputation that close-up photography has for being technically difficult is no longer as well-deserved as it once was. The calculations that used to plague photographers, such as working out the extra allowance for exposure and exactly how close to position a flash unit, have largely been done away with by camera automation. And increasingly, the standard lens supplied with some cameras has a macro facility, allowing it to be focused closer than normal.

All these lens-extending devices make longer exposures necessary. The further the film is from the lens, the less light reaches it. However, any camera with TTL metering handles this normally.

Using daylight for close-up work

Technically, and aesthetically, there are two approaches to outdoor close-up shooting – with and without flash. Flash is convenient and efficient, but it can produce a

Coverage of a complete wildlife habitat follows the principles of a picture essay, with variety in both subject and treatment a paramount feature. The subject here is a wildlife reserve in Sri Lanka. A sense of place, as well as different lighting conditions, are as important as covering the major species.

Indian roller in rain
600mm lens, Ektachrome ISO 400, ¹⁄₁₂₅ sec., f4

Sambar sheltering from rain *600mm lens, Ektachrome ISO 400, ¹⁄₁₂ sec., f4.*

Elephant herd *180mm lens, Kodachrome ISO 64, ¹⁄₂₅₀ sec., f2.8*

Spoonbill *600mm lens, Kodachrome ISO 64, ¹⁄₂₅₀ sec., f5.6*

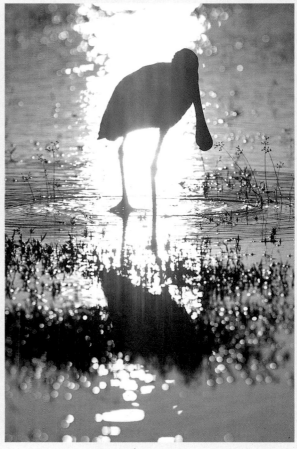

sameness in close-up images if used all the time. Natural light has many qualities that may make it more interesting. Direct sunlight can give a harsh effect when frontal, but as backlighting it strengthens shapes and can make leaves, for example, almost luminous; when strongly directional, it gives a sparkle to water droplets. A dull, overcast sky can bring beautiful tranquil lighting in close-up. And, because the subjects are small, it is easy to manipulate reflected light with small mirrors or pieces of white card, bouncing sunlight into shadows or shading it from other areas.

Grasshopper The conventional treatment for insects is a small portable flash, either mounted directly on the camera or held a little to one side on an extension sync lead. Flash guarantees reasonable depth of field and bright, clean colours.
200mm macro lens, Kodachrome ISO 64, automatic setting.

Pitcher plant, Sabah, Borneo Photography on a smaller scale calls for different techniques. Much of it is at or close to ground level, such as this insectivorous plant right, one of several species on the slopes of Mount Kinabalu. A macro lens and tripod are standard equipment, using either slow shutter speeds in natural light, or flash.
55mm lens, Kodachrome ISO 64, automatic setting

Dragonfly, Khao Yai National Park, Thailand
Provided that the insect remains still (because of the behaviour of the species or a low temperature), small creatures such as this dragonfly right can be photographed by natural light. Although originally a slow shutter speed would be needed to allow a small aperture and good depth of field, in this case a virtue was made of shallow depth of field to concentrate attention on the insect's eyes. A shaft of sunlight allowed a reasonable shutter speed and hand-held shooting.
200mm macro lens, Kodachrome ISO 64, ¹/₁₂ sec., f5.6

To work with daylight, it is nearly always essential to use a tripod; the one important technique is to keep the camera steady enough for the inevitable long exposures. As the majority of close-up subjects outdoors are close to ground level, use either a small tripod or one that has the facility for its legs to be spread wide. Alternatively, the column that carries the head can, on some tripods, be reversed so that the camera is suspended.

Flowers and fungi are among the easiest outdoor subjects, but the essential skill is, in nearly all cases, to find a way of isolating them visually. Often, other plants get in the way and clutter up the picture – something that the eye tends to ignore but the camera cannot. Sometimes the composition can be improved with a little judicious "gardening", although rooting up plants is not a good way of treating the environment, and may even be illegal.

Lenses for close-up work

Macro lenses (see Close-up and macro lenses in Part 1) are central to close-up work, and allow shooting unaided up to half life-size, which is quite adequate for most small plants and large insects. In the field, a long-focus macro, such as a 200mm, has special advantages: for insects and small animals it enables the photographer to work at a less threatening distance, while for plants it makes it easier to isolate the subject from its surroundings by deliberate use of the shallower depth of field.

To work closer than half life-size calls for an attachment that moves the entire lens further from the camera body. Extension tubes, which can be plugged together, are simple, rigid, and easy to use outdoors. A bellows extension allows greater magnification, but is a little delicate for using in rough outdoor conditions.

Isolating the subject

A key technique is to use depth of field intelligently (see Depth of field in Part 1). The closer the lens is focused, the more shallow the depth of field, and this is very characteristic of close-up photography. A flower with a complicated background will usually benefit from having only just enough depth of field to keep it sharp while throwing the surroundings out of focus. This usually works best if the camera is positioned on a level with the flower and aimed horizontally, rather than downwards. If the camera has a depth of field preview button, this will give the best indication of the appropriate aperture setting. Set the shutter accordingly, or use whatever programme an auto-camera has to give aperture priority.

An alternative way of isolating a subject is to introduce a background; black velvet or white card, for example, hung a little way behind the flower, will create a near-studio setting. Flowers are surprisingly mobile even in the slightest air movement, and to deal with the effects of a breeze during a long exposure, either improvize a windbreak from card or the camera-bag, or else hold the flower steady by coiling a piece of soft, thick copper wire around the stem (out of sight), and fixing the other end in the ground.

Mantis The fall-off in illumination from a small flash unit gives a typically black backdrop to this photograph of a mantis, heightening the contrast. Photographed in the forest at night, a hand-held torch/flashlight was used for focusing. *55mm lens, Kodachrome ISO 64, automatic setting*

Using flash for close-up work

Flash involves rather different techniques, and for insects and other small animals is virtually essential. For this kind of subject, good depth of field is highly desirable, and this means that the lens must nearly always be stopped down to a very small aperture. With natural light, even on the brightest day, the shutter speed would then have to be extremely slow – too slow to prevent camera shake without a tripod, and too slow to freeze the movements of an active subject – (and a high-speed, grainy film would defeat the purpose of getting a crisp, clean shot).

On-camera flash, however, has the drawback that the lens extension may block its light from reaching a close subject. More useful is a detachable portable flash that can be positioned close to the animal. Although a single flash-head is satisfactory, the close working distances often mean that it has to be positioned to one side of the insect, and as a result casts a strong shadow. A better set-up is to position a reflector (mirror, foil or white card) or a second flash unit on the other side of the animal.

A dedicated flash unit, linked to the camera's metering system, is obviously a convenience, but many photographers who specialize in close-up work devise a fixed set-up, with the flash units in a pre-set position, so that at each of a few lens extensions, they are familiar with the aperture settings. With this method, which calls for some testing at home beforehand, even small, inexpensive, non-automatic flash units can be used. A flash extension lead gives much more freedom in positioning the light – overhead, for example, to simulate sunlight.

Close-up equipment

Medical lens

Specialized medical lenses (right) contain their own built-in ringlight. The circular flash tube surrounding the front of the lens is so compact that the unit can be used in very confined spaces and provides its own shadowless lighting. Auxiliary lenses vary the magnification.

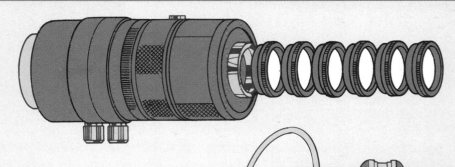

Bellows

An extension bellows (right) gives the best quality close-up images, and allows continuous focusing. Some even offer shifts and tilts in the front lens panel, giving fine control over perspective and depth of field.

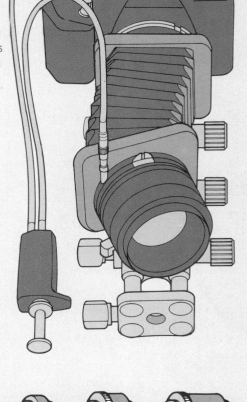

Ringlight

To give virtually shadowless lighting a ringlight (above) can be either a simple circular flash tube that fits over the lens, or an adjustable unit with supplementary lights to give some modelling

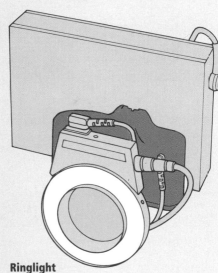

Reversing ring

Normal lenses are inefficient when the lens-to-film distance is greater than the lens-to-subject distance – in other words, at magnifications greater than 1:1. A reversing ring (below) enables you to turn the lens around and reduce lens-to-film distance.

Auxiliary lenses

These simple lenses (below) screw on to the front of a normal camera lens and shorten the lens-to-subject distance, so increasing magnification.

Extension rings

These are used to extend the lens from the camera body in order to increase magnification. They are available in various sizes (above) for manual, semi-automatic, or automatic use.

The microscope

A microscope magnifies the image in two stages. The first magnification comes from the objective lens, positioned close to the specimen. This lens is engraved with its magnifying power, generally ranging from x4 to x100. The primary image projected by the objective is then magnified a second time, by the eyepiece; this is also marked with its magnifying power, between about x5 and x20. The total magnifying seen by the eye is the product of the objective and the eyepiece magnifications; for example, a x20 objective and x10 eyepiece would combine to give x200 magnification.

For photomicrography, a special camera attachment is invaluable, allowing focusing adjustment and a light-tight fit. With the camera lens removed, the magnified image from the eyepiece is projected onto the film plane. When changing from visual focusing to the camera, some adjustment is necessary – either the eyepiece lens must be moved higher, or the objective must be focused further away from the specimen.

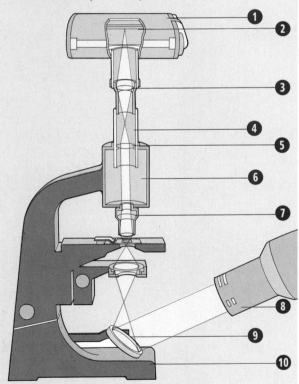

1 Camera	**6** Body tube
2 Film plane	**7** Objective lens
3 Eyepiece eye lens	**8** Lamp
4 Eyepiece	**9** Mirror
5 Eyepiece field lens	**10** Base

Photomicrography

At reproduction scales greater than about 20:1, the normal optics used in camera lenses, and normal lighting techniques, become inadequate. A microscope is needed, and although some of the advanced techniques are complex, basic photomicrography is within the reach of the non-specialist.

At these high magnifications, microscope optics give the best image quality. The camera, therefore, should be attached without its lens, and microscope adaptors are available for this. Only an SLR camera with removable lenses is practical. The camera's TTL metering system can still be used, although if flash is used as the illumination, some testing will be needed.

The principal microscope lens is known as the objective, and its two most important qualities are magnification and resolving power. The magnification is normally between 5x and 100x, but a second lens, in the eye-piece, enlarges this further. Eye-piece lenses are normally between 5x and 25x, and the total magnification is that of the two lenses multiplied together. The resolving power is the ability of the lens to distinguish fine detail, and is measured as the numerical aperture, or NA. The highest normal NA is 1.0.

At high magnifications, lighting affects image quality. The sub-stage condenser (so called because it is underneath the stage where the specimen is mounted) focuses the light and is a part of the microscope's optical system. The actual lighting, normally tungsten, may be separate or built into the microscope, and often has a diaphragm to control the size of the beam.

The basic method of lighting is known as brightfield illumination. In this, the light shines up through the specimen, and the background appears white. The light source must be centred and focused so that the illumination is even across the picture area. Use the camera's TTL meter as a starting point for the exposure, but make a series of tests. Lock the mirror up in a SLR to lessen the vibration, and use a cable release.

Darkfield illumination gives better contrast to some specimens, and is normally achieved by blocking the light from directly behind the subject. A darkfield stop, as it is called, effectively turns the light source into a ring surrounding the specimen to give a kind of rim lighting. The effect can be striking, but the light level is reduced considerably.

Special films are available for photomicrography, giving extremely fine grain and high contrast, but a normal high-resolution camera film is perfectly adequate for most circumstances. The colour balance of the film should be matched to the light source.

Dolerite sample This image of a crystal specimen clearly demonstrates the dramatic colour effects that can be achieved by use of polarizing filters in a microscope.

Water flea with winter eggs Using darkfield illumination, this flea (right) was photographed with electronic flash to freeze movement. The eye-piece and draw-tube of the microscope were replaced by a bellows to adapt it for a reflex camera.
Leica, Ektachrome, image magnification x8.

Underwater

- Camera equipment
- Underwater optics
- Flash techniques
- Natural light

Although serious underwater photography at a reasonable depth and for prolonged periods still remains a specialized field, and needs scuba-diving techniques, shallow waters are accessible to most people. The range of camera equipment available includes not only housings for standard SLRs, but amphibious models of varying degrees of sophistication. Many of the exposure uncertainties that once severely restricted casual underwater photography have now been removed by automation. This, together with the new popularity of underwater tourism, makes this a rewarding field.

Equipment

There is a wide range of equipment available, but the basic choice is between submersible housings for standard cameras, and amphibious cameras that are themselves sealed against water at pressure. Submersible housings have certain advantages. One is that, although the initial expense can be high for a metal housing, plastic housings are quite moderately priced and there is no need to buy extra camera equipment; the existing camera and its range of lenses can be used. Indeed, the range of focal lengths is another advantage, as is the ability to use an automatic camera's existing functions, including exposure metering and film-winder. Against this, housings are necessarily bulky, and if the optics of the port (in front of the camera lens) are not the best, image quality suffers. Also, careless assembly can cause leaks that could effectively write off the camera.

Amphibious cameras, of which the Nikonos has been the pioneer and prime example, have the advantages of being compact and purpose-built. The special optical problems of working underwater give a theoretical advantage to lenses that are computed for submerged use, and amphibious camera controls are deliberately simplified – ease of use is an important consideration when shooting underwater, where so much of a photographer's attention is taken up with diving. The Nikonos accepts a range of water-contact lenses of different focal lengths. The disadvantages of amphibious cameras are the non-reflex viewing, which causes complications with framing until the photographer is experienced, and the additional expense.

Flash is essential for virtually all underwater shooting, as the section on optics below explains. There is a range of automatic and semi-automatic underwater flash units available, most mounted on jointed arms so that they can be fired from at least a short distance away from the camera to overcome back-scatter – the reflections from particles suspended in the water.

Natural light underwater

Water modifies sunlight in several different ways (below). Some is reflected back from the surface, more when the water is choppy and the sun is low. The surface also tends to diffuse the light. As the light rays penetrate deeper, they are scattered by suspended particles and vibrations, which reduce their intensity and the colour saturation. In addition, light is absorbed by water, so that at great depths there is virtually no illumination. This absorption affects different wavelengths at different rates; red is absorbed before any other colour, and red filters of different strengths are needed to correct this deficiency in natural light photography.

Starfish Taken in Ibiza while snorkelling, this is a double exposure of the same frame; the starfish and the sun were photographed on separate occasions.
Starfish shot: supplementary close-up lens, ¹⁄₆₀ sec., f16. Sun shot: 15mm lens, ¹⁄₁₂ sec., f22

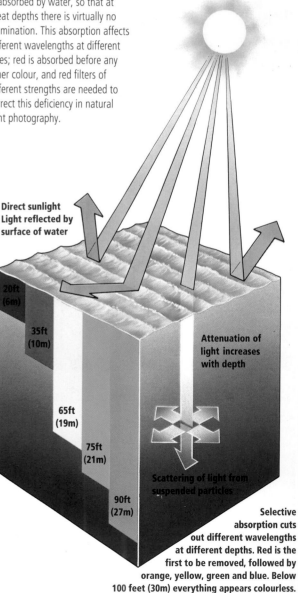

Direct sunlight
Light reflected by surface of water

20ft (6m)

35ft (10m)

65ft (19m)

75ft (21m)

90ft (27m)

Attenuation of light increases with depth

Scattering of light from suspended particles

Selective absorption cuts out different wavelengths at different depths. Red is the first to be removed, followed by orange, yellow, green and blue. Below 100 feet (30m) everything appears colourless.

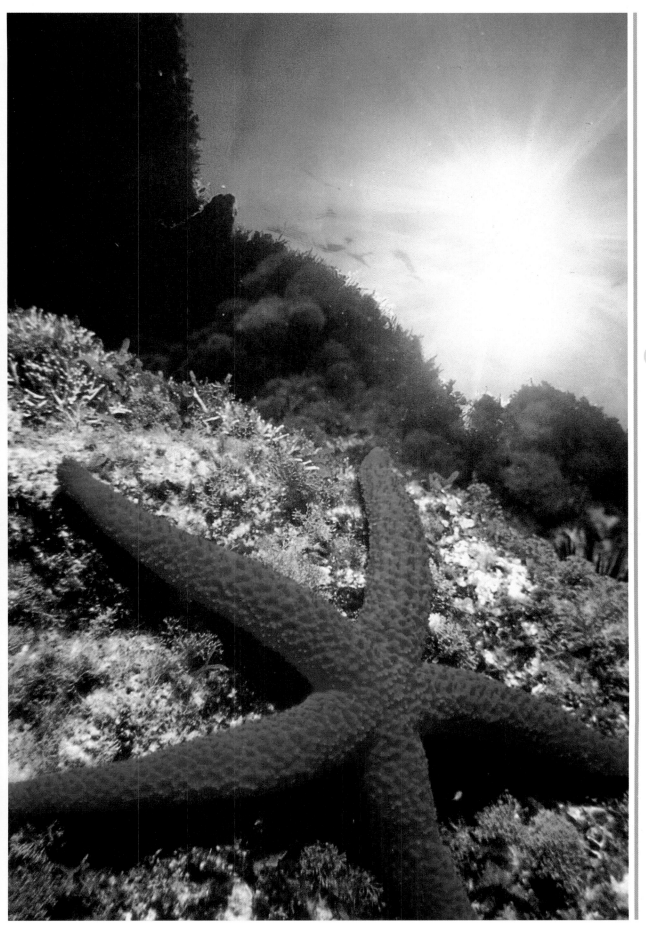

Red fish with soft coral
Although it looks bigger, this fish is in fact only 2-3cm (about 1in) long. The photograph was taken very close to the subject with the lens on minimum focus.
Nikonos III with a flashgun, 1/60 sec., f22

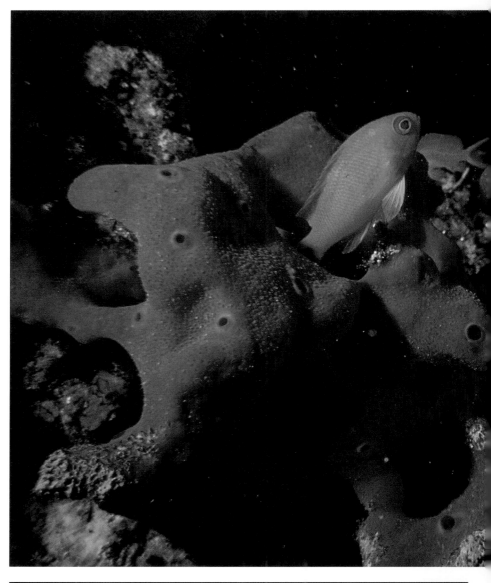

Sea urchin This close-up of a sea urchin was taken in Plymouth, England.
Nikonos III with a flashgun, 1/60 sec., f22

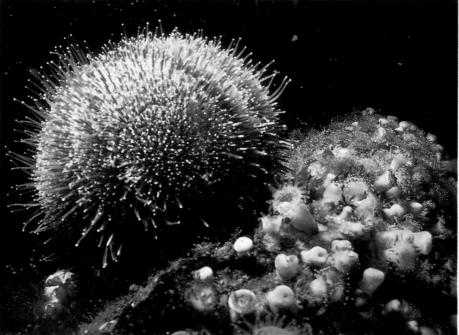

Underwater optics Refraction has the effect of making objects underwater appear to be one quarter closer than they actually are (top). This basic characteristic also makes objects appear to be larger than they really are, by one third. The simplest solution is to move further back by one quarter. A further related effect is that the in-air angle of coverage of a lens is reduced by one quarter (above). The focal length does not in fact change, although the narrower angle may give this impression.

1 Actual distance
2 Apparent distance
3 In-air lens coverage (46°)
4 Underwater lens coverage (34.5°)

Underwater optics

Just as glass has a higher refractive index than air (see Forming an image in Part 1), so does water. Water has a pronounced optical effect. A stick dipped into water at an angle demonstrates this – it appears bent and foreshortened in the water. In effect, the water behaves as an extra lens in underwater photography, the most important results being that objects appear to be one quarter of the distance closer than they really are; objects appear to be one third larger than they really are; and the angle covered by any lens is one quarter less than it would be in air.

These effects are interrelated, and when shooting, the most obvious is probably the last one; a 35mm lens, for instance, which normally has an angle of coverage of 62°, covers only 46° underwater – equal to the coverage of a normal, 50mm lens. In practical terms, what was a wide-angle lens becomes significantly less so. Naturally then, as it covers a smaller angle, objects fill more of the frame, and seem closer.

Amphibious cameras and their lenses are built to take care of this, the controls and viewfinder being calibrated to take account of the refraction. With a standard camera in a housing, however, these optical effects are very noticeable. The design of the housing's port makes an important difference. A flat port does nothing to correct the refraction, and in addition tends to exaggerate various optical faults: chromatic aberration (see Forming an image in Part 1) increases, resolution falls off towards the edges of the picture frame, and pin-cushion distortion (see Extreme wide-angle lenses in Part 1) occurs.

The solution is a curved or dome port. This acts as an extra-large negative lens, correcting the refraction so that the lens angle of coverage – and therefore the apparent size of the subject – is restored to what it was in air. In doing this, however, it introduces a new effect: the object being photographed appears even closer. In order to be able to focus properly, particularly on distant objects, most lenses need to have either a plus-diopter supplementary lens or a thin extension ring attached. Dome ports also correct some of the chromatic aberration, loss of sharpness towards the edges, and pin-cushion distortion.

Water also absorbs much of the light entering it. This is partly due to the surface of the water reflecting sunlight back into the sky (particularly in rough seas), and

Underwater equipment

Underwater flash Electronic flash is increasingly more common than bulb flash, now that electronic units are more reliable. Most electronic flash units use rechargeable nickel-cadmium batteries and can therefore remain factory sealed; a few units are available with replaceable batteries, but these tend to have a lower output. Jointed arms on the flash allow different lighting angles. Bulb flash holders have the advantage of simplicity and power, although they are slow to use repeatedly. An inexpensive alternative to a purpose-built underwater electronic unit is a custom housing for an ordinary pocket flash.

Underwater camera The Nikonos is the latest professional underwater camera from Nikon, and accepts interchangeable lenses from 15mm to 80mm. The body is fully watertight, and features through-the-lens exposure metering. The lens units are interchangeable, and some (which have not been completely corrected for close-focusing underwater) can be used on the surface, also making the camera practical in wet or dusty conditions in general photography. Because of the camera's small size, a hand-grip is a useful accessory.

Camera maintenance

1 Check out a new housing by taking it underwater without the camera inside. Salt water will damage most cameras permanently.
2 It is not enough just to rinse the camera/housing in fresh water after each diving session. Dried crystallized salt can penetrate the screw threads and O-ring grooves, and can eventually cause leakage. Soak the equipment for at least half an hour in fresh warm water.
3 Coat all screws, threads and the O-rings with special O-ring grease. Check O-rings constantly for grit and sand.
4 Ports are easily scratched. Protect them with a soft cover.
5 You may have to "trim off" the weight of the housing so that it balances in your hand; do this by taping small weights inside.
6 Rinse salt water out of your hair and hands before unloading or disassembling.
7 Never leave equipment in the sun; apart from the damage this can cause to the film, it can cause the O-rings to expand and encourage leakage.

Cast aluminium housing The most rugged and expensive housings are made from cast aluminium. This Hydro 35 case (right) made by Farallon/Oceanic Products accommodates the camera's motor drive. Because the face mask and housing make it difficult to get close to the camera body, a magnifying prism viewfinder is normally fitted. Waterproof light meters are available from some manufacturers. An alternative is to fit a surface light meter into a custom housing.

partly to particles in the water scattering light. Not only does water absorb light, it does so selectively, by wavelength. The first wavelengths to be absorbed, at even shallow depths, are at the red end of the spectrum. Lower down, yellow is absorbed, then green, leaving only blue at great depths. All of this – less light and loss of colour – limits natural-light photography underwater. Colour compensating filters can correct the colour absorption only to about 10m (30ft) conveniently. In practice, the only way to restore colour to underwater scenes is to light them, and for this reason flash units are essential.

Flash techniques

Electronic flash is relatively straightforward to use underwater, provided that the flash is positioned away from the camera. The reason for this is back-scatter, which is the snowstorm effect caused by reflections off particles; it occurs when the light comes from close to the lens axis. The usual system is for the flash to be mounted on an arm and aimed from above and to one side of the camera. The advantage of this is that the photographer quickly becomes familiar with the lighting direction. Alternatively, the flash can be held at a greater distance on a coiled extension cable, preferably by a diving companion. An additional flash, triggered in sync by a photo-cell, gives more elaborate lighting possibilities. For close-up work, reposition the flash-head.

Natural light

Photographing by natural light is quite possible at shallow depths, and indeed is the only way of shooting underwater landscapes. The best weather conditions are bright sun, clear sky and calm, clear water. A wide-angle lens has the advantage of giving an apparently clearer image than does a longer focal length lens, as even the clearest water has large numbers of particles that degrade the view. In principle, one of the most effective types of composition is to shoot quite close to an interesting foreground, such as coral, and include some of the underside of the water surface. This gives both depth and contrast. A wide-angle lens is also less susceptible than a normal lens to camera shake, which can easily be caused by water currents and a slight negative or positive buoyancy – one hand is sometimes needed to hold on to coral or rock.

Even so, the light levels reduce the possible depth of field and call for slow shutter speeds, while a colour compensating filter is needed according to the particular depth. In many ways, underwater landscapes by natural light are best combined with flash for the foreground. The foreground colours are then bright and normal, and their contrast with the blue cast of the distance is both acceptable and attractive (use no colour compensating filters with flash).

Moulded transparent housing The most common style of housing is a contoured case made from a moulded transparent material such as the GE Lexan used in this Ikelite range (above). Gear wheels fixed to the lens controls are connected to external controls to allow focus and exposure adjustments underwater. With these housings, white numerals and lettering on the front of a lens will, under certain conditions, reflect back off the port onto the film, so it is advisable to black them out with paint or black tape.

Soft vinyl housing The simplest underwater housing is a soft vinyl bag with a built-in glove and flat port (above). Models like this EWA-Marine are inexpensive, and will accommodate most cameras, although they are safe only down to 10m (30 feet).

Action

- Timing
- Shutter speeds
- Sequences
- Slow-motion photography

Stopping a moment in time is at the heart of still photography. When the action in front of a camera is fast, a photograph does more than just preserve a remembered scene – it reveals an image that the eye alone cannot appreciate. One of the earliest and clearest examples of this was the famous sequence of a galloping horse photographed in 1878 by Eadweard Muybridge. Muybridge was employed to do this to settle a bet made by his sponsor as to whether all four of the horse's legs were off the ground at the same time. They were, but it took a photograph to prove it.

From this basic ability of a camera to freeze a moment in time springs a range of skills for dealing with fast action. In some ways this could be considered more of a technique than an application, but there are certain areas, notably sports, which rely on the treatment of motion and are at the same time coherent fields of photography. Fast action has special characteristics, and to capture it well requires fast reactions, a knowledge of the ways in which camera and film respond to movement, and an appreciation of the structure and tensions of the action itself.

Timing

Because the slices of time in action photography are so short, a sense of timing is more critical here than in almost any other field. For the photographer, anticipation is the primary skill. The time available for shooting many sports events, such as when a high-jumper clears the bar or a goal is scored in football, is extremely compressed, and the photographer has to be completely prepared. This involves a combination of two things: familiarity with the camera equipment so that there is no technical delay in shooting, and familiarity with the particular event. Different sports or action sequences have their own characteristics. Thus, the high-jump is a repeated action and follows a set sequence. Having watched a few, it is fairly straightforward to predict when to shoot. A goal in football, however, is much less predictable, and even though it is likely to occur only at certain points in the game, it still takes most people by surprise.

In addition there are clearly certain instants within a sequence of an action that convey its essence better than others. If the action is continuous for most of the time, as in a race, this instant is the one that conveys the sense of movement. If, on the other hand, most of the activity leads up to a burst of action, as in basketball, then there is likely to be a peak instant – for example when the ball is about to be dropped in the basket.

In a way, this is an extension of the "decisive moment" that has influenced so much of classical reportage photography. And, just as there are different decisive moments for different reportage photographers, so the key moment in action photography depends partly on how the photographer sees and reacts to events. There is nearly always a subjective decision involved in choosing the instant to shoot.

One of the favourite moments is the peak of the action – the moment that is crucial to the nature of the event, such as a knock-out punch in boxing. Another is the tense momentary pause just before the release of rapid or

White-water rafting
The shutter speed needed to freeze all the action in this medium-telephoto view of rafting on the Rio Grande River was a moderate $\frac{1}{250}$ sec. – the important speed is that inside the viewfinder frame. Shot from much closer, the moving limbs would have needed at least $\frac{1}{500}$ sec. *180mm lens, Kodachrome ISO 64, $\frac{1}{250}$ sec., f8*

Boxers Fast action in low light can only realistically be handled by flash, and the classic situation is a boxing match (above). On-camera dedicated flash is the practical solution.

The start of an event At the start of the women's 100-metre pre-Olympic heat at Lille, the photographer has carefully chosen the position that will show most of the contestants in one frame – slightly ahead of the start line. With a medium telephoto lens, and needing a fast shutter speed to freeze the burst of movement, there is no possibility of any worthwhile depth of field, and the photographer has wisely chosen to pre-focus on one runner.

Corraleja This sequence was taken at a popular regional event in Colombia, where the public tries its luck with local bulls. A charge like this one starts very suddenly, so I had to be ready. I focused on the bull the whole time and pressed the motor drive trigger, set for continuous operation at 3 frames per second, as soon as the charge began. It was important to keep a check on how much film was left in the camera.
Nikon, Kodachrome, 1/500 sec., f2.8

Time-lapse photography

Time-lapse photography is a form of sequence that takes place over a long period of time, often hours or days. Although the sequence can be triggered manually according to a schedule decided in advance, the ideal equipment is an intervalometer, which automatically triggers the shutter at set intervals.

violent action, when the energy of the participant is coiled up like a spring ready to unwind in an explosion of movement. Examples of this are a sprinter on the running-blocks at the start of a race, or the concentration of a weight-lifter immediately before a snatch.

Some moments are, by their nature, unpredictable: a unique, or at least unusual, expression or action that needs luck and quick reactions on the part of the photographer. Then there is the moment away from the main event and principal action, often behind the scenes. A boxer in the dressing-room, a runner after the race: at times like these, contestants can show every type of reaction and emotion, from catharsis to exultation.

Fast shutter speed

The normal way of treating fast action in photography is to freeze it, using not only a sense of timing and an effective viewpoint, but a shutter speed appropriate to the situation. The factors involved in choosing shutter speed (see Shutter) are of critical importance in most sports photography. Ideally, the shutter speed should be just fast enough to stop only those elements that are essential, and no more than that. If, for instance, 1/500 sec will freeze the movement of a high-diver, using 1/1000 sec or 1/2000 sec means less depth of field or a grainier image (because of the need for a faster film). As in much of wildlife photography, there is competition between several picture qualities. Shutter speed usually has priority, but there is no point in sacrificing the other qualities unnecessarily.

Apart from the obvious mechanical limitations of maximum lens aperture and film speed, the actual shutter speed necessary depends on the sports event itself and on the viewpoint. The nature of the action varies between sports. Jerky action, such as in a football game, needs higher shutter speeds than smoother, more predictable movement, as in a track race. One reason why races can be handled with slightly slower shutter speeds is that, from an appropriate viewpoint, the camera can be panned to follow a subject. This, as in photographing birds in flight (see Wildlife), simply involves keeping the subject in frame, and in focus, and because the position in the frame is more or less stable, shutter speeds of as low as 1/250 sec or 1/125 sec can sometimes be used.

An auto-focus lens in these circumstances – as indeed in all action photography – has an undeniable advantage. With a manually focused lens, the alternative techniques are either continual refocusing as the subject approaches, or pre-focusing on a particular position on the track (track markings aid this). In races, one of the most favoured camera positions is head-on to the participants.

Slow shutter speed

While a clear, frozen moment is the expected treatment, it is by no means the only way of handling movement. In situations where the details of what is happening are less important than the flow of action and the sense of movement, it can be more effective to use a deliberately slow shutter speed that will record some of this as a blur. A moderate shutter speed used while panning will retain some of the sharp details of the subject but set it against a horizontally streaked background, which can give a strong feeling of speed as well as isolating the subject visually. The techniques for panning are to use a tripod

Moments off An injured footballer doubles up with pain during the 1990 World Cup match between Belgium and Uruguay. Although a break in the game, moments like these are nevertheless very much a part of the event. A long telephoto and fast film – standard equipment for football matches – were used.

Camera position and lens
Covering a motorcycle event, the key pictures are likely to be frame-filling shots at the bends. Left, the riders bank to the full extent, while the slower speeds are a bonus for the photographer.

The unpredictable moment
Although the goal mouth is the most likely focus of intense action in soccer (and for this reason a prime position for professional sports photographers), the situation is always charged with uncertainty. At the 1990 World Cup in Italy a spectacular flying save by the goalkeeper (right) is caught only by the photographer's understanding of the game and very fast reactions.

Slow-motion photography

Slow-motion photography with much slower shutter speeds – ½ sec and longer – gives effects that are not easy to predict, but at their most successful can convey grace and liquidity of motion. As with a fast shutter speed, it is the combination of the actual speed with the movement of the subject in the picture frame that controls the effect. As this effect is pictorial rather than informative, the technique is very much open to experiment. Locking the camera on a tripod so that only the movement records as a blur against sharp surroundings is one method; another is to hand-hold the camera and deliberately allow camera shake to play its part – this often works best with a telephoto lens. Here, non-reflex cameras are at an advantage, as they permit viewing during the exposure. Slow-motion photographs of this kind generally work best in colour, as the difference in hues helps to separate the elements of the picture.

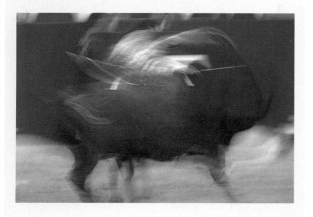

with the head loosened or, if hand-held, to move the body rather than just the hands. Depending on the subject, try a shutter speed of between 1/125 sec and 1/30 sec.

Sequences

Although some key moments leave time only for a single shot, others are extended and, if the view remains clear allow continuous shooting over a few seconds. In a piece of action, the normal technique is to take a rapid series of exposures simply to produce one good image. Nevertheless, if the extended action is sufficiently interesting, or has a conclusion, it may justify being treated as a sequence. Sequence photography is a succession of shots, normally on adjacent frames but occasionally as a multiple exposure on one frame. Similar in a way to a strip of motion picture film, it describes the action as it unfolds, rather than taking a slice from it.

If the action is fast, a motor-drive is essential for this kind of sequence. Set for continuous operation, most standard motor-drives allow rates of fire of up to five or six frames per second, but the more common winders are slower. Non-reflex cameras are easier to use because there is no interference with the view as the sequence is triggered. With an SLR camera, the flickering of the mirror can be distracting enough to affect focusing.

Some cameras have a lever or button that prevents the film from being wound on and so allows several exposures on one frame. Multiple-exposure shots require planning, as not only is there a risk of the overlapping images confusing the event, but each successive exposure potentially lightens the image. The most effective treat-

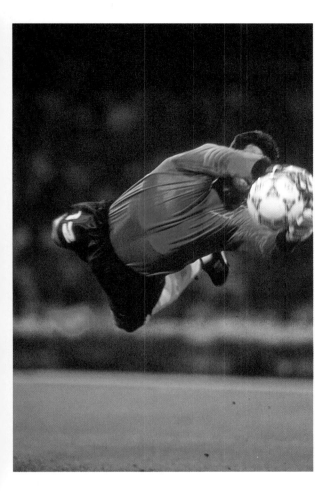

Panning

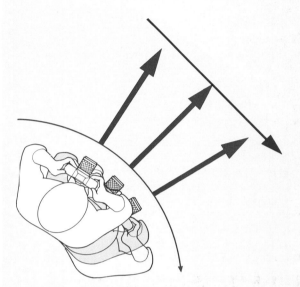

With the focus set at a fixed distance which the moving subject is expected to cross (above) you can be reasonably certain of one, but only one, sharp image. Pan by moving the whole upper half of the body, keeping the arms steady.

ment for multiple exposure is against a black background in a controlled situation, such as a studio. The principles of multiple exposure explained apply here. Stroboscopic lighting is designed expressly for this kind of image, emitting a rapid sequence of flash pulses. In a darkened setting, the camera shutter is left open while the stroboscopic flash fires a burst of up to 20 flashes per second. The effect depends on the relationship between the speed of the movement and the rate of flash pulses. Ideally, there should be a closely-spaced succession of images across the frame, adjusted by setting the flash rate to match the speed of the action. If the subject moves across the frame, and there is hardly any overlap between images, the exposure will be the same as for a single flash exposure. With the famous image of the golfer, the exposure setting was a compromise between the body of the man (over-exposed because each successive flash added to the previous one) and the club and ball (which in each position are lit by only one flash pulse).

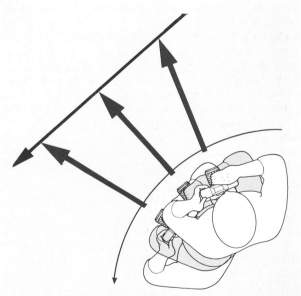

More picture opportunities are possible by continuously re-focusing the lens (above). Revolve the focusing ring beyond the distance of the subject after each exposure and work back to sharp focus by progressively finer adjustments.

Aerial

- Equipment checklist
- Flying technique
- Camera technique

Aerial photography offers a fresh perspective on landscapes and settlements – not just from a visual point of view, but also on the way people live and their relationship with their habitat. Although it is no more than a working tool for surveyors, planners and so on, it can also be, in the words of Georg Gerster, the doyen of aerial photographers, "a new training in observation, an unusual school of vision; to the concerned contemporary it is a mirror in which he can see himself as part of his terrestrial environment".

Flying technique

The ideal camera platform is either a single-engined, high-winged aeroplane or, more expensively, a helicopter. Cost is, in any case, a prime factor in planning an aerial shoot, making it important to get the maximum photography time from a flight. Although for manoeuvrability nothing beats a helicopter, hiring one can cost around ten times more than a fixed-wing aircraft, and a small helicopter will be slower in direct flight, taking longer to reach the photographic target. In addition, helicopters are best not used when hovering, as the increased vibration increases the risk of camera shake.

Among fixed-wing aircraft, high-winged models such as a Cessna offer the advantage of a less restricted view. In any case, always make sure that it is possible to either open a window or remove a door – there is no point whatsoever in attempting aerial photography through glass or plastic. Not all pilots appreciate this. With the window or door open, beware of the slipstream – use the camera strap to avoid the expensive consequences of having it whipped out. The noise is also likely to be considerable, and it may be easier to brief the pilot beforehand, on the ground. Retractable wheels increase the angle of view, and therefore the range of focal lengths that can be used; check which wide-angle lenses can be used without including wings or undercarriage in the shot.

For vertical and near-vertical shots, the aircraft will have to be banked. One technique is to side-slip the aircraft by reducing throttle, banking slightly and slipping it towards the target. Another, which allows a faster return to the best position, is for the pilot to circle the target tightly; the angle then allows a continuous view. For mountains, which may be higher than the aircraft, the pilot should bank away, thus raising the wing-tip out of view. This allows only a second or two for shooting.

The flying height depends not only on the weather conditions, but on the type of subject. In general, however, the lower the better for a clear view, such as between 300m (1000ft) and 600m (2000ft). The closer to the ground, the less the effect of haze and so the stronger the colours and the contrast, exactly as in underwater photography.

Grand Canyon and aircraft
Another light aircraft below the photographer's Cessna lends the essential scale to this aerial view of the Grand Canyon, a wide-angle lens was necessary to take on the width of the canyon, and the exposure was timed for the moment at which the lower aircraft crossed an area of shadow.
20mm lens, Kodachrome ISO 64, ¹⁄₅₀₀ sec., f3.5

Equipment checklist

1 Two camera bodies, both fully loaded to cut down film changing time in the air. Single lens reflexes are preferable for precise framing.

2 Motor-drive for one or both bodies.

3 Lenses: a normal lens (50–55mm) and a wide-angle lens (possibly 24mm or 28mm) are the most useful. A moderate telephoto lens such as 135mm can be used on occasions, but it needs a high shutter speed, and sometimes registers areas of soft focus on the film due to rising pockets of moist air.

4 Neck or hand strap – in either case, attach to the waist rather than the neck.

5 Lens hood.

6 Filters: B/W – yellow, deep yellow and red are the most useful for minimizing haze;
colour – UV and polarizing filters also to cut down haze and increase colour content.

7 Film: most aerial photography is in colour, but there are of course, equally good possibilities in B/W. In either case, a fine grain film is important for preserving detail. An exception to this is infra-red film, which records more detail through haze than the eye, and at a higher contrast. 35mm infra-red colour film was originally designed for aerial survey work and can produce some remarkably beautiful images, particularly of forests.

Camera technique

The scale of relief in most landscapes seen from the air is quite limited, and sunshine is nearly always preferable because of the better contrast that it gives. Early morning or late afternoon, when the low rays of the sun bring out texture the most strongly, are normally the ideal times. You will need visibility of at least 10 miles (16km) under a clear sky with no more than scattered clouds. A light wind to blow away smoke and fog improves conditions even more. Because there is no need for good depth of field, even at a relatively low altitude such as 300m (1000ft), it is normal to shoot with the aperture wide open to allow a fast shutter speed. Not only is there vibration within the aircraft (and for this reason it is safer not to rest arms, hands or camera on any part of the airframe), but the buffeting from passing air when holding the camera out of a window can be severe. A shutter speed of 1/500 sec is normally perfectly safe, and slower speeds are practical with wide-angle lenses, which are less prone to camera shake. Greater care is needed with a telephoto lens, not only in holding the camera steady, but in focusing. At low altitudes with a focal length of, say 150mm, focusing on infinity will give a slightly soft image; it is not easy, however, to judge sharp focus if there is significant vibration or buffeting.

As the best camera angle for a subject often occurs for just a few seconds during a pass, a motor-drive or rapid winder is a decided advantage. Aerial photography encourages fast shooting, and with good picture conditions below the aircraft, it is easy to work through a roll of film in less than a minute. An automatic rewind speeds up the rate of working.

Comoros Islands, Indian Ocean Spectacular volcanic relief and tropical reliefs are the ingredients for this aerial view of the coastline of an island in the Mozambique Channel. The available aircraft was a light helicopter, and to make the most of the scenery, the flight was timed for the half-hour following sunrise. Low sun delineates the geology. To reduce the effects of haze, apparent even this early in the heat of the tropics, a wide-angle lens was used from a height of about 600m (2,000ft).
20mm lens, Kodachrome ISO 64, ¹/₂₅₀ sec., f6.3

White ibis over mangroves, Florida Everglades Isolated clumps of mangroves are themselves colourful and graphic enough from the air in the late afternoon sunlight (which illuminates the roots). However, a small flock of ibis adds the finishing touch. The light aircraft, a Cessna, had to circle several times to achieve the right juxtaposition of birds and swamp.
180mm lens, Kodachrome ISO 64, ¹/₂₅₀ sec., f4

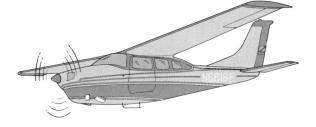

The aircraft The ideal light aircraft for aerial photography has a high-wing design for an unrestricted view. If the windows or door cannot be removed completely, the port window, at least, can be opened fully – in flight, air pressure will hold the window firmly against the underside of the wing. Some aircraft have retractable wheels, further increasing visibility.

Architecture

● Viewpoint
● Using a shift lens
● Interiors
● Archaeology

APPLICATIONS ARCHITECTURE

200

As a description, architectural photography has a highly specialized ring to it, but its subject matter – all and any buildings – is wide enough for it to be of interest to almost all photographers. The essential thing is to appreciate why a particular building was constructed, and how it relates to its surroundings. Good architectural photography recognizes and presents the purpose of a building; it conveys information about the architecture and displays it in a style or atmosphere that suits it. All buildings are constructed with a purpose, which may be as simple as providing shelter, or as complex as conveying a rich religious symbolism.

In terms of content as well as design, architecture is a rich subject for photography, and by treating it sensitively it can be used to reveal aspects of culture and social behaviour, not just the ways in which concrete and bricks are used. Vernacular architecture, from stone cottages in Ireland to adobe houses in New Mexico, often has an intimate connection with the environment and with the way a society works. Prestige corporate architecture may reflect the current version of high style. Religious archi-

tecture follows precepts that may have nothing to do with the practicalities of construction.

Knowledge of the subject is therefore a prerequisite. A particular building may have been designed to be seen from a certain viewpoint, and the perspective and proportions worked out accordingly. There is no compulsion when photographing it to follow this slavishly, but it is at least important to know about it. Understanding and following the architect's intention might lead, for instance, to a view of a European cathedral from a distance that shows it dominating the surrounding town and countryside; or to a photograph of an extension to a public building in a city that emphasizes its continuity and the way that older decorative themes have been picked up and repeated, in the newer building.

Lighting

As with landscapes, lighting is the key to variety of image, and there will be times of day and weather conditions that suit a building better than do others – or at least according to an individual photographer's prefer-

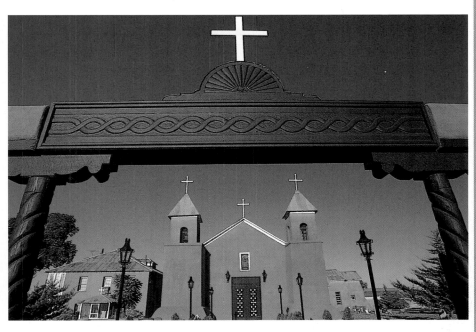

Mount Vernon, Virginia

A viewpoint chosen to show the façade as clearly as possible, lighting conditions that highlight all the main features, and the use of a shift lens to keep the sides of the building vertical, all combine for a classic view of George Washington's home. Without a shift lens, the solution would have been to make more of the foreground.
28mm PC lens, Kodachrome ISO 64, ⅟₃₀ sec., f16

Adobe church, Santa Cruz, New Mexico

One solution to the problem of converging verticals is not to correct them at all, but instead to exaggerate them and work them into the composition. Here, a low viewpoint and wide-angle lens produce the effect; gridlines on the camera's viewing screen helped make sure that the composition was symmetrical.
20mm lens, Kodachrome ISO 64, ⅟₆₀ sec., f22

US Supreme Court, Washington, DC

The foreground steps provide a compositional counterpoint to the columns of the neo-Classical Supreme Court building on Capitol Hill – and also make it possible to avoid converging verticals without a shift lens. The timing was chosen not only for the most interesting shadows, but for the warm tones it gave to the stone.
20mm lens, Kodachrome ISO 64, ⅟₃₀ sec., f8

ences. Often, again as with landscapes, the low-angled sunlight of early morning or late afternoon will bring out form and detail, and can add obvious pictorial qualities. In all cases, however, the decision about the best time to shoot can only be decided by visiting the actual site. Seemingly small details, such as the shadow cast by an adjacent building, or the reflections off a bank of glass windows, can make a substantial difference to the photograph. In city centres, closely packed buildings have effects on the light that are difficult to predict without experiencing them directly. The sun may appear only briefly in the high gap between two skyscrapers, for example, or may be reflected around a corner for just half an hour or so.

The differences in appearance between a cloudy and a sunlit day are usually considerable, and offer some choice, although one that is at the mercy of the weather. A radical alternative, possible with a large number of public buildings, is to shoot at night, under floodlighting. This usually needs a reconnaissance one night beforehand, and it is important to know when the floodlighting is switched on and off. With this option, it may be even more effective to time the shooting for dusk, when there is just enough residual light left in the sky to define the outline of the building and its surroundings. Again, only the specific location will give the answer.

On the smaller scale of a house, it may be worthwhile to arrange special illumination with photographic tungsten lamps, using a longer exposure to overcome the low light intensity.

Village church, Montezuma, New Mexico Here, the verticals remain vertical in a wide-angle view by making use of the foreground. The camera was aimed horizontally, and a position found that included all of the church and a cross in the cemetery to balance the picture. *20mm lens, Kodachrome ISO 64, ⅟₆₀ sec., f11*

Tuscany Most architecture allows considerable choice in the timing of the shot. For this church the viewpoint was obvious, and the slight haze in the sky made it possible to include the late afternoon sun in the frame without sacrificing shadow detail. *28mm PC lens, Fujichrome Velvia ISO 50, automatic setting*

Sovana, Tuscany A viewpoint from across a gorge and a telephoto lens give an alternative way of maintaining the verticals. Clear viewpoints of this type suitable for a long focal length treatment are not always immediately obvious, and can take time to find.
400mm lens, Fujichrome Velvia ISO 50, automatic setting

Viewpoint

For any particular building there are a limited number of viewpoints. Even though there is no guarantee that any of them are completely satisfactory, there are nearly always more possibilities than seem obvious at first glance. The first step in planning an architectural shot is to take time to walk around the building and study it from different angles, anticipating how it might look at different times of day and under a variety of lighting conditions. A close view with a wide-angle lens is usually the most obvious angle to look for, but more distant views with a telephoto lens may be less obvious. One method of checking these out is to see from the building itself what viewpoints, such as balconies on other buildings, open spaces or hilltops, are visible.

Think not only about a general view, but search out details, both decorative and constructional. These, whether gargoyles on the buttress of a cathedral or the jointing of stones in a wall, can enhance the photographic interpretation of a building. Ultimately, find a balance between the informative record-taking imagery and the subjective view. Much modern architecture lends

Shift lenses

The coverage of a regular camera lens is a circle just large enough to take in the film frame; there is no need for it to be any bigger. A shift lens, however, covers a considerably wider circle. As the lens is shifted in one direction or another, it brings a different part of the image into the frame. The main use of this lens is in architectural photography, to preserve the verticality of a building's walls.

Normal lens

Corrective lens

Reflected buildings, down-town Phoenix Glass-walled office buildings that are coated to reflect heat offer this kind of picture possibility (above), which makes a change from the normal, straight treatment of architecture. *105mm lens, Kodachrome ISO 64, ¹⁄₆₀ sec., f16*

San Francisco Using the metallic side panel of a truck and a tightly-framed composition, this view in the business district of San Francisco (right) is deliberately abstracted. *35mm lens, Kodachrome ISO 64, ¹⁄₃₀ sec., f19*

way in which the image is projected onto the eye's retina as well as onto the film, the brain accepts this distortion from experience and ignores it – except in a two-dimensional image. There are occasions when, by making the convergence deliberate and extreme, using a wide-angle lens tilted strongly upwards, the effect can be dramatic. When the convergence is more moderate, however, it can simply look like a mistake.

There are a number of different solutions to this problem. One is to find a higher camera position, such as from part of the way up a building opposite, so that the camera does not have to be tilted. Another way of reducing the angle is to shoot from further back, using a telephoto lens to fill the frame with the building. Both of these techniques, however, depend on available viewpoints and accessibility. A more generally useful approach is to use a wide-angle lens, but you need to find foreground elements (such as a fountain, some flowers or a sculpture) that allow a workable composition with the camera aimed horizontally. Technically the best, but certainly the most expensive solution is to use a shift lens.

itself more readily to expressive photography than does, for instance, European classical styles.

Distortion

One special problem of architectural photography is avoiding the kind of perspective distortion that in most other fields is hardly even noticeable. What makes buildings so prone to it is the regularity of their lines: most have vertical walls and a large number of other vertical lines. Viewpoints, as already discussed, are nearly always limited for a particular building, and the majority of obvious – or at least, convenient – camera positions are at ground level and fairly close. This inevitably means that for a normal, frame-filling view with an ordinary lens, the camera has to be tilted upwards in order to include the top of the building.

The result of this is to make the vertical lines of the building appear to converge, and is a perfectly normal perspective effect. However, even though this is just the

Architectural details The details of buildings, particularly decorative ones, can make compelling images in their own right. For all except those at ground level, a telephoto lens is the easiest way of selecting a detail.

Ballroom, Stanton Hall, Mississippi This beautifully preserved ballroom in one of the South's major ante-bellum houses retains all the flavour of its past. As in many well-designed interiors of the period, the natural lighting is well balanced even when you are facing towards the windows at midday, and no additional lights were needed. The chandeliers were lit only to help balance the composition.
28mm PC lens, Ektachrome Type B ISO 64+85B filter, ½ sec., f16

Interiors

Interior shots are integral to architectural photography, but require different techniques, notably lighting management. Space restrictions make a wide-angle lens essential; apart from close-ups of furnishing and decorative details taken with a more normal focal length, virtually all interior room photography is wide-angle. Because the light levels are lower than outside and good depth of field is nearly always wanted, a tripod is essential.

As with exterior shots, the camera angle must first be chosen with care. Quite often, there is more in a room than can be included in a single view. For this reason, in professional architectural coverage of an interior, such as in a magazine, it is normal to shoot more than one view of each room. In this case, the choice of viewpoints has to give the greatest contrast between the shots.

Camera position: As a general approach, select the position from which the most important elements in a room are visible. In order to include these, the best position is often close to one corner, but with a very wide-angle lens there may be a danger of unacceptably distorted shapes close to the edges of the frame. Circular objects, such as round tables, are particularly susceptible to this, and it may be necessary to rearrange some of the furniture. Another reason for moving things around is that, to our eyes, a room usually appears tidier than it really is; to achieve the same impression in a photograph, the interior can benefit from cleaning and tidying.

Lighting: While it may not be necessary for the photographer to light a room, the lighting must be assessed and balanced. The choices usually lie between mainly natural lighting, ambient artificial lighting and redesigned lighting with photographic lamps. There are various combinations of these, but an early decision should be whether to capture the effect of the existing lighting, or to alter it. Consider the mood and effect of the interior. Perhaps the very unevenness of the lighting gives the interior a special atmospheric quality. This may well be true in many

National Cathedral, Washington, DC To emphasize the vaulting of the high nave, which makes such a strong, immediate impression on entering the cathedral, the camera was tilted strongly upwards. Perfect symmetry is essential when framing this kind of wide-angle shot, but it demands great care. The first step is to position the camera on the axis of the building, and to make sure that the top of the frame in particular is not skewed. A grid on the viewing screen helps enormously.
20mm lens, Ektachrome ISO 64+85B filter, 4 sec., f22, tripod

Japanese apartment, west London The rectangular geometry of these transplanted Japanese rooms called for a head-on treatment, with no diagonals. To balance the lighting from the central screened window, two tungsten lamps covered with blue gels were bounced off walls and ceiling close to the camera. *20mm lens, Ektachrome Type B ISO 64+85B filter*

historical buildings; before electricity or even gas-lighting, a good architect designed interiors to work as well as possible with natural daylight. In many modern interiors, lighting design is an essential part of the architectural effect, and it may be important to preserve this. On other occasions, photographic lighting can be used to improve an interior.

Opening doors can help lighten dark areas, as can switching on more of the existing tungsten lamps, but if the aim is to maintain the existing effect, whether in daylight or ambient artificial light, there is still often a need to add some supplemental lighting to fill shadows and control contrast. The imbalance of lighting in most interiors creates a high level of contrast, with pools of light and areas of darkness, but our eyes' rapid ability to accommodate masks this. Film, nevertheless, records it. If the walls are dark, the illumination from a single window falls away rapidly from it.

Interiors with windows

A special problem is including the main window in frame in a day-lit shot, while overcoming the enormous contrast between the outside scene and the interior. Increasing the interior illumination to help balance this is only possible up to a point, and while the flare can sometimes be attractive, if the view outside is important to the photograph, there are two solutions. One is to wait until later in the afternoon, when the exterior light level falls. The other, more complicated and needing experience, is to make two exposures. The first is very short, just for the exterior view; the second, for the interior light level, is made with a sheet of black cloth pinned over the outside of the window.

La Purisima Mission, California A small amount of fill-in lighting was used for the left-hand part of this interior, to balance the mono-directional light from the window – a 1000 watt tungsten lamp and blue gel bounced off the left corner behind the camera. In this way the lighting effect stays natural, and appropriate for this old Spanish mission.

In these conditions, the job of supplemental lighting is to balance the existing illumination, and should never be obvious. A cardinal rule is not to allow these lights to be obtrusive, and this means being extremely careful about shadows. If an undiffused light is aimed into a shadow area from outside the picture frame, the hard shadows it casts will point it out and destroy the illusion of natural lighting. Diffusion is the easiest solution, either by hanging diffusing material in front of the light, or by bouncing light off a wall or part of the ceiling behind the camera. If a part of the interior needs to be lit from inside the picture frame, conceal the added lights in such a way that they could appear to be part of the existing lighting. In a church, for example, lights could be placed behind pillars and facing away from the camera.

Tungsten or flash: Tungsten lamps are usually much easier to use than flash in interiors. As explained earlier (see Studio flash in Part 1), exposures can be adjusted simply by time, whereas extra light output from a flash is only possible by triggering it several times. Colour balance is straightforward as gels can be clipped or taped in front of the lamps; blue gels can raise the colour temperature to match that of daylight. However, for a quick shot a portable flash can be useful, and if the overall light level is low enough to permit a time exposure of many seconds, the flash unit can be triggered separately by hand and from different positions in the room – a technique sometimes referred to as "painting with light".

Archaeology

Photographically speaking, archaeology is a branch of architecture, but with special concerns. Many of the technical considerations – such as dealing with viewpoint and converging verticals – are the same, but the best-known sites are heavily visited and carefully controlled. Permissions may be necessary, particularly if a tripod is used, and visiting times may be restricted. These logistics need to be checked out beforehand.

Usually, one of the key shots for any ancient monument is an overall view that evokes atmosphere. As with any other building, the principal ways of achieving this are through careful choice of viewpoint and good lighting conditions, but it is usually important to avoid including elements that are anachronistic or distracting, such as nearby modern buildings, power cables, and so on. Also, few sites benefit from having tourists visible in photographs of them, and it may take time and patience to have a clear, unpopulated view. Where possible, it may be worth trying for permission to shoot outside normal opening hours. Of course, in a few instances, the great contrast between an archaeological site and its modern surroundings can be exploited for effect.

Prasat Muang Tam, northeast Thailand This view of a ruined stone gateway to a 10th-century temple stresses the atmosphere of collapse and decay while at the same time including some significant architectural details in the foreground. A tight composition makes the most of the leaning walls. Facing west, the obvious time to shoot was at the end of the day.

20mm lens, Ektachrome Type B ISO 64+85B filter, 1 sec., f32

Face-tower, the Bayon, Angkor Lighting, so important in most archaeological photographs, is particularly critical here. The intention was to use a medium telephoto lens in order to crop out the surroundings and fill the frame completely with stone. Given this, the key to the shot was lighting that would catch just the edge of the profile of one of the many face-towers at this monument.

180mm lens, Fujichrome Velvia ISO 50, 1/60 sec., f8

Prasat Phimai, northeast Thailand The sanctuary tower of this important, recently restored Khmer temple is its most significant feature. The viewpoint from the corner of the central courtyard was chosen to give it maximum emphasis (the tower is surrounded by concentric enclosures). The shot was timed to catch the last rays of sunlight .

28mm PC lens, Kodachrome ISO 64, 1/8 sec., f11

Still life

- Composition, props and sets
- Lighting
- Photographing food
- Copying

The still life is the most completely controlled type of image in photography, and demands a rigorous and measured approach. Because of these factors, the scale of the subject matter, and the time normally put into still-life images, most are photographed in studios. Nevertheless, just as in the longer tradition of still life in painting, this field of photography can be practised anywhere, and one distinctive type of still-life image is the found object shot *in situ*.

Because so much depends on the photographer's own ideas, the still life can be a very personal accomplishment. Equally, though, it lends itself well to commercial use; being essentially the photography of small to moderate-sized objects, it is called on frequently as a means of presenting and selling merchandise. At its most imaginative it can enhance the appearance and qualities of objects in an advertising campaign, and is also a favourite vehicle for conceptual imagery.

There may sometimes, but not always, be an idea underlying the still life, and this may be stated obviously, or left to the viewer to discover and interpret. Thus, at its simplest, a still-life image is an exploration of the physical qualities of an object, but techniques such as juxtaposition and lighting can be used to make a point.

Composition

More than anything, the still-life image is an exercise in the arrangement of inanimate objects, and in their lighting. These two skills – composition and lighting – distinguish a competent still-life photographer, while the best in the field use their imagination to create distinctive and original styles.

There is so much room for idiosyncracy that working methods vary greatly, even in the sequence of setting up a still life. Some photographers prefer to have a precise layout in mind before starting, even to the extent of preparing sketches, while others rely on their intuitive ability at the time of shooting. Some construct the arrangement logically, one object at a time, others visualize the image before even setting foot in the studio.

Alternatively, when a photographer is working a commission for a client, the set-up may be planned by an art director, who has the responsibility for making sure that the final pictures meet the client's requirements.

The most common procedure, and the most useful for anyone beginning to explore still-life photography, is to work step by step. In particular, following a sequence in building up the image helps to bring some order to the infinite number of choices. A still life often starts as a completely blank setting, making it easy to get lost in all the possibilities.

Given that the photographer already has the motive for the shot – this may be a particular object or setting, for instance, or a concept that needs to be symbolized – the first step is to define its purpose. This might be simply to present an object as attractively as possible, or to play with certain of its qualities, such as the reflections and refractions from glass surfaces, or it may be to create a certain mood. Try to work out, even if only roughly, a mental image of the shot in advance. It may be better to keep this a little vague, and allow room for exploration.

Collect the ingredients for the picture. These will include the principal object or objects, possibly secondary props to build up the atmosphere or provide graphic counterpoint, and the setting. Settings can be as simple as a plain surface to support the object, to a reconstruction of part of a room. Commonly, they include at least a backdrop and a level surface for the foreground. At opposite extremes are the setting that is plain or abstract, in which the object is isolated, and the setting that is contextually related to the main subject.

If the photographer already has an idea of the lighting style, as an experienced professional is likely to, then this will be roughly set up over the set. Otherwise, ignore the lighting for the time being, and concentrate on the composition. Similarly, unless there is a distinct need for an

Antique spectacles in sunlight Natural lighting conditions often provide visually more interesting conditions than many photographers would develop for themselves in the studio. Low, direct sunlight through a window throws a tight arrangement of shadows and refractions with the inclusion of these spectacles. Such hard-edged shadows come only from a strong point source of light, very difficult to reproduce in a studio.
55mm lens, Kodachrome ISO 64, automatic setting (but with other exposures quite widely bracketed for choice)

Titanium products Conventional area lighting was used for this arrangement of suspended objects made of titanium, in order to give a reflected, metallic, matt sheen. The curved reflections in the lenses echo the frames. To give depth to the image, graduated background lighting was produced very simply by aiming an area light up from the floor onto a white wall.
55mm lens, Fujichrome ISO 50, two studio flash-heads fitted with area light attachments, flash-metered setting f32

Chinese wedding baskets
While it was important for an intentionally documentary shot to show an entire basket, the availability of a pair gave the opportunity to make the composition more interesting by showing two halves and framing tightly. A combination of side-lighting and back-lighting was used, with area lights.
55mm lens, Ektachrome ISO 100, two studio flash units fitted with area-light attachments, and pre-formed translucent plastic table, flash-metered setting f32

Making a colour test To check that the light, background and film are all perfectly balanced, use the basis still-life set described on page 214. Take a Kodak colour separation guide, grey scale, and any familiar handy object. After processing, compare the transparency with the originals. If there is a colour imbalance, use a weak colour compensating filter of a complementary hue (05 or 10 will normally be sufficient strength).

unusual focal length, the basic composition can be made by eye, and refined later with the camera in position. Because of the enormous flexibility in making a still-life arrangement, a normal lens is more usual than an extreme wide-angle or telephoto.

The most common angle of view is moderately oblique, looking down or towards the set, but again this is no more than a convention. A more unusual angle, such as vertically downwards, may be more striking or graphic for certain objects. The decision on viewpoint needs to be made at the start.

If there is one key object, as there often is, this is the first to be placed. Consider the angle it presents to the camera. Continue adding other objects and props, one at

Herbs This shot was taken for a magazine cover illustrating an article on herbal medicine. The only problem was to make a tight pleasing arrangement. The first step was to assemble the principal elements in rough positions. The tubs were to form the background, and the book would dominate the foreground. To fill in the empty space in the lower right-hand corner, the edge of a tub lid was moved in, and some of the other containers re-positioned. To control the verticles, the 35mm perspective-control lens was then adjusted, and as final refinements, herbs were scattered in the foreground and the salt bag cut open to give a more casual feeling.

because everything is under the control of the photographer, there is no excuse for sloppiness. Every aspect of the picture reflects the photographer's decisions. This extends to the choice of objects in the shot: what they are, their style and their quality. In still-life photography, props is the term used for all subsidiary objects – the things that enhance or accompany the principal subject. Although they are not always needed, as for instance when the subject is isolated in a completely neutral setting, or when the purpose is to show an object as found, there are also occasions when a collection of props can itself be the subject. As a still-life image invites scrutiny, it is very important to pay rigorous attention to this selection.

In professional advertising photography, full-time specialists, known as stylists, will provide a full range of props to order. In cities where there is an established photographic, television or movie industry, there are specialized props hire firms. From a large stock, they hire out a wide variety of props for any conceivable use – anything from a stuffed tiger to a quill pen – and charge a rental fee based on the value of the object (and the value is usually the deposit). Some props hire firms specialize, for instance, in food-related items, or weapons, or uniforms. However, constant use of such props can affect their condition, and an object that may look good enough on a movie set may not be up to the standard necessary for the close inspection it is likely to receive in a still-life shot.

Other sources of props are stores and antique dealers, and the usual procedure is to pay a deposit of the full price, refundable less a hire charge when the item is returned. Manufacturers may sometimes be willing to lend products, while cheaper items may be worth buying.

Lighting

The quality of the lighting is always important, and may be the principal element in a still-life shot. There are as many techniques and styles as there are subjects. Certain objects make technical demands on the lighting – to reveal transparency, for example, or to suppress reflections – but the preference of the photographer is the crucial component. In other words, while it may be considered "correct" to use diffuse side-lighting for a standing bottle of red wine (because this is efficient and reveals its shape and reflective properties), a more distinctive and unusual treatment can produce a more powerful image. One of the pleasures of still-life photography is the ability to experiment with lighting that must be created from scratch. There should be no preconceived rules; any lighting is admissible – as long as the image works.

One useful and basic lighting set-up that can function as a starting point for many still-life arrangements is an

a time, if necessary retracing steps. In still-life composition, the addition of each element tends to close off the possibilities, so that the design of the image becomes channelled more and more in a particular direction. Consider at each stage proportion and lines; diagonals, for example, could be used to converge on one point in the composition, drawing the eye to the main subject. At a later stage, the lighting can also be adjusted to direct attention, and this should be borne in mind at this time.

Props and set dressing

Throughout still-life photography there is an underlying element of perfection – in composition, lighting, and technique in general. This stems from the fact that

Creating basic lighting

Take a sheet of white laminate, such as Formica, and place it flat on a table or desk that is significantly smaller in area. Clamp its front edge to the front of the table, then move both back up against a wall, so that the laminate curves naturally up to the wall. The effect is a scoop that is completely neutral in colour and space. Place an arrangement of objects close to the front of the laminate, where it lies flat, and position an area light directly overhead, pointing straight down. This directional but broad light source gives a generally pleasing range of highlights and soft shadow edges, while the white surface underneath throws a considerable amount of light back into the lower shadow areas. Behind, the fall-off of light on the scoop gives the impression of an infinite, horizonless background. If the camera angle is quite low, the top highlights on the subject will appear outlined against the dark background that grades smoothly from the white foreground. Mirrors, foil and white card can be positioned outside the picture areas to reflect light and fill shadows.

This is only one basic lighting arrangement, and by no means a recommendation. Even small movements of the light create significant changes in effect, and it is important to experiment with these until you are completely familiar with them. The selection and arrangement of props also affects the lighting, as does the camera angle (which might, for instance, be directly overhead). Gross movements of the light – used from the side, for example – alter the situation radically, as does the addition of other, secondary lights.

Biology laboratory, Maryland Straightforward back-lighting from a single flash unit was used for this shot of a laboratory worker inserting phials containing blood cells in containers. To provide evenly diffused light, a translucent sheet of Perspex was laid flat over an upward-pointing light (the slight fall-off in illumination top and bottom is due to the wide-angle lens). A silver-foil reflector at right lightened the hand. The electron microscope image of cells on the small television screen was exposed later.

20mm lens, Ektachrome ISO 100, studio flash unit, diffused, flash-metered setting f22

Domesday Book, London

These famous volumes were photographed with a portable lighting set up at London's Public Records Office from where they could not be removed. The arrangement was similar to the basic lighting set-up described opposite – an area light suspended overhead with card reflectors at either side. The plastic laminate base gives a neutral backdrop that absorbs any shadows underneath.
55mm macro lens, Ektachrome ISO 100, studio flash unit, area light fitting, flash-metered setting f22

Burmese lacquer box A single, small (50cm/19¾in square) area light suspended directly overhead illuminates the black, polished surface of this box. Reflectors and secondary lights were deliberately not used, so that the surface qualities are allowed to come across quite starkly. Diffuse lighting from beneath the translucent plastic on which the box sits holds its outline.
55mm macro lens, Ektachrome ISO 400, two studio flash units, area light fittings, flash-metered setting f32

**Swallow-tail joints on
Shaker box** A "semi-found" still
life, this oval box on display in a
Shaker village in Massachusetts
caught the sunlight through an
adjacent window. What raises the
picture beyond a straightforward
detail is the dappling effect of the
imperfect 19th-century window-
panes; the box was also rotated
slightly to position the shadows
precisely.
*55mm lens, Kodachrome ISO
64, ⅟₁₅ sec., f 11*

area light (window light) suspended over the subject. It is
efficient, if sometimes lacking in character, for a surpris-
ingly wide variety of subjects. The size of the front diffus-
ing screen of an area light *in relation* to the size of the still-
life set determines the depth and definition of the shad-
ows; it is normal to use a light that is somewhat larger
than the subject or group of subjects. This enclosed kind
of diffusing head is unsuitable for tungsten, other than
the low-wattage modelling lamp fitted to a flash head.

As an example of a contrasting lighting style, a
focused spot aimed from a distance gives intense high-
lights, and if the angle is adjusted carefully the light will
graze the set. Reflectors or secondary lights opposite can
then lift the shadows. This style has had a considerable
vogue in food photography, where one of the important
functions of the lighting is to reveal and enhance texture.

Still-life lighting is so full of possibilities, and this
freedom is so important, that only a few lighting set-ups
are described here. It would be a mistake to imagine that
there is a catalogue of formula lighting. Daylight, for
example, has marvellous properties, and these occur
partly because of its unpredictability. At one extreme,
the intensity of bright sunlight and deep shadow can be
exploited for a chiaroscuro effect. At another extreme,
the diffusion of indirect daylight gives a soft, enveloping
effect; Edward Weston used just this for his famous
photograph of the green pepper taken in 1930.

Secondary lighting: Secondary light sources are used to fill
shadows more than anything else, but can also add catch-
lights in reflective surfaces, or pick out separate objects.
Reflectors are both an alternative and a supplement to
lights; indeed, if sufficiently powerful they can effec-
tively become light sources. Essentially, a reflector re-
directs light from another source, and can be graded
according to its efficiency. A mirror is the most efficient
of all, and a selection of hand mirrors in different sizes
and shapes is useful. Cooking foil and metal also reflect
quite strongly; if the foil is crumpled, then flattened out
and stuck to a board, it gives a more even, slightly softer
reflection. White card has a gentler effect than all of
these.

When using reflectors, it is normal practice to place
the main light or lights first, and then bring in the reflec-
tors one at a time. As a basic principle it is wise to choose
and position reflectors in such a way that their use is not
obvious in the final image. Over-filling shadows is a com-
mon mistake.

Back-lighting: A radical lighting alternative to any of the
above is back-lighting. At its simplest, a sheet of white
translucent plastic is laid flat on a frame that supports it
only at the edges, and raises it above the light. The effect

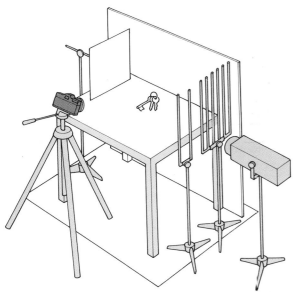

Keys Spotlighting from a low angle produces characteristically long, well-defined shadows. In this photograph of a set of keys, rods at various positions between the light and the picture area provide additional shadows to dress the set. A textured paper background also takes advantage of the light. To balance the lighting across the picture area and to avoid dense shadows, mirrors on the left of the set reflect back the light – standard procedure with this kind of lighting. A diffusing filter gives a slight halo to the specular highlights.
55mm macro lens, Fujichrome ISO 50, focusing flash spotlight, flash-metered setting f22

Drawing instruments

Exclusive use was made of backlighting for this skyline-like image of drawing instruments, with a protractor in the position of the sun's halo at sunrise. The pens, pencils, ink and so on were arranged flat on a horizontal sheet of translucent plastic. Beneath this, an area light was aimed upwards through a sheet of black card in which was cut a large circular hole to concentrate the light. Yellow and orange gels were used to complete the sunrise effect.
55mm macro lens, Ektachrome ISO 100, one studio flash fitted with area light, flash-metered setting f22

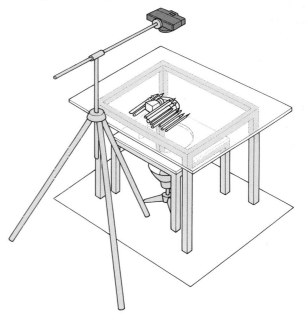

Credit card gold chips
Photographed at an oblique angle, these gold discs, ultimately to be embedded in credit cards, store banking information. It was a straightforward matter to position the area light so that its reflection was completely covered by the strip of gold chips.

55mm macro lens, Kodachrome ISO 64, studio flash with area light fitting, flash-metered setting f32 for maximum depth of field

is essentially the same as a light-box of the type used for viewing transparencies, and indeed one of these light-boxes can be used for this kind of photograph if it is large enough and provided that the appropriate colour correction is made with filters for the fluorescent tubes. Whatever the set-up, the camera is then aimed straight down onto the arrangement of objects. Used like this, the objects are silhouetted if solid, but reveal any transparency very clearly.

Additional light aimed from above, or reflectors placed to do the same thing, gives a more normal treatment, and in this case the function of the back-lighting is that of a clean, shadowless white backdrop. Coloured gels and cut pieces of paper arranged between the light and the translucent plastic can vary the effect. Another version of this back-lighting set-up is to position a large,

flexible sheet of white translucent plastic as a scoop. The construction is rather more complicated, as the sheet can only be supported at the edges. Proprietary still-life tables are manufactured like this, and have a preformed curved front edge so that the back-lighting effect can extend below the object in the picture frame. Different positions for the light source have different shadow and highlight effects.

Special problems

Transparent objects and those with reflective surfaces are the two categories that cause the most common technical problems for lighting. Clear glass, clear liquids and clear plastics need something light-toned behind in order to show that they are transparent. Back-lighting as just described is one way of achieving this, and is especially effective if the objects are coloured. If they are plain, there is a danger that they will merge into the background, and this raises the secondary issue of defining the edges. The simplest way of doing this is to place black card or paper close, so that the edge is darkened. Alternatives to straight back-lighting are to use a pale background and aim the light, or a second light, at this; or to position a bright reflector, such as a small mirror or foil, behind the transparent object. Adding frontal, top or side-lighting emphasizes form.

Polished silver, other bright metal surfaces, and dark glass are among the second category of problem object. Their surfaces can reflect not only the lights, but also the camera and surroundings, and these can be distracting and irrelevant. The basic principle in treating such highly reflective surfaces is to control what will be reflected. For example, a large sheet of white paper is not particularly distracting; by extension, a plain, rectangular area light also has quite a neutral appearance – much more so than, for example, an umbrella. If the object is essentially flat, the problem can usually be solved by angling the object and camera so that an area light or sheet of white card is totally reflected.

Rounded surfaces are more complicated, as they act like convex or concave mirrors reflecting a large part of the surroundings. One answer is to construct what is known as a light-tent. This is a seamless translucent enclosure – commonly a cone – that surrounds the object as completely as possible, leaving only a hole just large enough for the camera lens. There are proprietary light-tents made from translucent plastic, but for small still-life sets it is feasible to make one from tracing paper.

To use a light-tent, the lighting is arranged outside it, evenly or asymmetrically according to the effect wanted. With some rounded objects the camera lens may still be visible, but you may be able to conceal this reflection by angling the object differently.

Fifties kettle and cruet
Curved shiny surfaces can be among the most difficult to light, and this nearly spherical stainless steel kettle is an extreme example. In the first shot (top), a single naked flash gives a hard specular reflection, while the surface of the kettle reflects everything in the room. Arranging a large curved sheet of tracing paper around the set makes all the difference in the second shot (above). It diffuses the light from the flash head and prevents the background appearing as reflections from the surface of the kettle. A small hole cut for the lens would, however, still have been visible; hence the positioning of the salt cruet to cover its reflection.
55mm lens, Ektachrome ISO 100, single high-output portable flash, flash-metered setting f32 (first photograph) f22 (second)

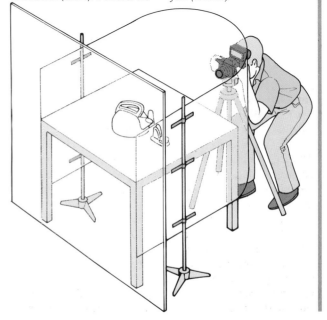

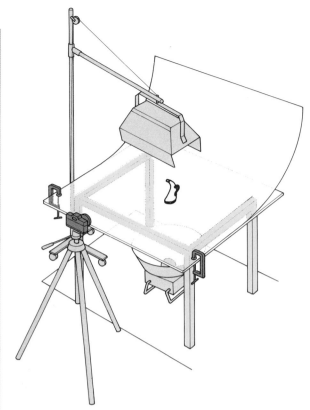

A last resort is dulling spray, available from photographic supply shops. It should be used with discretion, if at all, because while it is effective at removing reflections, it can also make the surface dull and lifeless, and completely alter the nature of the object. A more natural alternative is to place the object in a freezer for at least half an hour – the condensation on its surface when it is brought out into a warm studio will give it a matt finish for a minute or so.

Illusion

A considerable amount of still-life photography involves illusion, whether in the sense of recreating a historical period, or in making objects appear to behave unusually. This latter category of illusion is quite often used in advertising photography, for dramatic effect. Increasingly, this is performed after the photography by manipulating the image and in advertising at least it is frequently a job for computer retouching. Nevertheless, many illusions can be performed on a still-life set so that they can be recorded directly by the camera. Other, post-production manipulation is dealt with in Part 3.

Suspending objects is the stock-in-trade of the still-life illusionist. The single viewpoint of a still camera makes it relatively easy, as the mechanics of the illusion can be kept on the camera's blind side. However, as a still life is open to close scrutiny, there should be no evidence or clues visible – such as a tell-tale shadow from something out of sight. Back-suspension is a straightforward technique, in which the object is secured to one end of a bar or rod. If the camera is aimed horizontally, the bar also must be horizontal, and must also be pushed through the background. Shooting straight downwards may be easier, as the object then rests by gravity. Alternatively, the camera can be positioned on the ground looking upwards, and the object hung from a

Antique glass bottle The patterned blue glass called for back-lighting, but at the same time the silver fittings needed some conventional diffused lighting. The bottle was placed standing upright against a translucent plastic sheet and lit from behind. A second flash unit, fitted with a window-style diffuser, was suspended overhead, *55mm macro lens, Kodachrome ISO 25, f22.*

wire or line. In all of these cases, the attachment at the other end must be concealed, either behind the object, or behind a backdrop. A black background simplifies this kind of illusion, as any supports, whether rods or wires, can be painted black to blend in.

Tilting the set and camera is another kind of illusion that can be used to make objects seem to defy gravity. This works particularly well when liquids are included; thus, if the set and props are all secured and tilted to one side, and the camera also, all appears normal except for the reaction of liquid, which follows gravity.

Perspective distortion also exploits the camera's fixed viewpoint, by creating an illusion of depth where none exists. A famous optical illusion used in studying the psychology of perception is the Ames Room, which is specially constructed so that part of it is much further away than it appears to be. When two people stand in different parts of the room, one appears smaller than the other, because the observer takes the room as the reference and believes it to be normal. The same principle can be used on a much more modest scale on a still-life set by building perspective into it. This has a particular use when constructing a model landscape to appear as if full-scale (a technique, incidentally, much used in special effects cinematography).

Perspective model moonscape To simulate a future lunar base, a perspective model was constructed on a board measuring approximately 1 x 1.3 metres (3 x 4 ft). Using high alumina cement from a sculptor's supply shop for its extremely fine texture, the model moonscape was designed so that the distances were compressed when seen from the camera (see diagram). Black velvet was hung for the background and earth and stones added later by double exposure. *24mm lens, Ektachrome ISO 64, single small flash unit, flash metered setting, f22 x 4 flashes.*

Avoiding flare

A white background or a large area of back-lighting will cause flare, particularly if it extends beyond the picture frame, and the result will be a degraded image with less contrast. A lens shade counters this, but masking placed around the background itself is even more effective, as illustrated. Place pieces of black paper or card right up to the edge of the frame, checking their positioning through the viewfinder so that they cannot be seen. Alternatively, if the photograph is to be used as a cut-out in a publication, the background is irrelevant, and the black masking can be taken right up to the edges of the subject.

Perfume bottle designs and coloured resins With so many possibilities open to a still-life photographer, there is every reason to use imagination, lighting and composition to enliven the subject. In this case, the theme was the design and manufacture of perfume bottles. Instead of a conventional industrial approach, the elements used were collected from around the workshop, some of them discarded off-cuts, and arranged in a technically straightforward back-lit shot.

55mm macro lens, Kodachrome ISO 64, high-output portable flash fitted with area filter attachment, diffused through translucent plastic, flash-metered setting f32

Food

Because of commercial demand more than anything else, food photography has become an important area of still-life work. The demands of advertisers, magazine and book publishers for images that enhance dishes and make food appear as appetizing as possible has created this specialization. In fact, food – or at least the ingredients – has always been a popular component of still-life compositions, in photography and in painting. The combination of food's interesting physical characteristics and its fundamental role in our lives makes it an appealing subject to work with. The standards of modern food photography are extremely high, and have attracted photographers and home economists who specialize in it.

The basic appeal of food is sensual, and a food advertisement or a recipe feature in a magazine aims to convey this. Above all, this kind of image is intended to entice the viewer, but as the photographer can only work through the visual medium, it takes considerable effort and skill to convey taste and smell. Lighting and composition are used to put across the tactile qualities of food – its texture and colour – and to create an appropriate ambience. And, whatever the skills that the photographer can bring, they need the perfect subject. The appearance and authenticity of the prepared dish is crucial. In this kind of imagery, cook and photographer are in partnership.

Just as certain objects in normal still-life photography have technical needs (see Special problems earlier), so the presentation of food has to be correct by culinary standards. More often than not, the food is being shown in its ideal form, or in an instructional way as for a recipe. So, not only must the ingredients be of the highest quality, but they must be prepared and displayed according to the standards of the particular cuisine (and there are many). This is such a specialized area of expertise that wherever possible a professional cook or home economist is used. The role of the home economist is to apply cooking skills with an appreciation of the needs of the camera.

Problems with food: There is a second, more arcane technical need. Certain foods do not look as good as they taste (curries and other formless dishes, for example), and some do not photograph as well as they look to the eye. Soups, gravies and sauces, for instance, can look tired within a minute or two of being prepared. Fat congeals as a dish cools, and soufflés fall. Knowing the possible pitfalls, and which dishes are likely to need special treatment and assistance, is part of the specialized skill of food photography and comes with experience. With dishes that must be photographed when freshly made, it can help if the cook prepares two identical versions, several minutes apart. The first is used to set up the shot,

Raking light for texture

In both these photographs of French food – in style, an elaboration of nouvelle cuisine – natural daylight produces an uncontrived yet atmospheric effect. Raking sunlight from a low angle was used to bring out the texture of the food, and incidentally to add warmth to the shots. This lighting technique is only possible with reliable weather conditions – in this case the Mediterranean coast. Even so there was only a small "window" of opportunity to capture this effect – less than an hour each in the early morning and evening. This had to be preceded by at least an hour's preparation, cooking and presentation. The high contrast inherent in bright sunlight was countered by using panel reflectors fronted with cooking foil, while plants and window frames were strategically placed to cast shadows. A camera position almost directly overhead helps to simplify the composition and concentrates attention on the dishes.

55mm macro lens, Kodachrome ISO 25, metered reading, tripod

when camera and lighting adjustments are made; the second is brought out when the photographer is ready and the shot can be made instantly.

Frozen dishes cause another kind of problem. Even with flash, which is cooler than tungsten, studios are usually quite warm. This and the modelling lights will quickly melt ice-cream, sorbets, ice-cubes, and so on. Even the slightest melting, which can occur in less than a minute in some circumstances, is enough to take the crispness off the surface of a scoop of ice-cream. In practice, some commercial photographers and home economists cheat by using substitute ingredients, a practice which is effective visually but of no real merit. To shoot authentically means preparing the photographic side of things fully, and then shooting quickly. A freezer spray can help maintain a low temperature on-set. More acceptable than substitute food are acrylic ice cubes, which not only do not melt but are crafted to an ideal shape and transparency; these are, in any case, secondary to the food or drink being photographed.

Most dishes are served hot, and one special problem for the photographer is to convey this visually. Very few dishes are in reality steaming hot, yet this is the obvious clue to temperature. One method is to keep the studio as cold as possible and to photograph the hot dish, fresh from the cooker, against a dark background – this will show up the steam more clearly. Another method is to use a commercial liquefied titanium compound, which produces imitation steam, and a third is to blow smoke, such as from a cigarette, gently across the set.

Photographers who specialize in food often adapt or construct their studios for the special demands of cooking and shooting close together. The cooking facilities must, of course, be adequate, and this may entail extra space, ventilation and plumbing beyond what is normal in a domestic kitchen. The line of delivery of dishes from the cooking area to the photography area should be direct and uncluttered. There may be a number of people working together, and there should be enough room so that they do not get in each other's way. Either the studio can be located next to a kitchen, or the cooking facilities and studio can be combined in one space. For photographs of dishes being prepared, or kept hot, a portable gas ring – say, a butane cooker – is a useful accessory. The dish can be started on the kitchen cooker and then transferred quickly to a set that incorporates the gas ring.

Lighting food: In terms of effect and style, most of what has already been discussed under Lighting earlier applies to food. The emphasis, however, tends to be more single-mindedly tactile, with surface textures of particular importance. A diffuse area light placed slightly behind and above a dish creates slight back-lighting, which will

Cooked dish with ingredients This photograph (above) of a Chinese dish – duck in lemon sauce – employs relatively straightforward studio lighting. The principal light source is a flash fitted with a 3 x 2 ft area light, suspended over the set. Its position – a little back and tilted slightly forward – gives an even illumination but also highlights texture and reflections. A tungsten spotlight aimed from low, back and left adds extra lighting interest and a warm glow. Foil reflectors below the camera fill in foreground shadows.
55mm macro lens, Ektachrome ISO 100, metered flash exposure and 1 sec. tungsten, f16

Japanese food architecture Certain cuisines, notably formal Japanese with its strict emphasis on presentation as a part of the experience of eating, enable you to treat the food as a graphic still-life subject. Dry dishes with distinct shapes are best suited to this kind of treatment, in which composition and background are very important. A kind of minimal approach, as in this shot (above right) of shrimp tempura is often the most striking.
55mm macro lens, Ektachrome ISO 100, flash light with area fitting, f22

accentuate highlights and texture. With a focusing spot, a low position for the light will give grazing illumination that also emphasizes texture. In most cases, efficient reflection or secondary lights are advisable to give good shadow-fill.

Glasses and bottles often feature prominently in food

Traditional Thai fruit and vegetable carving Even uncooked food can be made an interesting photographic subject, if inherently attractive. With a centrepiece of a water-melon carved into a rose (skilfully making use of differences in colour in the manner of a cameo), this arrangement (right) of carved fruits and vegetables makes a formal study under basic diffused studio lighting.
55mm macro lens, Kodachrome ISO 64, flash light with area fitting, f22

photography, and their reflective surfaces have to be considered in the lighting and composition. Great care needs to be taken in the way that a reflection falls on curved glass – a simple shape, such as a rectangle, is often the best. With standing bottles and tall glasses, it is common to place an area light in a vertical position at one side, directed horizontally towards the set. In this way, the reflection runs the height of the bottle or glass. Liquid in glasses needs special attention, of the kind described earlier under Special problems. One method is to enliven it by placing a shaped reflector behind, propped up out of sight of the camera, and angled to catch the light.

Copying

The controlled techniques of still-life photography, particularly the lighting, can be applied to two-dimensional subjects as well. Copy shots, of paintings, drawings and any other flat artwork, offer few opportunities for creativity, but are nevertheless sometimes necessary. Generally speaking, there is no room, or need, for interpretation, and the single measure of a successful shot is faithful reproduction of the original. The two key factors in all copy shots are aligning the camera so that there is no distortion of shape, and lighting the surface absolutely evenly. Neither of these is always straightforward.

Before anything else, the best film for the subject must be selected. Film types and makes introduce their own differences, particularly with colour, as the dyes used are never perfect. If the final result is to be a colour reproduction, then either colour negative or transparency film is needed (the latter if the image is to be reproduced in print, such as in a magazine or book). User-processed film (typically C-41 or E-6) allows additional contrast control by pushing or reducing the development, and is for this reason more useful than, say, Kodachrome. In all cases, the finest-grained slow emulsion is the best choice.

In order to give the darkroom printer or separation maker an accurate reference to the colours and tones, it is essential to include in the shot a standard guide, like the Kodak Colour Separation Guide; it can be taped to the picture frame or laid next to it. This reference is also important for the tonal range in a black-and-white reproduction. In black-and-white the choice of film lies between a slow panchromatic emulsion for continuous tone originals (such as a photograph) and line or lith film for engravings and pen-and-ink drawings. Selective filtration can be used to remove stains and improve the appearance; for example, if a print is stained yellow, use a yellow filter to render the stains invisible.

Align the camera so that it points perpendicular to the artwork; the artwork will then be parallel to the film. Otherwise, there will be some shape distortion, and the opposite sides of the frame – nearly always rectangular – will not be parallel to each other; convergence like this is called "keystoning". The simplest method, suitable for small originals, is to lay them flat on the floor or on a table, and aim the camera vertically downwards. A spirit level placed on the camera back or in the accessory shoe is another method; even more accurate is a mirror. This works with SLR cameras only, but is very simple. Place a small mirror in the centre of the artwork and adjust the camera position until the reflection of the camera lens is exactly in the centre of the frame.

Paintings that are hanging on a wall are likely to be at a slight angle, which complicates alignment; ideally, the

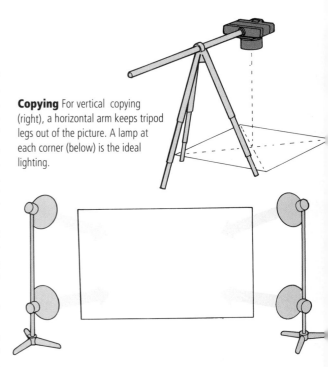

Copying For vertical copying (right), a horizontal arm keeps tripod legs out of the picture. A lamp at each corner (below) is the ideal lighting.

A flat surface (below) can be evenly lit by using two lamps, each aimed at the opposite edge. The strength of the two shadows cast by a pencil held up to the surface will show if the illumination is equal. Shade the camera lens (bottom) from the direct lamp light with large pieces of card.

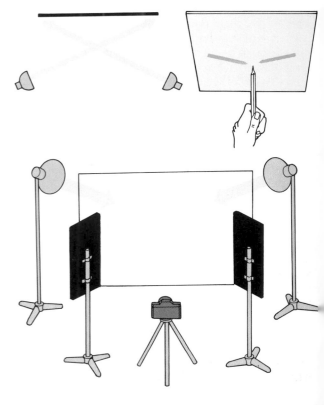

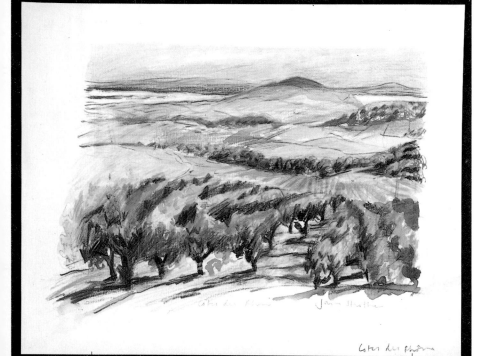

Ensuring accurate colour
When photographing fine art, faithful colour reproduction is essential. The placement of a standard colour guide within the shot gives you an accurate point of comparison when you check the final result.

angle of the painting should be measured with a clinometer, and then the camera tilted to the same angle; in some circumstances it may be enough to do this by eye alone; checking that the sides of the painting are parallel to the edges of the viewfinder frame in the camera.

Lighting artwork: With the camera in position, add the lighting. Tungsten lighting is easier to use than flash, because it is continuous and the effects are visible before shooting, but with colour film it is important either to block out daylight from windows or to add blue gels to the lights to give them the same colour balance as daylight.

In any case, for the lighting to be even, the artwork must be lit at least from two sides, and ideally from each of the four corners. By placing the lights so that the angle is acute, reflections from the surface of the artwork are kept to a minimum. If the artwork has a deep frame, this will cast longer shadows. The best compromise is usually to position the highest at around 45° to the picture, but this must be checked visually, particularly with an oil painting that has a shiny finish. Aim the lights not to the centre of the artwork, but to the opposite side. This helps to create an even intensity of light, which is best checked with incident-light readings made at various positions around the original with a hand-held meter (alternatively, hold a pencil close to the surface, and check if the shadows are equal).

Shade the lights from the camera, as there is a real danger of flare, and if possible mask off any large white areas around the original, using black paper, card or cloth. If the original is fronted with glass, and this cannot be removed, position a sheet of black cloth in front of the camera, with a small hole cut in it for the lens; this will screen reflections from the camera, tripod, lights, and so on. A more expensive alternative is to use a polarizing filter over the lens and polarizing sheets over the lights.

With rare and delicate originals, as is often the case in copying, care needs to be taken to conserve them. If the artwork contains any organic materials, as do most paintings, it is liable to deteriorate under bright lights. Heat and ultraviolet are the chief culprits, and eventually cause fading. As an indication of the precautions demanded by conservation experts, the Smithsonian Institution regulations demand that heat filters (such as Colortran G-112-7) and UV filters (such as Plexiglass UF3) are fitted over lights, that lamps are set up under reduced voltage until the actual shots are taken, and that photography lasts for no more than eight minutes before an equal interval is allowed for cooling.

Manipulating the Image

3

From the earliest days of photography, is has been possible to alter the images that the camera produces, sometimes for obvious effect, sometimes skilfully attempting to conceal the alteration. With black and white prints, and particularly with large-view camera negatives that were easy to work on, there were few technical difficulties, even in the 19th century. The advent of 35mm film and colour has made image manipulation more demanding, but the techniques and equipment have kept pace.

This is the ultimate control that the photographer has – being able to alter the negative, slide or print in a large number of convincing ways. At its most sophisticated, it allows the photographer to become virtually an art director, planning and executing an image even though the imagined shot may not exist.

Measuring fragrance dispersion Combining images for more information or a stronger effect is the most common reason for manipulating a photograph.

Here, a laboratory experiment with a rose is added to a tone-separated halo re-constructed from the measurements.

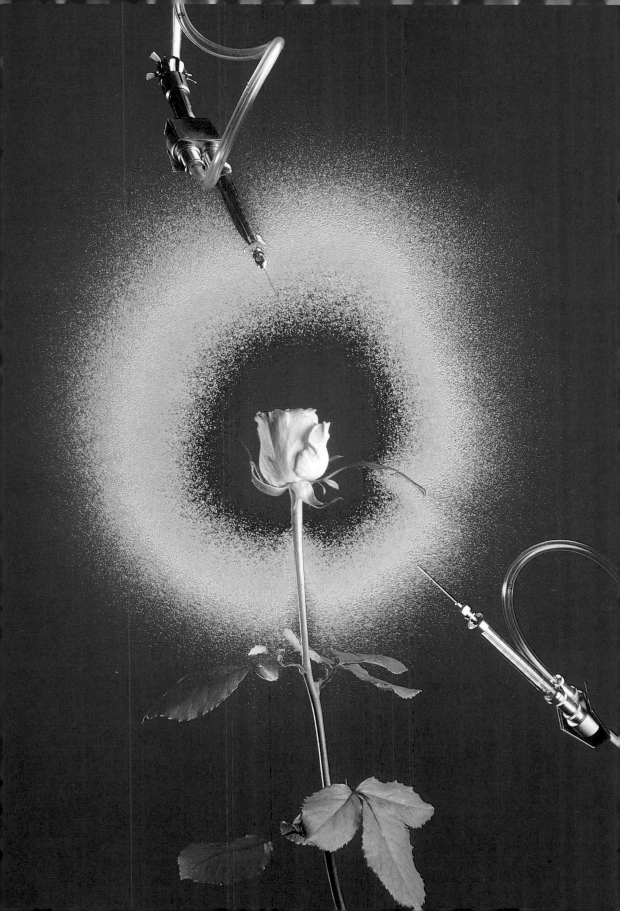

Combining images

- Combining and sandwiching images
- Making a multiple exposure
- Photo-montage techniques
- Retouching and hand colouring

Most of the manipulation described here is performed in what is known as the post-production stage – after the photography is complete. However, if the photographer is familiar with the range of techniques, and plans to use one or two right at the conception of an image, it can be even more effective to combine the shooting with the manipulation. For instance, knowing what will be done to a negative or transparency later, it is possible to make the process easier or more convenient at the time of shooting, such as by deliberately leaving a blank space in part of the frame.

In professional hands this gives the art director and photographer a free hand to create whatever image they decide on, and many such photographs begin on a designer's sketch pad. In execution, the photographer may achieve the graphic freedom of an illustrator yet retain the basic realism in appearance of photography. This level of manipulation occurs principally in advertising, where the commercial use justifies the often high costs and lengthy technical work.

The techniques described here demand less expertise and less expensive facilities, but are still capable of producing effective, fresh images. Simple double-exposure of two shots onto one frame, for instance, is well within the ability of most photographers, and yet can produce a tremendous variety of images. The introduction of desktop-computer image management widens the scope even more; the programs for manipulating a photograph cost no more than a mid-range 35mm camera, and yet can do almost as much as a high-end mainframe system. The only limitation for desktop-computer imaging is the resolution of the picture, and even this is not really noticeable on the screen or on a small print (a professional system is needed to manipulate images to the resolution needed to print in a book like this).

This ability to alter a photograph after it has been taken raises some important issues. In nearly every case, the effectiveness is directly related to the realism. This, after all, has always been one of the great strengths of photography: it is assumed to be real, hence the cliché, once largely true, that the camera does not lie. Now that more and more published photographs are manipulated, especially in advertising, the situation is changing.

Photography, as we have already seen, covers an unlimited range of subjects. The entire world, and a good many abstract ideas too, are material for the camera. Inevitably, each field of photography, as defined by the type of subject, has its own ethos. It also has its own codes of working – a consensus of what is acceptable and what is not. For example, the essence of most reportage photography is a documentary approach: a faithful and honest interpretation of people's lives and interactions. Any gross interference by the photographer would reduce the value of this kind of work. Or rather, we should say, such interference would change the nature of the photography. It would no longer be reportage. A reasonable rule to follow is that a photograph should show whatever it *purports* to show. In humorous advertising, on the other hand, anything is permissible. No one expects bizarre images in this medium to be real. A news event in a magazine, however, is another matter. It is expected to be unmanipulated simply because news photographs have always been presented as true documents.

Perfume bottle sandwich shot The idea for this image was to produce a still-life in the style of the subject – a perfume bottle designed by surrealist Salvador Dali – by having it appear to float in the sky. First, the bottle, in the shape of a woman's lips and nose, was photographed on a backlit curved sheet of translucent plastic. Lit from above and behind, this image has a clean white background and no shadows. A previously-shot transparency of sky was then chosen from the files, and the two sandwiched. For permanence, this combination was copied using a duplicating machine.

Perfume bottle: 55mm lens, Kodachrome ISO 64, incident reading from hand-held meter. Sky: 20mm lens, Ektachrome ISO 64, 1 stop lighter than automatic reading. Duplicate: 100mm Componon lens, Ektachrome ISO 100 pull-processed 1 stop

Aircraft sandwich shot
Essentially the same techniques as illustrated on the previous two pages were used for this apparently straight shot of a 747 taking off. To produce this kind of silhouetted image, it is essential to have a bank of sky backgrounds taken as a matter of course whenever the opportunity arises on other assignments. These sky backgrounds can be photographed in a range of exposures. Lighter ones are often best for sandwiching to reduce the overall density. For this shot a scale-model aircraft was photographed in the studio, painted black and backlit against a large hanging sheet of translucent plastic (suspended on a horizontal pole invisible to the camera). This was photographed in a range of exposures. Once processed, the two images were then sandwiched.
Aircraft: 55mm lens, Ektachrome ISO 100, 2 stops lighter than automatic reading. Sky: 20mm lens, Fujichrome ISO 50, 1 stop lighter than automatic reading. Duplicate: 100mm Componon lens, Ektachrome ISO 100 pull-processed 1 stop

Combining images

Probably the largest group of photographic special effects are those that involve bringing two or more images together in one picture. There are many uses to which this is put: adding a moon to an otherwise blank night sky, inserting a more interesting sky, adding objects and people to a setting, or juxtaposing two elements that it would normally be impossible to photograph together.

The techniques, of which there are several, can be applied at various stages of picture-making. Some are possible during shooting, others immediately after processing, yet others during printing or by rephotographing the originals. Some image combinations are best planned at the outset, some are serendipitous and only suggest themselves during picture editing.

Sandwiching

The easiest technique for combining images involves hardly any actual manipulation, simply the selection of two appropriate slides. In sandwiching, all that is needed is to choose two transparencies and mount them together. It generally works best when the dark and light areas in each transparency are in counterpoint so that, for example, a silhouette on one shows clearly through an area of clear sky on the other. As even a light-toned transparency has some density, adding two together often produces a rather dark image, lacking in contrast.

Sandwiching procedure

1 Experiment on a light box by trying out different combinations. Then remove one transparency from its mount, and tape it down.

2 Position the second transparency and tape that down. Cut round the edges of the tape.

3 Use a blower and an anti-static brush or gun to remove dust particles that could be trapped in the sandwich and then mount it.

For this reason it rarely works to combine more than two, and if there is a choice of exposures for each slide, the paler, more overexposed ones are likely to work best in a sandwich. If photographs are being taken with the intention of using them in a sandwich, it is best to bracket exposures quite widely for this reason.

The two slides mounted together provide the finished effect, but there is often an advantage in making a duplicate copy of the sandwich, using a duplicating machine like that described under Multiple exposure post-production. This solves the problem of dust collecting between the originals, completes the illusion of a single image, and can heighten the contrast to overcome dull highlights in a sandwich.

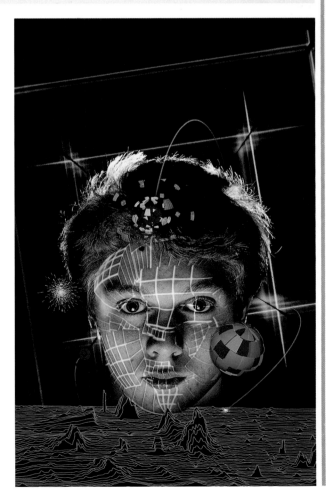

Projection-video game player Combined with other special effects, straightforward projection is used here to create the illuminated grid covering the boy's face. Computer generated line artwork, in the form of a high-contrast 35mm slide, was the basis of the grid pattern. The slide, with an orange filter, was mounted in a carousel projector and focused from a few feet onto the boy's face. Projection was much more effective than double-exposure would have been as it wrapped the grid shape around his head.

Consciousness This photograph was taken for a magazine cover to illustrate a feature on levels of consciousness. (The idea of a rising sun superimposed on a head seemed appropriate.) First, the image of sunrise over a lake was constructed by sandwiching together two transparencies. To ensure that the image would follow the contours of the head, the transparency sandwich was placed in the carrier of a disassembled enlarger and projected. The head, a phrenology model, had been sprayed to a matt white finish, and was separately back-lit .
Nikon, 55mm, Kodachrome, f22

Projection

A projector provides another straightforward method of combining images, and allows the effect to be previewed. There are two techniques. In the first, one or two ordinary slide projectors are used to project slides onto a screen or white wall. If two projectors are used, the images are combined on the screen, and then re-photographed. Here, the combination is the reverse of sandwiching, in that bright areas in one slide are added to dark areas of the second. When using one projector, two separate exposures have to be made onto the same piece of film (see Multiple exposure post-production), and the outline of the first image must be noted in order

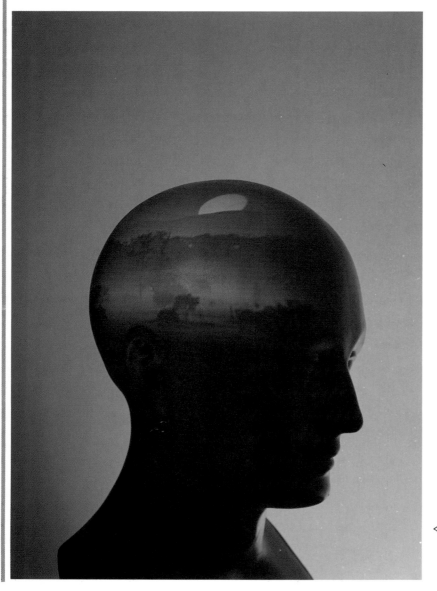

Front projection This image was commissioned for a company brochure. The background consisted of large pieces of muslin fabric behind which an acetate sheet with the company logo printed on it was placed. This was lit from behind by a tungsten light coloured by blue and yellow gels. Further colour and type effects were produced by slides projected through a yellow gel from the left and, from the right, through a blue gel and onto a model of a man's head.

to position the second correctly – this is most easily done on a sheet of paper temporarily taped to the screen or wall .

The second technique is to project a slide or slides onto a three-dimensional surface. The shape of this surface – curved, for instance – will distort the image, but does not have to be visible itself. Alternatively, the object onto which the slide is projected can be lit so as to make it a part of the new image (in this case, the lighting must be kept off the area where the slide is projected). The best treatment for surfaces is a matt white paint. Reflections can be reduced further with a dulling spray. An enlarger can be substituted for a slide projector.

Front projection

A development of the above use of a slide projector is a system designed to give a convincing background image to a regular studio shot by projecting a transparency onto

the backdrop. Front projection employs a half-silvered mirror position in front of the camera lens, angled so that the camera shoots through it without interference, while it reflects an image from a slide projector that is positioned below it. The image is projected exactly along the lens axis, but is invisible to the camera because of the half-silvered mirror. The second special element of the system is a highly reflective background screen made of Scotchlite, the surface of which is covered with extremely small, transparent spheres. The effect of these is to reflect any light that strikes them head-on with great efficiency. This screen reflects the image from the slide projector, straight back to the camera very brightly. Provided that the subject, such as a person standing in front of the screen, is lit carefully, with minimum light-spill onto the screen, the result is a bright background (the clothes and skin of the person are nowhere near reflective enough to show the projected image).

As the equipment needed for front projection is fairly specialized, only a few professional studios have it, and it is normal to hire either the equipment alone or a studio equipped with it. The main skill lies in choosing an appropriate background slide, and then adjusting the quality and level of the studio lighting to match it. There is some danger of a dark fringe around the subject.

Titanium implants: double exposure Here, a straightforward double exposure was used to show the position of titanium prosthetic implants in a girl's hip and leg. The two subjects were set up close to each other in the studio. Lying on a raised sheet of plastic, the girl was strongly backlit with lights underneath and behind projected against the white wall. With the prism head off the camera, the outline of the girl was drawn on the screen with a draughting pen. Without winding on, a second exposure was then made of the implants laid on black velvet cloth. *55mm lens, Ektachrome ISO 100. Girl: automatic reading. Implants: incident reading from hand-held meter*

Making a multiple exposure

Take two objects to combine into one shot (they can be very different in size, as they do not have to be photographed together). Use whatever method the camera allows for making a second exposure without winding on the film (some models have a control designed specially for this). Set the first object against a black background – black velvet absorbs the most light – light it, and make the first exposure. Note the position of the object and the remaining black space; do this either by memory, or by making a small sketch. With a camera that allows the prism head to be removed, you can mark the position of the object on the ground-glass screen. Screens etched with a grid pattern are useful for this. Set up the second shot, with the new object also against a black background, in a different position from that of the first object.

Multiple exposure in-camera

Multiple exposure, in which separate images are shot on the same frame of film, has the potential for the highest image quality, particularly if it can be done in the camera on the original roll of film. The technique works best when there are fairly large, dark areas on one of the exposed images in order to leave space for the second exposure. The classic situation is a first exposure having a black background, followed by a second exposure of a small brightly lit object, also on a black background, positioned against the first area.

This type of situation is a little ordinary, but makes a good introduction to the technique. Other applications can be more imaginative, and there is no need each time for the subject of the second exposure to be placed in a completely black area. Experiment with dark and medium-toned areas, and with overlapping images for a ghosting effect. Keeping a note of the positions is more important, particularly with true multiple exposure when several images are added together. With a large number of exposures, even quite dark backgrounds will add up on the film to a pale overall effect.

On location, there may be no opportunity to shoot the different exposures consecutively. One solution is to forego in-camera multiple exposure and use a duplicating machine later, another is to re-run the film. Re-running involves rewinding the film to the same frame as the first exposure, and then making the second.

Re-running

When loading the film, mark its exact position, as shown. Then make a series of exposures of the first subject. At a later time, rewind the film but do not allow the leader to be drawn back into the cassette. Line up the mark used to indicate the starting point of the film, and start shooting again with a range of exposures of the second subject.

 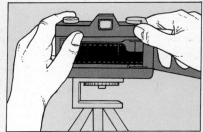

CDs: double exposure Double exposure in the camera was used here without any need for careful positioning. The CDs were laid out on black velvet (for its light-absorbent properties) and photographed at an angle. The camera was then aimed at a graded background created simply by directing a light with coloured gels at one end of a white wall. The second exposure was made without winding on the film. The slight merging of the two images, as the most distant CD enters the lighter part of the background, actually helps to consolidate the final image.
55mm lens Ektachrome ISO 100. Background: automatic reading. CDs: incident reading from hand-held meter

Multiple exposure post-production

The great advantage of making multiple exposures after the originals have been processed is that mistakes are not serious, and images can be experimented with endlessly. Against this, the duplicating machine itself is an extra cost, and the quality of a duplicate is never quite as good as that of the original. The 35mm format is small for post-production work, but the duplicating machine brings a precision and consistency that allows quite refined combinations of images.

The basic procedure of multiple exposure is the same as when it is performed in-camera, but with all the components available at the same time, there is no need for such complications as re-running. There are less expensive attachments available for duplicating slides, but for this kind of work a proper slide duplicating machine is a sensible investment.

As the original transparencies are all available, it makes considerable sense to plan the final image by tracing the different images together, using tracing paper or drawing film. Assemble the transparencies on a light-box and make the selection. To improve the quality of the final image, it is possible to darken the receiving area of one transparency, by using a neutral density filter (see Filters in Part 1), or a piece of card held out of focus in front of the duplicating machine's lens, or a card positioned underneath the translucent plastic sheet underneath the transparency.

The slide copier

A basic tool for manipulating images on transparencies is a slide duplicating machine. It also has more prosaic uses in making accurate copies of valued images. Although an extra investment, this kind of machine is much more useful than the kind of copying attachment that fits directly onto a camera. Essentially, the duplicating machine is a calibrated light source with a bellows attachment that allows different degrees of enlargement. The light source may be a tungsten lamp, or a flash tube corrected for daylight. The equipment incorporates a metering system, a holder for colour filters and, in some models, a device for leaking a small dose of light onto the film, fogging it slightly to reduce the apparent contrast.

1 Scale showing magnification and exposure increases
2 Focusing track
3 Contrast control unit
4 Photo-electric cell
5 Altering the height of flash/ modelling lamp platform varies the light intensity
6 Sync lead
7 Bellows
8 45° glass
9 Transparency holder
10 Filter drawer
11 Light control knob
12 Open flash switch
13 Modelling light/flash exposure switch
14 Exposure indicator needle

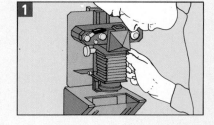

Making a duplicate

1 With the lens aperture wide open, and the transparency placed in the holder, adjust both the lens and camera positions until the image is correctly framed and focused.

2 Stop down the lens to the aperture previously selected by testing, and, with the photo-electric cell swung over the transparency, rotate the light control knob until the needle is zeroed.

3 According to the amount of fogging needed, select the light output from the contrast control unit by rotating the rear dial. With experience you can judge the best level for each original.

4 Swing the photo-electric cell away, switch the unit from modelling light to its flash exposure setting, and expose by pressing the camera's shutter release.

Register pin and bar system

1 Tape the smallest 63mm (2½ in) size of Kodak Register Bar to one end of a 12 x 9 cm (5 x 4 in) sheet of glass.

2 Using a 5 x 4 in box attachment on the slide copier, tape the glass and bar securely on top.

3 Tape a second, identical, register bar to the surface of a light box.

Research scientist: double exposure

The photomicrograph of a cell cross-section was shot first, and processed. The second image, of the scientist, was photographed with black velvet drapes behind to simplify the background. The actual double exposure of the two separate images was made using a duplicating machine.

Duplicate: 60mm Rodagon lens, Fujichrome ISO 50, pull-processed 1 stop

Endocrine system: double exposure

This high-tech image was made by combining three originals: a silhouetted photograph of a naked man against a white background, artwork of the human body's endocrine system drawn to scale, and a background made from individually-lit and coloured sheets of plastic.

60mm Rodagon lens, Fujichrome ISO 50, pull-processed 1 stop

Aligning the image

1 Cut a hole in a sheet of discarded film to the size of the transparency. Punch one edge of the sheet with register holes.

2 Fix the sheet onto the register bar on the light box, and mount the first transparency with dimensionally stable tape.

3 Repeat the process with the second transparency, but mount it in exactly the position you want in relation to the first transparency. Check with a magnifying glass. The two transparencies will now remain in register.

Head and brain: sandwich and double exposure Both of these were used to produced this image of a girl's head and brain, silhouetted against lightning. The lightning display had already been produced by passing sparks through unexposed film – a hit-and-miss affair that gives very uncertain results. The girl was then photographed with a small amount of side-lighting from the left and backlighting through a suspended sheet of translucent plastic, at different exposures. The brain was a computerized image. The head and lightning were sandwiched together, and placed in the duplicating machine. An outline of the head was traced on the camera's screen with the prism head removed. The second exposure in the duplicating machine was of the brain. *60mm Rodagon lens, Ektachrome ISO 100, pull-processed 1 stop*

Photomontage This colour photomontage by Slovak photographer Luba Luflova is made from two Cibachrome prints. The print of the torso was cut around the outline, its back edges chamfered so that they would not appear to stick up, and then pasted onto the background print. The assembly was then re-photographed.

A much more demanding technique, but one that is the basis of most professional image combinations, is photo-composition. Photo-composites are multiple-exposure images in which masks are used to hold back precise areas from each image. These masks are normally made from line film that is contact-printed with each of the transparencies and re-touched. So, for instance, the image of a person can be isolated from its background by making a copy onto line film and sandwiching the two together to give an image of the figure against a solid black background. In order to make sure that the images line up exactly, a register system has to be used. While it can be used for fairly simple outlines, 35mm film is a little small for this.

Photo-montage

This technique involves working with prints, which can be cut and assembled physically. In principle, this is much simpler and less prone to mistakes than the other methods described above. Making a convincing fit, however, is often more difficult because of the problems of matching the paper and image qualities, and of concealing the edges of the cut paper. Nevertheless, if there is no need to conceal the montage, and the exercise is more of a free association of images, it can be very effective.

The usual procedure is to size up the images that are to be assembled, possibly by making a sketch first, and then tracing the outlines of each onto paper by projecting the negatives or transparencies one at a time in the

Statue, Borghese Gardens, Rome The basis for this hand-tinted print was a black-and-white photograph taken in natural light. This was printed to 12x16 inches and coloured with blue, green and yellow crayons. The colour was blended with the fingertips. *28mm lens, Tri-X, natural light*

enlarger. Then make a few prints of each, varying the density and/or the colour balance to allow yourself a choice when assembling. Then, carefully cut around the outline of each image with a scalpel, and chamfer the edges on the back of each print so that the joins are not obvious when they are stuck together. Using one print as a full-sized background, stick down the other cut-out prints with removable adhesive. Re-touch around the edges to conceal them; an airbrush is particularly effective for this.

Double printing

This method of combining images on a single print uses multiple exposure in the enlarger, in much the same way

as multiple exposures are made in the camera (see above). The darkroom, however, allows much more freedom of movement and adjustment, and the basic technique is fairly simple. The secret is to hold back the appropriate parts of each image to allow unexposed areas on the print to accept other images; this is most easily done by using the shading and printing-in techniques described under Colour printing in Part 1.

Re-touching

Re-touching, which can be performed on the film or on a print, is used in two ways. It can be used to tidy up, remove blemishes, make corrections, and generally improve the image quality. It can also be used to make

Double printing without masks To illustrate a special feature on college book reviews in a scientific magazine I wanted to combine the image of a textbook with a university building, in this case the Radcliffe Library in Oxford. WIth a rough layout in mind, I photographed each separately. The book was shot in the studio against white so that the background would already be partially masked. As the positioning was not critical, and I wanted the two images to blend, there was no need to make precise masks – hand shading would do.

With the negative of the book in the enlarger, I marked the outline of the image on the baseboard. I then exposed one sheet of printing paper, shading the area above the book with my hand.

Returning the sheet to its box, I replaced the negative of the book with one of the library building, positioning it against the marked outline on the baseboard. Then, with the already exposed sheet replaced on the baseboard, I made the second exposure, masking the lower part of the building so that the latent image of the book would not be over-printed.

deliberate alterations to the image, for the same reasons and in much the same kind of way as the various manipulating techniques just covered. In practice, the difference between the two approaches is one of extent and sophistication – re-touching for special effect needs a high order of skill.

Cosmetic re-touching normally has to deal with problems such as scratches, dust, colour cast, too dense or too weak an image. Because 35mm film is so small, most re-touching is best performed on a print. The exception is overall re-touching, in which the entire image area is treated. Re-touching is also easier with black-and-white film and prints than with colour. Colour paper generally responds poorly to dyes, and it is often more effective to use pigments (also known as body-colour). Before starting, clean the surface of the print with de-natured alcohol to remove traces of fingerprints and other marks.

Black-and-white prints: Black-and-white prints are considerably more receptive than colour papers to re-touching techniques. This is particularly the case if traditional fibre-based paper is used rather than the more common resin-coated varieties – it absorbs dyes much more easily and responds to chemical treatment. There are two principal re-touching media: dyes, which enter the silver image, and pigment, which sits on the surface and covers the image underneath. The former have the potential for a longer-lasting finish, but need more care in applica-

Wet dye technique

1 Moisten the retouching brush by dipping it in a solution of water and stabilizer (such as Kodak Ektaprint 3 Stabilizer).

2 Transfer the dye or mixture to a palette. To reduce colour intensity, add neutral dye if necessary. Load the brush with dye, then draw it across a piece of scrap paper to form a point and remove excess.

3 Retouch, making sure that no dye overlaps the edges of the spot (this would form a dark ring). use blotting paper to remove excess colour. It is safer to build up intensity with several applications rather than risk oversaturating the print.

Dry dye technique

1 Make sure that the print surface is absolutely dry. Breathe onto the surface of the cake of dye and pick up a small quantity with a cotton swab.

2 Rub the dye-loaded cotton swab over the print in a circular motion. Repeat with more dye of the same colour or greater intensity, or with a different dye for a mixed colour. Buff with a clean cotton swab to smooth out the dye. This will also lighten the colour. To remove excess dye from the print's surface, use the cake of reducer in the same manner, breathing on it and then rubbing with a cotton swab. Afterwards, remove excess reducer from the print by buffing.

3 Make the retouching permanent by holding the print about 10in (25cm) over steam from a boiling kettle for 5–10 seconds. You can tell when the steaming is complete by examining the print surface; waxy marks caused by applying the dye should have disappeared. By alternatively dyeing and steaming several times, greater intensity can be achieved. In each instance, dry the print thoroughly. To remove steam-set colours in an emergency, use undiluted Photo-flo wetting agent with a cotton swab. Do not leave the Photo-flo on the print for more than a minute; remove completely by swabbing with water and stabilizer.

Basic wet and dry techniques on colour prints can be carried out with a bottle of stabilizer (**1**), brushes (**2**), blotting paper (**3**), cotton swabs (**4**), and cakes of coloured dye (**5**).

Reducing print density

1 Pre-soak the print in water for 10 minutes to soften the emulsion and paper base. Lay the print on a smooth surface, such as a sheet of glass, and swab off excess water.

2 With brushes or cotton swabs, apply the diluted bleach or reducing solution to the print. If you are in any doubt about how fast the solution will work, or whether it will cause any discolouration, test first on an unwanted print. In any case, use a very diluted solution so that you have more control – for instance, use Farmer's Reducer at a dilution of 1 part in 6. Work the solution over the print continuously so as to avoid hard and conspicuous edges to the reduced area.

3 (Alternative procedure). If the areas to be reduced have precise boundaries, use rubber cement to protect those areas that must be left alone. This can be painted on, and dries to a thin coating, which can be peeled off afterwards, and allows the entire print to be immersed in reducer.

Painting with dyes

Pre-soak the print in water for 10 minutes. This enables the dye to penetrate more easily, and prevents hard edges to the dye washes. On a sheet of glass, or other smooth working surface, swab off water droplets and allow the print to dry slightly for about 10 minutes. With self-adhesive masking film, mask off the areas that are to be untreated. When using masking film, first peel off the backing, and then carefully lay the film down over the whole print, smoothing it down so that there are no wrinkles. Using a sharp scalpel, cut round the edges of the area to be dyed with just enough pressure to break the film but not enough to

damage the print. Peel off the film from the areas that have been cut round. Mix a dilute solution of dye, making sure that it matches the hue of the print. Working from two dye bottles, one brownish-black and the other bluish-black, you can prepare a precise match.

Apply the dye in washes with a brush. Build up the density in a number of applications. If you make a mistake, or find that the added density is too great, place the entire print under running water for several minutes and begin again.

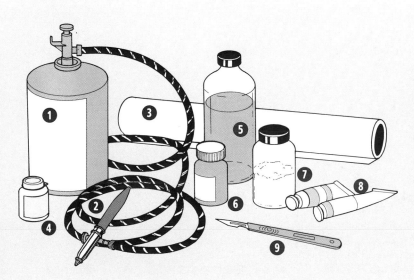

Basic items of equipment are a can of compressed air (**1**), and an airbrush (**2**), with transparent masking film to cover areas not being retouched (**3**). Re-touching fluid (**4**), gives a "bite" to the print surface. Bleach (**5**) and hypo crystals (**6**) are also needed, and masking fluid (**7**) can be used for complicated masking. Water-colour pigments (**8**) are used in the airbrush and a scalpel (**9**) for cutting and knifing.

Hand colouring

In the case of this advertisement for a cosmetic manufacturer, the advertising agency wanted to give as much emphasis as possible to a new range of colours, and decided that a contrast between a black-and-white image and the coloured make-up would be the most dramatic means. The problem was to hand-colour the black-and-white print so that the colours appeared completely authentic and matched the actual colours of the make-up.

1 On a 40x50cm (16x20in) black-and-white print, the first step was to mask the areas that were to remain uncoloured. This was done by laying a clear, slightly-adhesive film over the whole print and knifing around the outlines with a scalpel, being careful not to cut into the print itself. As the hand-colouring would add density, the darker areas, such as the neck shadows, were washed over with a bleaching solution.

2 The whole skin area was then sepia toned, using a brush, to provide a base colour similar to the flesh hue desired. The remaining masking film was removed and the flesh was coloured, starting with broad washes using a No. 8 brush and diluted dye.

3 The stronger colours were then gradually worked in by stages, using smaller and smaller brushes and more concentrated dyes. To make sure that the make-up colours were identical to those of the client's product, the retoucher applied them to the back of his hand as a reference. The orchid, whose colours were intended to match those on the girl, was also treated in the same way.

tion. The dyes or pigments used should be chosen to match the colour of the print – there is a range of subtle colour variations on black. If the print is to be exhibited, it is important to blend the surface texture of the re-touching medium with that of the print.

If several procedures are to be used on one print, they should follow a definite sequence. All chemical action, such as bleaching, comes first, and this ends with a thor-ough wash and dry. Then dyes are added, by brush, swab or air-brush, one dilute layer at a time. Pigment applica-tion follows, and finally, physical knifing with a scalpel. At each stage, it is better to begin the re-touching on large areas and work down towards details.

Black-and-white negatives: Only a few of the available tech-niques can be used on 35mm film, because of its small

Airbrushing and knifing

The airbrush is a precise instrument that, with practice, can be used to produce smooth gradations of tone of almost photographic perfection. It is the stock-in-trade of many commercial artists, and is useful when major retouching is needed. Body-colour – opaque watercolour pigment – is used rather than dye, and although there remain the problems of altered surface texture and the danger of smudging, large amounts of pigment can be applied rapidly and effectively. Nevertheless, considerable practice is needed to apply the controlled gradations of tone that are the airbrush's best attribute.

Press down for air flow

Pull back for pigment flow

Airbrush action Most airbrushes are double-action, requiring a downward pressure to increase the flow of compressed air (from either a compressor or a can above), and a backward movement to increase the flow of pigment (above right). Synchronizing these two finger movements is the key to successful airbrush use. The principle of the airbrush is to produce a fine spray of pigment; the greater the air-flow,

the smaller will be the individual specks. By adjusting this flow you can, to some extent, match the graininess of a particular print. For a soft edge to the airbrushed areas, use either cotton wool or a constantly-moving piece of card instead of masking film.

Basic airbrush technique Dilute a small quantity of pigment in water. The ideal consistency for most airbrushes is that of milk. Partly fill the bowl of the airbrush with the diluted pigment, using a pipette. Test the action of the airbrush by spraying against a piece of card. With the print suitably masked – in the same way as for dye application – begin spraying.

Knifing to remove dark spots
1 With the broad edge of a sharp scalpel blade, gently shave the blemish on the print's surface. Make short strokes, keeping your fingers steady and using your wrist for movement. Stop before all the emulsion is removed, otherwise the roughened paper base will begin to show through.

2 For small spots, use the tip of the blade, but remember that there is a greater risk with this method of cutting through to the paper base. Knifing should never be done before any wet retouching (such as bleaching or dye application) as it physically damages the print and can result in dry bleeding away from its area of application.

size, which makes detailed work by hand difficult, even using a magnifying glass. Nevertheless, the advantage of working on a negative is that the re-touching, once complete, serves all future prints.

It is safest to limit negative re-touching to the broad correction of density. Decide whether or not any action is needed by first making a test print. If the negative is too dense, resulting in a light print and long exposure times

in the enlarger, it can be thinned by treating it with a reducer, which removes silver from the negative. To an extent, it is possible to favour one part of the negative by applying the solution locally with a swab. As with any irreversible chemical process, it is safest to reduce a small amount at a time, repeating the process until the right density is achieved. Adding density to a thin negative requires treatment with an intensifier solution.

Print enhancement Using simple techniques, the original print (below left) was retouched to achieve the more striking finished result (below right). To silhouette the cat, the background was bleached away into roughly the desired shape. The cat's eyes and light areas of fur were also lightened. Using dye, the edges were softened whilst trying to retain the natural appearance of the fur. The cat's dark markings were enhanced and solid blacks put around the eyes and nose. Some knifing was needed to smooth out imperfections in the eyes and to brighten the highlights. Lastly the whiskers were knifed in with a dark line brush ruled in as well to hold against the light areas.

Retouching black-and-white negatives

Equipment A light box (**1**) is the principal working surface. Cotton gloves (**2**) prevent finger marks on the film, and a magnifying glass (**3**) is essential for detailed work. A palette (**4**) is used for mixing dyes, and fine brushes (**5**) for applying them. Cotton swabs (**6**) have a number of uses. Water (**7**), opaque paste (**8**) and dyes (**9**) are the basic materials; de-natured alcohol (**10**) is used for cleaning negatives prior to retouching work, and reducer (**11**) is used for removing density.

Reducing negative density for a darker print tone

1 Prepare the two-part reducing solution according to the manufacturer's instructions and depending on the strength of the mixture that you want. Normally, mix one part of Solution A with two parts of Solution B. Solution B slows down the reducing action. Once mixed, the reducer will remain active only for about 10 minutes.

2 With the negative emulsion side up, on the light box, swab with water for two or three minutes.

3 With either a brush or cotton swab, apply the reducer smoothly and continuously. Keep the boundaries of the reduced area vague, so that the reduction will blend with the rest of the negative. Swab off the solution with water. If the reduction seems insufficient, repeat the process.

Increasing negative density for a lighter print tone

1 Clean the negative on both sides, with a cotton swab dipped in de-natured alcohol. Soften the gelatin by swabbing with water. You can work on either side of the negative – the emulsion side accepts dye more readily, but mistakes are difficult to correct. If you need to apply a considerable density of dye, use both sides.

2 Dip the brush in a weak dye solution, and remove the excess fluid by drawing if off against your thumbnail or a discarded piece of film. Alternatively, use a swab.

3 Apply the dye with gentle overlapping strokes. Some dyes, such as Kodak Crocein Scarlet, are designed to be used on the back of a negative. Others are intended for the emulsion side. Continue to add dye until you reach the density that you want.

Blocking out backgrounds with opaque paste

1 Opaque paste mixed to a working consistency with water is used in 35mm work together with shading (see page 107) to reduce vignettes or large white areas.

2 Clean the back of the negative with alcohol.

3 Apply the opaque with a fine brush to block any unwanted image.

Digital retouching

Electronic imaging makes it possible to manipulate pho-
tographs in an almost unlimited number of ways.
Provided that the image has been digitized, there is now
a variety of software that can process the information for
different effects. Until recently, digital retouching was
the preserve of repro houses who make the separations
for printing magazines and books like this. The reason
was simply the high cost of the scanners and computers
needed. Printing technology made early use of electronic
imaging, and the high end scanners required for making
screened separations for high-quality print work digi-
tally.

However, as computing power rises and computing
costs fall, desktop electronic imaging is now possible –
although the image quality and speed of operation are
not as high. A desktop computer with relatively inex-
pensive software such as Photoshop or ColorStudio®
allows scanned photographs to be manipulated to a high
degree of accuracy.

Scanners

There are three main kinds of scanner: flatbed print
scanners, chip slide scanners, and drum scanners.
Flatbed scanners are generally the least expensive, but
are better for black-and-white prints than for colour.
Higher quality colour scans are better performed with a
slide scanner, even if the original is a negative. Slide
scanners that use a CCD array form the bulk of low- to
mid-range models. Drum scanners, developed for the
printing industry, are at the high end of the market, and
can be extremely expensive. The quality of the result

Digital changes In this image
of the Pinnacles, a desert
landscape of petrified trees in
Western Australia, digital
retouching is being used to move
elements and extend the picture.
The original is above: the
retouched version, deliberately
shown in the middle of being
worked on, is at right. First, the
transparency was scanned on a
Nikon LS-3500 Film Scanner, a
medium-quality desk-top scanner
made for 35mm slides, at a fairly
high resolution to produce an
18MB file. Adobe Photoshop
software was then used for the
retouching: the rock on the left of
the picture was selected using the
lassoo tool and a "feather edge"
(for a soft outline). This selection
was reduced in scale and, using
the cut-and-paste facility, was
inserted in the distance. The rubber
stamp tool was then used to
"clone" some of the foreground
sand and cover over the space left
by the rock's removal.

depends first on the resolution of the scan, measured in lines, pixels or file size (Kb or Mb). As an indicator, a sharp 35mm transparency scanned and outputted at 8000 lines should look perfectly acceptable, but just noticeably softer than the original when examined under a 4x loupe. Another rule of thumb for publication is that a scanned colour image with a file size of around 12Mb should print perfectly well in a magazine or book at a size of around 15x15cm (6x6in). Colour and contrast also affect image quality, and nothing less than 24-bit colour is really acceptable. Software sophistication accounts for most of the differences between models of comparable specifications.

Computers and imaging software

Although the Macintosh has traditionally had a lead in desk-top image manipulation, PC compatibles are, after a late start, also usable. Image-file sizes for these applications can be very big – 20Mb is by no means unusual – and must all be capable of being stored in the memory together so that they can be worked on. Moreover, any change to the image requires a copy, thus doubling the amount of space needed by each image. As a solution, imaging software normally uses part of the hard disk space as virtual memory. Even so, a greatly expanded memory is essential – 2Mb at the very least – as is a fast processor. Both, naturally, are expensive. A good, large monitor is a great advantage, as is a graphics tablet with a cordless stylus. Images can be stored on removable hard disks, or optically on CDs, for which separate drives are necessary. Even though hardware prices regularly fall with time, computer image processing involves no mean investment. However, the possibilities are so great that photographers are increasingly taking this route.

Software programs are available that enable re-touching to be undertaken at a scale *less* than film grain size, thus being invisible to the eye. This kind of software offers painting features, with different sizes of "brush" having different edge effects and different textures. Masking is an essential feature – masks can either be drawn or created by the software from colour or value. Parts of the image can be sharpened, softened, blurred or streaked by means of custom "filters", and any selected part of the picture can be "cloned" to another area. Detailed work is done on enlarged sections. From repairing a scratch faultlessly to creating entirely new images, digital retouching has an undeniable role in photography.

Output

This is traditionally the weak link in the chain from the photographer's point of view. Most systems have been developed to make printer's separations from images, which is fine only if the image is being produced for a known publication. For most photographers, a print or slide is more useful, but while printers are reasonably well developed, there is less choice among film recorders, and all are expensive. Probably the best option is to send the image on a removable hard disk or CD to a service bureau.

Working 4
professionally

Much of this final section of the book is taken up with the needs of professional photographers, but its scope is actually much broader. The title has been chosen with care, because it is here that we show how the ways in which professionals work can be used to improve non-professional photography.

The term "professional" in this context ultimately means no more than earning a living from taking pictures, and by no means implies that amateurs are in any way second-class photographers. John Szarkowsky of the New York Museum of Modern Art commented that "a photographer's best work is, alas, generally done for himself", and although I only partly agree with this sweeping view, he pointed out an important issue: that a personal commitment, and individual vision, is at the core of good photography.

Professionalism remains an issue in photography. Is commercialism crass, and the value of the photographs taken in the pursuit of a career diminished proportionally? Is there instead an insufficiency of expertise and talent among amateurs, making only the dedication of professionals the proper platform from which to practice photography? These are the extremes but, on one side there are undeniable difficulties for amateurs, who usually lack the time and finance that would help their work, and, on the other, professionals have the problem that they must work within constraints imposed by their clients.

Tools of the trade Professional equipment extends beyond cameras and lenses (which are rarely pristine) to the logistics of photography. As well as the expected accessories, this includes documents – which range from press cards to a roll-by-roll shooting record.

The assignment approach

- Planning a shoot
- Travel
- Editing and presentation

Working methods developed for professional photographers can be entirely relevant to amateurs. The most fundamental is the structuring of a shoot as an assignment. For professional assignments, there is a contractual understanding, under which the photographer takes a considerable responsibility to produce images to a certain expected standard. Although this is not the case in non-professional photography, the value of treating a project as an assignment is that it gives a sense of purpose and direction. Some photography suffers from aimlessness, and a self-assignment will at least impose some conditions, such as the theme for the pictures, and a notional deadline. One of the great advantages that a professional photographer has is that someone else – a client – makes demands on that photographer's ability. This kind of challenge, applied regularly, is used by the best photographers to further their work.

Planning and logistics

While it is normally *creative* skills that make good photography, the ability to get into a position to *exercise* those skills is no less important. One of the essential qualities of a professional photographer is to be in the right place at the right time – and to be able to guarantee this by good organization. The art of photography is not always aesthetic; it can also be the art of managing situations so that the camera is where it needs to be. Luck, inevitably, plays a large part in all location photography, but efficient planning and logistics shorten the odds. One important method is to make up a checklist to cover all eventualities, covering the equipment, film, travel arrangements, personal baggage and administrative details. Not everything is needed each time, but such checklists can be trimmed down to order.

X-ray precautions

X-ray examination is all but unavoidable when travelling internationally by air. In theory, all X-ray machines have some effect on film; in practice, a few passes on normal film produces no visible damage. This at least is true of modern machines labelled "film-safe", but older machines are not reliable. X-rays fog unprocessed film in much the same way as visible light, but whether the results can be seen or not depends on the output, its duration, and the sensitivity of the film. X-ray dosage is cumulative, so that even if one pass through a machine has no effect on the film, a certain number will. Fast film is more sensitive than slow. Modern X-ray machines give dosages well below one milliroentgen – often around 0.3mR – and it would take 30 or more passes to damage ISO 100 film. This said, however, the matter is still disputed, as is the effectiveness of various proprietary containers that are claimed to be X-ray proof.

Wherever it is allowed, ask for a hand inspection. Under Federal Aviation Authority rules this is an entitlement in the USA, but nowhere else. This can be made easier for airport staff who are willing to do it by carrying the film in clear plastic bags; makes of film that are packed in clear plastic cans are even easier to check. Unless a trip involves many changes of flight (and so many inspections at airports), the problem is likely to be more theoretical than practical. One solution, increasingly possible nowadays, is to buy and process film in the country of destination

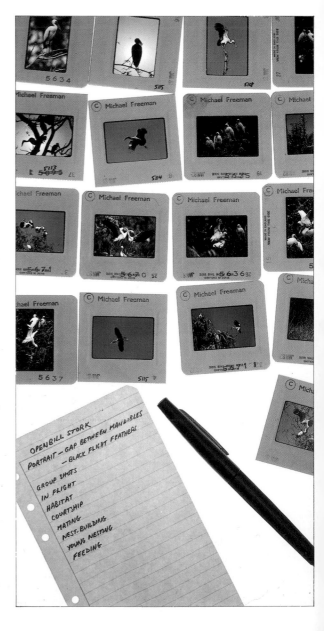

Rose petals for perfume, Grasse, France An image like this, used as the cover of a commissioned magazine story on perfume, is no casual lucky shot, but an organized event. During the brief harvest, rose petals arrive each morning at the perfume distillery and are emptied on the floor and scooped, like this, into buckets. However, making a strong image out of this involved ideas and planning. The whole operation was first watched the day before. For the shoot, the morning delivery was dumped below a catwalk, giving this overhead view. Also, the scooping was delayed until there were enough petals to fill the frame completely. This kind of planning is typical of the assignment approach to photography.

Organizing the material Having completed an assignment, a part of the job not to be under-estimated is arranging the photographs for presentation to the client. This may well include providing notes on picture content.

Equipment checklist

- General equipment and accessories
- Film storage and processing
- Special circumstances
- Insurance

Camera bodies

Carry at least one spare body. If possible, make sure that all are of the same make, so that parts can be interchanged. If you are likely to need to use two kinds of film at the same time (e.g. colour and black and white, or slow and fast colour film) you will definitely need a third body.

Special cameras and remote control

High-speed, panoramic and underwater cameras all have special uses, but if you have no real need for them, they will simply be an extra burden. Remember that a purpose-built underwater camera, such as the Nikonos, can survive rain or dust better than an ordinary camera. A small, simple viewfinder camera may be better than an obtrusive motor-driven Nikon in situations where you need to be inconspicuous. Also, consider taking a cheap Polaroid camera; if you can give to people that you wish to photograph an instant picture of themselves, you may find it easier to gain their co-operation.

Lenses

Even if money were no object, you would not be able to carry all the lenses that you might find useful. Decide what you really need, but take only the best that you can afford – the lens is your most important piece of equipment. Check whether you need any of the following lenses:
Fish-eye.
Extreme wide-angle.
Wide-angle.
Normal.
Moderate long-focus.
Extreme long-focus: If weight is important, consider instead a tele-converter' for use with a moderate long-focus lens.
Fast lens, for low-light conditions: This could double up as your normal lens, but also consider whether the high-speed film you are taking might be sufficient with your basic range of lenses.
Macro lens, close-up attachments and extension rings: Many professionals use a 55mm lens as their normal lens; while not particularly fast, its resolution is normally excellent through the focusing range. Use a bellows extension for extreme close-ups.
Perspective control lens: This is highly specialized and rather slow to use. Remember that, in an emergency, you can achieve a similar effect by using an extreme wide-angle lens, pointing it horizontally, and cropping the lower part of the picture later.
Zoom lens: If it covers a range of focal lengths that you find useful, and can actually replace two or more lenses, then it may be a useful weight-saver. There are also some situations, particularly those involving action, where it has a definite advantage over fixed-focal length lenses.

Camera and lens accessories

Neck straps.
Lens hoods.
Lens caps, front and back.
Camera body caps.
Filters: UV, polarizing, graduated, soft focus, effects, neutral density, colour conversion, colour compensating.
Filter holder.
Soft release button.
Cable release.
Double cable release.
Extension release for motor-drive.
Rubber eye caps.
Spirit level.
Spare batteries for TTL meter, motor-drive.
Spare focusing screen.

Camera supports

Tripod: You will have to compromise between weight and rigidity. Decide under what conditions you are likely to be using it.
Tripod head: Detachable locking screws often come loose, so carry a spare.
Monopod or table-top tripod.
Clamps, and small ball-jointed tripod head to fit thread adaptor.

Camera repair kit

Should include jeweller's screwdrivers, jeweller's claw, long-nosed pliers, file, heavy pliers, tweezers, tape, spare screws from old camera.

Cleaning equipment

Blower brush.
Lens tissues.
Cloths.
Chamois leather.
Anti-static gun or brush.
Lens cleaning fluid.
Toothbrush.
Cotton buds.
Compressed air.

Light meters

TTL heads.
Hand-held meter or spot-meter.
Flash meter.

Colour temperature meter.
Spare batteries.

Lighting

Portable flash and attachments.
Hot-shoe.
Extension cable.
Photo-electric cell if using secondary slave flash.
Mains adaptor.
Voltage adaptor (transformer).
Spare batteries.
Flash sync junction if using several flash units.
Small tripod with head to fit portable flash.
Light umbrella for diffusing portable flash.
Hand mirror.

Heavy-duty lighting

Heads.
Spare tubes.
Spare modelling lights.
Tripods.
Other stands, including boom arms and weights.
Power packs.

Power leads.
Reflectors for heads.
Diffusers, including umbrellas.
Barndoors and other shades.
Filters.
Fill-in reflectors – white card, foil.
Sync leads and junctions.
Photo-eclectic cells.
Spare fuses.
Spare length of lead.

Clamps – G, C, and spring.
Scissors.
Retractable-blade knife.
Screwdriver.
Cross-head screwdriver.
Allen keys.
Tape measure.
Clips.
Pins.
Safety pins.
Rubber bands.
Blue tack.
Glue.
Stapler.
Spare plugs.
Plug adaptors.
Tape.
Changing bag.

Cases

Consider a metal or high-impact plastic case for transporting equipment. It should be strong, waterproof and dustproof, gasket-sealed and capable of being locked. Its main function is to protect equipment on the move rather than be a case to work from. It should either have movable compartments or contain a foam block which you can cut to take your own pattern of equipment. When packing, make sure that there is adequate padding for all hard-edged items and that the camera shutters are not cocked (this relaxes the strain on the mechanism). Take care that nothing will activate any electrical equipment, such as the trigger release of a motor-drive, and for extra safety disconnect batteries. Leave at least one camera body loaded with a fresh roll of film in case you need to open the case and shoot in a hurry. On aircraft always try to take this case as carry-on baggage.

Shoulder bag: This should be light enough and flexible enough to work out of easily, but it should also be at least showerproof and fairly well padded. An anorak or light jacket can be stuffed inside to double as padding.
Tripod carrying case.
Lens cases.
Camera case: Most professionals dispense with these as they slow down the use of the camera, relying on the protection of a shoulder bag.
Lead-lined film bag.
Lighting cases.
General accessory case: A mountaineering stuff-sack is ideal.

Cold weather extras

Winterization: This is a factory or repair works operation, and involves changing some of the lubricants for thinner ones. Once done, you should use the cameras only in cold conditions until the original grade of lubrication has been replaced.
Camera tape: This not only protects your skin from sticking to the cold metal, but also keeps moisture out of the equipment (condensed moisture from your breath quickly freezes in gaps in the body, only to melt when the camera is taken indoors).
Space blanket: An extremely useful light wrap with highly efficient insulating properties, developed for emergency mountaineering use.
Electric element heaters: Battery-powered hand warmers and thermal garments are also useful for protecting camera and film from the effects of cold. Remember that the most serious problems are:
1. Film becomes brittle and can snap, particularly if a motor-drive is being used.
2. Mechanisms can jam, commonly because the lubricants have thick-

ened or moisture has entered and frozen.

3. Batteries become inactive.

Selenium-powered light meter: CDS meters, such as those in TTL heads, may cease to work in extreme cold.

Sealable bags and desiccant (silica gel): Put equipment inside the bags with the desiccant before taking them from the cold into a warm room, otherwise condensation may affect all parts of the camera.

Tropical extras

Camera tape: Essential for sealing gaps in the body in dusty conditions.

Desiccant (silica gel): Necessary in humid tropical conditions, both for equipment, which can rust and acquire fungus (lenses can be permanently ruined by fungus), and for film which deteriorates fastest under the combination of heat and humidity.

Underwater camera or housing: Although this may seem an extreme solution, under the worst conditions, such as during the rainy season in the Amazon basin or the monsoon in South-East Asia, it may be the only practical one.

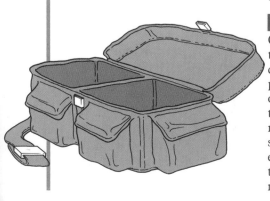

Film and processing checklist

Film supply

Always try to carry your own film with you on assignment, rather than buy it on the way. Check whether it is possible to buy and/or process film at the destination. If so, this will remove the difficulties of passing film through X-ray machines at airports. The standards of the stores and labs must, however, be reliable. Ideally, order film in bulk making sure that all the rolls of each type of film are from the same manufacturing batch (the batch number is printed on the pack). Test one roll of each type before leaving, to make sure that the film speed is actually as stated by the manufacturer and the colour balance is neutral. This way, you can be certain of your results, even though the assignment may be long. If you *do* have to buy film from an unfamiliar source, choose the largest retail outlet you can find (the stock turnover will be faster) and look for the expiry date on the pack.

Film types

Only experience with particular types of work will tell you what quantities of each type to take. Some photographers shoot more film than others, and uncertain subjects, particularly those involving action, will need more film than static, reliable subjects. If in doubt, take six 36-exposure rolls for each day you plan to be shooting; this will probably be more than you need, on average.

Film designated "professional" has been tested and shipped to higher standards of tolerance in speed and colour balance, but on a long trip, and particularly to a hot country, standard film may be better if fresh, as it is designed to "mature" on a dealer's shelf over a few months.

Basic colour transparency film.

Fine-grained colour transparency film.

High-speed colour transparency film.

Tungsten-balanced colour transparency film.

Special-purpose colour film.

Basic colour negative film.

High-speed colour negative film.

Basic black-and-white film.

Fine-grained black-and-white-film.

High-speed black-and-white film.

Special-purpose black-and-white film.

Absolutely essential on a long assignment is a record of what you shoot. If special processing may be required, you must be able to identify rolls without any doubts. For safety, if you have a good subject in front of you and sufficient time, split the shooting over more than one roll; if a mishap occurs with one, the other will be welcome insurance. Take a notebook and/or pocket tape-recorder, making sure that at the end of each day you have a legible written record. Also take stick-on labels for numbering rolls.

Film storage

Film deteriorates under high temperatures and high humidity, therefore protect it against these two conditions. Before processing, exposed film is more susceptible than unexposed film, and should be your top priority. Do not open cans of film before you are ready to use them, particularly when it is humid. If pos-

sible, keep the film in an insulated container, such as a polystyrene-lined cool-box. Always use liberal amounts of desiccant in porous bags. Periodically dry out the silica gel by heating in an oven or gently "cooking" it over an open fire. In an emergency, rice can be substituted for silica gel, although it is approximately ten times less effective. Packing the film container as fully as possible leaves no room for humid air.

Processing

If you are away on a long assignment, you must either (a) keep all the film with you for processing on your return, thereby running the risk of its deterioration, (b) send it home for processing, at the risk of it going astray, (c) have it processed locally, or (d) process it yourself. If you send it home, check the methods available beforehand – mail, air freight, or courier – and try to assess their reliability (ask someone with an unbiased opinion and local knowledge, such as a consul or magazine stringer). Also arrange for its reception at the other end, and establish some means of communication whereby you can get an idea of how the processed material looks (an agent may be able to do this for you).

Local processing can be unreliable; as soon as you arrive, send in a test film for express processing. Judge the results before sending anything important. For other processing systems, try to contact local professional photographers and ask their opinion about the most reliable laboratory. In small towns and remote areas, you may find that the local professionals process their own film, and you may be able to persuade one to handle yours.

Processing your own film is really only practical with black-and-white materials, and even then it will involve you in a great deal of effort. Think twice before attempting it.

Personal baggage checklist

In addition to your normal clothing and personal items, there are some things that are photography-related. Most location work is physically active, and frequently the weather conditions and terrain are not what you might choose. Your choice of clothing and footwear should reflect these considerations.

Clothing

Jacket: Ideally waterproof and with lots of pockets for film, documents and bits and pieces. However, many jackets that are very efficient in this respect can make you quite conspicuous. A light anorak for protection from the rain is an alternative.
Footwear: Important if your work involves a lot of walking, climbing and scrambling. Jogging shoes are excellent for general use, but if you are going to be moving over difficult ground a pair of boots will be better.

Medical supplies

Particularly when travelling abroad, you can save a great deal of time by supplying your own first-aid treatment. Take plasters, bandages, surgical tape, alcohol, scissors, antibiotics, water purification tablets, germicidal cream, and supplies for any conditions you are personally susceptible to.

Cold weather extras

Cold weather is not confined to the polar regions and high mountains. Even in warm climates, dawn can be cold, particularly if you are standing around waiting for sunrise, and aerial photography is nearly always cold.
Gloves: In really cold conditions, use a pair of thin silk gloves inside an outer pair.
Down jacket.
Over-trousers.
Balaclava.
Extra sweaters.

Tropical extras

Light waterproof anorak: In the wet tropics a necessity.
Salt tablets.
Sunglasses.
Suntan lotion and sunburn cream.
Mosquito netting, if you intend camping.

Travel and administrative checklist

Briefing
Do you have sufficient background information?
What is the best timing for season, weather, dates of events?
What is the client's deadline?

Other documents
General and specific letters of introduction/accreditation from client.
List of contracts (sources of information and help) at the location.
Documentation: Passport, including relevant visas.
Receipts, guarantees and list of serial numbers of equipment
Press card.
Driving license, including international licence.
Travel tickets, and separate confirmation list (most airlines issue a computer print-out showing confirmation status).
List of alternative transportation schedules.
Check weight restrictions for baggage.
Insurance: Both personal and equipment – check exclusions.
Finance: Advance against expenses from clients.
Cash, in relevant currencies.
Travellers cheques, and separate list of numbers.
Credit cards, separate list of numbers, and local contracts in case of theft.

Insurance
As a professional photographer, there are several areas of your work where you may be involved in losses or liabilities.

Equipment
All Risks Insurance will cover your equipment and film for accidental loss and damage, although mechanical failure, wear and tear are normally excluded. Check that the policy covers the particular countries involved in an assignment abroad, and that the equipment is insured on a "new for old" basis.

Car
If you use your car for business purposes, make sure that your existing motor insurance covers this.

Home
If you work from home, this may not cost any more than normal household insurance, but you will need to notify the insurers.

Public liability
You could be legally liable for causing injury or damage during an assignment. In particular, if you use a studio, you may find yourself responsible for the entire building.

Travel
If you travel abroad frequently it will pay you to take out an annual policy. In any event, check that medical expenses, loss of deposits, personal effects and personal accident are covered, and that the policy includes business travel.

Health
As most photographers' income depends on their personal work, insure against loss of income due to accident or illness.

Legal costs
To cover litigation that you may become involved in.

Weather
You can insure against costs involved in delays due to bad weather if you are working on location.

Professional indemnity
Unless the client indemnifies you against such claims, you can insure against your legal liability for libel and breaches against various Acts, particularly in advertising.

Editing

- Mounting transparencies
- Labelling and filing
- Making duplicates
- Audio-visual presentations

Whether a single roll of film, or a large number from a lengthy assignment, the processed images need to be viewed, selected and ordered. This is not, or at least should not be, simply a mechanical process. The choice and layout of photographs is a creative activity in its own right, and can add to the strength of the original images. There are two ways in which editing can make a creative contribution to a photographer's work. One is that it offers a chance to view the images in different circumstances. Having had time to reflect, and seeing the pictures over a light-box or with a projector, the photographer might see the assignment in a different light. The second way is through the juxtaposition of different photographs. If, say, a project yields about 50 pictures taken in different circumstances and at different times, there will be many ways of ordering them. The way in which photographs are seen in relation to each other has a very important effect on the viewer – this is, after all, the principle behind the picture essay (see Reportage in Part 2).

In a professional situation people other than the photographer often become involved in editing, but it is primarily the responsibility of the person who took the pictures. For convenience, it is best to develop a logical system for editing.

With slides, which are separately mounted, first discard all the frames that are technically unsatisfactory, whether wrongly exposed, slightly out of focus, scratched or whatever.

Then stamp or mark every frame with some reference, such as a number. This makes captioning easier later, and makes it possible to keep track of photographs. For instance, each roll of film might be given a number, and within this, each frame. The 12th frame of roll 20 could be stamped 20/12.

Look at each roll carefully, either on a light-box with a loupe (a small magnifying glass), or in a projector. If a number of exposures were made to get the best version of one shot, select the best frame at this stage. Some photographers at this point choose only the very best images from the take, and consign the remainder as "overs" or "seconds". Other photographers prefer to make a broader selection and then whittle this down to the very best. In any event, the aim is to end up with a relatively small selection of "first selects". Of course, the size of the final selection depends on the nature of the project. If, for instance, the photography is very much of a documentary style, and the subject matter is much more important than the style, the selection may well be big.

With black-and-white negatives, first make a contact sheet, and then assess the frames from this and by examining the negatives with a loupe. The best frames can then be marked with small labels or a chinagraph pencil.

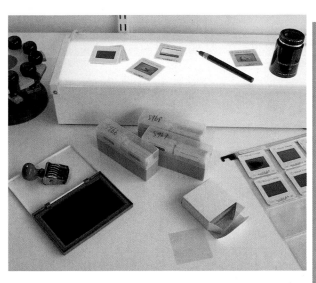

Logging in pictures

Professional photographers, and in particular those who earn their living from selling reproduction rights to their images, depend on an efficient filing system. Any number of methods are possible, but the prerequisites, as shown here, are a caption for each picture, a means of identifying each one (such as a number), and a way of storing them so that they can be viewed easily. Here, a light box is used when the newly processed transparencies arrive to caption and stamp them. Acetate slip covers protect the individual slides, which are then placed in a transparent sheet for hanging in a normal office filing cabinet.

Storing and filing transparencies

Although transparencies may be used for printing, it is more usual to view them directly, either in a slide projector or with a loupe on a light-box. Processing laboratories offer a choice between mounted and unmounted film, and mounts are usually either plastic or card, and may be hand-closed, glued or heat-sealed. Slide mounts with glass on either side of the transparency offer protection, but also the risk of causing scratches from trapped particles, or worse, broken shards if badly handled. All these options are a matter of personal preference. The reasons for having processed film unmounted to begin with are to give the photographer a chance to edit out unusable frames, or to use custom frames printed with the photographer's name.

At any one time, therefore, there may be sheets of unmounted film awaiting editing, and mounted slides. The latter can be filed in a number of ways: in acetate display sheets, typically holding 24 frames, that hang from bars in a standard filing cabinet; stacked in trays or boxes for maximum-density filing; or in the slide trays used with a particular projector.

If transparencies are to be sent to clients or agents, it is important to label and protect them adequately. With white card mounts, information can be written or printed directly; an alternative is printed or written adhesive labels. Essential information is the copyright notice (see Copyright and ownership later in Part 4), caption and reference number. Valuable added protection is given by an acetate slip cover; a number of slides can then be either boxed or mounted together in a clear plastic display sheet.

Mounting and labelling transparencies

It is essential to ensure that transparencies are adequately protected and properly identified. Develop a system for logging in transparencies, stamping your name, copyright mark, date and description on them. Many films are normally cut and mounted at the processing laboratory. Use a transparent slip-over cover. If a publisher uses a transparency for reproduction, it will have to be removed from the mount, so be prepared to re-mount used transparencies.

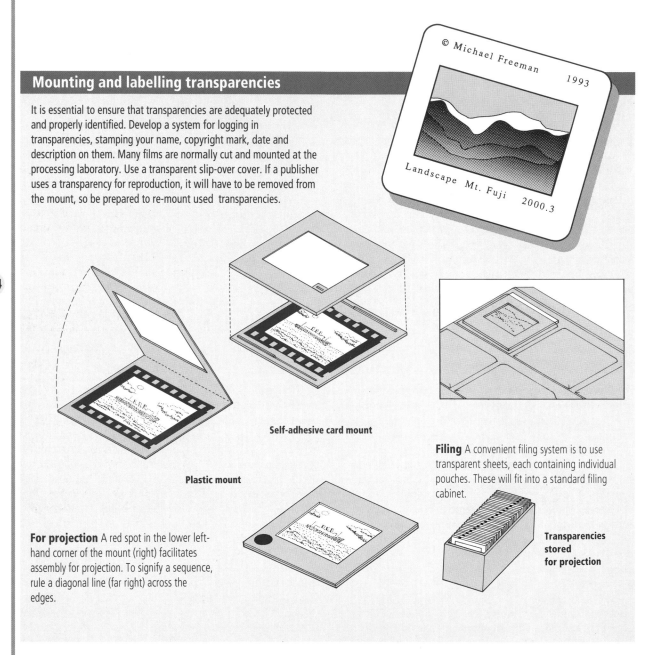

Self-adhesive card mount

Plastic mount

Filing A convenient filing system is to use transparent sheets, each containing individual pouches. These will fit into a standard filing cabinet.

For projection A red spot in the lower left-hand corner of the mount (right) facilitates assembly for projection. To signify a sequence, rule a diagonal line (far right) across the edges.

Transparencies stored for projection

© Michael Freeman 1993

Landscape Mt. Fuji 2000.3

Storing and filing negatives

As negatives are an intermediate stage and are used only in the darkroom it is not normal to cut and mount individual frames. Storage for 35mm negatives is fairly standardized: 36-exposure rolls are cut into strips of 6 frames, and these are arranged side-by-side in sheets of acid-free paper. For easy reference and assessment, a contact sheet is a key part of any standard filing system, the strips arranged in the same order as the sheet of negatives. The most common type of negative sheet is punched for filing in a ring-binder; the contact sheet can be punched and placed next to it. Storage conditions for negatives, as for any photographic emulsion, should be dry.

Storing and filing prints

Final prints are often made with a particular presentation in mind, and so are often mounted. Working prints need slightly less care in handling, but scuffing at the corners and scratches to the surface are the chief dangers. Store prints by size where possible, ideally in boxes made of acid-free card (the original paper boxes will do). Interleave the most valuable prints with acid-free tissue.

Duplication

There are a number of reasons for making duplicate slides from originals. Negatives are only used occasionally, for printing, and so can be stored safely for most of

the time. Transparencies, however, are both originals and the finished image. They are used in slide projectors or by printers for publication, and are at some risk of damage, or at least wear and tear. Also, a professional photographer may want to send a number of copies of an image to different clients or stock libraries, and while the best method is to shoot a larger number of originals, this is only possible with a static subject such as a landscape. Often, in one sequence of exposures, only one frame is just right. This is an obvious candidate for duplication.

The ideal method for making duplicates is to use a duplicating machine of the type described on page 239. Any step away from the original slide will cause some loss of image quality, although it may be neither obvious nor even important. When an original is compared side by side with a duplicate, the differences are usually clear. However, in normal circumstances, no one else ever sees the two together. And, with certain images there may even be an apparent improvement – in the intensity of certain colours, and in contrast if the original is flat.

The first step is to make a series of tests to calibrate the machine. Select one slide that has a normal range of tones and colour, and includes flesh tones and mid-greys, which are easy to judge visually. Choose the duplicating film; films made specially for this purpose have built-in masking to avoid or reduce the increase in contrast that is normal when copying slides.

Follow the machine manufacturer's instruction for calibration. Once the calibration has been set up, it is a relatively straightforward matter to alter filtration and

Mounting prints

1 Measure the picture area that is to appear when mounted, and mark the frame lines on the borders of the print in pencil.

2 Mark these dimensions on the back of a sheet of thick card and, using an angled mat cutter, cut each of the lines up to the corners. Trim with a scalpel.

3 On a second sheet of card – the backing for the mount – position the print and mark round the corners in pencil.

4 Having sprayed or brushed a light, even covering of glue onto the back of the print, roll it down onto the backing card using a sheet of tracing paper to avoid making marks.

5 Apply glue to the edges of the backing card, position the top piece of card, and press down firmly.

6 The mounted print is ready for display, but handle it carefully until the glue is completely dry.

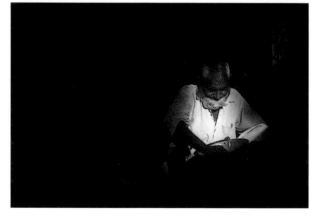

exposure for a fresh batch of film. The duplicating machine has a metering system, which usually works no better or worse than a simple camera TTL meter. Judge the original being duped as if it were a real scene in front of the camera; if it has a small, bright subject against a dark background, it will probably need less exposure than the meter indicates.

Good colour balance is the hallmark of a well-made duplicate. Gelatin filters can usually be placed in a drawer under the slide, or above it, in front of the lens. Colour film used for copying does not always respond to the dyes in the original transparency in the same way as it would to a real scene. One particular colour, for instance, may intensify, or change. Occasionally, there may be what is known as a cross-over effect, in which highlight colours acquire one cast while shadow colours acquire an opposite cast – this, unfortunately, cannot be corrected in this kind of duplicating.

If, on the other hand, the original suffers from a colour cast, such as from reciprocity failure during a long exposure, duplicating can correct it. This involves nothing more complicated than using the appropriate opposite colour filter. As a rule of thumb, the strength of filter

High contrast in duplicates
Slide copying tends to increase contrast in the duplicates. Special slide duplicating film is one answer. Failing this, most duplicating machines have a fogging device that gives an apparent reduction in contrast with regular camera film. Here, an already-contrasty transparency (top left) has been copied onto Kodachrome ISO 25 film. The straight version (top right) has lost all shadow detail. Using the fogging attachment at a medium setting (bottom left) has given some improvement; at full setting (bottom right), the contrast has been lowered even more, but at the expense of degraded whites.

needed tends to be about half of what looks visually correct if a filter is half over the original on a light-box. Another useful filter is a graduated type. This can be used in much the same way as it would be over the camera lens when taking an original photograph.

If ordinary camera film is used for duplicating, contrast tends to increase. This can be countered by overexposing slightly and reducing the processing (this lowers overall contrast), or by using the light-fogging facility offered by some duplicating machines. Neither technique, however, is really satisfactory, and a purpose-made duplicating film is a better choice.

Adjustable bellows allow various degrees of enlargement, and if the original is moved sideways, this can be selective. The graininess and sharpness of the image will be affected, however. Having calibrated exposure for normal 1:1 reproduction, the calculations for increased exposure with this enlargement are straightforward.

Audio-visual and multi-media

The basic audio-visual presentation is the slide show, and this can be as simple as a single slide projector showing a sequence of pictures on one screen, with a

Enriching colour by duplicating Copying slides does not necessarily always reduce quality. With simple images that rely on basic dramatic effect for their success, duplicating can add more punch. Here, a sunrise view of the Mittens in Monument Valley in the American South-west, the essential elements are a silhouette against a strongly coloured sky. Duplicating (right) makes the reds and oranges even stronger. For this type of effect, avoid over-exposure – this is easy in a case like this, where there are no shadow details to preserve.

An audio-visual presentation

An audio-visual presentation is an effective way of conveying many different kinds of information from educational material to sales promotions. The sophistication of the presentation largely depends on the equipment available to you, but even with a relatively modest set up of two slide projectors and a sound system, with careful planning you can communicate your message in an attractive and professional way. The assignment shown here was a promotion for a catering company. The presentation needed to impress potential clients with the standard of the product and to provide essential details about the service offered.

The equipment The basic set up for an audio-visual presentation consists of two projectors linked to a programmable dissolve unit that allows you to fade smoothly from one shot to the next at a predetermined rate. The visuals can then be linked to a prepared soundtrack of music and/or commentary.

The storyboard This essential planning stage for the film- and video-maker, is also a valuable way of constructing an audio-visual presentation. here the storyboard was used to provide a framework for the shots that the photographer had taken during the course of a day spent with the firm. It also highlighted the need for additional graphics that would have to be shot separately and allowed the photographer to begin thinking about a suitable soundtrack.

commentary by the photographer. It can also, however, be developed to a much greater degree by adding extra projectors, devices to fade smoothly from one image to another, using multiple screens, employing a script, soundtrack and music. The sequence of pictures can also be transferred onto video or onto a computer screen.

The first step up from a single projector show is to link a pair of projectors with a dissolve unit. This permits a smooth flow of images, without the disruption of a back screen between pictures, and the rate of dissolve, or fade, between images can be varied. Dissolve units can be programmed in advance, and linked to a soundtrack tape. In all, they offer some of the qualities of film editing, and can make an audio-visual presentation a creative form in its own right.

Sequence and timing assume a special importance. Dissolving rather than cutting from one image to another creates a special relationship between the images. At its most obvious, this fade can be used to point out similarities, such as shape or colour. The rate of the dissolve, from a fraction of a second to several seconds, also alters the viewer's perception; a slow dissolve gives the viewer's eyes time to wander around the screen, while a very slow dissolve can bring up the new image almost surreptitiously. Many of these effects have to be experimented with.

For the greatest control and polish, prepare a script, and then sketch out a rough storyboard from the choice of slides available. As work progresses, these can be

Cuts and dissolves

1 A close up of the company logo on the chef's jacket opens this sequence showing the preparation of the food.

2 A dissolve to a shot of the chef working in the kitchen, provides a simulated zoom effect.

3 Another dissolve – this time to the finished dish – conveys the impression of time passing.

4 A cut to a shot of another display of finished dishes indicates the wide range of food available.

Sandwich shot This shot of one of the directors sandwiched with a shot of a banquet scene encapsulated two key points of the promotion – friendly service and lavish presentation.

Pie chart This graphic device constructed in the studio was photographed in a sequence showing the various segments slotting into place. Displayed in rapid succession, these slides provided the opportunity for some simulated animation.

Portraits A set piece portrait of one of the serving staff provided the visual back up for commentary describing the company's attention to detail.

Closing shot A shot that emphasized the overall quality of the service was felt to be an appropriate way to end the presentation.

refined until finally there is a complete list of slides and a soundtrack with a commentary timed by the second. Cue words are noted for slide changes.

Slides can be cued manually during the presentation, but unless there is some value in being able to *ad lib* (such as for comic effect), many systems have facilities for pre-recording. The commentary is recorded onto tape, and music or sound effects are added. The slide changes, with the various dissolve rates, are then also recorded onto one track of the tape.

If the slide presentation is to be shown only a few times, there is no harm in using original transparencies. Repeated exposure, however, may damage slides, and it might be worth considering using duplicates.

Adding titles: Titling and special effects normally involve duplicating. Titles can be separate or superimposed on photographs; in either case line film gives a high-contrast image. Line film titles can be positive – black lettering on clear film, which can then be sandwiched with a normal slide, or negative – white lettering out of black. Titles can also be sandwiched with coloured gel for effect. Make up the title artwork with transfer lettering or the laser printer output from a word-processor, and photograph this directly onto 35mm line film. This film will then need to be processed in a special high-contrast developer – follow the film manufacturer's recommendations.

Professional photography

- Stock photography
- Fees and expenses
- The agent's role
- Getting published

When photography is used as a source of income, certain matters assume a new importance. While the majority of camera users may never need this information, the line between professional photographers and amateurs who earn money from their images is becoming increasingly blurred. Stock photography, in particular, is by no means the exclusive preserve of full-time professionals.

Stock photography

Stock photographs are existing photographs, which may have been taken on an assignment or for pleasure, that are available for hire. There is a highly developed stock picture industry in which stock libraries offer images to potential clients such as book publishers, advertising agencies and any company needing photographs that are immediately available. Stock photography, in fact, competes with commissioned photography; it carries the advantages for the client that the images can be bought as seen, without delay and usually for less than it would cost to employ a photographer to take them. The disadvantages are non-exclusivity and that even the best image may only approximate to what the client had in mind.

All photographers have a potential stock library, made up from accumulated work produced for various reasons, commercial and personal. By no means all, however, organize these pictures so that they can be leased. The great success of stock libraries – which tends to increase during recessions – reflects the enormous gap that exists between clients in need of all kinds of image, and the millions of transparencies and prints lying idle in photographer's filing cabinets. Almost every photograph ever wanted by an art director, however obscure the subject matter, probably exists already.

For the photographer, stock is cumulative. As time goes by and the photographer continues to shoot new material, the library of images increases. Also, a picture that has sold once is likely to continue selling, for the simple reason of inertia. A great deal of picture research is conducted on the basis of having actually seen an image already published. Stock libraries exploit this by publishing illustrated catalogues of selected images; this usually provides a significant boost to the sales of the published images.

Some photographers handle their own stock libraries, thereby retaining the full fee for each sale, but this naturally involves a considerable amount of work. The number of potential clients for stock images is so high that a large part of a stock library's costs lie in reaching them.

Fees

Given that most professional photographers are independent freelances, photography is very much an open market. Companies who use photography regularly, such as weekly or monthly magazines, often have a fee structure for normally commissioned work, and some photographers' organizations, such as the Association of Fashion Advertising and Editorial Photographers (AFAEP) in the UK, have also published guides to fees. Ultimately, however, guidelines like these are no more than a starting point. For a particular assignment, one professional photographer may be able to offer some quality of facility that commands a higher price than normal; on the other hand, a certain client may be unwilling to pay the recommended rate and be looking for a photographer willing to work for relatively little.

One method of working out a fee is on the basis of the time it takes – expressed as a day rate. Even if a single fee is agreed for the entire job, it may be arrived at by calculating how many days it is likely to take. Day rates vary according to the type of work and the standing of the photographer. Editorial day rates are normally less than advertising day rates, and within broad categories there is a range.

In magazine publishing, another fee basis is the size and number of pictures used, calculated on a page rate or space rate. Again, page rates vary according to the size and revenue of the magazine. It is also common on an assignment to link the day rate to the page rate, so that the photographer may be paid by the day (up to an agreed limit of the number of days to be spent) but, if the pictures used add up to more on the space rate, the difference would be added to the fee. Alternatively, a magazine may simply guarantee a certain amount of money, based on either day or space rates, and this would be the minimum.

Expenses are usually paid in addition to the fee, but this must be carefully established at the start. There is likely to be a limit on the expenses, and it is normal for the photographer to submit an estimate for the client to agree beforehand. There are differences in what is allowable as expenses; payment for an assistant, for example, or for the rental of the photographer's own studio space, is acceptable to some clients but not to others.

Agents

An agent sells a photographer's work for a commission. There are essentially two kinds of agents: those who represent and acquire work for the photographer, and those who sell reproduction rights to the photographer's existing body of pictures. In the first case, the agent and photographer have a fairly close business relationship, and the commission tends to be in the region of 25 per cent. In the second case, the agent functions as a stock library, and the commission is likely to be between 40 per cent and 50 per cent. Such stock agents may do no more than

Assignment confirmation/Invoice

From:

Your purchase order no.:

To:

Date:

Project:

Description:

Media Usage:

Photography fees

Basic Fee: at per day/ per photograph (if applicable)

Space Rate: at per (if applicable)

Travel/Prep Days: at per day

Postponement/Cancellation/Reshoot: % of basic fee

Tax (if applicable)

Amount

Total fees

Expenses

Film & processing

Assistants

Deliveries

Travel

Accommodation

Subsistence

Equipment/film transportation

Location search

Location/studio rental

Special equipment rental

Talent

Sets/props/wardrobe

Miscellaneous

Tax (if applicable):

Total expenses

Total

Stock photograph delivery

To:

From:

Date:

Project:

Delivery note no.:

Print/transparency

Picture no./description

Total

Total

Terms and Conditions

1. These photographs are submitted at your request on approval only and must be returned within one month except where my permission to reproduce has been obtained. After one month from the date of this delivery note a holding fee of per photograph per month is payable, except where permission to reproduce is granted, in which case the same holding fee shall be payable after six months from the invoice date.

2. The search fee shown below is now payable.

3. No use may be made of the photographs for any purpose whatsoever without my prior consent. Any reproduction rights granted must not be sold, transferred or otherwise dealt with.

4. Upon receipt, photographs are held entirely at your own risk against loss, theft or damage until received back by me. In the event of loss, theft or damage, a minimum fee of per transparency and per print shall be payable by you to cover loss of future resale income. The payment of this fee shall not entitle you to any additional rights in the photographs lost, stolen or damaged. If a lost or stolen photograph is subsequently found, this fee shall be refunded, less a holding fee of 10% thereof for each month elapsed after the notification of such loss or theft. Any loss, damage or theft should immediately be notified to me.

5. Reproduction fees and credit lines are to be agreed before publication.

6. Reproduction fees are payable within thirty days of the invoice date or upon first publication, whichever is sooner. After thirty days 2% per month of the unpaid balance will be charged.

7. All photographs shall remain my property and must be returned immediately after authorized use.

8. Two copies of any reproductions shall be sent to me upon publication.

9. While all reasonable care has been taken to ensure correct identification and captioning of these transparencies, I am not liable for losses caused by any errors.

10. The total number of photographs herein listed shall be presumed to have been received by you unless written notice to the contrary is received by me within 48 hours of receipt by you.

11. No warranty is made in respect of any releases or permissions for these photographs, unless specified in writing.

12. You shall indemnify me against any loss through your use of photographs for a purpose not expressly granted by me.

Upon receipt of these photographs the above terms and conditions are understood to be accepted unless the package is returned immediately to me by registered mail or by hand.

Search fee:

Received the above photographs under the terms and conditions stated on this delivery note.
Please sign and return one copy to acknowledge safe receipt.

Date:

Signed:

Formal agreements With commissioned work, it is important to agree all the conditions of the assignment in advance with the client, particularly usage, fees and expenses. A formal agreement can then later be used for invoicing. If you plan to handle your own stock photographs, then it is essential to use some comprehensive form of documentation when supplying photographs to customers. This serves as a record of the material sent out and lays down all the terms and conditions of the transaction. The sample forms (right) cover all the important points.

make the photographer's images available to anyone who asks for them, along with work of many other photographers, or the agent may sell more actively, such as syndicating picture stories to magazines in various countries.

The degree of service that the agent offers varies considerably. There may be very little contact between a stock agent and the photographer, but an agent actively seeking advertising work is likely to represent a small stable of carefully chosen photographers who rely on this for their entire schedule of work. An agent of this type will negotiate fees and terms, and undertake a large part of the photographer's own business.

Reproduction

The aim for most professional photographers is to have their work published, and most photographs that earn money end up on the printed page. Reproduction methods vary, as does the quality. The several stages of printed reproduction all have an effect on the final image: making the colour separations (in which the original photograph is converted into separate pieces of film each of which carries just one colour component); choosing the paper weight, quality and coating; proofing and corrections; printing; and any subsequent processes, such as spot varnish. Separation houses are accustomed to working with colour transparencies rather than prints, and it is for this reason that most professional photographers shoot transparency film.

A photographic image has a continuous range of tones, but in order to reproduce this with printing ink, it must be converted into a pattern of dots. This pattern, when seen at a normal viewing distance, resembles the continuous tone of the original, but makes it possible for each of the solid process colours – normally yellow, magenta, cyan and black – to be deposited on the paper without running and blurring.

This is done by means of a halftone screen, used at the stage of making the colour separations. Halftone screens are of different degrees of fineness or coarseness to suit the porosity and smoothness of the paper. The key measurement is the distance between dot centres, referred to as the frequency per centimetre or inch. Screens are available from 20 lines per cm (50 lines per in); the coarser screens are used with newsprint, which absorbs ink easily, while the finest screens need very smooth, coated art paper. The finer the screen, of course, the higher the reproduction quality.

There are three normal printing processes used: letterpress, gravure and offset-litho. In letterpress printing, the dots, which vary in size to give the range of tones, are raised above the surface of the plate, which may be zinc, magnesium, copper or plastic. The ink is carried on these raised dots. In gravure printing, by contrast, the ink is held in depressions in the plate. Gravure printing surfaces usually have a thin copper skin electroplated onto a steel cylinder, and because of the cost of cylinder-making, this process is usually reserved for long print runs. In offset-litho printing, instead of the image being carried in relief, the process makes use of the principle that grease on the image areas attracts the ink, while water on the non-image areas repels it. Because the plate is delicate, it transfers the inked image to a rubber "blanket" cylinder, which, in turn, comes into contact with the paper.

Halftone screens When a picture is photographed through a halftone screen, the light is split up into dots which vary in size according to the relative tone of the image. In the shadow areas the dots are large, crowding out almost all the white background, whereas in the highlight areas the dots are much smaller. Screens vary in degrees of fineness and the choice of screen depends on the quality of paper to be used. This picture (below and right) has been reproduced through five different screens.

65 dots per inch

85 dots per inch

133 dots per inch

150 dots per inch

175 dots per inch

Legal matters

- Photography in public places
- Copyright
- Permissions
- Loss and damage

There are four important legal areas that can affect photographers, particularly if the photographs are intended to make money. They are: restrictions on taking photographs, and the consequences of loss or damage. The law on some of these matters varies from country to country, from state to state, and even occasionally between cities as local ordinances or bylaws may be relevant. Moreover, laws and decisions affecting these can and do change. The guidelines given here are necessarily general and should not be taken as the last word. In specific cases, seek specific legal advice.

Taking photographs

In most public places there are few restrictions facing the photographer. An elaborate set-up, however, such as tripods, lights and models in a busy street, may be considered by police as an obstruction or a public nuisance. If in doubt, check local ordinances. Military and security-classified installations are almost always restricted, and in some politically sensitive countries this category may even extend to such seemingly innocuous subjects as bridges and railway stations. Most international airports also forbid photography for security reasons. Places open to the public but under private control, such as some parks, may impose their own regulations, and if these are not followed the photographer may be guilty of trespass.

There are normally no legal restrictions on photographing people in public places. Equally, though, the law is unlikely to protect a photographer who, by being intrusive, has angered the person being photographed. Using such photographs for different purposes is another matter, however (see below).

Copyright and ownership

Copyright is a property right relating to authors, in a general sense. Recent changes in the law in Britain and the USA have meant that photographers are now considered authors of their work. Nevertheless, copyright disputes in photography are quite frequent and rarely simple. The law differs considerably between countries, as do interpretations of the existing laws in individual cases; if the parties in a dispute are in different countries or states, the jurisdiction of the case may have an important bearing on the outcome.

In Britain, the Copyright, Designs and Patents Act 1988 gives photographers the first copyright in their work, whether commissioned by a client or not. This copyright can still be assigned to someone else, with the photographer's agreement. The exception is photographers who are employed; any pictures taken by them during their work belong to the employer. The copyright lasts until 50 years after the photographer's death, as it does for any other artistic work.

In addition, photographers have "Moral Rights", which cannot be transferred. These include the right to be identified as the author, the right to object to derogatory treatment of the photograph, the right not to have a picture falsely attributed to them. Someone commissioning a photograph also has a moral right – to privacy – that prevents the picture being published or exhibited without permission.

In the USA the Copyright Act of 1976 applies to photographs taken after 1 January 1978, and provides protection against the reproduction of any copyrighted work "in whole or any substantial part and by duplicating it . . . exactly or by imitation or simulation". Basically, unless a separate agreement has been made, the photographer is considered the owner of the copyright. The major exception to this is "work made for hire", when the photographer is an employee. Then the employer is the copyright owner. Protecting the copyright is the responsibility of the owner; normally this is done by displaying a copyright notice on the photograph and wherever it is printed, in the form: "(year) (photographer's name)". In a book or a magazine, a single copyright notice can protect all the contents. A more secure, but more involved, way is to register the copyright at the US Copyright Office. This might be considered for photographs of value. The period of copyright in most cases lasts for the photographer's life plus 75 years.

This said, there are in practice numerous loopholes and areas for dispute. Copyright can be assigned, in whole or in part, and some clients write this into contracts. Then the ownership may rest with the photographer, but the rights to use with someone else. Some courts have interpreted even a temporary client-photographer relationship as one in which the photography is work for hire. There have been cases in which one photographer has copied another photographer's work, making only slight alterations, and claimed that the new photograph is original.

Using photographs

Owning the copyright in a photograph does not automatically confer the right to use it – that is, to have it published. As a general rule, a photograph of a person can be published without his or her permission if it is for news or educational purposes, but not if it is for advertising or purposes of trade. For the latter, it is essential to have a model release signed by the person or people in the photograph. Many professional photographers have such releases signed as a matter of course.

Libel actions can occur if the text accompanying a published photograph is inaccurate or demeaning. This is normally, but not always, the responsibility of the publication. The photographer should, in any case, make

sure that caption information supplied with a photograph is accurate.

Images that appear in a photograph may themselves be copyrighted (see above), and here the right to publish depends very much on the way in which such images appear. If a copyrighted image, such as a picture on a television screen, appears in the background of a photograph, infringement is unlikely. In Britain, if a copyrighted image is "incidentally" included in another photograph, its copyright is not considered infringed.

Loss and damage

If a person or organization to whom a photographer has supplied work loses or damages the photograph, they are liable. The extent, and even the proof, of that liability depends on the agreement stated at the time the pictures were supplied. For this reason, all professional photographers and their agents accompany deliveries of photographs with a form stating the terms and conditions. All the clauses are designed to overcome known problems. In practice, even such terms and conditions do not necessarily prevent further dispute, particularly over the amount of compensation. There are basically three ways of valuing a photograph: market value, based on what that or a similar photograph has earned; intrinsic value, based on the cost of producing or replacing the photograph; and stipulated value, which is the amount stated in the agreement accompanying the photographs in the first place.

The right to use So much reportage photography involves taking pictures of people who are unaware of the camera that there are potential pitfalls in using the photographs. This is especially true of street photography. A picture such as this clearly depends on the subject being natural and not knowing that there is a photographer about to shoot. No permission is needed to take this kind of photograph, but it ought not be be used for advertising a product without the subject's permission. A legitimate use would be as reportage – in a newspaper, magazine or a book, for example.

Glossary

A

Aberration Lens fault in which light rays are scattered, thereby degrading the image. There are different forms of aberration, such as chromatic and spherical aberration, coma, astigmatism and field curvature.

Achromatic lens A lens constructed of different types of glass, to reduce chromatic aberration. The simplest combination is of two elements, one of flint glass, the other of crown glass.

Acutance The objective measurement of how well an edge is recorded in a photographic image.

Additive process The process of combining lights of different colours. A set of three primary colours combined equally produces white.

Aerial perspective The impression of depth in a scene that is conveyed by haze.

Anastigmat A compound lens, using different elements to reduce optical aberrations.

Angle of view The widest angle of those light rays accepted by a lens that form an acceptably sharp image at the film plane. This angle is widest when the lens is focused at infinity.

Angstrom Unit used to measure light wavelengths.

Aperture In most lenses, the aperture is an adjustable circular hole centred on the lens axis. It is the part of the lens system that admits light.

Aperture priority In-camera metering system in which the photographer selects the aperture and the camera meter adjusts the shutter speed accordingly.

ASA Arithmetically progressive rating of the sensitivity of a film to light (American Standards Association). Although superseded by the ISO system (qv), the latter makes use of ASA. In practice, the ratings are the same. ASA 200 film is twice as fast as ASA 100 film.

Aspherical lens Lens design in which at least one surface has a curve that is not a section of a sphere. Although expensive to grind, aspherical elements help to reduce certain aberrations, such as coma (qv).

Astigmatism A lens aberration in which light rays that pass obliquely through a lens are focused, not as a point but as a line. Astigmatism is normally found only in simple lenses.

Auto-focus Camera system in which the lens is focused automatically, either passively by measuring the contrast in a small central area of the picture, or actively by responding to an ultrasonic or infra-red pulse emitted by the camera.

Automatic exposure control Camera system where the photo-electric cell that measures the light reaching the film plane is linked to the shutter or lens aperture to adjust the exposure automatically.

B

Back lighting Lighting from behind the subject directed towards the camera position.

Barrel distortion A lens aberration in which the shape of the image is distorted. The magnification decreases radially outwards, so that a square object appears barrel-shaped, with the straight edges bowed outwards.

Base The support material for an emulsion – normally plastic or paper.

Between-the-lens shutter A leaf shutter located inside a compound lens, as close as possible to the aperture diaphragm.

Bounce flash Diffusion of the light from a flash unit, by directing it towards a reflective surface, such as a ceiling or wall. This scatters the light rays, giving a softer illumination.

Bracketing A method of compensating for uncertainties in exposure, by making a series of exposures of a single subject, each varying by a progressive amount from the estimated correct aperture/speed setting.

Brightfield illumination The basic lighting technique for photomicrography, directing light through a thin section of the subject. In effect, a form of backlighting.

Brightness The subjective impression of luminance.

C

Camera shake Unintentional movement of the camera during exposure, causing unsharpness in the image.

CCD array A silicon chip connected to electronic circuitry containing tightly-packed sensors known as charge-coupled devices (CCDs). In a digital camera (qv) or scanner (qv), a lens focuses an image on the array, and each sensor converts light falling on it from one small part of the scene into an electronic impulse. The image is thus digitized, the image quality depending largely on the number of CCDs in the array.

CD Compact disc, on which digitized information is recorded, for later reading by optical means. Originally developed for recording sound, CDs are now also used for storing other kinds of digitized information, including images, for which their high capacity makes them well-suited.

CdS cell Cadmium sulphide cell used commonly in through-the-lens light meters. Its proportionate resistance to the quantity of light received is the basis of exposure measurement.

Centre of curvature The centre of an imaginary sphere of which the curved surface of a lens is a part.

Characteristic curve Curve plotted on a graph from two axes – exposure and density – used to describe the characteristics and performance of sensitive emulsions.

Chromatic aberration A lens aberration in which light of different wavelengths (and therefore colours) is focused at different distances behind the lens. It can be corrected by combining different types of glass.

Circle of confusion The disc of light formed by an imaginary lens. When small enough, it appears to the eye as a point, and at this size the image appears sharp.

Coating A thin deposited surface on a lens, used to reduce flare.

Colour compensating filter Filter used to alter the colour of light. Available in primary and complementary colours at different strengths.

Colour contrast Subjective

impression of the difference in intensity between two close or adjacent colours.

Colour conversion filter Coloured filter that alters the colour temperature of light.

Colour coupler A chemical compound that combines with the oxidizing elements of a developer to form a coloured dye. It is an integral part of most colour film processing.

Colour temperature The temperature to which an inert substance would have to be heated in order for it to glow at a particular colour. The scale of colour temperature significant for photography ranges from the reddish colours of approximately 2000K through standard "white" at 5400K, to the bluish colours above 6000K.

Coma A lens aberration in which off-axis light rays focus at different distances when they pass through different areas of the lens. The result is blurring at the edges of the picture.

Complementary colours A pair of colours that, when combined together in equal proportions, produce white light.

Compound lens Lens constructed of more than one element, which enables various optical corrections to be made.

Condenser Simple lens system that concentrates light into a beam.

Contact sheet A print of all the frames of a roll of film arranged in strips, same-size, from which negatives can be selected for enlargement.

Contrast Difference in brightness between adjacent areas of tone. In photographic emulsions, it is also the rate of increase in density measured against exposure.

Converging lens Lens which concentrates light rays towards a common point. Also known as a convex lens.

Covering power The diameter of usable image produced at the focal plane by a lens when focused at a given distance.

D

Darkfield illumination Lighting technique used in photomicrography, where the subject is lit from all sides by a cone of light directed from beneath the subject.

Dedicated flash On-camera flash unit designed for use with a specific camera, linking directly with the camera's internal circuitry.

Definition The subjective effect of graininess and sharpness combined.

Density In photographic emulsions, the ability of a developed silver deposit to block transmitted light.

Depth of field The distance through which the subject may extend and still form an acceptably sharp image, in front of and beyond the plane of critical focus. Depth of field can be increased by stopping the lens down to a smaller aperture.

Depth of focus The distance through which the film plane can be moved and still record an acceptably sharp image.

Diaphragm An adjustable opening that controls the amount of light passing through a lens.

Diffraction The scattering of light waves that occurs when they strike the edge of an opaque surface.

Diffuser Material that scatters transmitted light.

Digital camera Camera that uses a CCD array (qv) in place of conventional film to record the image.

DIN Logarithmically progressive rating of the sensitivity of a film to light (Deutsche Industrie Norm).

Diopter Measurement of the refractive ability of a lens. It is the reciprocal of the focal length, in meters; a convex lens is measure in positive diopters, a concave lens in negative diopters.

Diverging lens Lens which causes light rays to spread outwards from the optical axis.

Dye cloud Zone of colour in a developed colour emulsion at the site of the developed silver grain, which itself has been bleached out during development.

Dye transfer process Colour printing process that uses colour separation negatives which in turn produce matrices that can absorb and transfer coloured dyes to paper.

E

Electromagnetic spectrum The range of frequencies of electromagnetic radiation, from radio waves to gamma rays, including visible radiation (light).

Electron An elementary particle with a negative charge, normally in orbit around an atomic nucleus.

Electronic flash Artificial light source produced by passing a charge across two electrodes in a gas.

Electronic imaging The recording of images on an electronic medium, such as tape, disk or CD. This may be either in digitized form (such as by using a CD array) or analogue (as in still video). Electronic imaging is used directly with a digital or still video camera, or secondarily, with a scanner to convert a conventional photograph.

Emulsion Light-sensitive substance composed of halides suspended in gelatin, used for photographic film and paper.

Exposure In photography, the amount of light reaching an emulsion, being the product of intensity and time.

Exposure latitude For film, the increase in exposure that can be made from the minimum necessary to record shadow detail, while still presenting highlight detail.

Extension A fixed or adjustable tube placed between the lens and camera body, used to increase the magnification of the image.

F

f-stop The notation for relative aperture which is the ratio of the focal length to the diameter of the aperture. The light-gathering power of lenses is usually described by the wider f-stop they are capable of, and lens aperture rings are normally calibrated in a standard series: f1, f1.4, f2, f2.8, f4, f5.6, f8, f11, f16, f22, f32 and so on, each of these stops differing from its adjacent stop by a factor of 2.

Field curvature In this lens aberration, the plane of sharpest

focus is a curved surface rather than the flat surface needed at the film plane.

Film speed rating The sensitivity of a film to light, measured on a standard scale, normally either ASA or DIN.

Filter Transparent material fitted to a lens alters the characteristics of light passing through it, most commonly in colour.

Fish-eye lens A very wide-angle lens characterized by extreme barrel distortion.

Flare Non-image-forming light caused by scattering and reflection, that degrades the quality of an image. Coating is used to reduce it.

Flash guide number Notation used to determine the aperture setting when using electronic flash. It is proportionate to the output of the flash unit.

Flash synchronization Camera system that ensures that the peak light output from a flash unit coincides with the time that the shutter is fully open.

Fluorescent lighting Vapour discharge lighting in which the inside of the lamp's jacket is coated with phosphors. These add a continuous spectrum to the single emission spectra. The colour recorded on film is difficult to predict, depending on the type and age of lamp, but is generally greenish.

Focal length The distance between the centre of a lens (the principal point) and its focal point.

Focal plane The plane at which a lens forms a sharp image.

Focal plane shutter Shutter located close to the focal plane, using two blinds that form an adjustable gap which moves across the film area. The size of the gap determines the exposure.

Focal point The point on either side of a lens where light rays entering parallel to the axis converge.

Focus The point at which light rays are converged by a lens.

Fresnel screen A viewing screen that incorporates a Fresnel lens. This has a stepped convex surface that performs the same function as a condenser lens, distributing image brightness over the entire area of the screen, but is much thinner.

G

Gamma Measure of the steepness of an emulsion's characteristic curve being the tangent of the acute angle made by extending the straight line position of the curve downwards until it meets the horizontal axis. Average emulsions averagely developed have a gamma of about 0.8, while high contrast films have a gamma greater than 1.0.

Gelatin Substance used to hold halide particles in suspension, in order to construct an emulsion. This is deposited on a backing.

Grade Clarification of a photographic printing paper by contrast. Grades 0 to 4 are the most common.

Grain An individual light-sensitive crystal, normally of silver bromide.

Graininess The subjective impression when viewing a photograph of granularity under normal viewing conditions. The eye cannot resolve individual grains, only overlapping clumps of grains.

Granularity The measurement of the size and distribution of grains in an emulsion.

Ground glass screen Sheet of glass finely ground to a translucent finish on one side, used to make image focusing easier when viewing.

Gyro stabilizer Electrically-powered camera support that incorporates a heavy gyroscope to cushion the camera from vibrations. Particularly useful when shooting from helicopters, cars and other vehicles.

H

Hardener Chemical agent – commonly chrome or potassium alum – that combines with the gelatin of a film to make it more resistant to scratching.

Hyperfocal distance The minimum distance at which a lens records a subject sharply when focused at infinity.

Hypo Alternative name for fixer, sodium thiosulphate.

Hypo eliminator Chemical used to clear fixer from an emulsion to shorten washing time.

I

Incident light reading Exposure measurement of the light source that illuminates the subject (of refracted light reading). It is therefore independent of the subject's own characteristics.

Infra-red radiation Electromagnetic radiation from 730 nanometers to 1mm, longer in wavelength than light. It is emitted by hot bodies.

Intensifier Chemical used to increase the density or contrast of an image or an emulsion. Particularly useful with too-thin negatives.

Inverse Square Law As applied to light, the principle that the illumination of a surface by a point source of light is proportional to the square of the distance from the source to the surface.

Ion An atom or group of atoms with a positive or negative charge, because of too few electrons (positive) or too many (negative).

ISO International film speed rating system (International Standards Organization). Arithmetic ISO speeds are effectively identical to ASA (qv) and logarithmic ISO speeds are effectively identical to DIN (qv).

J

Joule Unit of electronic flash output, equal to one watt-second. The power of different units can be compared with this measurement.

K

Kelvin The standard unit of thermodynamic temperature, calculated by adding 273 to degrees centigrade.

L

Latent image The invisible image formed by exposing an emulsion to light. Development renders it visible.

Lens A transparent device for converging or diverging rays of light by refraction. Convex lenses are

thicker at the centre than at the edges; concave lenses are thicker at the edges than at the centre.

Lens axis A line through the centre of curvature of a lens.

Lens flare Non-image forming light reflected from lens surfaces that degrades the quality of the image.

Lens shade Lens attachment that shades the front element from non-image forming light that can cause flare.

Line film Very high contrast film that can be developed so that the image appears in just two tones – dense black and clear. Also known as lith film.

Lith film See Line film.

Long-focus lens Lens with a focal length longer than the diagonal of the film format. For 35mm film, anything longer than about 50mm is therefore long-focus, although in practice the term is usually applied to lenses with at least twice the standard focal length.

Luminance The quantity of light emitted by or reflected from a surface.

M

Manual operation Camera operation in which the photographer overrides or by-passes automatic metering and focus.

Masking Blocking specific areas of an emulsion from light. For example, a weak positive image, when combined with the negative, can be used to mask the highlights so as to produce a less contrasty print.

Matrix Sheet of film used in the dye transfer process that carries a relief image in gelatin. This is temporarily dyed when printing.

Mean noon sunlight An arbitrary but generally accepted colour temperature to which most daylight colour films are balanced – 5400K, being the average colour temperature of direct sunlight at midday in Washington DC.

Megabyte Unit of information capacity in a computer, standing for 1000 bytes and abbreviated to MB. A byte is the individual digital unit. Large computer files, such as image files, are measured in megabytes.

Mercury vapour lamp Form of lighting sometimes encountered in available light photography. It has a discontinuous spectrum and reproduces as blue-green on colour film.

Mired value A measurement of colour temperature that facilitates the calculation of differences between light sources. It is the reciprocal of the Kelvin measurement

$$\frac{\text{one million}}{\text{Kelvins}}$$

Mirror lens Compound lens that forms an image by reflection from curved mirrors rather than by refraction through lenses. By folding the light paths, its length is much shorter than that of traditional lenses of the same focal length.

Monopod Single leg of a tripod, as a lightweight camera support for handheld shooting.

Multi-pattern metering TTL metering system in which the exposure is measured from different areas of the frame, and the setting calculated according to how this pattern compares with a library of different types of image already analysed and programmed into the camera's system.

N

Nanometer 10^{-9} metre.

Negative Photographic image with reversed tones (and reversed colours if colour film), used to make a positive image, normally a print by projection.

Neutral density Density that is equal across all visible wavelengths, resulting in an absence of colour.

Normal lens Lens with a focal length equal to the diagonal of the film format. It produces an image which appears to have normal perspective and angle of view.

O

Open flash Method of illuminating a subject with a flash unit, by leaving the camera shutter open, and triggering the flash discharge manually.

Optical axis Line passing through the centre of a lens system. A light ray following this line would not be bent.

Orthochromatic film Film that is sensitive to green and blue light, but reacts weakly to red light.

P

Paint program Computer imaging software which enables pixels (qv) and groups of pixels to be altered and manipulate electronically.

Panchromatic film Film that is sensitive to all the colours of the visible spectrum.

Panning A smooth rotation of the camera so as to keep a moving subject continuously in frame.

Parallax The apparent movement of two objects relative to each other when viewed from different positions.

Pentaprism Five-sided prism, which rectifies the image left-to-right and top-to-bottom.

Perspective-control lens Lens that allows movement perpendicular to the lens axis and covers a larger area than the film format; this combination allows converging verticals to be corrected. Sometimes abbreviated to PC lens, and also referred to as a shift lens.

Photo-electric cell Light sensitive cell used to measure exposure. Some cells produce electricity when exposed to light; others react to light by offering an electrical resistance.

Photoflood Over-rated tungsten lamp used in photography, with a colour temperature of 3400K.

Photomacrography Close-up photography with magnifications in the range of X1 to X10.

Photomicrography Photography at great magnifications using the imaging systems of a microscope.

Photon A quantum of light and other electromagnetic radiation, treated as an elementary particle.

Pincushion distortion A lens aberration in which the shape of the image is distorted. The magnification increases radially outwards, and a square object appears in the shape of a pincushion, with the corners "stretched".

Pixel The smallest unit of area of a digitized image, normally a square. The number of pixels in which the image is recorded determines its resolution.

Polarization Restriction of the direction of vibration of light. Normal light vibrates at right angles to its direction of travel in every plane; a plane-polarizing filter (the most common in photography) restricts this vibration to one plane only. There are several applications, the most usual being to eliminate reflections from water and non-metallic surfaces.

Posterization Darkroom technique that converts an image into areas of flat single tones, using tone separations.

Primary colours A set of any three colours that, when mixed together can be used to make any other colour, and when mixed together in equal proportions produce either white (by the additive process) or black (by the subtractive process). Red, green and blue are one set of primary colours; cyan, magenta and yellow are another.

Printing-in Photographic printing technique of selectively increasing exposure over certain areas of the image.

Prism Transparent substance shaped so as to refract light in a controlled manner.

Process lens Flat-field lens designed to give high resolution of the image on a flat plane. This is achieved at the expense of depth of field, which is always shallow.

Program mode Method of automating a camera in which different priorities can be selected by the photographer.

Programmed shutter Electronically operated shutter with variable speeds that is linked to the camera's TTL meter. When a particular aperture setting is selected, the shutter speed is automatically adjusted to give a standard exposure.

R

Rangefinder Arrangement of mirror, lens and prism that measures distance by means of a binocular system. Used on direct viewfinder cameras for accurate focusing.

Rear-curtain flash Flash synchronization system in a focal plane-shutter camera, in which the flash is triggered at the end of the exposure. In this way, a time exposure of movement under a combination of existing light and flash gives the effect of streaking that leads up to a moving subject rather than continues ahead of it.

Reciprocity failure (reciprocity effect) At very short and very long exposure, the reciprocity law ceases to hold true, and an extra exposure is needed. With colour film, the three dye layers suffer differently, causing a colour cast. Reciprocity failure differs from emulsion to emulsion.

Reciprocity Law EXPOSURE = INTENSITY X TIME. In other words, the amount of exposure that the film receives in a camera is a product of the size of the lens aperture (intensity) and the shutter speed (time).

Reducer Chemical used to remove silver from a developed image, so reducing density. Useful for over-exposed or over-developed negatives.

Reflected light reading Exposure measurement of the light reflected from the subject (cf incident light reading). Through-the-lens meters use this method, and it is well-suited to subjects of average reflectance.

Reflector Surface used to reflect light. Usually, it diffuses the light at the same time.

Refraction The bending of light rays as they pass from one transparent medium to another when the two media have different light-transmitting properties.

Relative aperture The focal length of a lens divided by the diameter of the entrance pupil, normally recorded as f-stops, eg a 50mm lens with a maximum aperture opening 25mm in diameter has a relative aperture of f4 $\left(\frac{100mm}{25mm}\right)$.

Resolution The ability of a lens to distinguish between closely-spaced objects, also known as resolving power.

Reticulation Crazed effect on a film emulsion caused by subjecting the softened gelatin to extremes of temperature change.

Reversal film Photographic emulsion which, when developed, gives a positive image (commonly called a transparency). So called because of one stage in the development when the film is briefly re-exposed, either chemically or to light thus reversing the image which would otherwise be negative.

S

Sabattier effect Partial reversal of tone (and colour when applied to a colour emulsion) due to brief exposure to light during development of an emulsion.

Safelight Light source used in a darkroom with a colour and intensity that does not affect the light-sensitive materials for which it is designed.

Scoop Smoothly curving studio background, used principally to eliminate the horizon line.

Selenium cell Photo-electric cell which generates its own electricity in proportion to the light falling on it.

Sensitivity The ability of an emulsion to respond to light.

Sensitometry The scientific study of light sensitive materials and the way they behave.

Separation negative Black-and-white negative exposed through a strong coloured filter to record an image of a selected part of the spectrum, normally one-third. Used in dye transfer printing, and also in non-photographic printing.

Shading Photographic printing technique where light is held back from selected parts of the image.

Sharpness The subjective impression when viewing a photograph of acutance.

Short-focus lens Lens with a focal length shorter than the diagonal of the film format. For the 35mm format, short-focus lenses generally range shorter than 35mm.

Shutter Camera mechanism that controls the period of time that image-focusing light is allowed to fall on the film.

Single lens reflex Camera design that allows the image focused on the film

plane to be pre-viewed. A hinged mirror that diverts the light path is the basis of the system.

Shutter priority In-camera metering system in which the photographer selects the shutter speed and the camera meter adjusts the aperture accordingly.

Slave unit Device that responds to the light emission from one flash unit, to activate additional flash units simultaneously.

Snoot Generally, cylindrical fitting for a light source, used to throw a circle of light on the subject.

Soft-focus filter A glass filter with an irregular or etched surface that reduces images sharpness and increases flare, in a controlled fashion. Normally used for flattering effect in portraiture and beauty shots.

Solarization Reversal of tones in an image produced by greatly overexposing the emulsion. A similar appearance can be created by making use of the Sabattier effect.

Spherical aberration In this aberration, light rays from a subject on the lens axis passing through off-centre areas of the lens focus at different distances from the light rays that pass directly through the centre of the lens. The result is blurring in the centre of the picture.

Split-field filter Bi-focal filter, the top half of which consists of plain glass, the lower half being a plus-diopter lens that allows a close foreground to be focused at the same time as the background.

Still video Electronic imaging system that uses video technology to capture still images. Still video is analogue, not digital.

Spot meter Hand-held exposure meter of great accuracy, measuring reflected light over a small, precise angle of view.

Stop bath Chemical that neutralizes the action of the developer on an emulsion, effectively stopping development.

Subtractive process The process of combining coloured pigments, dyes or filter, all of which absorb light. Combining all three primary colours in this way produces black (an absence of light).

T

Test strip Test of various exposures made with an enlarger.

Through-the-lens (TTL) meter Exposure meter built in to the camera, normally located close to the instant-return mirror of a single lens reflex or to the pentaprism.

Tone Uniform density in an image.

Tone separation The isolation of areas of tone in an image, normally by the combination of varying densities of line positives and negatives.

Toner Chemicals that add an overall colour to a processed black-and-white image, by means of bleaching and dyeing.

Transparency Positive image on a transparent film base, designed to be viewed by transmitted light.

Tri-chromatic Method of reusing or reproducing specific colours by the variable combination of only three equally distributed wavelengths, such as blue, green, red or yellow, magenta, cyan.

Tri-pack film Colour film constructed with three layers of emulsion, each sensitive to a different colour. When exposed equally, the three colours give white.

Tungsten-halogen lamp Tungsten lamp of improved efficiency, in which the filament is enclosed in halogen gas, which causes the vaporized parts of the filament to be re-deposited on the filament rather than on the envelope.

Tungsten lighting Artificial lighting caused by heating a filament of tungsten to a temperature where it emits light.

U

Ultra-violet radiation Electromagnetic radiation from 13 to 397 namometers, shorter in wavelength than light. Most films, unlike the human eye, are sensitive to ultra-violet radiation.

V

Vapour discharge lighting Artificial lighting produced by passing an electric current through gas at low pressure in a glass envelope.

Variable contrast paper Printing paper with a single emulsion which can be used at different degrees of contrast by means of selected filters.

Viewfinder Simple optical system used for viewing subject.

W

Wavelength of light The distance between peaks in a wave of light. This distance, among other things, determines the colour.

Wetting agent Chemical that weakens the surface tension of water, and so reduces the risk of drying marks on film.

Wide-angle lens Lens with an angle of view wider than that considered subjectively normal by the human eye (ie more than about 50°). Wide angles of view are characteristic of lenses with short focal lengths.

Z

Zone System A method of evaluating exposure, with implications for the photographic approach to a subject, developed by Ansel Adams, Minor White and others. Light measurement is converted to exposure settings by dividing the tonal range into specific numbered zones.

Zoom flash An automatic on-camera flash feature in which the angle of the beam of light varies according to setting of the zoom lens fitted.

Zoom lens Lens with a continuously variable focal length over a certain range at any given focus and aperture. It is generated by differential l movement of the lens elements.

Index

Bibliography

Adams, Ansel. *Camera and Lens: The Creative Approach.* New York: Morgan & Morgan.

Adams, Ansel. *Natural Light Photography.* New York: Morgan & Morgan.

Adams, Ansel. *The Print.* Boston: New York Graphic Society/Little, Brown; 1983.

Adams, Ansel. *Examples: The Making of 40 Photographs.* New York: Little, Brown; 1983.

Adams, Ansel. *Yosemite and the Range of Light.* Boston: New York Graphic Society/Little, Brown; 1979.

Avedon, Richard. *Avedon Photographs 1974–1977.* New York: Farrar, Straus & Giroux.

Berger, John. *About Looking.* London: Writers & Readers; 1980.

Brandt, Bill. *The Shadow of Light.* London: Gordon Fraser.

Cartier-Bresson, Henri. *The Decisive Moment.* New York: Simon & Schuster.

Evans, Harold. *Pictures on a Page.* London: Heinemann.

Evans, Walker. *Walker Evans: First and Last.* Secker & Warburg; 1978.

Frank, Robert. *The Americans.* New York: Aperture; 1959 etc.

Freeman, Michael. *Photography Workshop Series* (4 vols.). New York: Amphoto. London: Harper Collins; 1988.

Freeman, Michael. *The Photographer's Studio Manual.* London: Harper Collins; 1991.

Freeman, Michael. *Photographer's Handbook.* London: Harper Collins; 1993.

Garnett, William. *The Extraordinary Landscape.* Boston: New York Graphic Society/Little, Brown; 1982.

Gernsheim, Helmut & Alison. *The History of Photography from The Camera Obscura to the Beginning of the Modern Era.* New York: McGraw-Hill.

Haas, Ernst. *The Creation.* New York: Viking; 1971.

Haas, Ernst. *Ernst Haas: Colour Photography.* New York: Harry N. Abrams; 1989.

Haas Ernst. *In America.* New York: Viking.

Kane, Art. *The persuasive Image: Art Kane.* New York: Morgan & Morgan.

Langford, Michael J. *Basic photography.* London: Focal Press.

Leifer, Neil. *Sport.* New York: Harry N. Abrams.

Penn, Irving. *Worlds In A Small Room.* London: Secker & Warburg; 1980.

Penn, Irving. *Flowers.* New York: Harmony Books; 1980.

Perweiler, Gary. *Secrets of Studio Still Life Photography.* New York: Amphoto; 1984.

Rowell, Galen. *Mountain Light.* San Francisco: Sierra Club Books; 1986.

Snowdon. *Assignments.* London: Weidenfeld & Nicolson; 1972.

Sontag, Susan. *On Looking.* New York: Farrar, Straus & Giroux.

Steichen, Edward. *The Family of Man.* New York: Museum of Modern Art.

Szarkowski, John. *Looking At Photographs.* New York: Museum of Modern Art.

Winogrand, Garry. *Winogrand: Figments From the Real World.* Boston: New York Graphic Society/Little, Brown; 1988.

The Techniques of Photography. New York: Time-Life Books; 1976

The World of Camera. London: Thomas Nelson.

Close-up Photography and Photomacrography. Eastman Kodak; 1969.

The Concerned Photographer. New York: Grossman.

Great Photographic Essays From Life. New York: Time-Life Books.

Images of the World. National Geographic Society; 1981.

Credits

Almost all of the photographs in this book were taken for other purposes – that is, on assignment for magazine and book publishers. As a result, I owe thanks to a range of individuals and organizations that extends far beyond the confines of photographic publishing. Among the many individual picture editors and designers who unwittingly but ultimately made this book possible, I am in debt to Narisa Chakra, Caroline Despard, David Larkin, Lou Klein, the late Pamela Marke, Didier Millet, Don Moser, John Nuhn, John Owen, and my agent Anna Obolensky.

Magazine and book publishers who have supported me over the years include the BBC, GEO, Houghton-Mifflin, National Wildlife Federation, Pan Books, River Books, Smithsonian Magazine, Stewart Tabori & Chang, Sunday Times Magazine, Thames & Hudson, Time-Life Books, and Weldon-Owen Publishing. In addition, specific thanks to Photobition for digital scanning, and Cowbell West Ten for their usual high standard of processing and laboratory work.

Quarto would like to thank the following companies for their help in providing information and transparencies: Buying Cameras Magazine; Canon UK Ltd; De Vere; Durst UK Ltd; Fuji Photo Film UK Ltd; Johnson's Photopia; Keith Johnson and Pelling; Kodak Ltd; Leica; Minolta UK Ltd; Nikon UK Ltd; Pentax UK Ltd.

All photographs in this book were taken by Michael Freeman with the exception of the following:

Abbreviations
l = left
r = right
b = below
t = top

p 28 Quarto Publishing Plc (l)
p 90 Barry Lewis/Network (b)
p 91 Trip/Helene Rogers (b)
p 122 © Arnold Newman (bl)
p 126 Barry Lewis/Network
p 136 Duclos/Gamma/FSP (t): Walker/Gamma/FSP (b)
p 137 Merillon Gamma/FSP (b)
p 139 Julian Broad
p 140 The Kobal Collection
p 141 Julian Broad
p 142 + 143 Phil Starling
p 144 Didier Millet
p 145 Barry Lewis/Network
p 148 Toni and Guy
p 149 Uli Weber/Cosmopolitan
p 150 Tony McGee
p 151 Paul Seheult/Trip
p 185 Trip/Ron Williamson
p 186 Trip/Ron Williamson
p 191 Gamma/FSP
p 193 Gamma/FSP (b)
p 194 Sporting Pictures UK Limited (t)
p 195 Gamma/FSP (tl)
p 227 Jane Strother (t)

Every effort has been made to trace and acknowledge all copyright holders. Quarto would like to apologise if any omissions have been made.